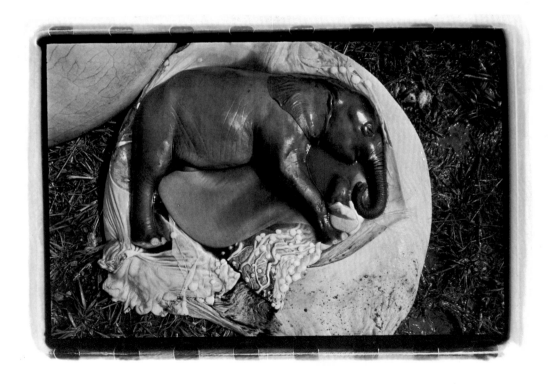

The End of the Game

text and photographs by Peter H. Beard

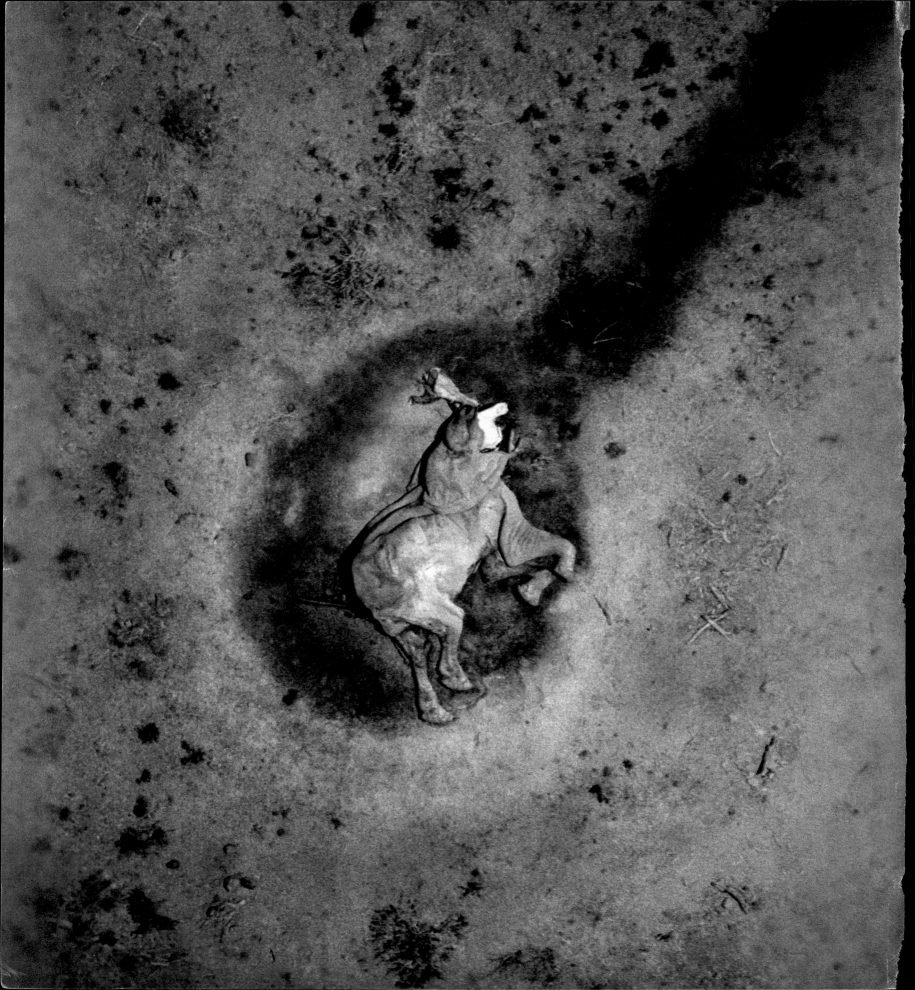

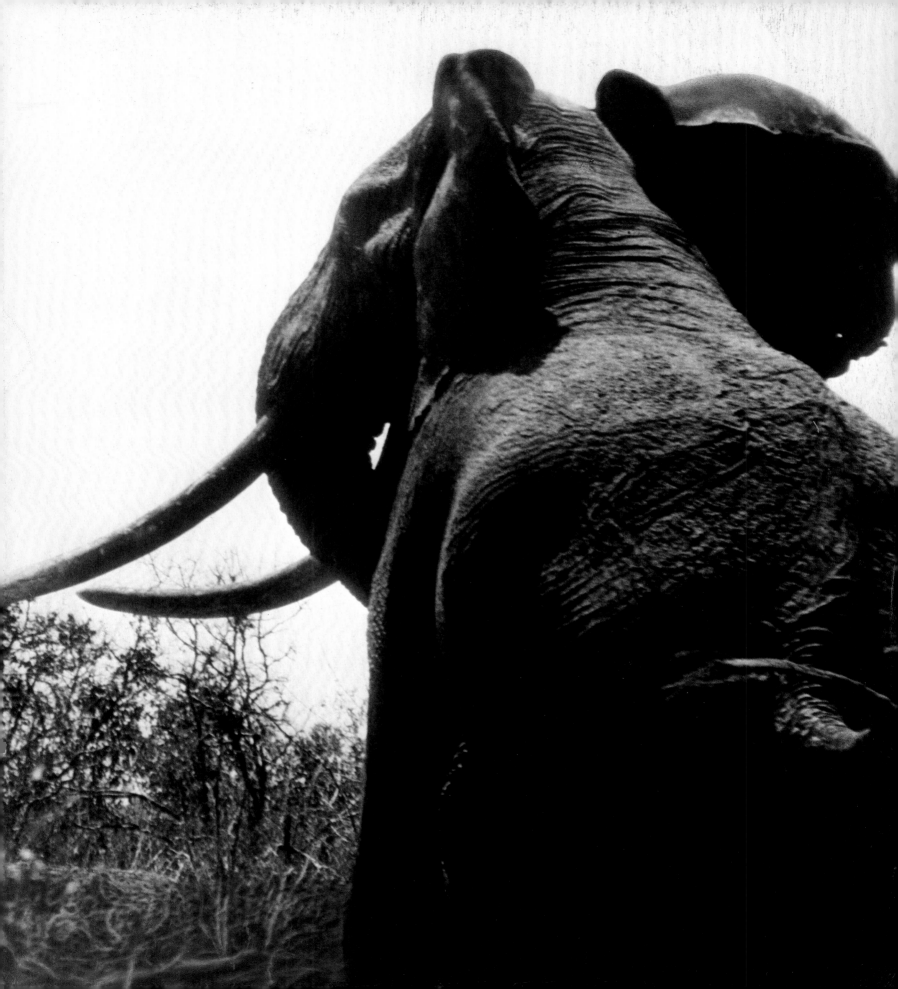

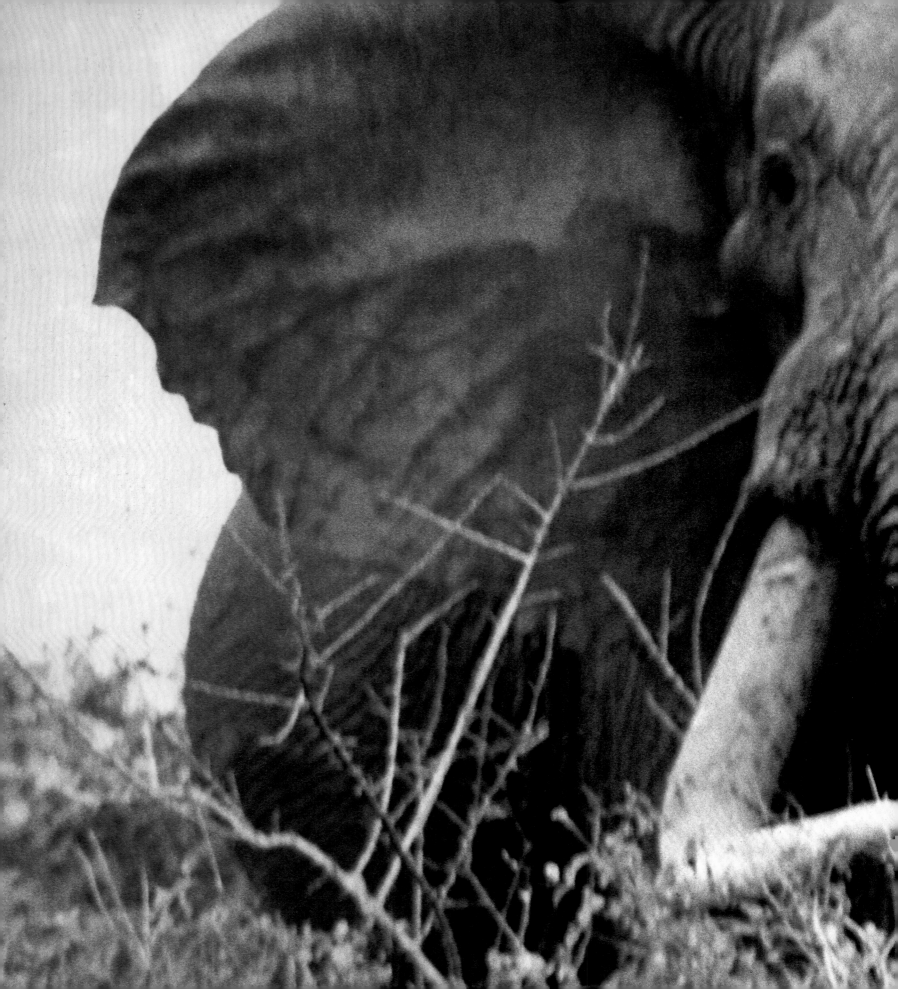

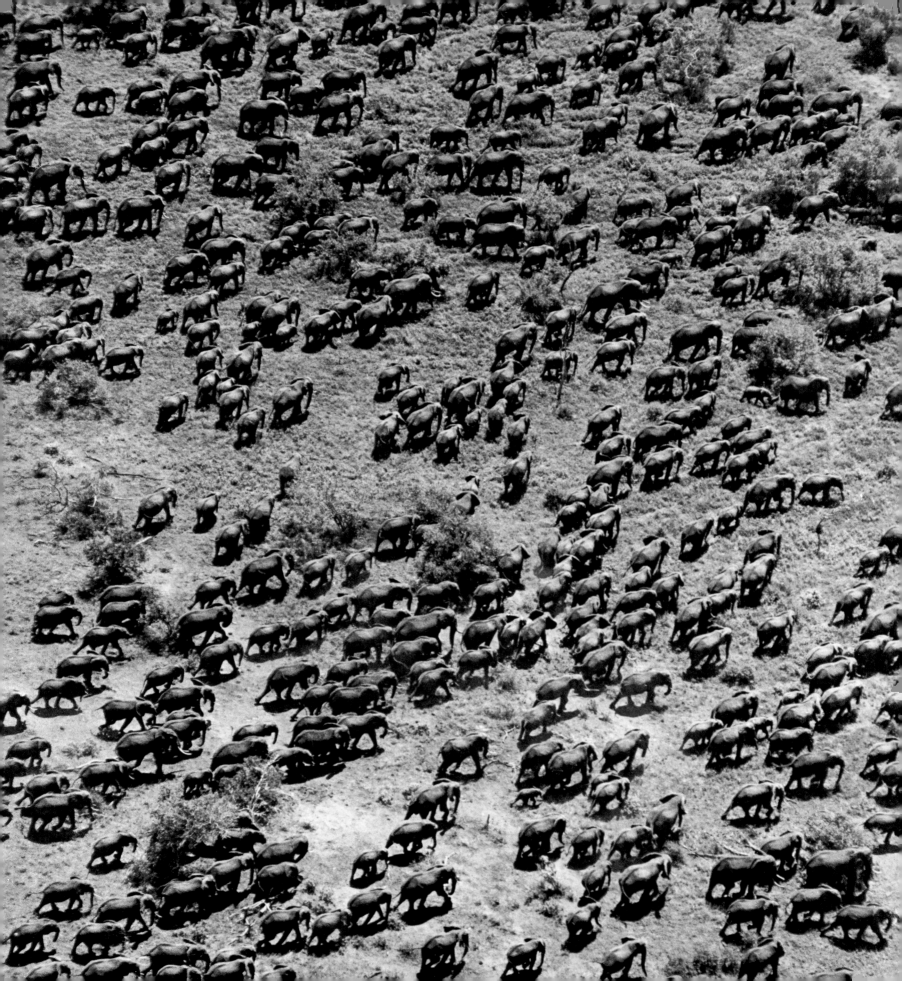

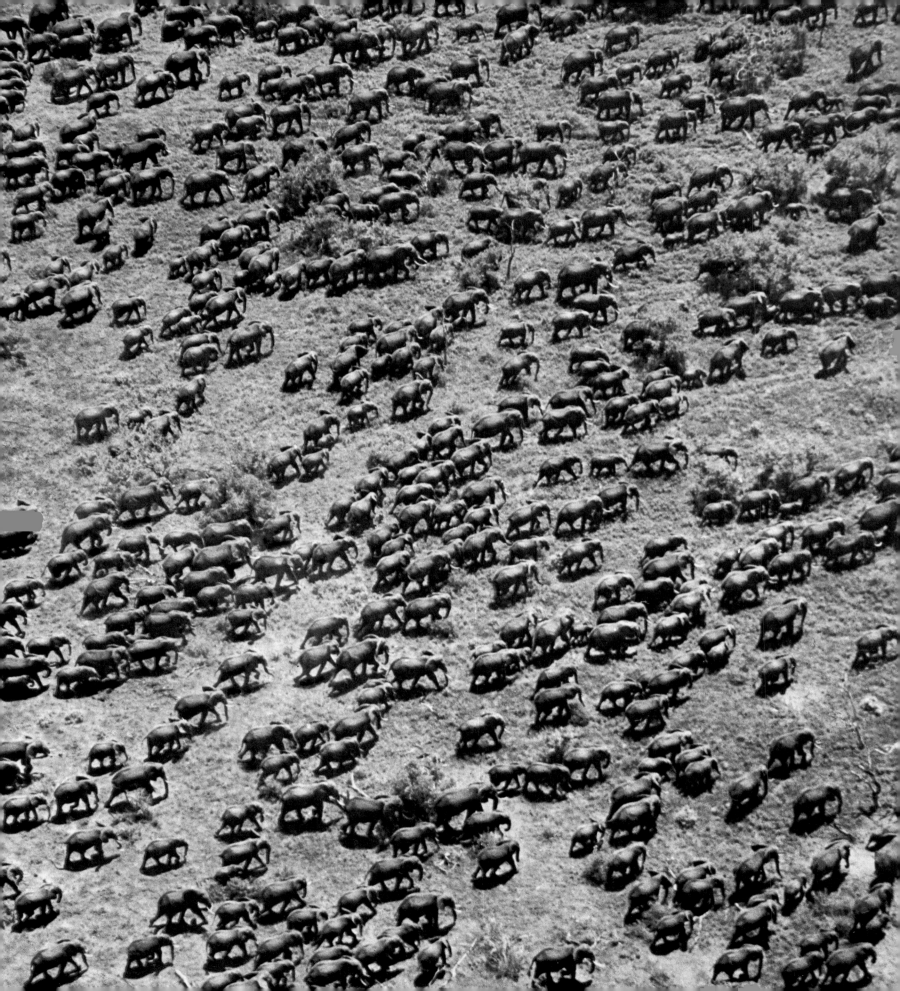

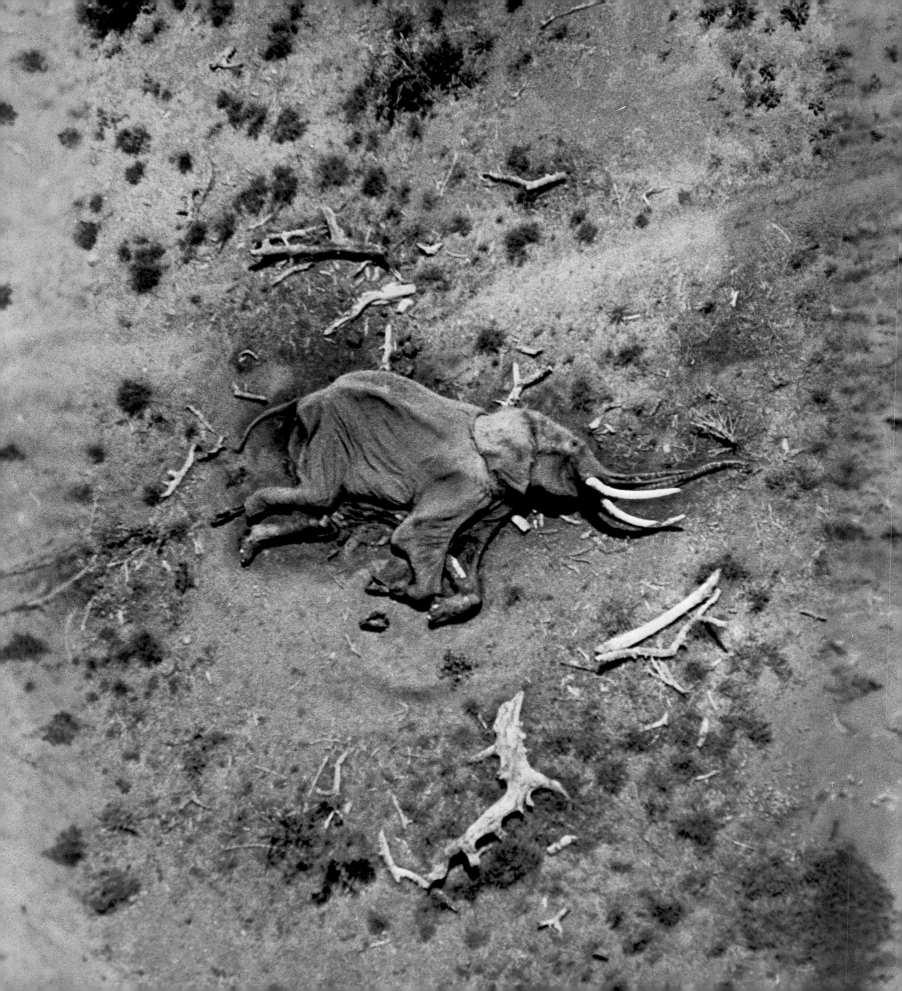

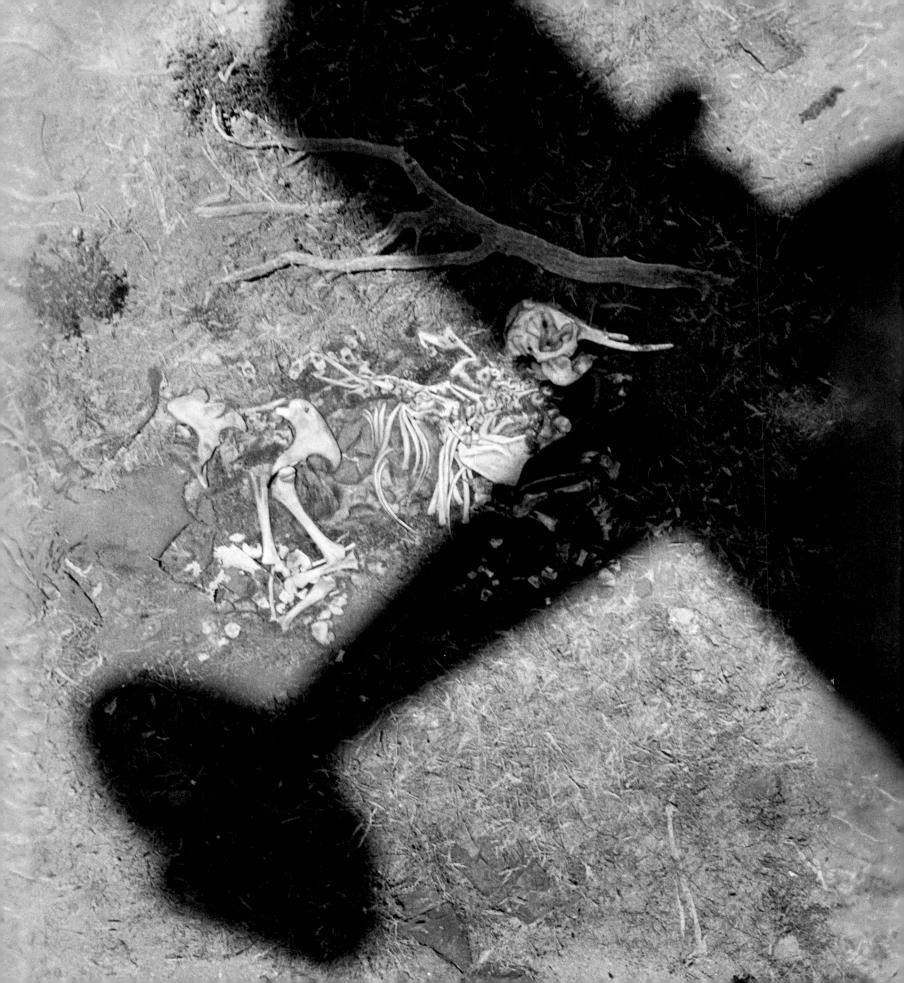

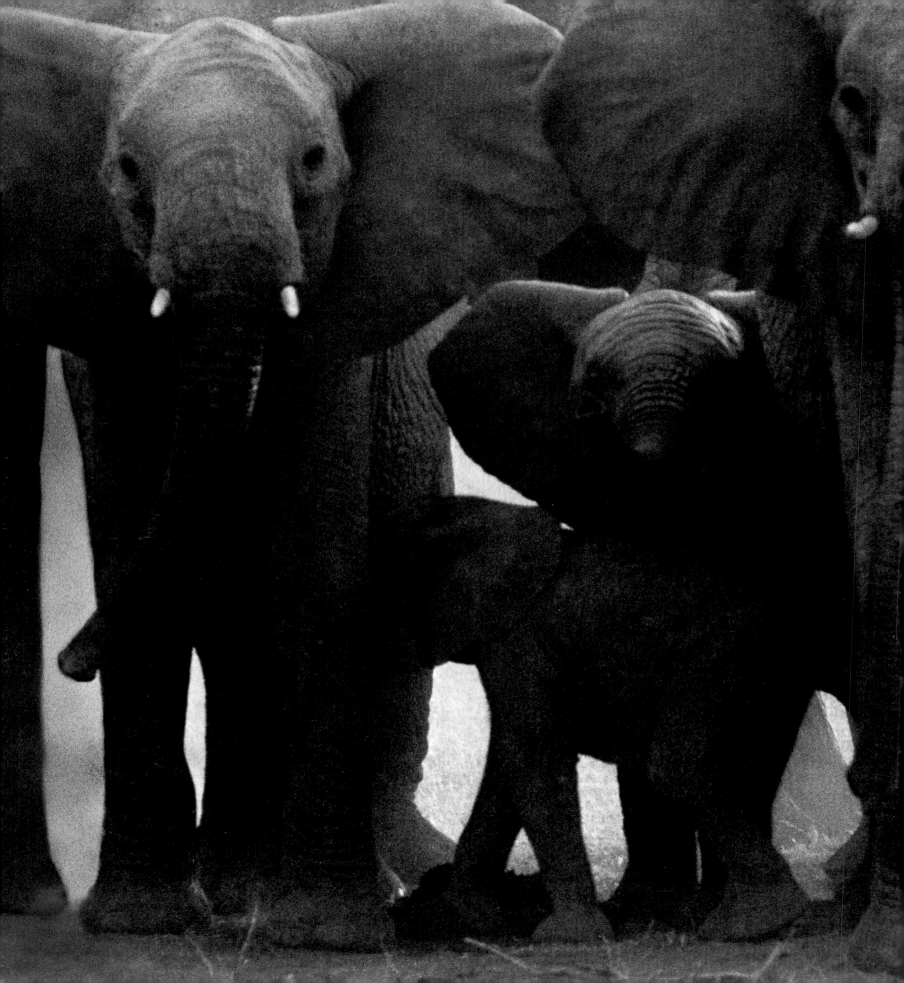

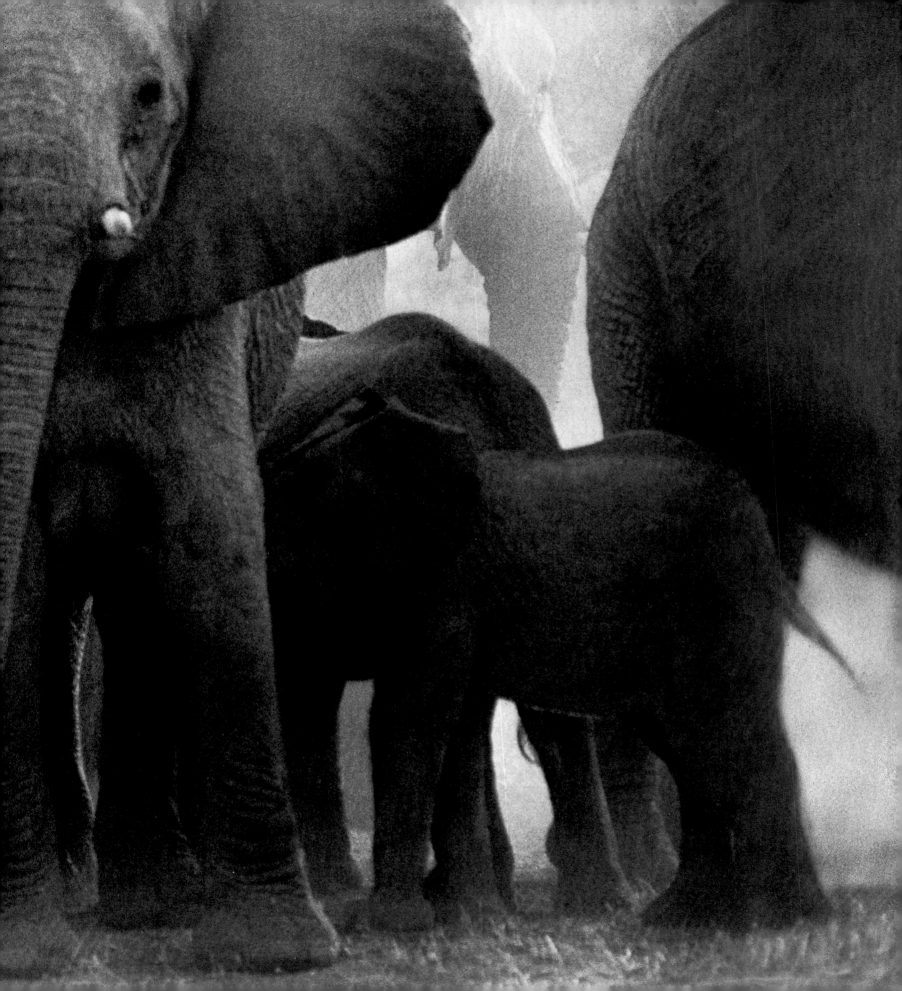

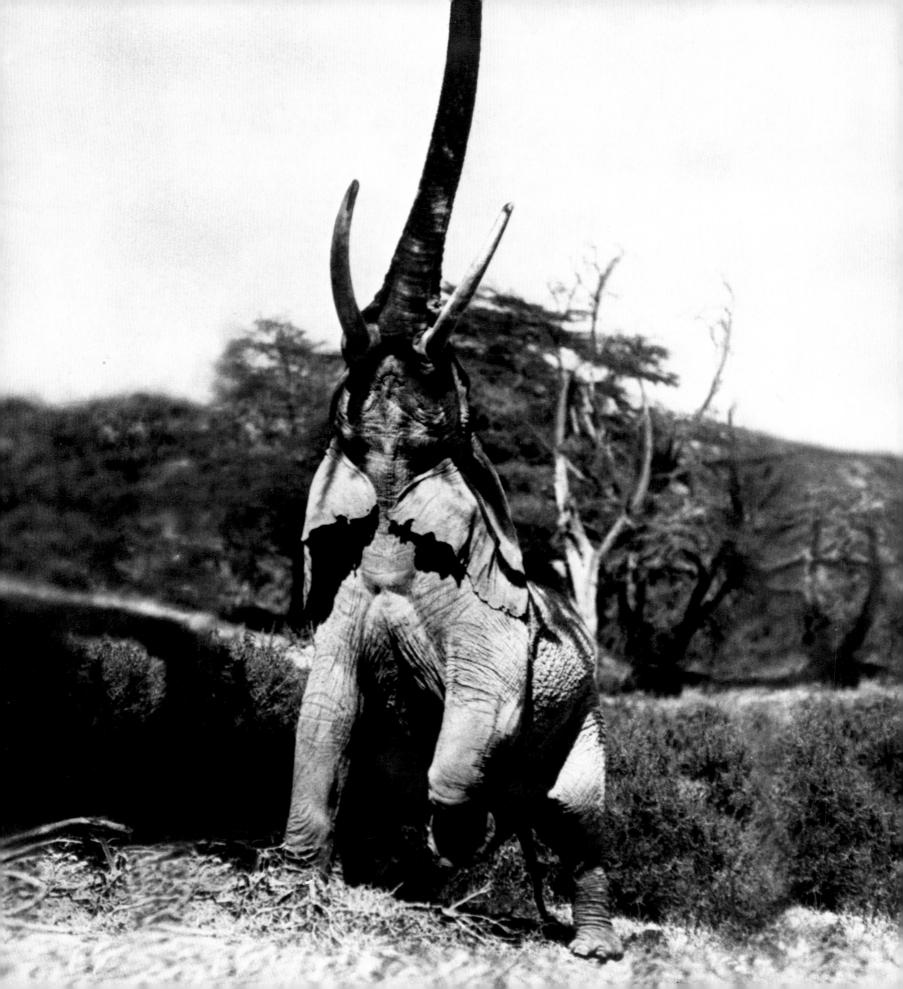

The End of the Game

THE LAST WORD FROM PARADISE

A PICTORIAL DOCUMENTATION OF THE ORIGINS, HISTORY & PROSPECTS OF

THE BIG GAME

IN AFRICA

ITS DIVERS PEOPLES, MOUNTAINS, RIVERS, RAILROADS, RESOURCES, RESERVES & INNUMERABLE RARETIES,
FEATURING, WITH FULL PERSPECTIVE, A TWENTY YEAR ILLUSTRATED RECORD

OF

THE GREAT PACHYDERM (LOXODONTA AFRICANA) AND MAN

TOGETHER WITH A

Stirring Narrative of Early Life, Exploration, Discovery, Daring Missionary Feats & Hunting Episodes
in Kenya Colony, Tanganyika, Uganda, Ethopia and various territories even more remote.

INCLUDING A COMPLETE, AUTHENTIC, RICHLY DETAILED REPORT ON HUMAN PROGRESS
AND ALL ITS MANIFESTATIONS IN THE HITHERTO UNSPOILED WILDERNESS WITH EXTRA-ORDINARY
EXPLOITS OF THE LATE KAREN DINESEN VON BLIXEN, PHILIP PERCIVAL, J. A. HUNTER,
COLONEL RICHARD MEINERTZHAGEN AND EWART S. GROGAN...

CONTRIBUTORS AND FRIENDS OF THE AUTHOR

Enlivened with Accounts of Human Despair and Endurance, Adventure & Achievement,
Triumph and Defeat, Amongst Local Inhabitants, Wild Beasts, and All the
Raw Forces of Nature——Fully Appreciating the General and Accelerating Course of Events.

Presenting the never-before-published, hand-written
diaries of Colonel John Henry Patterson, single-minded pursuer of
The Man-Eaters of Tsavo.

THE WHOLE ENRICHED with upwards of THREE HUNDRED Photoengravings & Stonetone Plates
Including genuine Portraits of all the most remarkable Travellers executed by artists of celebrity...
but deriving primarily from the personal collections and experiences of the concerned author & photographer

PETER H. BEARD

DOUBLEDAY & COMPANY, INC. GARDEN CITY, NEW YORK
CMLXXVII

Designed by Ruth Ansel

This is a revised and updated edition
of the book published under the same title by Viking Press in 1965.

Copyright © 1963, 1965, 1977 by Peter Hill Beard
All Rights Reserved

Library of Congress Catalog Card No. 77-12271

ISBN : 0-385-13124-0

Printed in the stonetone process, U.S. Patent No. 3,581,660, by
Rapoport Printing Corp., New York, N.Y. on the Roland Ultra VI 4-color press.

The 80 lb. matte coated, self binding® paper was manufactured by
P.H. Glatfelter Co., Spring Grove, PA.

Bound by Sendor Bindery Inc., New York, N.Y.
Each signature was individually welded by their patented process.

The text was set in 11 pt. Caslon Old Style by
D/G Typographers Inc., New York, N.Y.

The antique type faces from the
Frederic Nelson Phillips Collections were set by
Tri-Arts Press Inc., New York, N.Y.

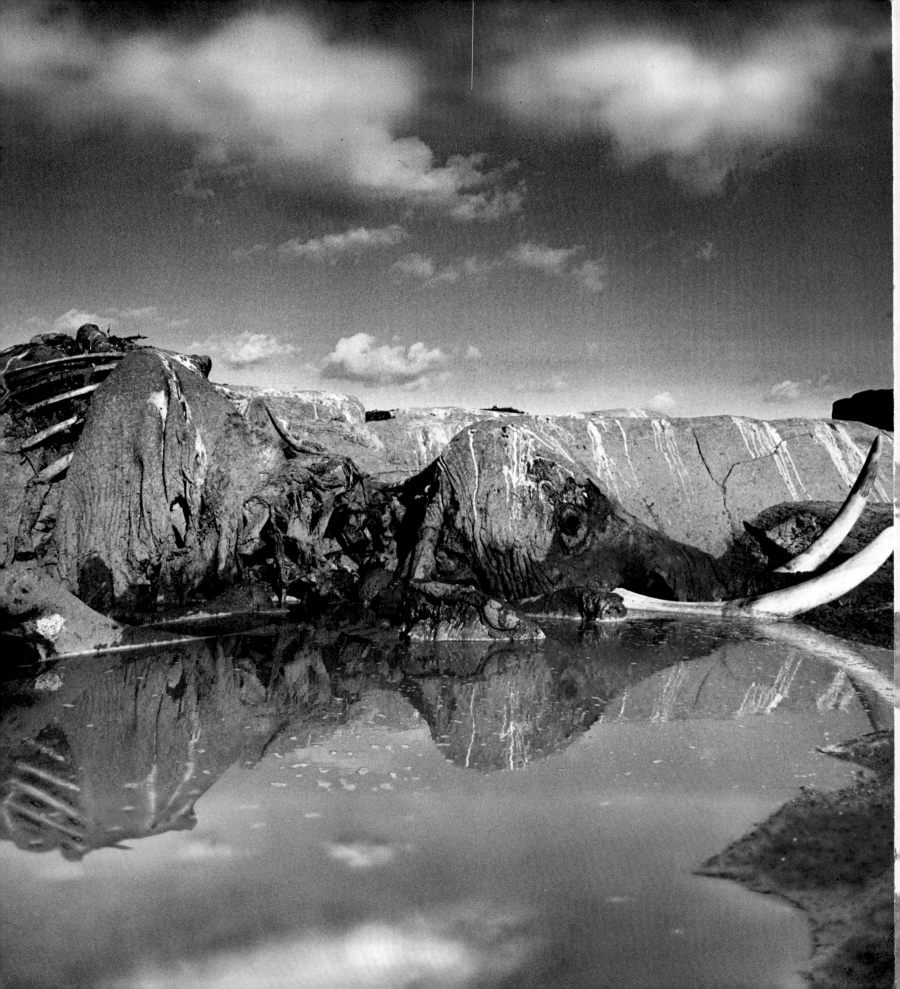

Theodore Roosevelt, during his safari of 1909, which inaugurated big game
hunting in East Africa, visited the small village of Londiani, where my father had a
shop. He was pleased to observe the hybrid roses my father had planted; and as
they both shared an interest in rose-grafting, they spent some time together discussing
gardening. Since then change has swept over East Africa at such velocity it is
hard to appreciate what was, what could have been . . . We suspect, for instance, there
is a good chance that fewer than 1,000 Grevy zebra remain, while black rhino
and Rothschild's giraffe are among the endangered species.*

For 20 years Peter Beard has devoted himself to making this invaluable record
for us—which should evoke our humility, as well as our willingness to re-evaluate what
appears to be an irreversibly selfish propensity for growth and waste.

But this is not a book of criticism as much as it is a work of art and enthusiasm to
remind us that it is Nature we are dismissing, literally overnight.

Joseph Murumbi
Former Minister of State,
Foreign Minister, and
Vice-President of Kenya

*from a wildlife advertisement
in the East African Standard
April 14, 1977

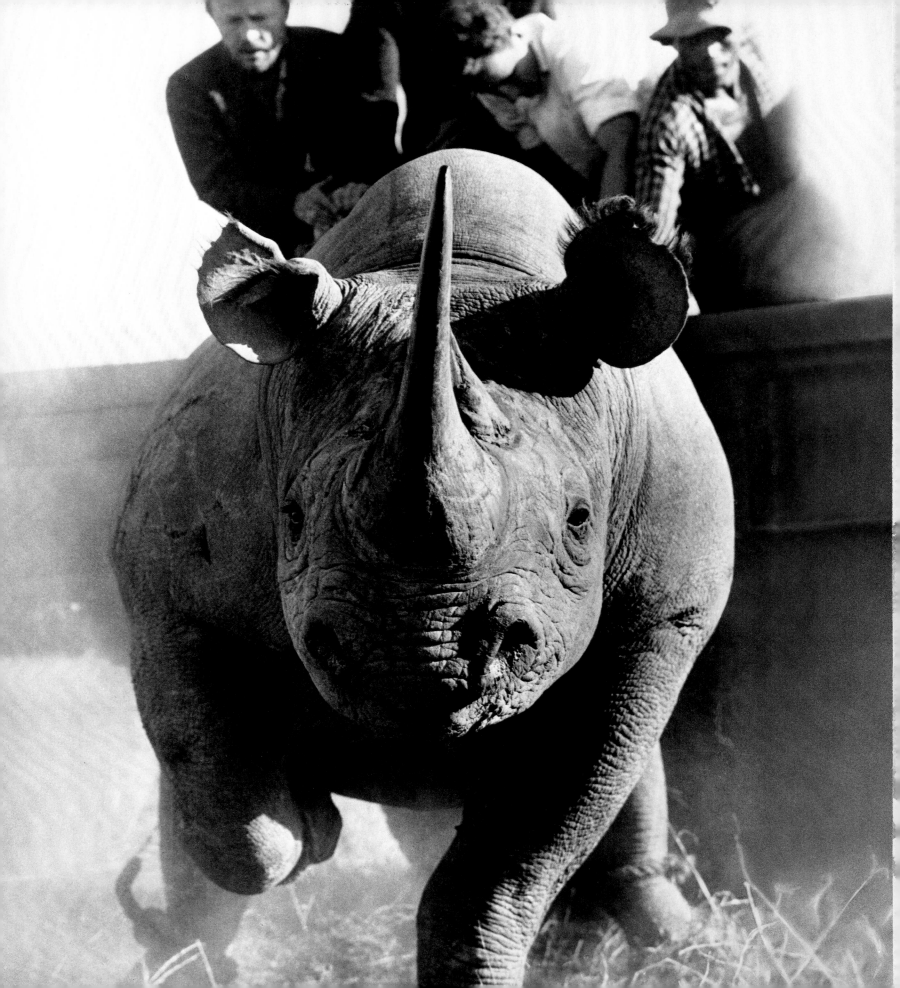

Introduction

 book that undertakes a subject as time-ridden as Africa is necessarily a memory of the past, a record of the present, and an image of the future. *The End of the Game,* focusing on the end of an era, tries to suggest the shape of things to come: an elephant reaching for the last branch on a tree, a vestigial giraffe plodding out of the picture, its legs lost in mirage.

The game is both the hunt and the hunted, the sport and the trophy. The game is killing the game. There was a time when the hunter killed only for his life and food, when wild animals were driven from one area into another instead of being shot or poisoned. Now there are few places left to drive the game. Only 50 years ago man had to be protected from the beasts; today the beasts must somehow be protected from man.

In Africa, life has always been abundant, so death has abounded; but in natural balance. Nature devoted eons to achieving this harmony for her infinitely complex "niche" structures. Again and then again we see evolution probing to the fullest every conceivable niche, accommodating the widest possible range of animals, allowing a vastly differentiated use of vegetation, resulting finally in balanced, mutual conservation of habitat. The elephant, with its great stride, was designed to break paths for the other game; with its trunk to uproot trees, aiding fertilization and irrigation; and with its huge feet in swamps or its trunk in sand, to leave water holes for small fish and fowl.

Nature has seen to it that individuals die but species and cycles live on. This immutable law is reflected in the following pages, in the rhino knocked over like a demobilized tank, in the spitting cobra mortally wounded yet vengeful still, in the zebra that ran itself to death. Death is the patiently awaited, unfeared fact of delicately poised African life. Its agents are everywhere; its beneficiaries circle gracefully overhead.

There is another, more cosmic death mirrored in these pages. This is the shadow of the end — the end of nature's processes, patterns, cycles, balances: all equilibrium and harmony destroyed. As boundaries are declared with walls and ditches, and cement suffocates the land, the great herds of the past become concentrated in new and strange habitats. Densities rise, the habitats are diminished, and the land itself begins to die. Imbalance is compounded.

To understand this final era in Africa we must first speak of the white man—his coming and his conquering. In the old days he was either an amiable eccentric or an explorer. Against enormous odds, equipped with a child's dreams and a man's courage, he opened up a new continent. The European missionary and the white hunter were the advance scouts of the Western World. When the game control officer J.A. Hunter worked on the Mombasa Railroad in 1908, they were already finishing up. They had filed their romantic reports, and the vanguard moved in. Railroad tracks were laid, steel shafts through the shadows. The advance of civilization called for the removal of wild game—the central symbol of African life. One page of Hunter's notebook records the shooting of 996 rhinos. Men acted because they had to, no questions were asked. In the plenitude that was Africa, everything seemed inexhaustible.

What now of the white hunter? He is still with us, though heavily compromised. Once an explorer, he is now a licensed hired hand whose function it is to keep peace in camp and make sure his clients obtain sizable heads and elephant feet suitable

for wastebaskets. He spends much of his time in Nairobi, bemoaning the politics of civilization—which seems to have a monopoly on triumphs.

To build a city where once there stretched an open plain is not to solve a problem but to create a more complex one. Benign in intention, practical in judgment, efficient in technique, we raze the land. If we continue in this way, the outcome is all but assured: Cybele with her turreted crown will rule over the land created by *Ngai*.

It may be a long time before electricity has illuminated every shadow in Africa and college students have peeped under every rock to decide where to build a dam. The white man is still in the process of parading through, but a parade quickens as it goes downhill. Even if untouched by concrete and wire, great stretches of land will be as good as dead without the balance of nature. Africa's soils are senile, lateritic, and unable to support themselves. Many species of game have already been crowded out. Life slowly gives way to a flat desert mirage.

It is too late to undo what has been done. The laws of inevitability which have ruled Africa for millions of years must now be accepted by Africa's conquerors. To understand this is to begin to realize that we have conquered nothing at all.

Man and his ways have intruded with little regard for Africa's customs and privacy. She has been pursued and despoiled. *The End of the Game* tells part of this story because it deals with the essence of African life, the animal. And with that very license of humanity by which we have presumed to conquer, we are challenged to reflect upon our defeat.

Peter Beard

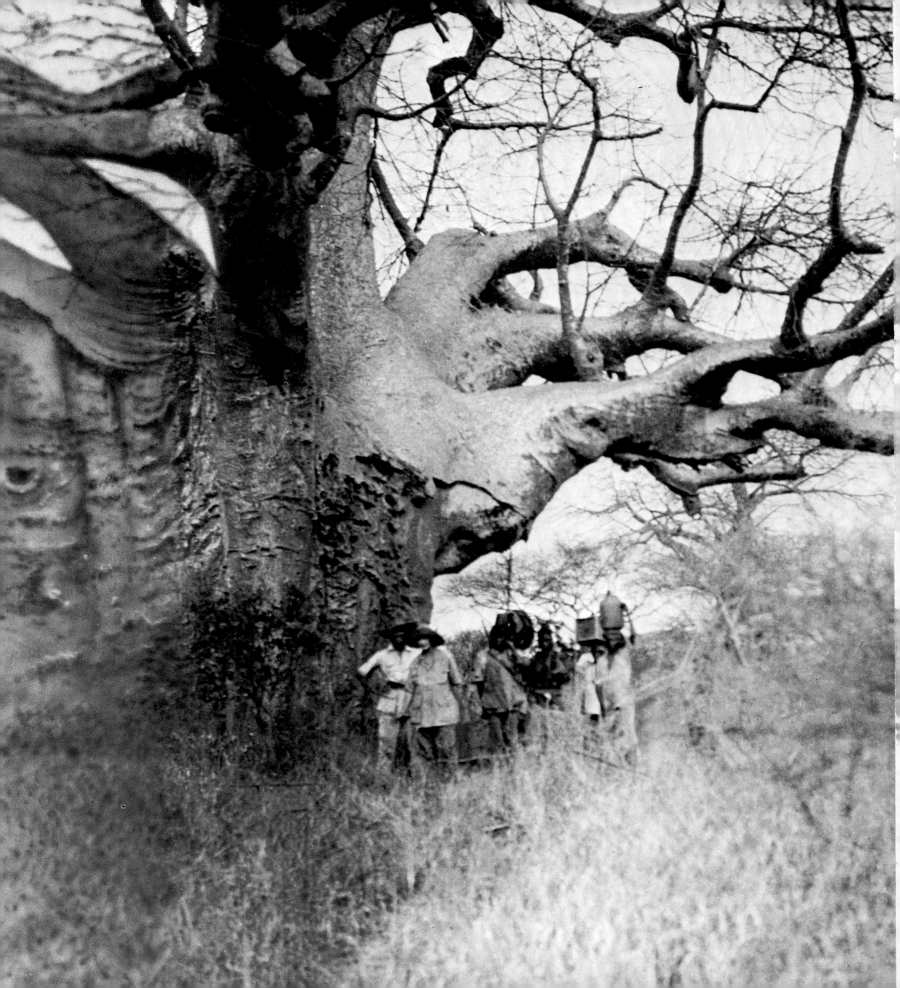

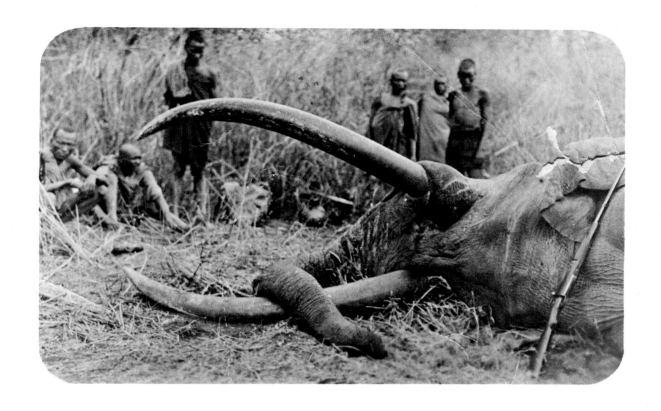

Start off for the jungle; after two hours tramp, mount a tree & sit
on a branch all night. Feel lonely away in the middle of africa
in the dark & silent night — am disturbed by the appearance
of enormous Rhino — afterwards a Zebra turns up...& then other
animals which I cannot see... have a splendid & most
exciting nights sport. Get down at daylight — Return to
Tsavo at 10 A.M. on Sunday morning: Swahili cooly run over
& killed by train near my bridge — trolly out to Rail Hd. & foot it
to Msongaloni — See "Gate of Africa" & take several photos. Have lunch
at 1 P.M. & start back to Tsavo by trolly at 3 P.M.... arrive "Mtoto"
at 4 P.M....Get word that lion took away a cooly last night — go to spot
& find remains of head & large bones — make a place to sit up &
watch for lion — Sit up all night: Took away another man
in a different place — track up as soon as day & find
half-body: lions were eating it (could not see them owing
to dense bush) — Get snake 6' long & keep skin in ashes —

J H Patterson

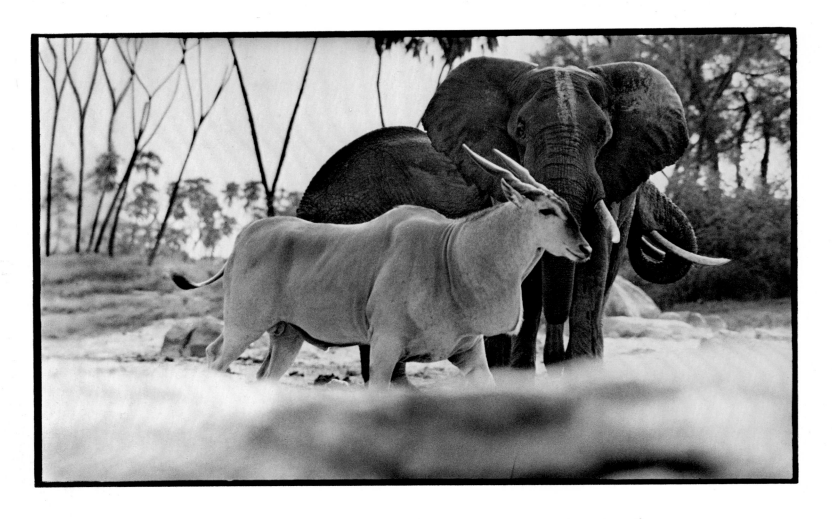

Camp on Tsavo River. We were disturbed in the night by lion roaring near camp — make raft to float down the river on — it is a failure — Went out in afternoon and sat for some time waiting for Hippo... but none appeared. I see crocodile at river bank, but only for moment; no chance of a shot — shoot guinea & spur fowls, but get nothing — saw large beast near Mtoto — did not shoot. Start 'Home' for Tsavo. Had magnificent view of Kilima Njaro (arrive 5 P.M) Develop photos — nothing else of much importance. Capt. Swain told us that poor Wilson had died at Mtoto of Blackwater fever. I was only talking to him a few days ago when he seemed to be full of life — was just writing up diary & heard a crackle in jungle — Lion scare during night — Two coolies taken from Railhead.

J.H.P. — 1st/11 October

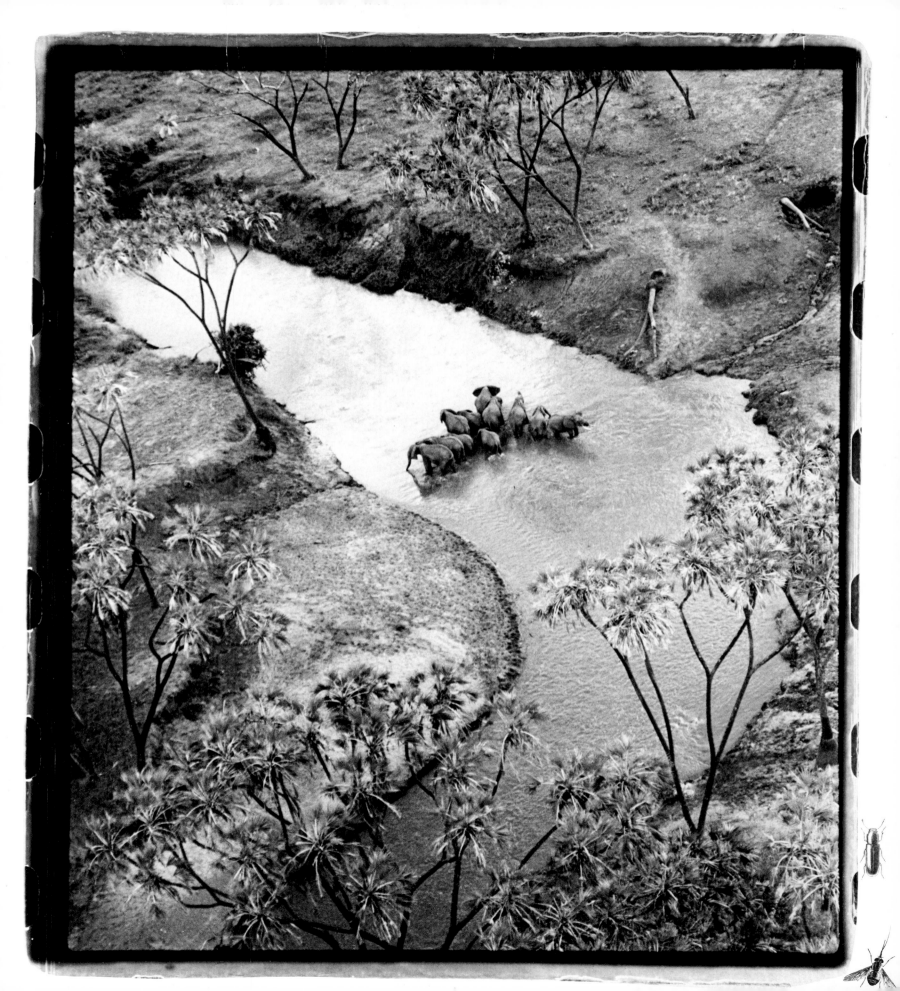

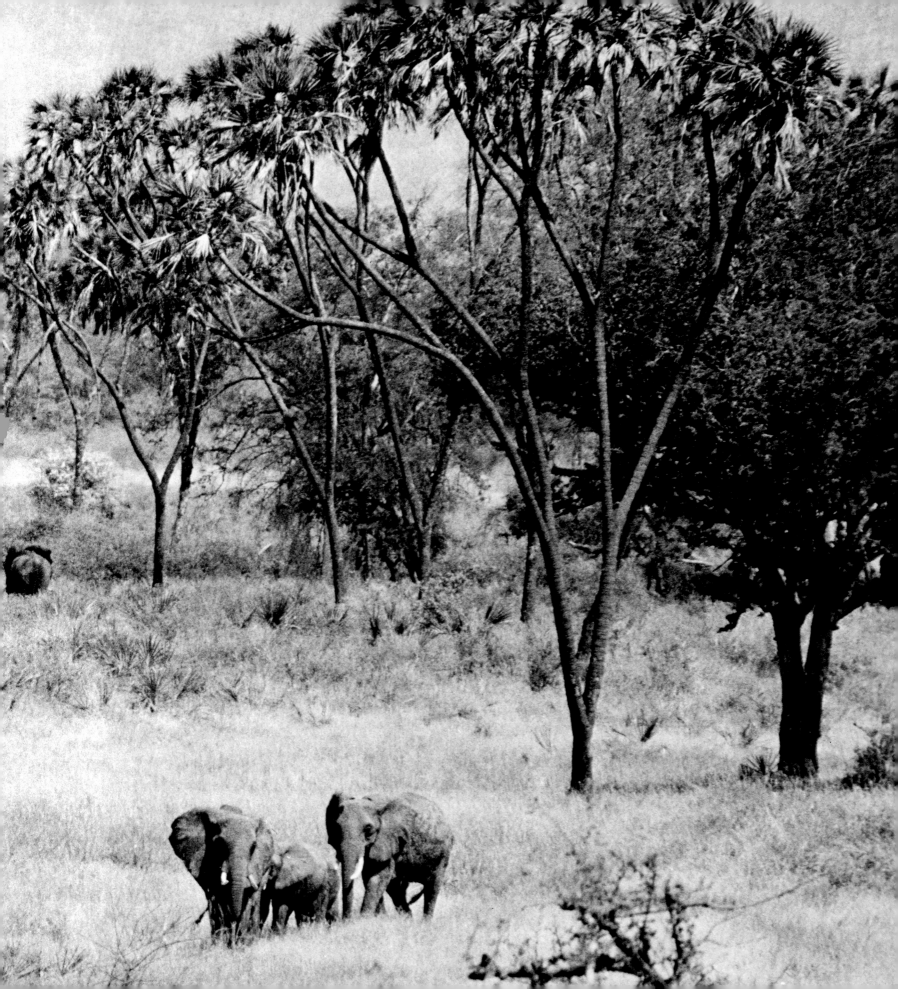

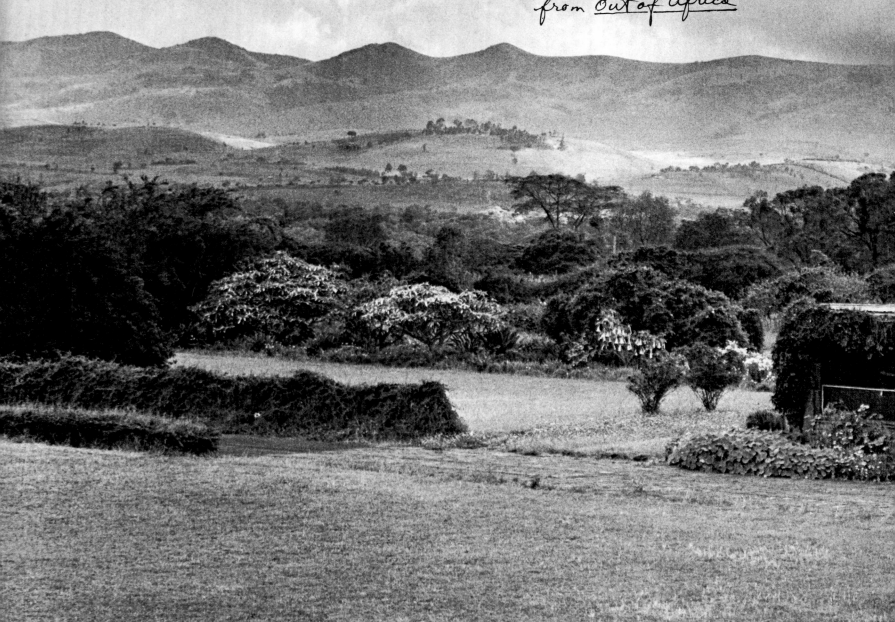

"I had a farm in Africa, at the foot of the Ngong Hills...
The geographical position, and the height of the land combined
to create a landscape that had not its like in all the world.
There was no fat on it and no luxuriance anywhere; it was Africa
distilled up through six thousand feet like the strong and refined
essence of a continent... The views were immensely wide—
Everything that you saw made for greatness and freedom, and
unequalled nobility... In the highlands you woke up in the
morning and thought: Here I am, where I ought to be."

Karen Blixen
from Out of Africa

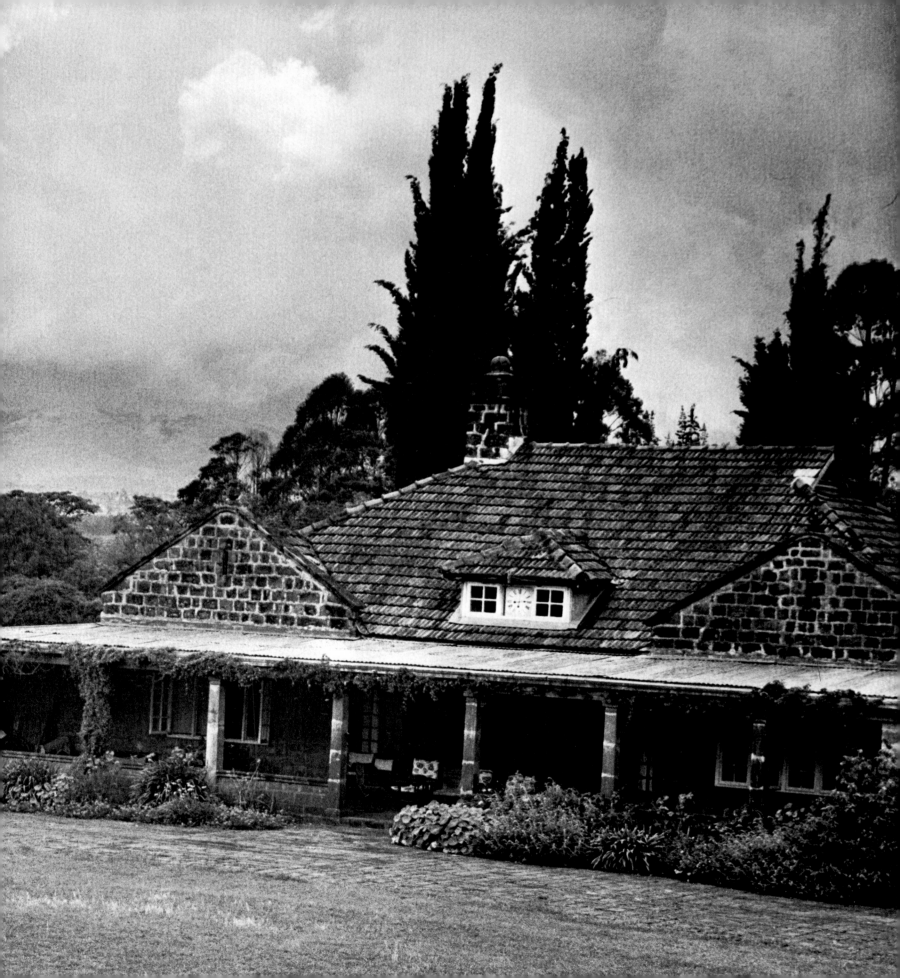

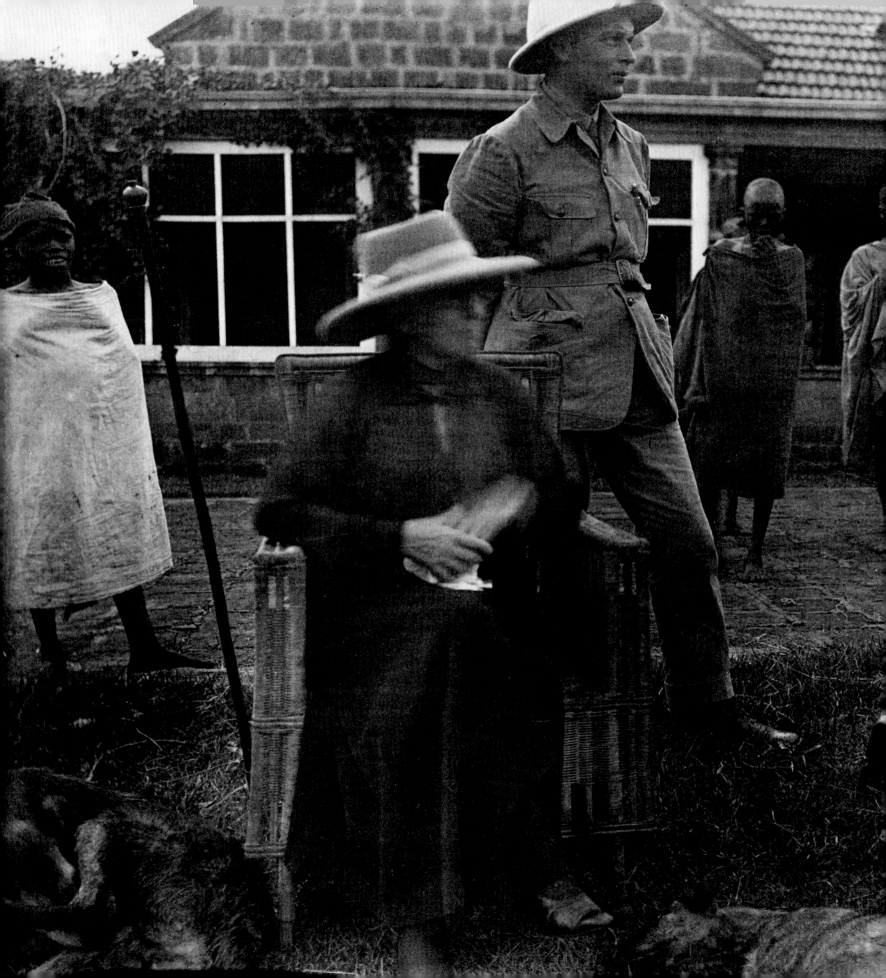

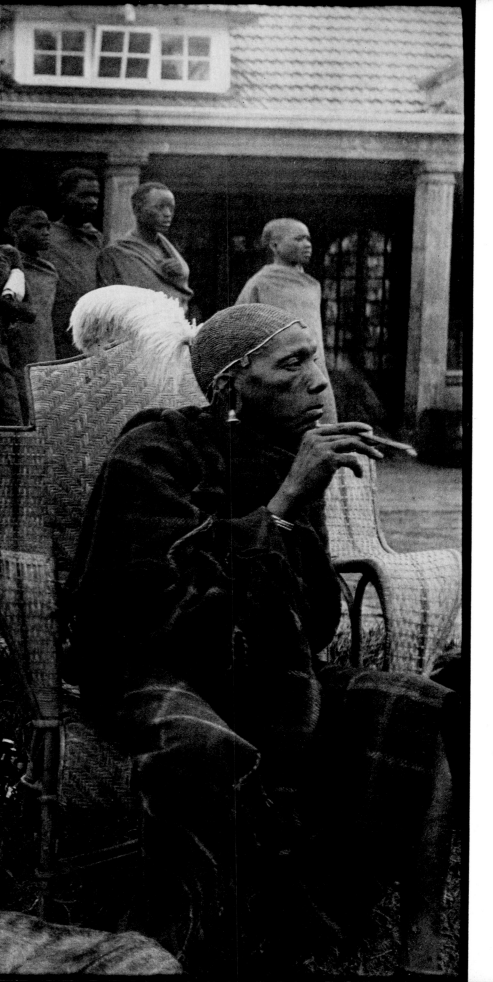

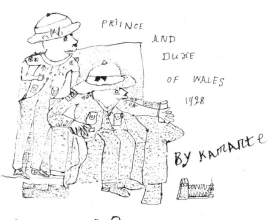

PRIINCE AND DUXE OF WALES 1928

BY KAMANTE

"The Son of the Sultan" Edward
Duke of Windsor

Paramount Chief Kinyanjui at an ngoma
for the Prince of Wales held at Bogani House
(Karen House), November 1928

31

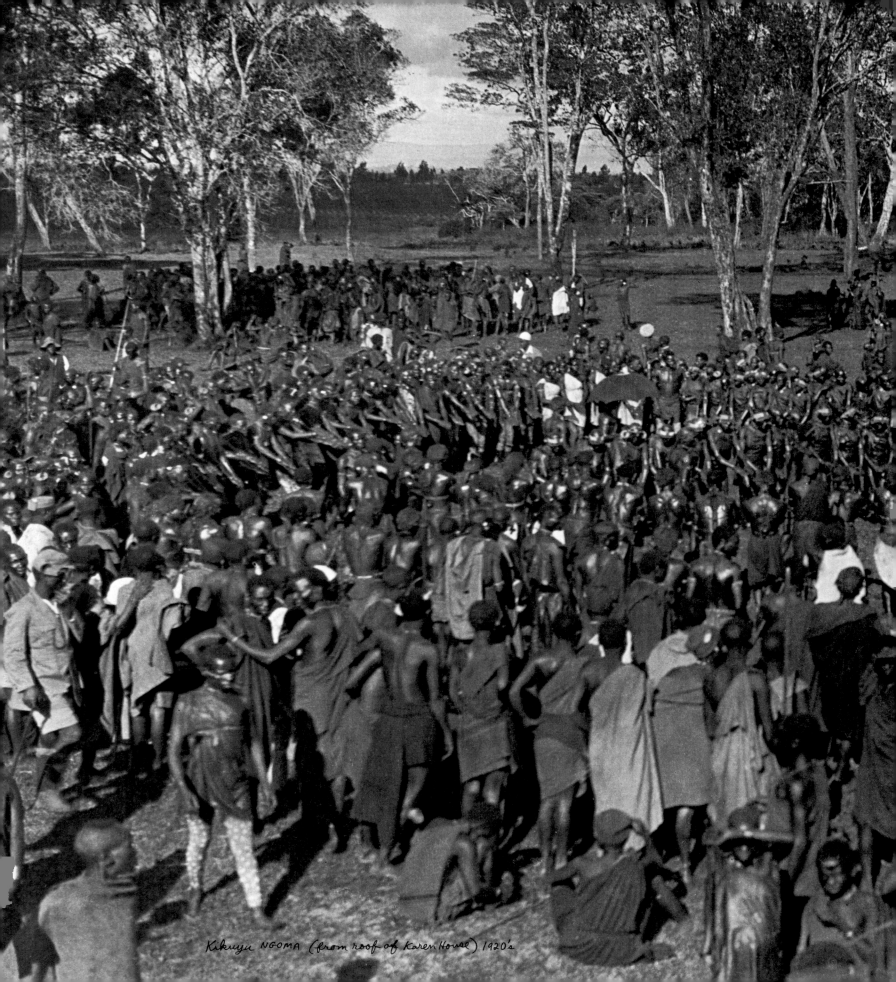

Kikuyu NGOMA (from roof of Karen House) 1920's

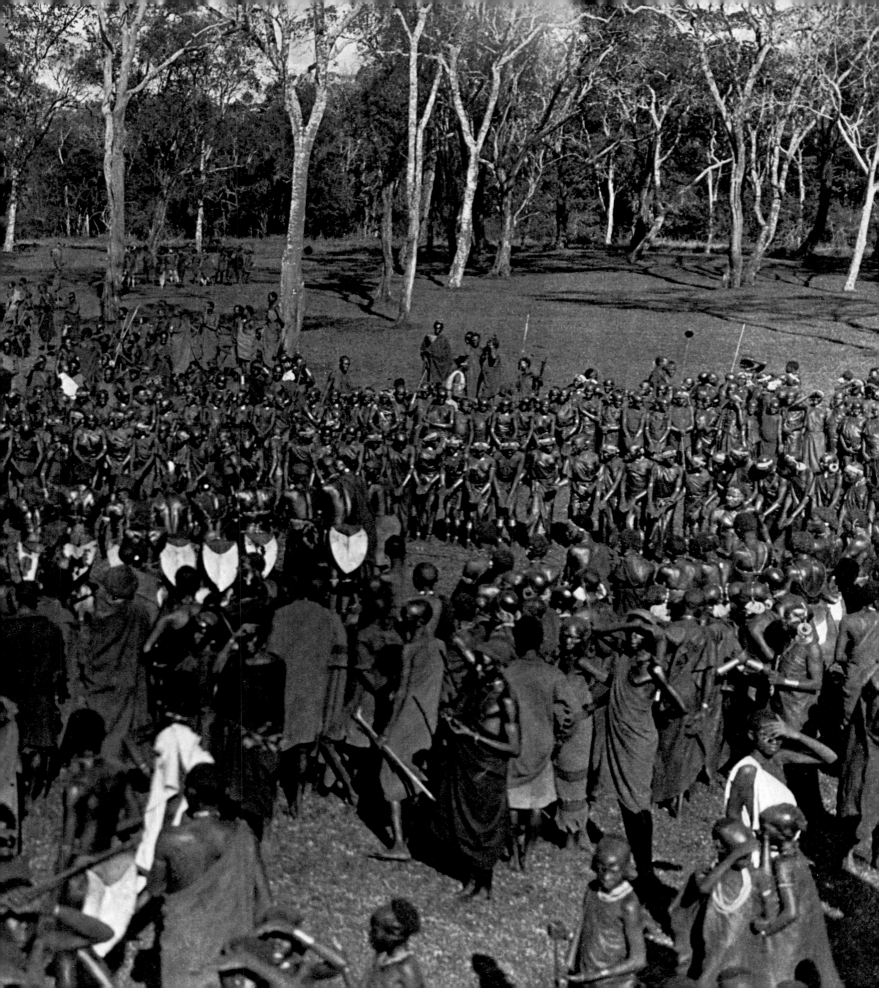

"Sometimes on a Safari, or on the farm,
in a moment of extreme tension, I have met the eyes
of my native companions, and have felt that we
were at a great distance from one another, and that
they were wondering at my apprehension of our risk.
It made me reflect that perhaps they were, in life
itself, within their own element, such as we can never
be, like fishes in deep water which for the life of
them cannot understand our fear of drowning.
This assurance, this art of swimming, they had, I
thought, because they had preserved a knowledge
that was lost to us by our first parents; Africa,
Rapramo the continents, will teach it to you: that
God and the Devil are one..."

K.B.

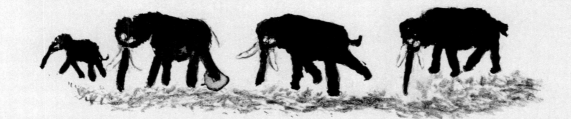

Karen Blixen.

Kamante

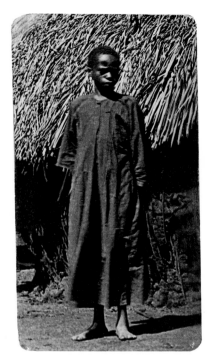

HAMANDE
GATURA
1921

If there is anyone who in her life and person sums up the old Africa, lost beyond excavation, it is Karen Blixen. An unseen support for me, a figure of real and poetic importance for the world, she was in the forefront of my mind as I prepared this new version of *The End of the Game*; in fact, the original was dedicated to her memory. Through her and the surviving Africans who had worked for her, I was able to touch the history of Kenya and East Africa. In 1961 and 1962, from the perch to which she had retired in Denmark, Karen Blixen urged me to continue photographing—before it receded forever—the African world she had had to relinquish during the Depression, and it was her perfect sympathy that enabled me to do so. "Very few matters," she wrote me, "could move me as deeply as your epitaph, or monument, over the Old Africa which was so dear to my heart—the continent of wisdom, dignity, and deep poetry, equally expressed in nature, beast, and man."

This new and final *End of the Game* deals with the decade that has passed since the book's appearance. In the light of what has happened almost everywhere, in the face of thinner and thinner illusions, it can no longer be categorized as a wildlife book. It is a book about human behavior—in a world that once had coherent meaning.

Karen Blixen and Ingrid Lindstrom at Ngong 1921

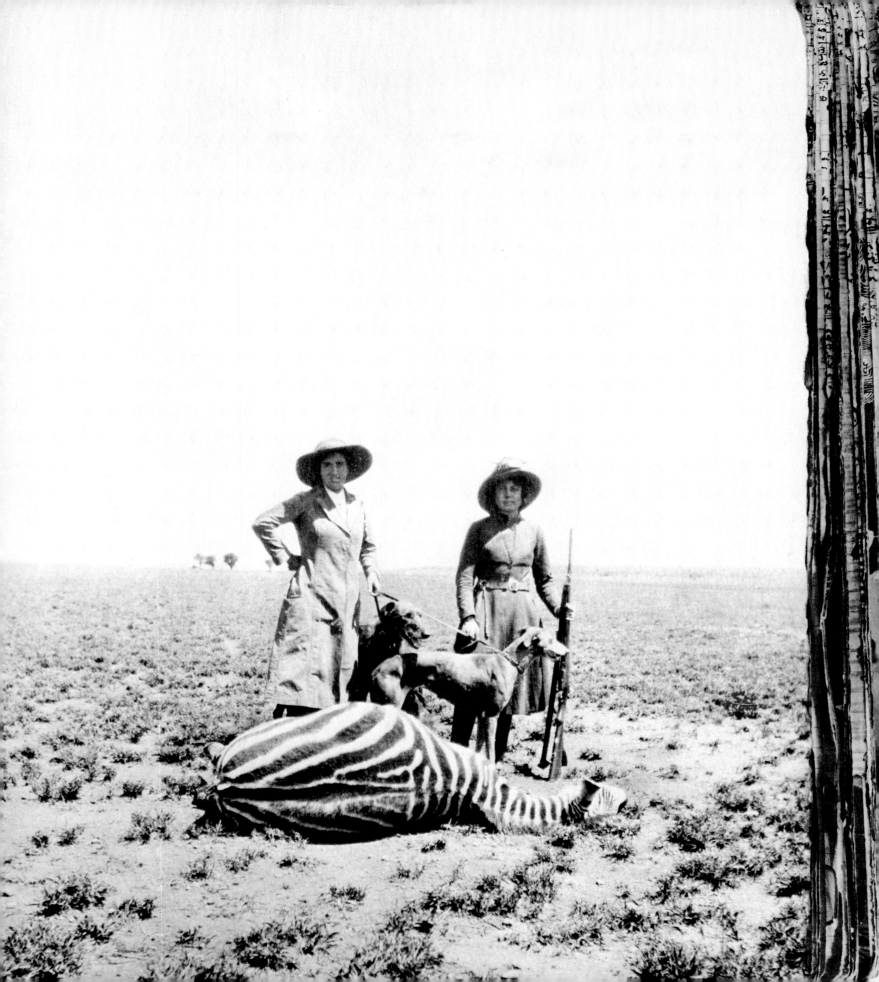

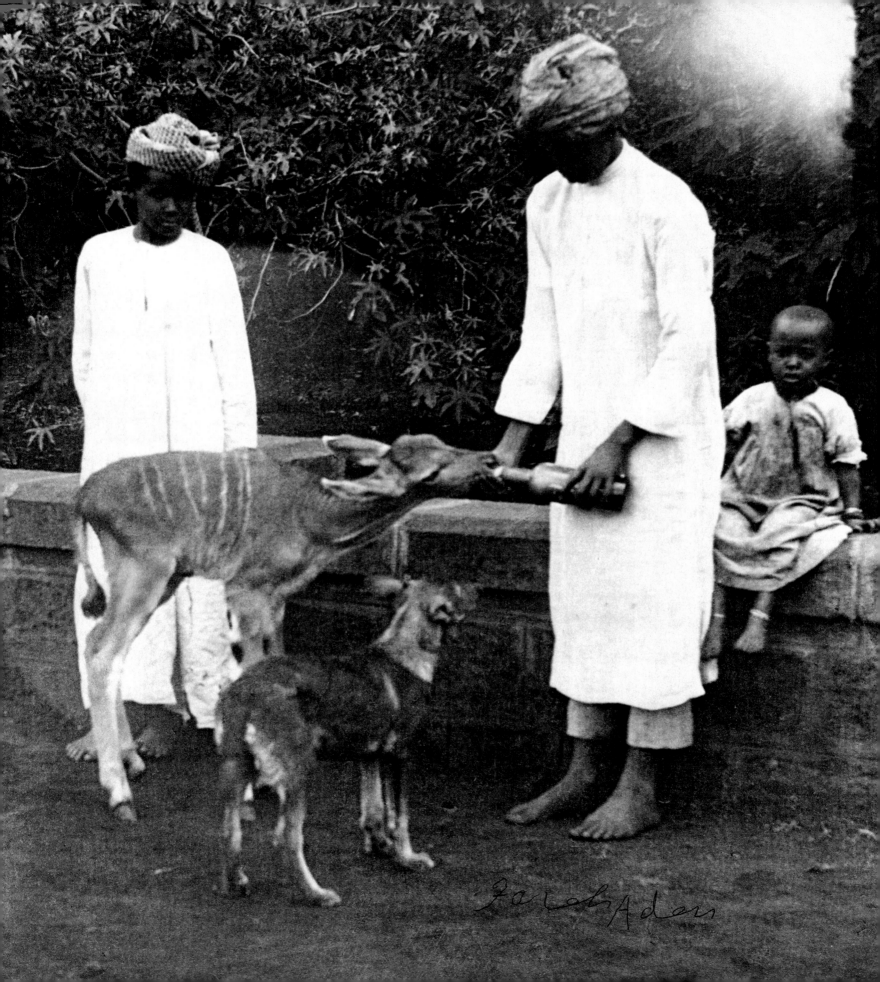

Abdullah, Farah and Tumbo feeding Lulu

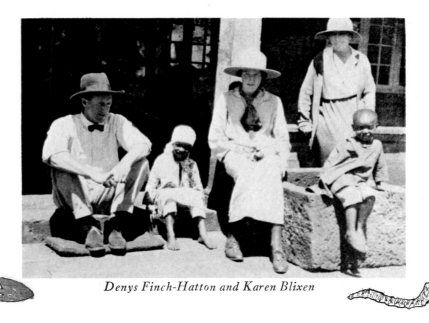

Denys Finch-Hatton and Karen Blixen

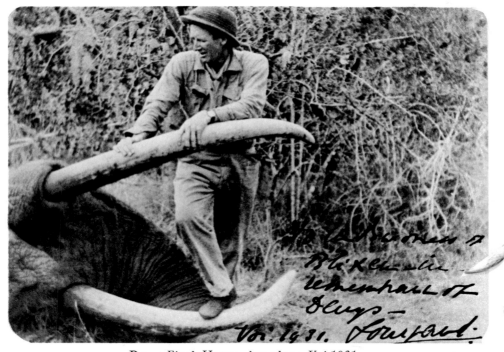

Denys Finch-Hatton, last photo, Voi 1931

Karen House 1914

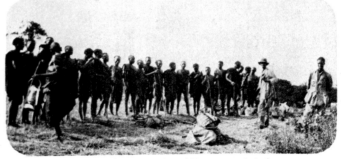

An early foot safari (Farah at right)

von Lettow-Vorbeck.

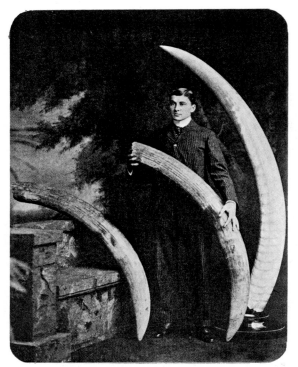

Ewart S. Grogan after his walk

Denys Finch-Hatton

Sendeyo

Karen Blixen's writings infuse these pages. Yet, for all the pleasure her work continues to give us, there is a shadow running along beside it.

Before The Great War, Karen Blixen sailed to East Africa from Denmark—full of gifts, full of dreams, ready to be reborn. In Kenya she found herself at the center of a largely untouched wilderness and did not know that it would be her terrible fate to help preside over its dissolution. For there she was surrounded by what used to be called "men of action," whose ways were fierce and whose effect on the interior was to be almost biblical in its conclusiveness. (For what other reason did it exist, they asked, than to be penetrated?)

Among her friends:

The German General von Lettow-Vorbeck, a fellow passenger from Marseilles to Mombasa in 1913-14, who frustrated and ultimately captivated the British (South African, Rhodesian, Nigerian, and Indian forces who outnumbered him ten to one) with ingenious military maneuvers, which incorporated tribal warfare strategies such as the Black Ruga Ruga Field-Units' and special German disciplinary systems. Accused of championing cannibalism and forcing his least successful officers to commit suicide, the "invisible enemy commander" went on to win the most prestigious British war medals for outwitting "Slim Janie" Smuts, "Jungle Man" Pretorious, "Japie" van Deventer, Meinertzhagen, Selous, Cranworth, Northey, Malleson, Smith-Dorrein, Stewart, Sheppard, Willoughby, Tighe, Beves, Hoskins, General Henry de Courcy O'Grady, and others.

"Cape to Cairo" Grogan, who undertook a two-year feasibility walk for the railroad builders in 1898 and 1899—from one end of Africa to the other—and who with Lord Delamere would open up East Africa to the ways and resources of the new world.

Delamere himself, founding father of the Kenya colony, who arrived before the railroad, made blood-brotherhood with the Masai, mastered their dialects, represented them against his own government, gave his life to the development of agriculture in a land riddled with heartwater, blackwater, Eastcoast fever, tsetse fly, and locusts; and who, only in the year he died (1931), managed to break even on his

Kenya investment.

John Boyes, the cabin boy from Hull, survivor of the Matabele wars and one of the first traders in Kenya, a seafaring remittance-chum who came up-country with the railroad as it was being built, mile by mile, and who one morning at the turn of the century bought Mt. Kenya from Chief Karuri and the Kikuyu elders for a dozen goats and cows.

Karuri's successor, Paramount Chief Kinyanjui, who trusted Karen Blixen more than he did any other European—trusted her to the extent that as he approached death he begged her to allow him to be buried according to his custom on her place. In perhaps the most resonant chapter in *Out of Africa,* she describes his fate at the hands of missionaries competing for his soul.

Sendeyo, son of the most revered of all Masai *laibons,* Mbatian, who was to have the highest peak of Mt. Kenya named after him.

Baron Bror von Blixen-Finecke, the Swedish cousin whom she had married in the Episcopal Church of Mombasa upon her arrival in January, 1914, and who, with his safari partner Philip Percival, was to become one of the most accomplished early hunters and perhaps the most inventive pursuer of big ivory in Africa.

Finding herself in a semi-circle whose members all knew and cross-fertilized one another at this turning point in the history of Africa, she proceeded with characteristic courage to live out the first motto she had adopted for her life: Navigare Necesse Est. Vivere Non Necesse. (To set sail is necessary. To live is not necessary.)

As one of her admirers wrote after her death: "For seventeen years, Karen Blixen was a woman of prodigious nerve and stamina, of common sense and generosity; she doctored her natives, she shot lions that beset their cattle, heard their disputes; with urbanity and without condescension, she learned her servants and her squatters as thoroughly as she might have learned a foreign language. Similarly, she learned the animals and the land."

She had arrived in a paradise caressed by light and air in their most special forms. She absorbed them, not imagining that there could ever be anything to make her leave (and she did and she did not know that it was already passing away before

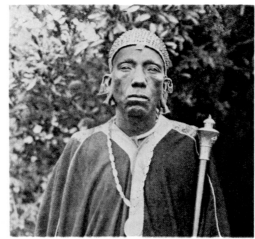

Chief Kinyanjui

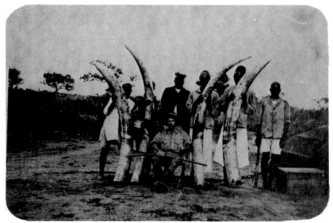

John Boyes

Lord Delamere

Bror Blixen and clients in Masailand

Karen Blixen en route to Tanganyika by ox wagon, 1914

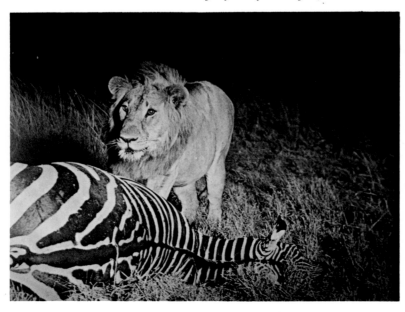

her eyes). As she lived on at Karen Farm, her 6,000-acre coffee estate at the foot of the Ngong Hills, paradise began to empty as the crowd pushed in, at first on foot, and then in trains and cars. She in turn would empty out the whole of her energy battling drought and disease; coping with the Kaiser's War as well as the hostilities and rivalries of surrounding tribes, the rampant thievery and murder; staving off bankruptcy. . . .

And yet, if this was a world without pity, a world of bare survival, she was not repelled. *"Je responderay,"* from the Finch-Hatton family shield, was another motto in her life. Though the Garden of Eden was stained, she stood ready to give back as much as she had received. By hardly perceptible degrees Africa had taught her not to be short-sighted, to avoid self-pity, to be wary of the artificial and the sentimental. In Africa she had learned, swiftly and conclusively, that "God and the devil are one, the majesty coeternal. . . ." She caught the rhythm of the country as no "immigrant" had ever caught it before ("When you have caught the rhythm of Africa," she wrote, "you find it is the same in all her music.") Years later she would turn her wild homesickness for Karen Farm into those masterpieces of contemporary literature, *Out of Africa* and *Shadows in the Grass*—two books which have so much of the continent's dark beginnings, of its very soil, in them. When Hemingway won The Nobel Prize in 1954, he paid tribute to her as one of his favorite authors; "that beautiful writer, Isak Dinesen," he announced, deserved the prize more than he.

Navigare Necesse Est. . . . Vivere Non Necesse. In the most courageous and non-mechanical of ways she set out to learn to hunt with Bror and with Philip Percival, who had hunted for Theodore Roosevelt in 1909, with Leslie Tarlton and R. J. Cunninghame, and with the early explorer Frederick Courtney Selous. Walking, riding, and eventually flying over the endless *Nyika* of the newly formed colony, she saw Karamoja Bell shoot guinea fowl on the wing with a *.256* elephant gun. She joined J. A. Hunter and Denys Finch-Hatton, the Old Etonian safari-guide whom she would make the romantic hero of *Out of Africa,* on their elephant-hunting reconnaissances into the Tsavo lowlands.

It was Bror who had discovered Tsavo for his restless clients. In those days the dry, heavily forested elephant area along the Athi, Tiva, Tana, Tsavo, Voi, Galana, and Sabaki rivers constituted a landscape so swollen with game it could have been a hunter's dream of pre-history. (*For what other purpose did it exist, Bror and his companions asked, than to be penetrated?*) They proceeded to hack their way in, making incisions literally hundreds of miles deep, building air-strips at Enyali, north of Ithumba on the Thuo River, at Diandaza, at Guyu Betchamu upstream of Lali near Sala, and beyond no-man's-land at Dakadima.

No one dreamed that the game could ever be depleted by a handful of immigrants with maps and gun powder, however immoderate they might be. And yet, within a matter of years, this paradise would become part of the modern world, a battlefield desert littered with the carcasses of elephants beyond number, a flatland boneyard, a treeless, bleached-out dustbowl, something climactic and conclusive. As Fitzgerald wrote, of another paradise, ". . . for a transitory enchanted moment man must have held his breath in the presence of this continent, compelled into an aesthetic contemplation he neither understood nor desired, face to face for the last time in history with something commensurate to his capacity for wonder."

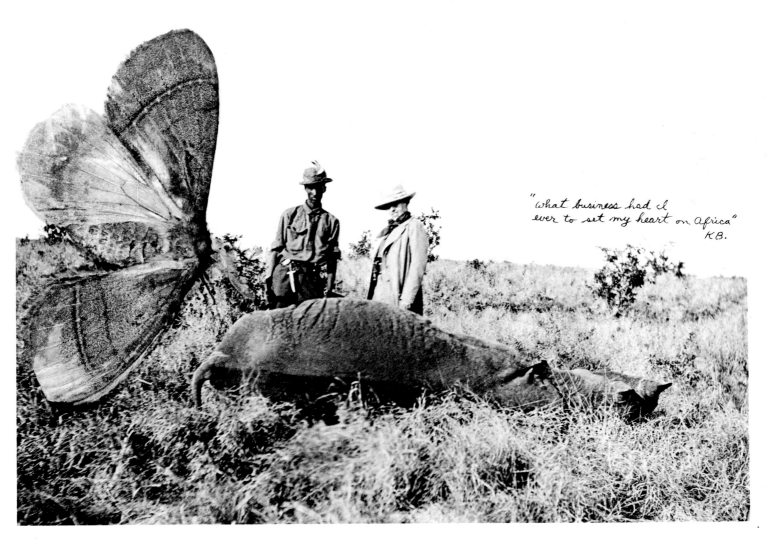

"what business had I ever to set my heart on africa"
KB.

But almost every reality, "even if it has its own immutable laws, nearly always is incredible as well as improbable. Occasionally, moreover, the more real, the more improbable it is." The Tsavo wasteland is a reality that, in its implications, is not at all cut off from the rest of the world. Karen Blixen had warned us, as if trying to wake us in the middle of the night, that everything in evolution has its built-in demise. Populations expand, land does not. Nature has *always* favored size and power. Size, however, can become a limiting factor—and when it does, it is extinction that is ensured in the long run.

By the end of her life—I can still see her Egyptian death-mask of a face, with its refined nostrils and dry skinfolds—she had taken to speaking of her first book about Africa as a "papyrus in a pyramid." Long after her African adventure, she was helpless not to take *personally* the loss of her paradise. In the meanwhile, the paradise of *Out of Africa* had come to stand for all paradises, enravishing but doomed to obsolescence. As long as her books are read, her vision will haunt the missionaries and businessmen and hunters who have made Africa what it is today. She, more than any recorder of African history, bore witness as the old continent sank like Atlantis.

Fifteen years ago, when *The End of the Game* was put together, life had already outstripped her most intemperate predictions. Today, sixteen years after her death, Xeno's arrow has halved its distance to the target many times. And we are left to wonder what will be next if the graph of progress continues to rise.

The wilderness of only half a century ago, then so completely itself, has been reduced, tree by tree, animal by animal, shadow by shadow, rock by rock, to its last rutted corners. The few remaining spaces have been infiltrated, divided-up, domesticated, deprived of natural systems, denuded of natural processes, systematized, similarized, artificialized, sterilized, commercialized . . .

Peter Beard
Montauk, June, 1977

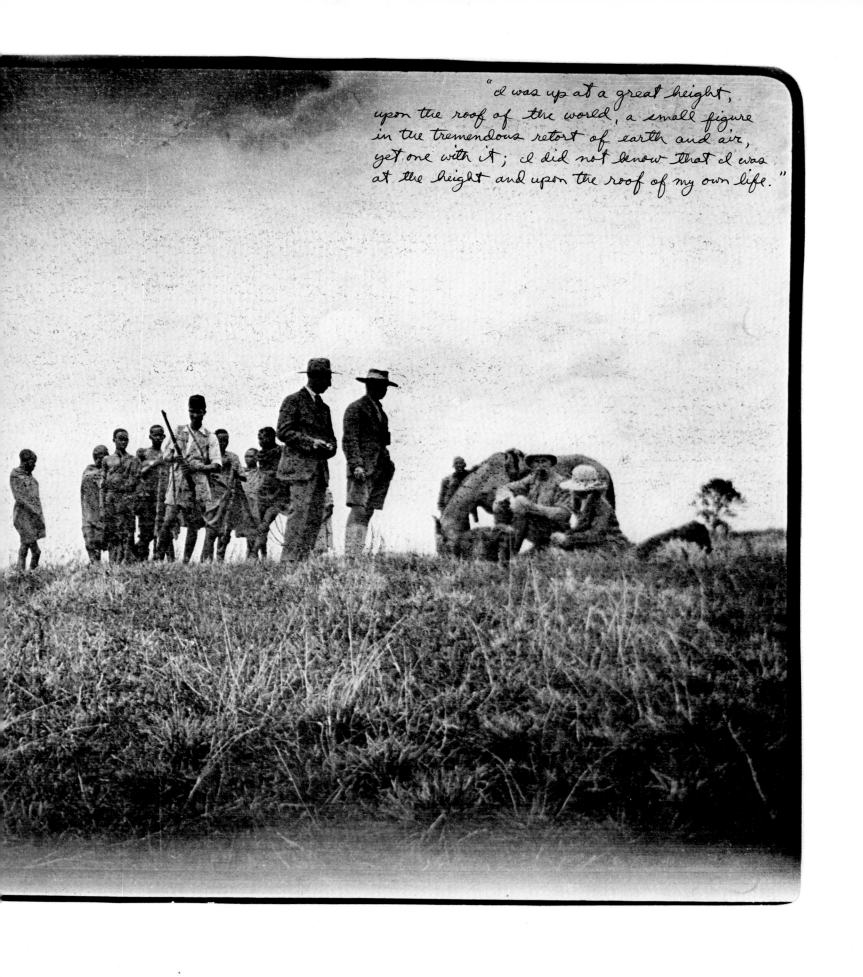

"I was up at a great height,
upon the roof of the world, a small figure
in the tremendous retort of earth and air,
yet one with it; I did not know that I was
at the height and upon the roof of my own life."

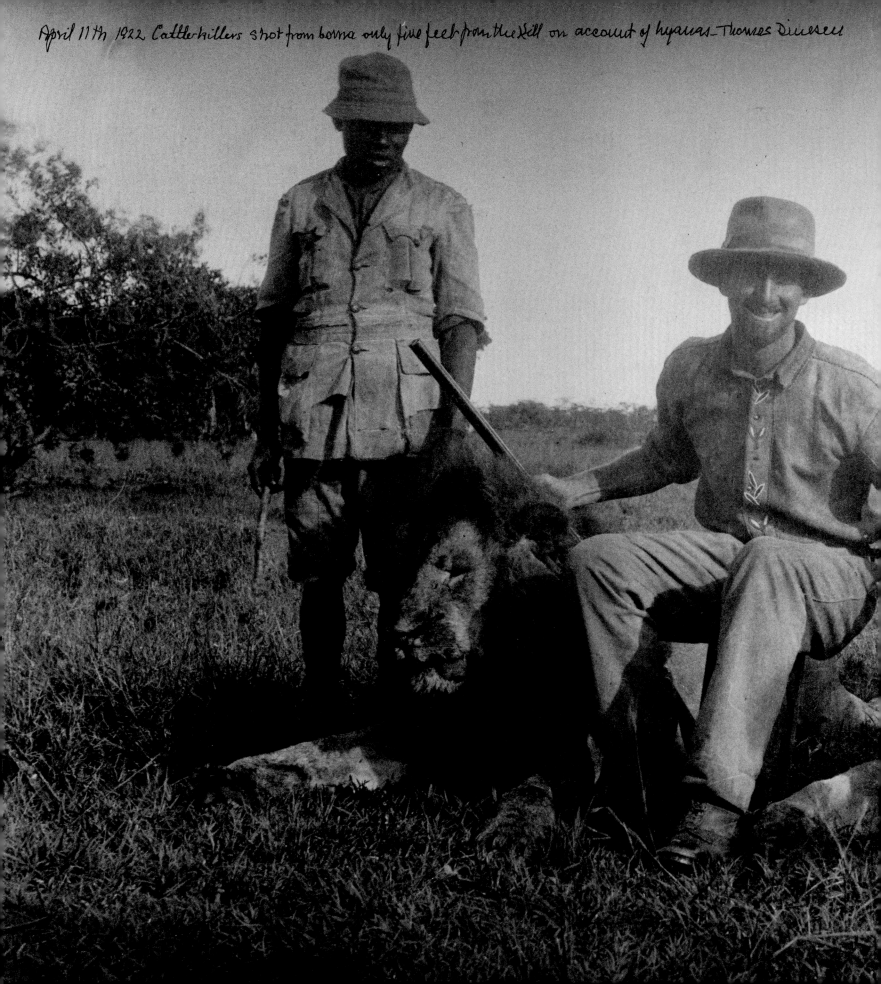

April 11th 1922 Cattle-killers shot from boma only five feet from the kill on account of hyanas - Thomas Dinesen

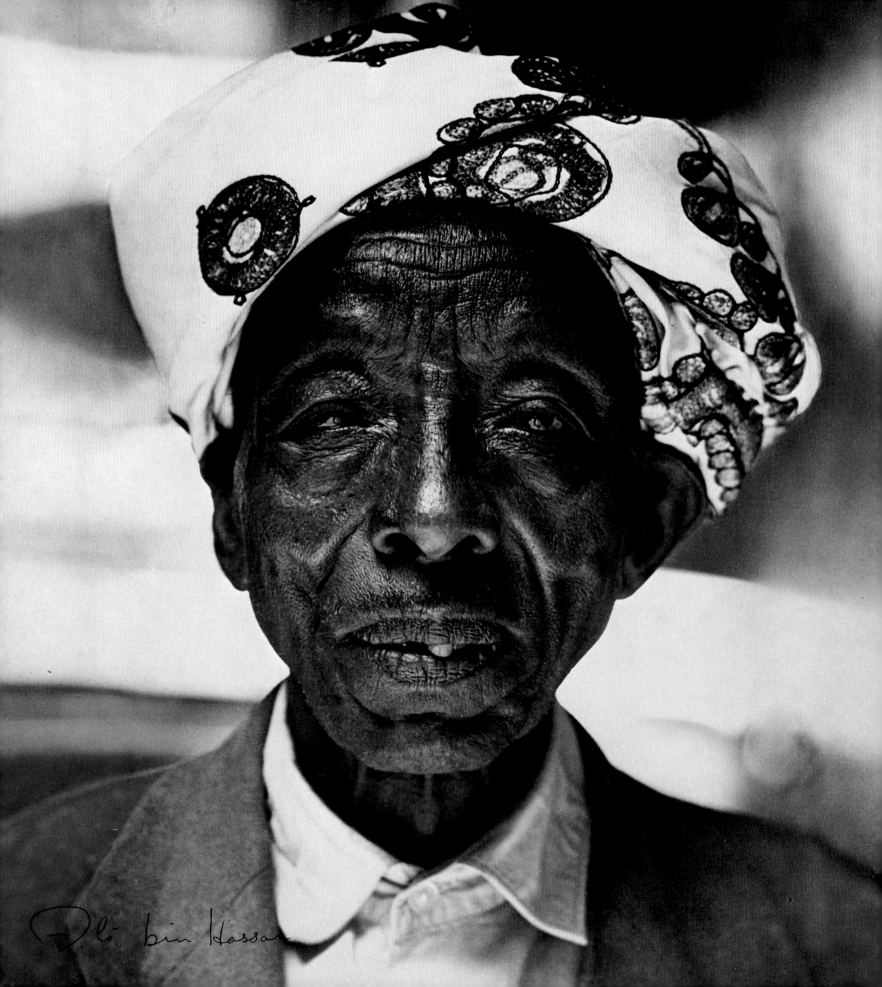

Ali bin Hassan

A giraffe is so much a lady that one refrains from thinking of her legs, but remembers her as floating over the plains in long garbs, draperies of morning mist or mirage.

Karen Blixen.

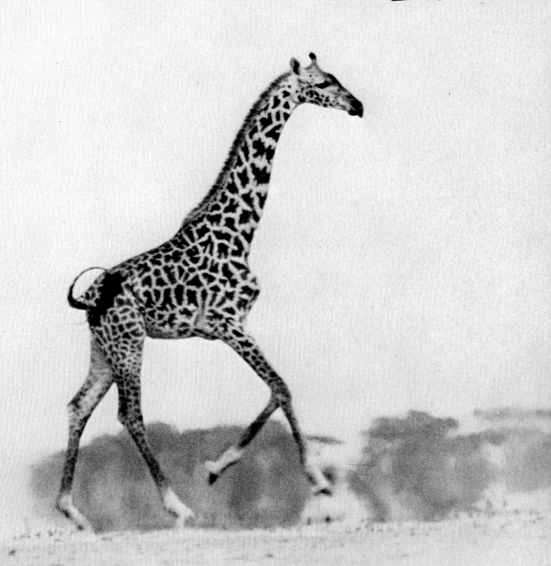

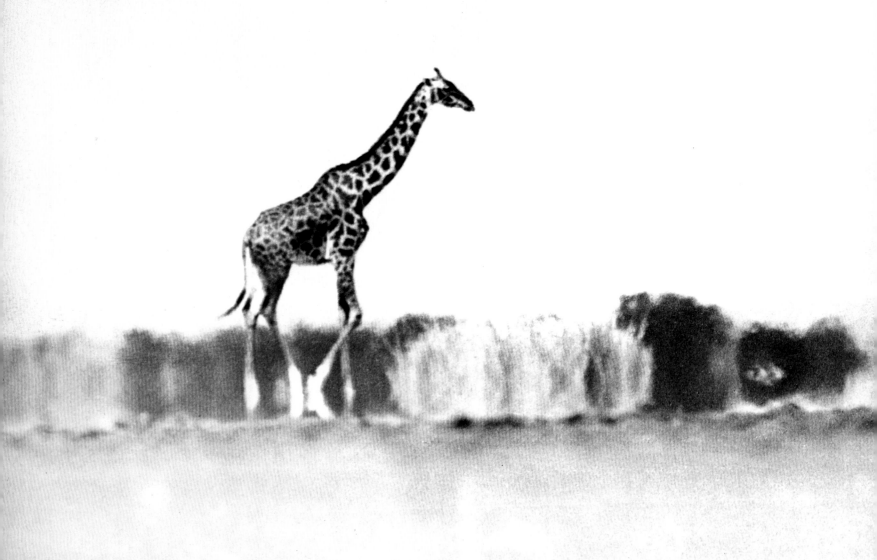

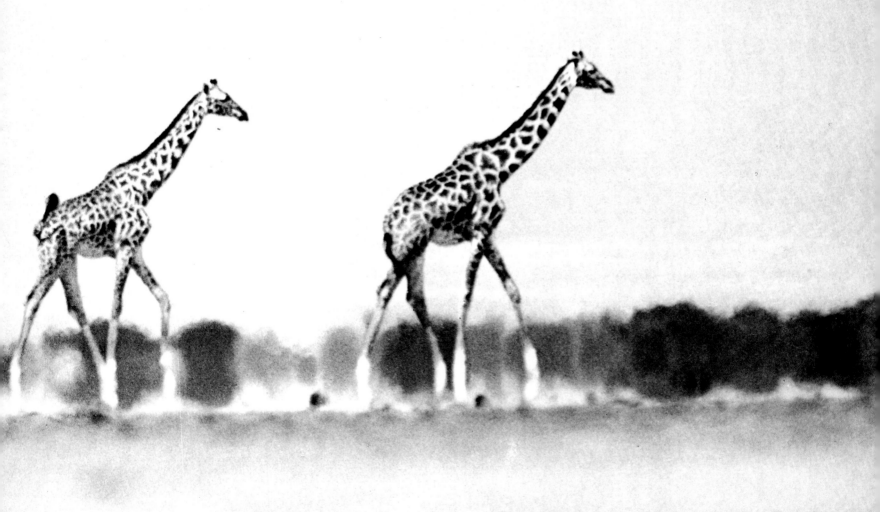

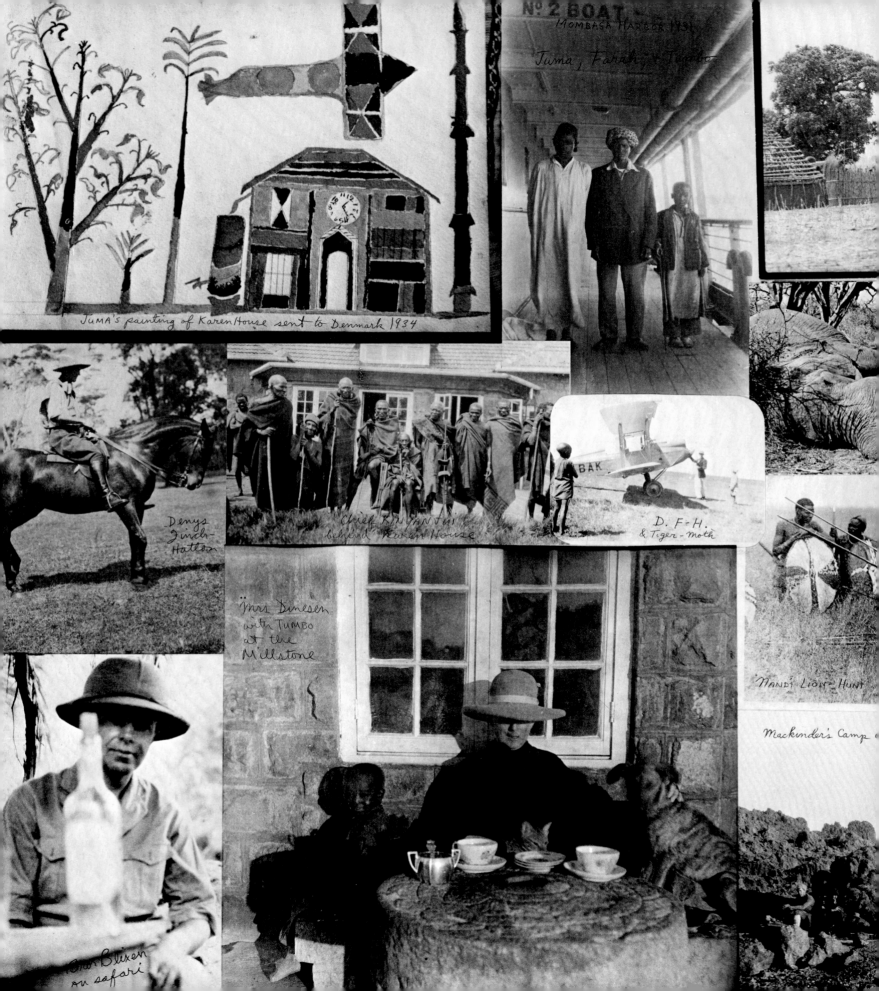

No 2 BOAT

MOMBASA HARBOR 1931

Juma, Farah, & Tumbo

JUMA's painting of Karen House sent to Denmark 1934

Denys Finch-Hatton

Chief KINYANJUI behind Karen House

D. F-H. & Tiger-Moth

Mrs Dinesen with TUMBO at the Millstone

Nandi Lion-Hunt

Mackinder's Camp

Bror Blixen on safari

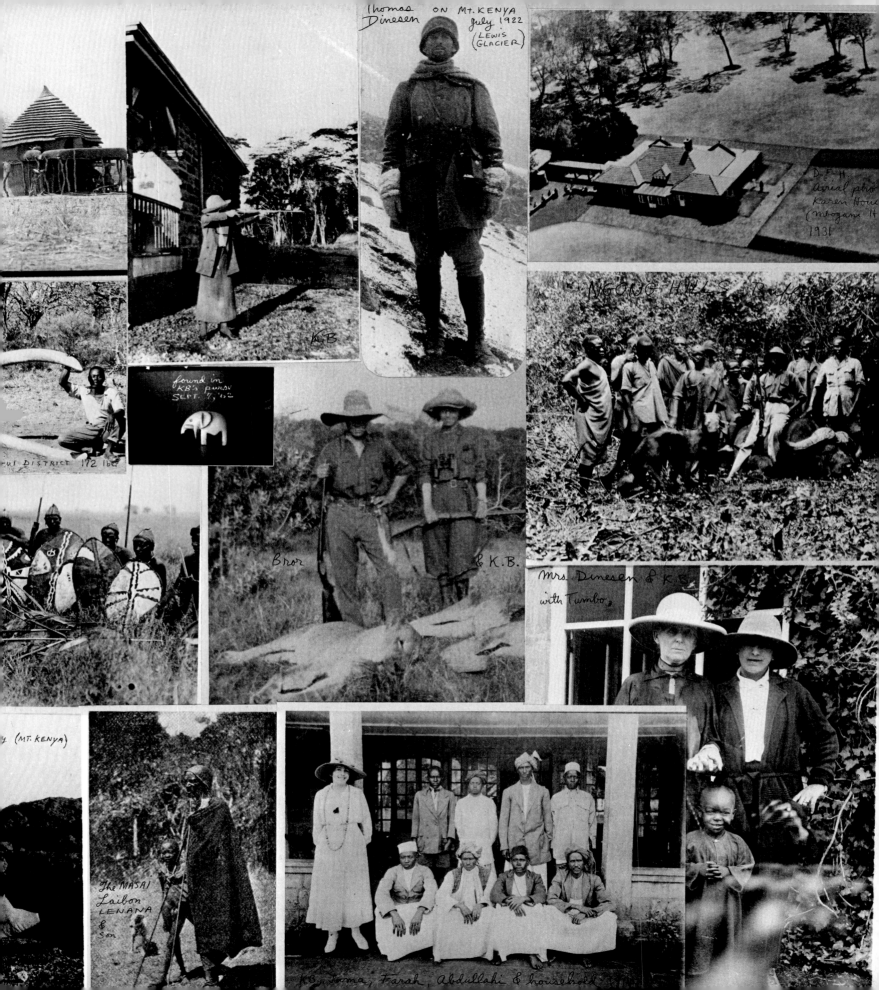

Thomas Dinesen ON Mt. KENYA July 1922 (LEWIS GLACIER)

D. F. H. aerial photo Karen House (Mbogani H 1931

NGONG HILLS Buffalo Ht

found in KB's purse SEPT 7, '62

ul DISTRICT 172 lbs

Bror & K.B.

Mrs. Dinesen & K. B. with Tumbo

(MT. KENYA)

The MASAI Laibon LENANA & son

K.B. Tumbo, Farah, Abdullahi & household

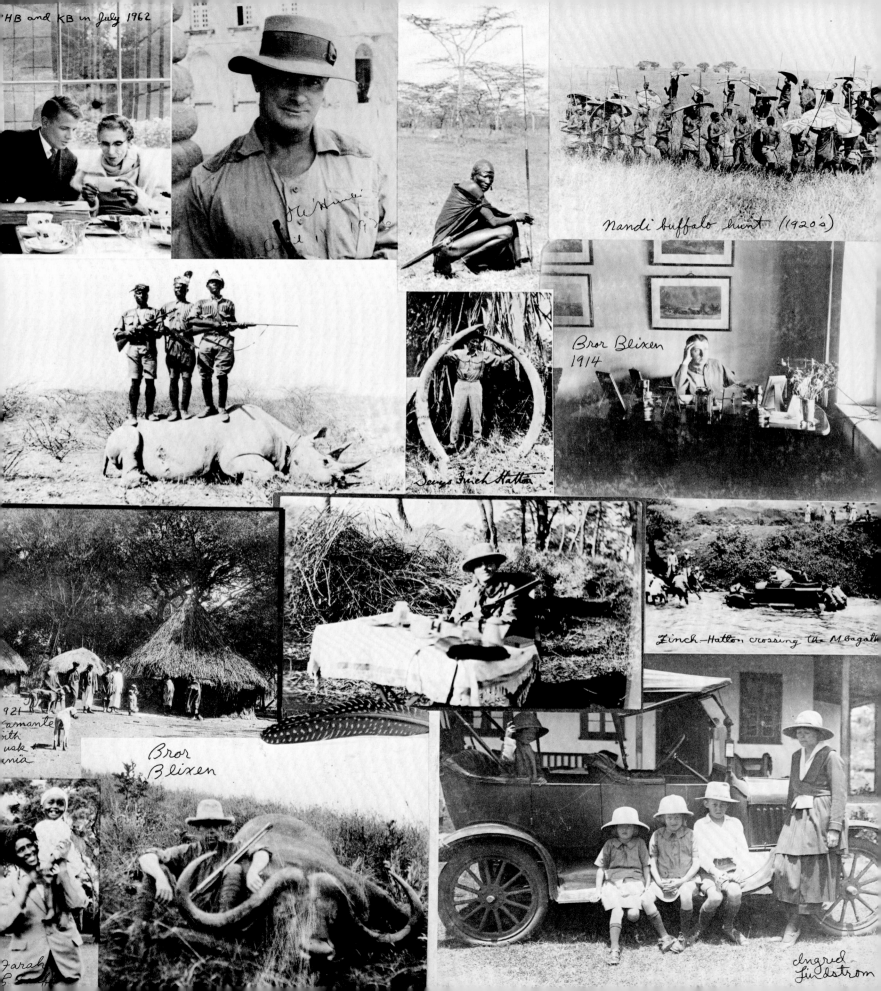

"HB and KB in July 1962

Nandi buffalo hunt (1920's)

Bror Blixen
1914

Denys Finch Hatton

Finch-Hatton crossing the Mbagathi

1921
Kamante
with
tusk
mania

Bror
Blixen

Farah

Ingrid
Lindstrom

K.B. 1931

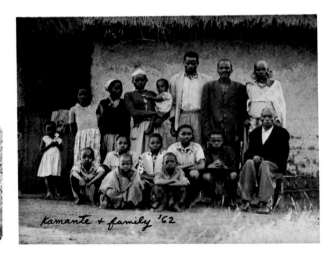

Kamante + family '62

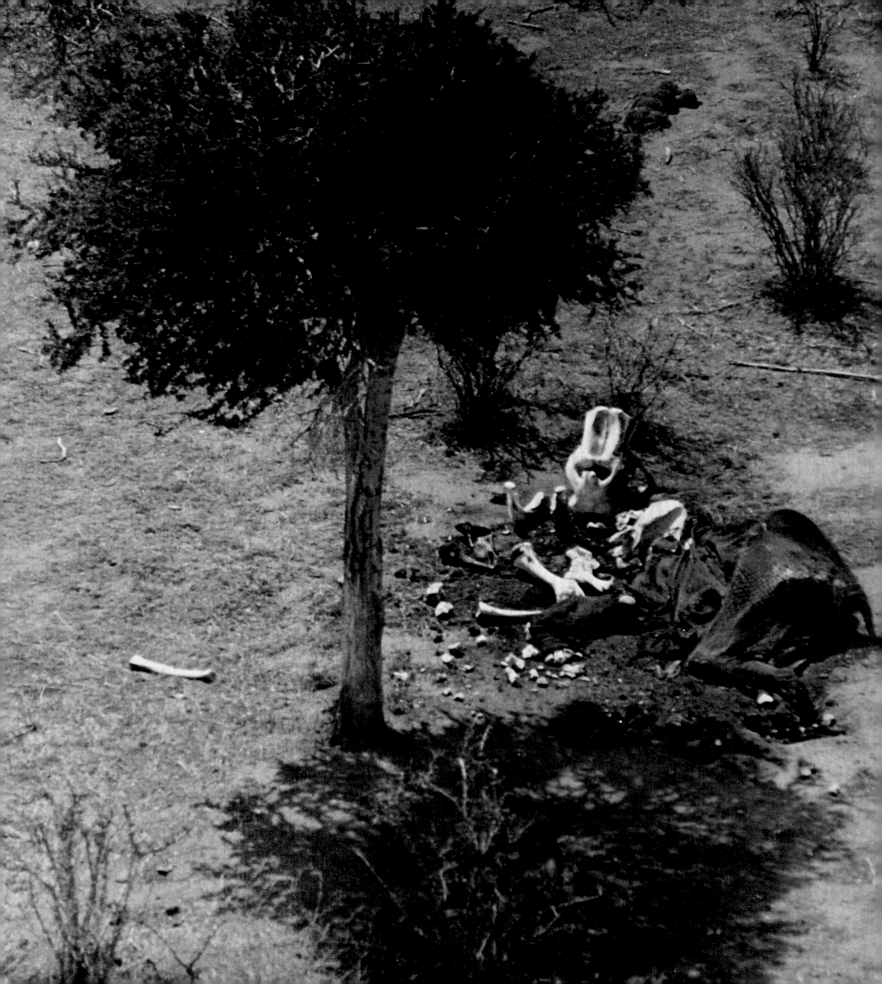

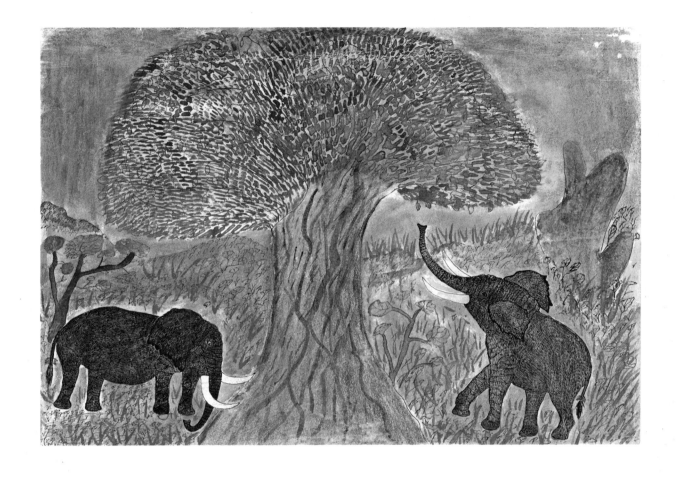

Surely it is obvious enough, if one looks at the whole world that it is becoming daily better cultivated and more fully peopled. All places are now accessible, all are well known; most pleasant farms have obliterated all traces of what were once dreary and dangerous wastes; cultivated fields and subdued forests, flocks and herds have expelled wild beasts; sandy deserts are sown; rocks are planted; marshes are drained; and where once were hardly solitary cottages, there are now large cities. No longer are islands dreaded, nor their rocky shores feared; everywhere are houses and inhabitants. Our teeming population is the strongest evidence: our numbers are burdensome to the world which can hardly supply us from its natural elements; our wants grow more and more keen, and our complaints more bitter in all mouths, whilst Nature fails in affording us her usual sustenance. In every deed, pestilence, and famine and wars, and earthquakes have to be regarded as a remedy for nations, as the means of pruning the luxuriance of the human race.

Tertullian 337 A.D.

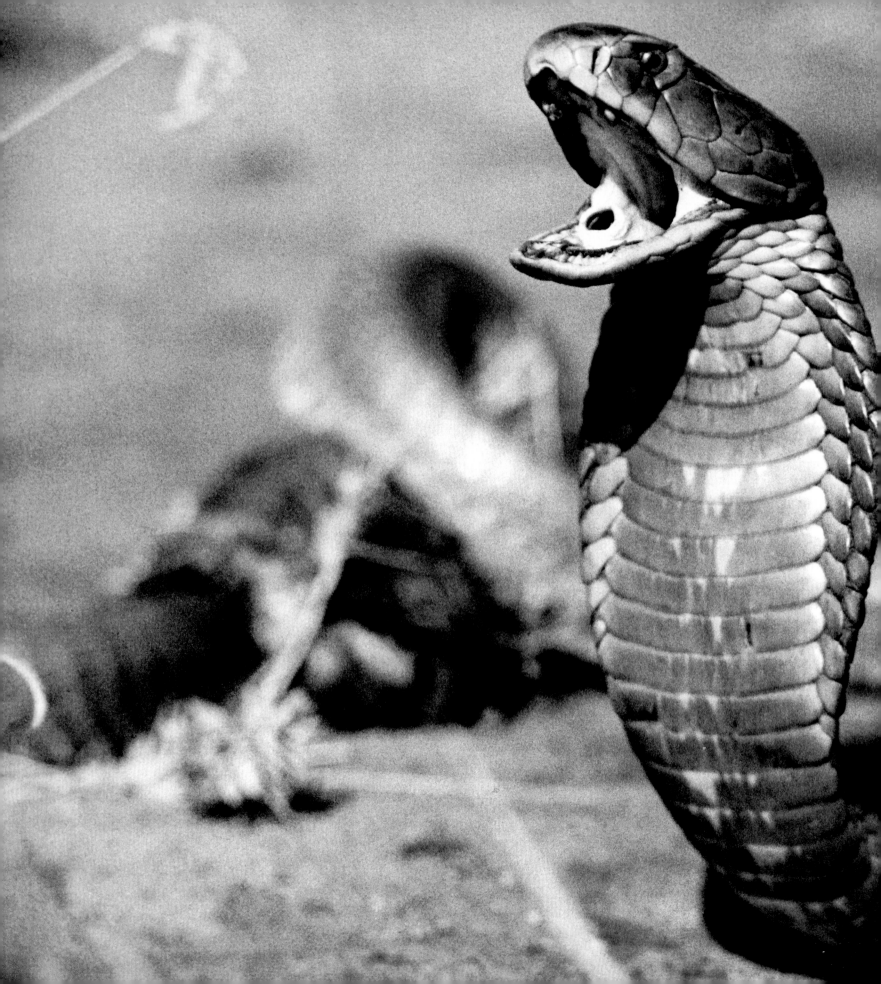

Prone on the ground, as since, but on his rear,
Circular base of rising folds, that towered
Fold above fold, a surging maze; his head
Crested aloft, and carbuncle his eyes;
With burnished neck of verdant gold, erect
Amidst his circling spires
 Paradise Lost

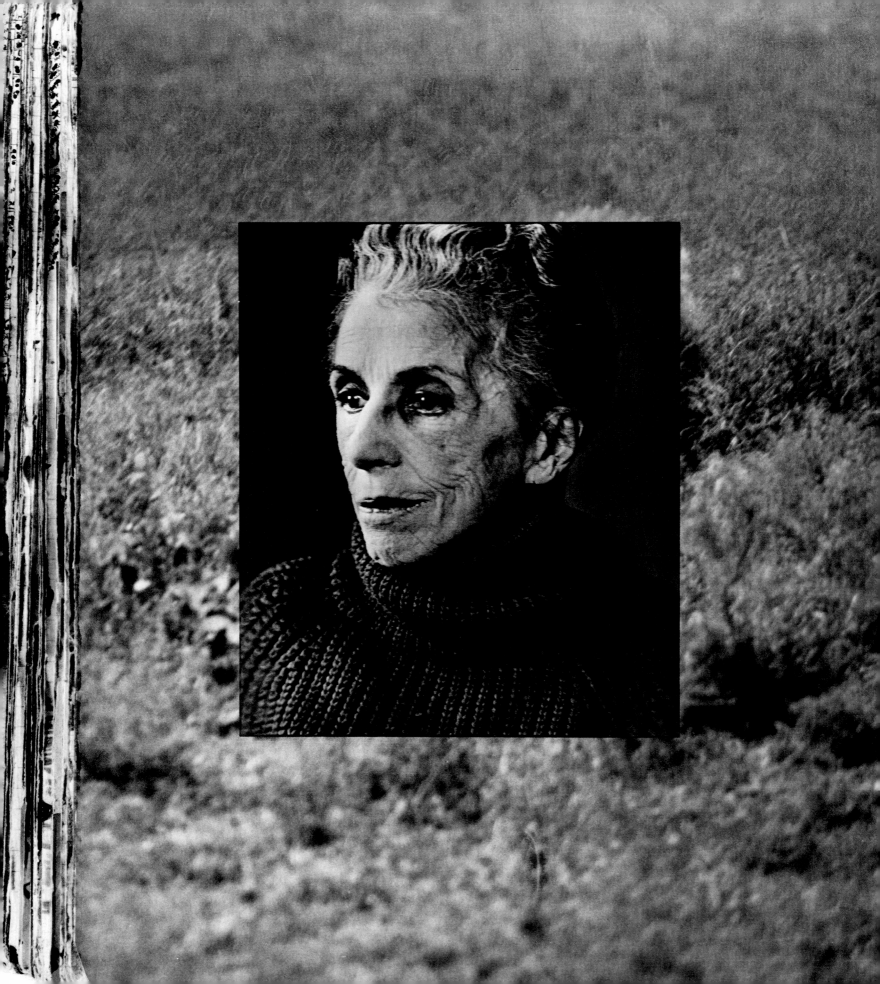

Elephant bones
TSAVO

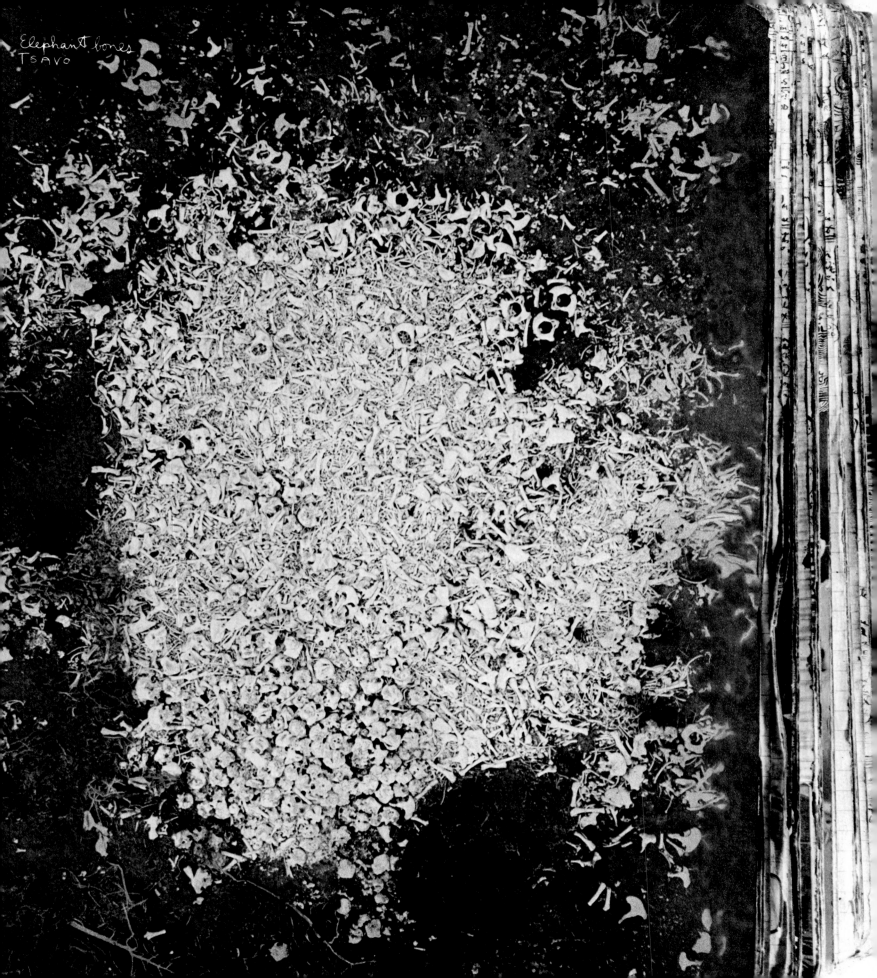

1

The White Mountain

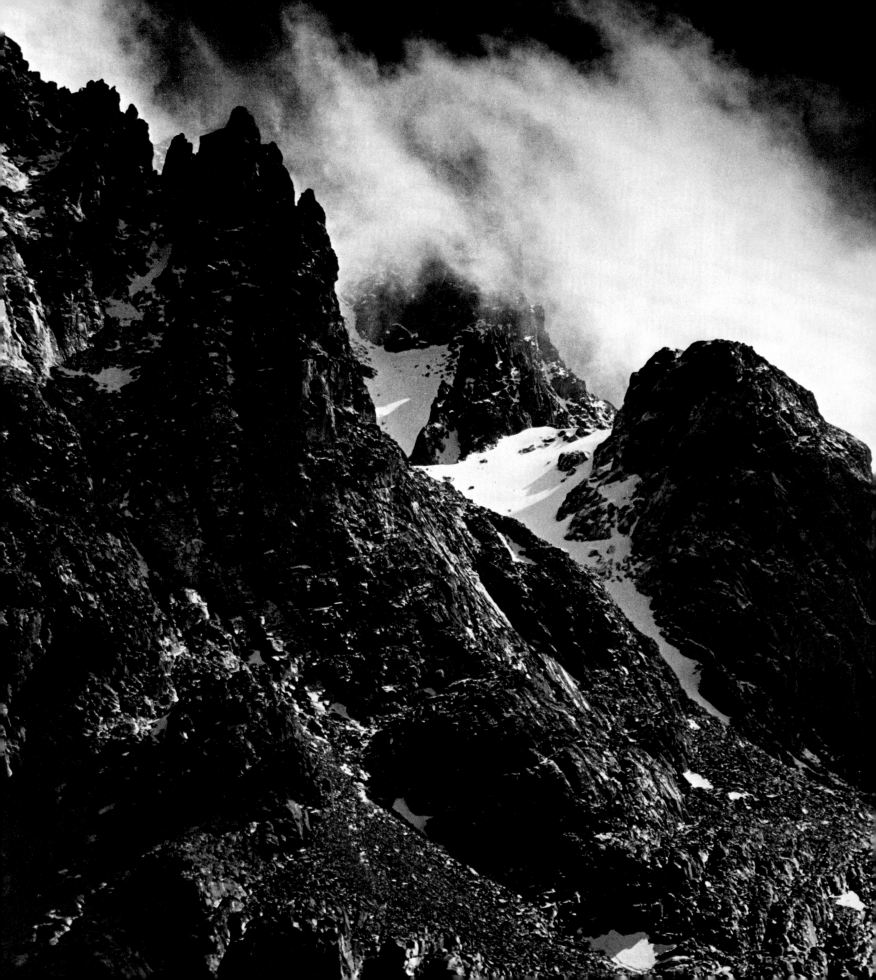

Some hundreds of years ere the White Man came,
The chiefs of the land were the kings of game.
When the buffalo herds moved wild and free
From the long fresh lake to the great salt sea,
One enormous herd there would always be
Under the mists of the Kenya snow.

> *Brian (Korongo) Brooke (1916)*

On December 3, 1849, Johann Ludwig Krapf was standing on a hill in Kitui, deep in the Wakamba country of East Africa, when a massive layer of cloud suddenly parted—to reveal, ninety miles away, "two large horns or pillars rising over an enormous mountain," strangely white. The German missionary became at that moment the first white man ever to behold the spectacle of two jagged, snow-capped mountain peaks shimmering in the middle of the African jungle. With his sighting, the story of *The End of the Game* begins.

In two letters to the British Consul at Zanzibar, the first one written in a handwriting reflective of his feverish state on the very day he returned from Ukambani, Krapf describes his fifty-day march through the "dreadful jungles" of "Tsawo", past Kikumbuliu (near Darajani), along the Athi River, up the Yatta plateau, and onto Chief Kivoi's hamlet in Kitui, less than 100 miles southeast of the white mountain. "I have seen the snow-mountain Kilimanjaro in Chagga," he writes, "and also a snow-mountain to the north . . . Chief Kivoi, who received me well, wishes that boats might be sent up the river and fetch his abundance of ivory. I myself think that if that river [the Tana] be navigable as far as to the vicinity of the snow-mountain Kenia, as it is called, we shall have gained an immense advantage regarding the exploration of Central Africa . . . On my first interview he [Chief Kivoi] mentioned the Kenia as a larger snow-mountain than Kilimanjaro, in Chagga, and said that I could see both mountains on an elevation at a little distance from his hamlet—three

Kima ja Kegnia, Mount of Whiteness . . .
It has only been seen by myself." J. L. Krapf

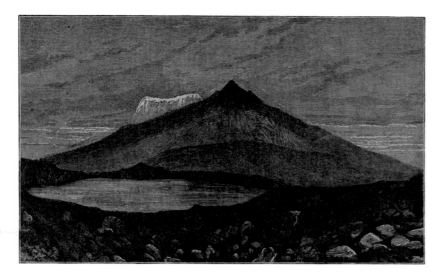

days' journey to the river Dana [Tana] and six days to the Kenia . . . On the afternoon of my departure from Kivoi's hamlet, I got a fine view of the Kenia, which I saw stretching from east to north-west. On its back I observed two horns towering heavenward . . . snow was on the horns of the peaks, as we may call them."

Krapf's native boy called the mountain Ke'Nyaa, Wakamba for "cock ostrich," a bird that is distinctly black and white; the Kikuyu who lived in the mountain's shadow called it Kirinyaga, *"like* a cock ostrich." So much did the black and white Ke'Nyaa symbolize the land of harsh contrasts that when Europeans took it upon themselves to name the region, they named it *Kenya.*

To Africans, Kirinyaga was the holiest of places, magnificent and terrifying, the house of *Ngai,* God. Ngai Himself had put the whiteness there to keep the mountain holy, and then wrapped it in biting cold to sanctify that holiness. Then the Europeans came: the beginning of the era of encroachment, the end of all that whiteness.

Discovery was in the air in Africa. Krapf's reports, and those of his fellow adventurers, filtered back to the Royal Geographic Society in London and inspired men such as Burton, Speke, and Grant to undertake a search for the sources of the Nile. Other authorities, however, remained intractable; one of them, the eminent geographer W. D. Cooley, went so far as to write: "With respect to those eternal snows on the discovery of which Messrs. Krapf and Rebmann have set their hearts, they have so little of shape or substance, and appear so severed from realities, that they take on quite a spectral character. No one has yet witnessed their eternity; dogmatic assertion proves nothing; of reasonable evidence of perpetual snow there is not a tittle offered."

Cooley was determined that not a tittle of snow could exist so near the equator. Yet in 1883, two years after Krapf's death, Joseph Thomson, crossing the plateau of Laikipia, was able to confirm that the white substance *was* snow, and not the "calcarious earth" of the ever-doubting geographers and armchair scientists. Many early African explorers were to be exposed to the same withering arrogance as Krapf had been—an arrogance that over the next

hundred years would inflame the scientists' dealings with any number of committed fieldworkers in the *nyika,* and to which the 8,000 square mile Tsavo wasteland now stands as a monument. It is anything but a pacifying irony that ninteenth-century Africa turned out to be less dangerous to unwary travelers than the conference rooms and journals of the learned societies.

After Krapf, there were others who tried to reach Mt. Kenya and approach the whiteness there. But with all its might Africa resisted: Mt. Kenya, seat of Ngai, a fastness of glacial cold and sheer, glassy sides, proved unassailable.

In 1887, a Hungarian nobleman, Count Samuel Teleki von Szek, managed to get as far up the slope as the Alpine Zone. He had struggled to within 500 feet of the vegetation line, to the valley which today is named after him. There, at 13,800 feet, he was compelled to turn back.

Five years after him, a British glacierologist, J. W. Gregory, had to give up at the glaciers, a mere thousand feet from the twin peaks, between which, according to legend, Ngai still rested on his white bed (called *Ira*). From their vantage point, Gregory and a German officer, Lieutenant von Hohnel, estimated the height of the peaks at 19,000 feet. (This estimate was proved wrong, but inasmuch as the twin peaks are the decayed stumps of long-dormant volcanoes, it might have once been correct.

Like most things African, the top of Kenya would all too soon be taken by the white man. What a missionary had gazed upon with freshness and wonder, explorers would conquer and give names to, geographers would explain, often incorrectly, and the tourist world would one day take for granted. It was Krapf, the scholarly member of the Church Missionary Society, who, in discovering the ancient home of Ngai and bringing his civilized god to the natives, had pointed the way—forward to ruin, backward to oblivion.

Fifty years later, in 1899, the explorer, geographer, and mountain climber, Halford Mackinder, led a party of six from Marseilles. Accompanying him (on June 10) were C. B. Hausberg, who was to act as camp master; E. H. Saunders, a collector, and C. F. Camburn, a taxidermist (both highly recom-

"No one has yet witnessed their eternity, dogmatic assertion proves nothing . . . of reasonable evidence of perpetual snow there is not a tittle offered."
W. D. Cooley

Kilima-Njaro
Mountain of Caravans

mended by the South Kensington Natural History Museum) ; and César Ollier, a famous Alpine guide, and his porter Joseph Brocherel.

The East Africa of 1899 was all uncharted desert and thick, lush, humid forest. Where a few years later the muddy tent town of Nairobi would spring up as if from the earth itself, there was now only a railhead fronting the wilderness. A single white man was established in the area, an English trader by the name of John Boyes. Disease, notably smallpox, thrived in the coastal regions around Mombasa, and famine had been decimating the population for two years (Boyes tells of losing thousands of his Kikuyu neighbors to it). It amounts to a miracle that on very limited funds Mackinder was able to organize 59 Zanzibaris, 96 Kikuyu *wapagozis* (porters), and two Masai guides for his attempt on the mountain; all the goods had to be carried on the natives' heads, for at that time there were no horses or mules or draught oxen in East Africa. Mackinder had only the summer in his favor, for then the rains in the valleys and the damp cold in the upper reaches of the mountain would surely drive him back.

The party reached Zanzibar on June 28. By the end of July, in spite of a railroad accident, it had assembled on the Nairobi River on the very spot where the slums of the modern city sprawl. "There one morning at dawn," Mackinder wrote years later in 1930, in a paper for the Royal Geographic Society of London delivered in memory of César Ollier who had just been killed in a rock fall in Courmayeur, Italy, "César and Joseph burst into my tent exclaiming excitedly, *'Monsieur, les montagnes!'* I went out into the freshness of the sunrise, and beyond great herds of game grazing peacefully within a few hundred yards saw to the south on the horizon 100 miles away the snowy dome of Kilimanjaro, and 100 miles to the north the twin peaks of Kenya, streaked with glaciers. César remains imprinted on my memory as he stood beside me at that glorious moment."

In a few weeks they had moved out of Kikuyu land into the treacherous Merenga country to an altitude of over 7,000 feet. Dusty bush gave way to forested hills where every day for two weeks it rained heavily from midnight to noon. Wild game abounded, and twice they were charged by rhinoc-

John Boyes, King of the Wakikuyu and one-time owner of Mt. Kenya

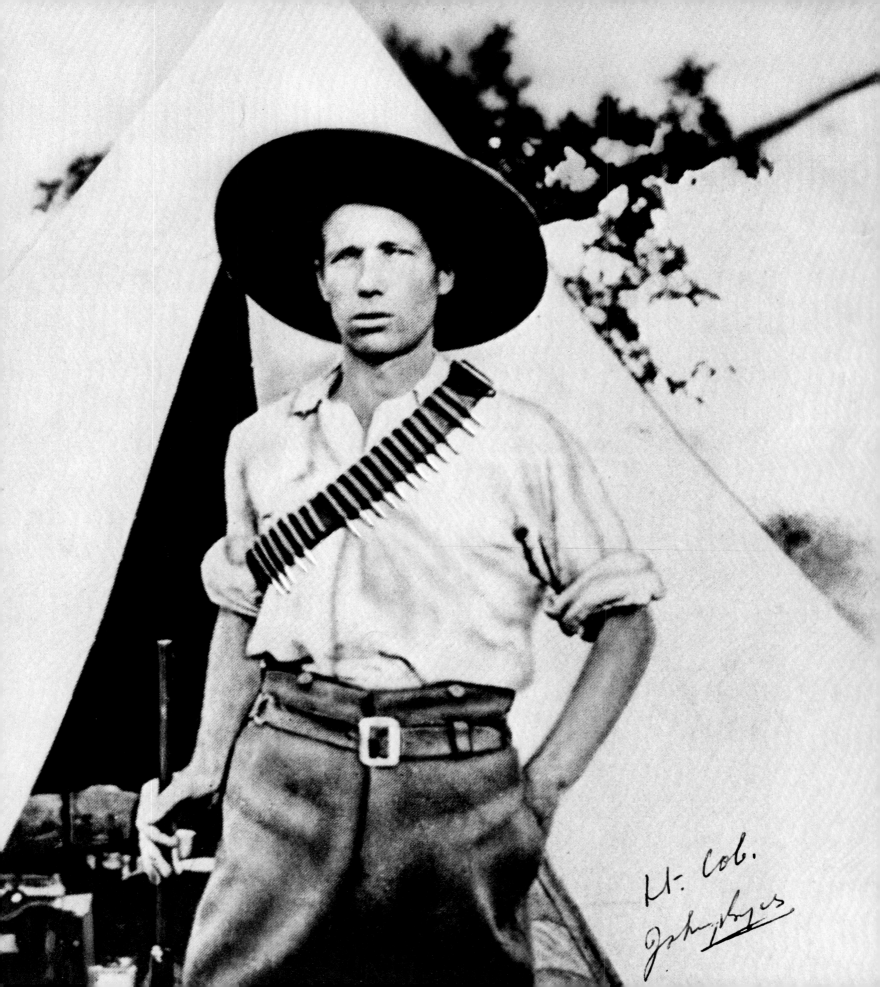

Lt. Col.
John Boyes

Nairobi, July 1899—a railhead against the wilderness.

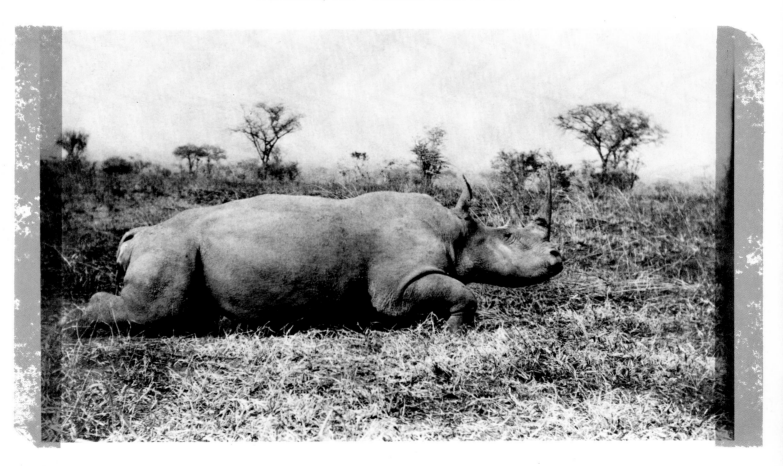

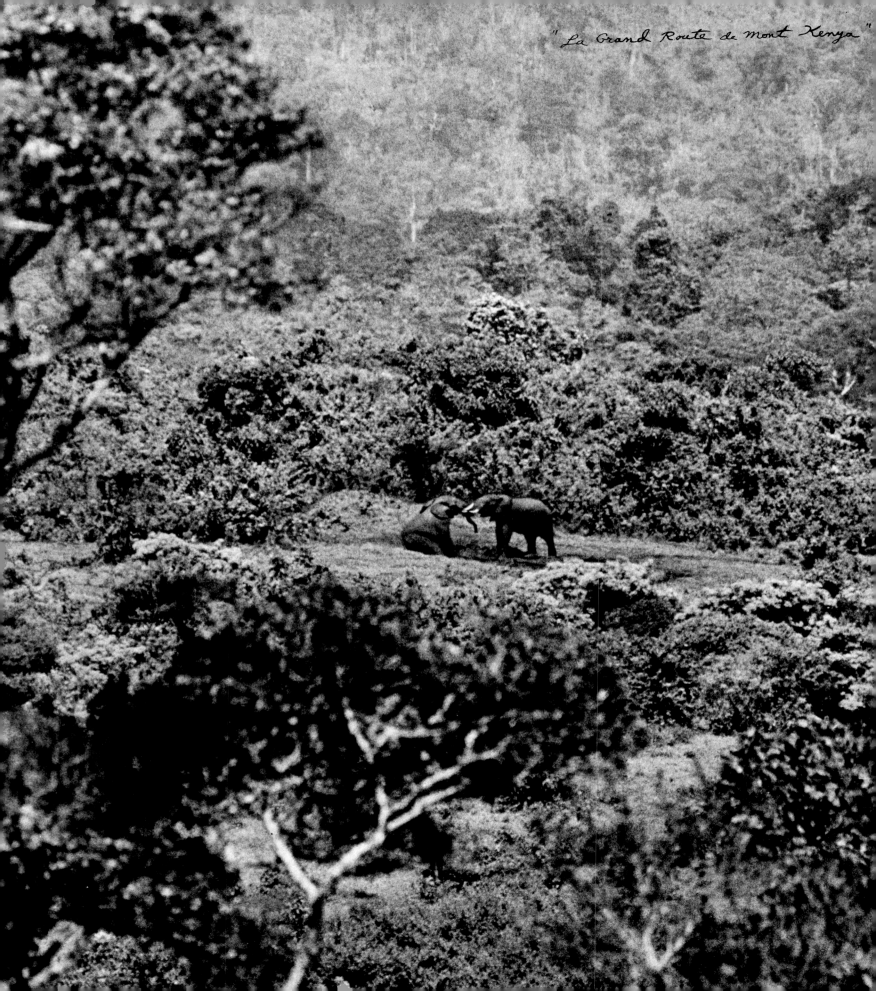

"La Grand Route de Mont Kenya"

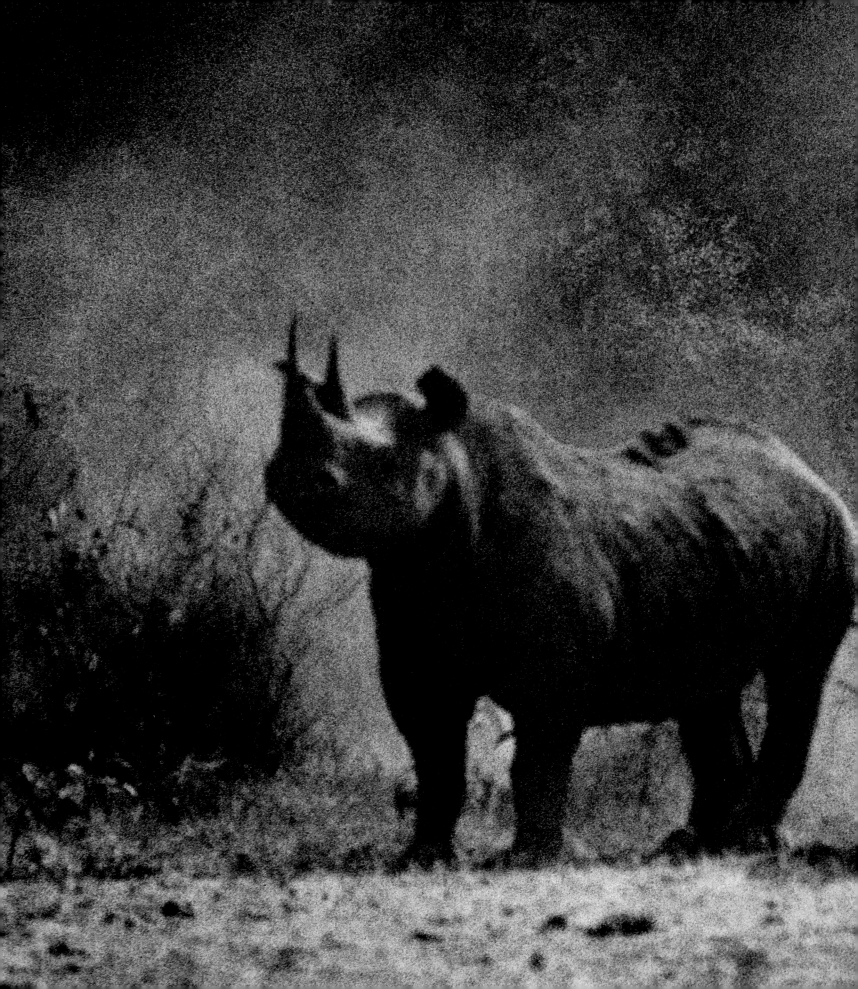

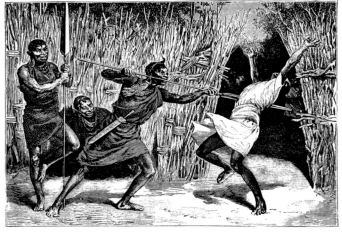

eros. The natives they encountered promised them food but then became hostile to the point where they tried to persuade porters to desert. Mackinder finally resorted to holding a gun to the porters' heads to keep the expedition moving. In recording the hardships of the journey, even when he tells of poisoned arrows falling at his feet, he is characteristically modest and understated. (In his paper, he speaks of the "hesitancy" he feels "in talking of that holiday many years ago, for since that time uncounted thousands of the younger generation have experienced adventure and danger in war, in the air, and on the high mountains.")

The mountain was Mackinder's goal; nothing else mattered. By August 18, advancing on an average of five or six miles a day, the expedition had reached the Plateau of Laikipia at the western foot of Mt. Kenya, where it halted to reorganize in task force. A Swahili headman was sent back for more food. Hausberg waited on his return while Mackinder pushed on with the guides. Together they hacked *La Grande Route de Mont Kenya* through the underbrush, until Mackinder realized that elephant trails were easier to follow.

They were able to establish a base camp at 10,200 feet, then two more at successively higher points. But the gods must have envied their hard-won access, for a fire almost wiped out the second camp, and from time to time Wa-Ndorobo hunters rifled their fast-dwindling supplies. The rarefied freezing air and surrealistic landscape of giant lobelias and groundsels spoke unkindly to the superstitions of the starving natives, and those not too weak from disease or hunger deserted. Hausberg had meanwhile learned that the Swahili headman had been ambushed and two Kikuyus killed. Mackinder quickly dispatched two parties four days apart, all the way back to Naivasha across the Aberdare mountain range, down into the Great Rift Valley, to look for food, and he and his companions redoubled their efforts to take the mountain.

At daybreak on August 20, they left camp. By nightfall they had made the base of the lower peak. At an elevation of 16,800 feet, "we tied ourselves to the rocks and prepared for twelve hours of equatorial darkness," Mackinder writes. The next day,

A group of the now extinct Wa-Ndorobos in the first photograph ever taken of "Sulguioto" (their word for bongo), 1909

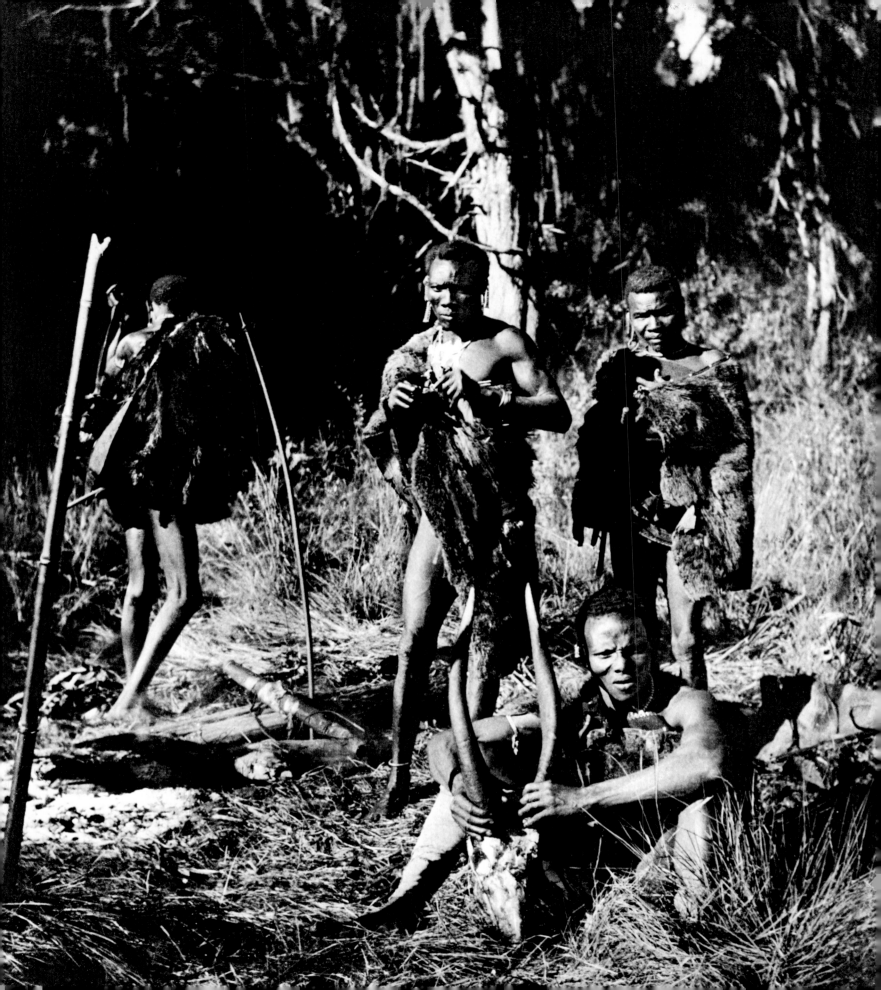

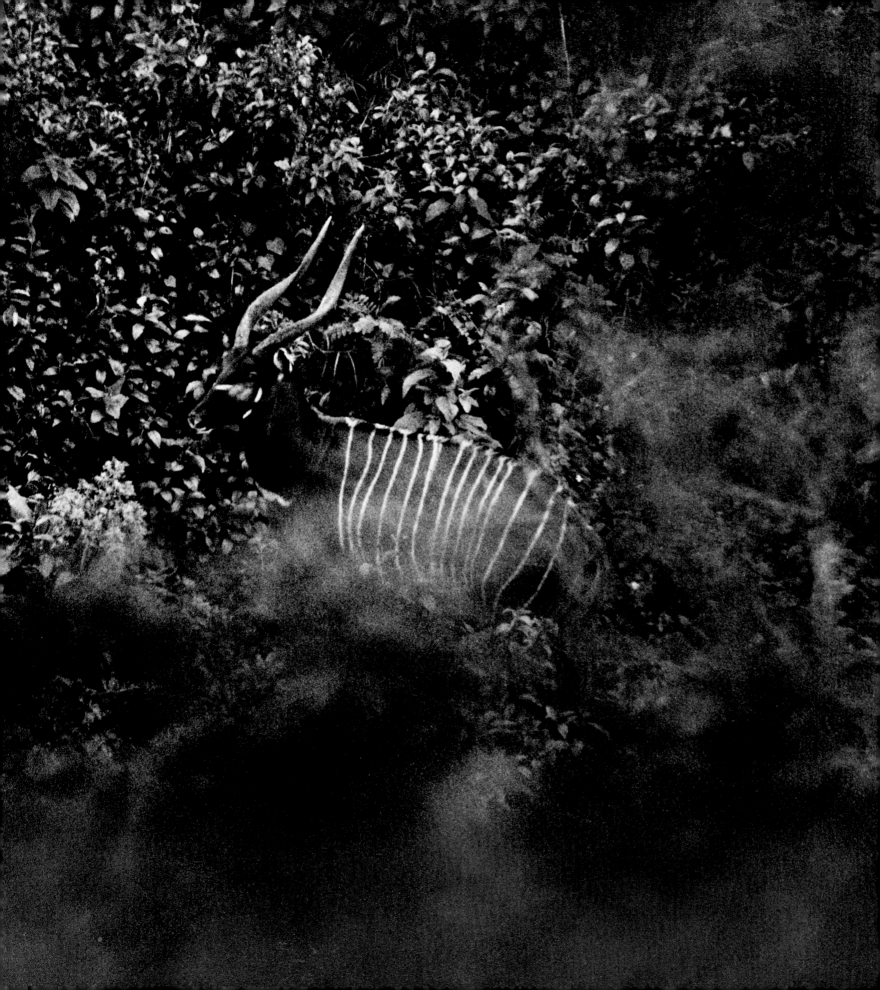

frozen from the night of the long darkness, they failed to find a way to the top (with "the ice . . . so solid that twenty and thirty blows are needed to cut a step; and snow that is powdery, in reality fine hail"), and, in fact were to spend all of the next five days circling the base for a new route of ascent. Meanwhile, neither party had returned. Mackinder decided that by September 7 they would have to turn back, but on the seventh, just two hours before they planned to break camp, the two foraging parties appeared within half an hour of each other. They had managed to bring back very little, but there was enough for one more attempt at the peaks.

On September 12, Mackinder and the Italians made camp at the head of the Teleki Valley. "The peak was again clear," he writes. "What a beautiful mountain Kenya is, graceful, not stern, but as it seems to me with a cold feminine beauty. The head of the Teleki Valley with its ruddy cliffs, edged and lined with snow or hail, appears more beautiful in tonight's sunset than ever before. Suddenly the sun must have sunk below the horizon, for the glow went and the whole scene chilled in a moment to an arctic landscape. Later the young moon gave it a third, less tangible aspect. The Equator is ten miles to the north of us."

Mackinder and his companions built a stone windbreak there, which stands to this day. In the morning, they started climbing the southwest face of the lower peak, cut across what are now called the "Mackinder gendarmes," crept along a rocky rib running down the western corner of the peaks, and came to a glacier about a hundred yards wide. This was *Ira*, the white bed of Ngai, which Brocherel estimated it would take them twenty minutes to cross. "It took three hours," Mackinder writes, "to cut our way across this hanging glacier to the farther side of the gap between the two summits, and I gave it the name of the Diamond Glacier. At first we traversed the ice obliquely upward. . . . There was a thin covering of snow. Then we turned a little towards the base of the lesser summit, but seeing no foothold on the rocks we resumed our oblique traverse upward towards the greater. The glacier was steep, so that our shoulders were close to it. Had we fallen we

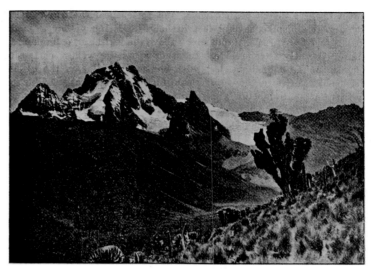

Mt. Kenya in 1899, photographed by Mackinder

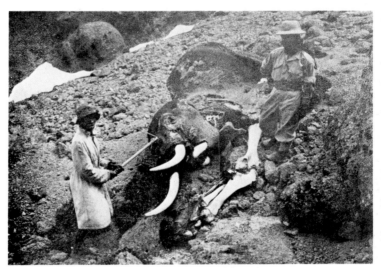

An elephant at 16,000 feet

Mountain madness on the Curling Pond below Lenana

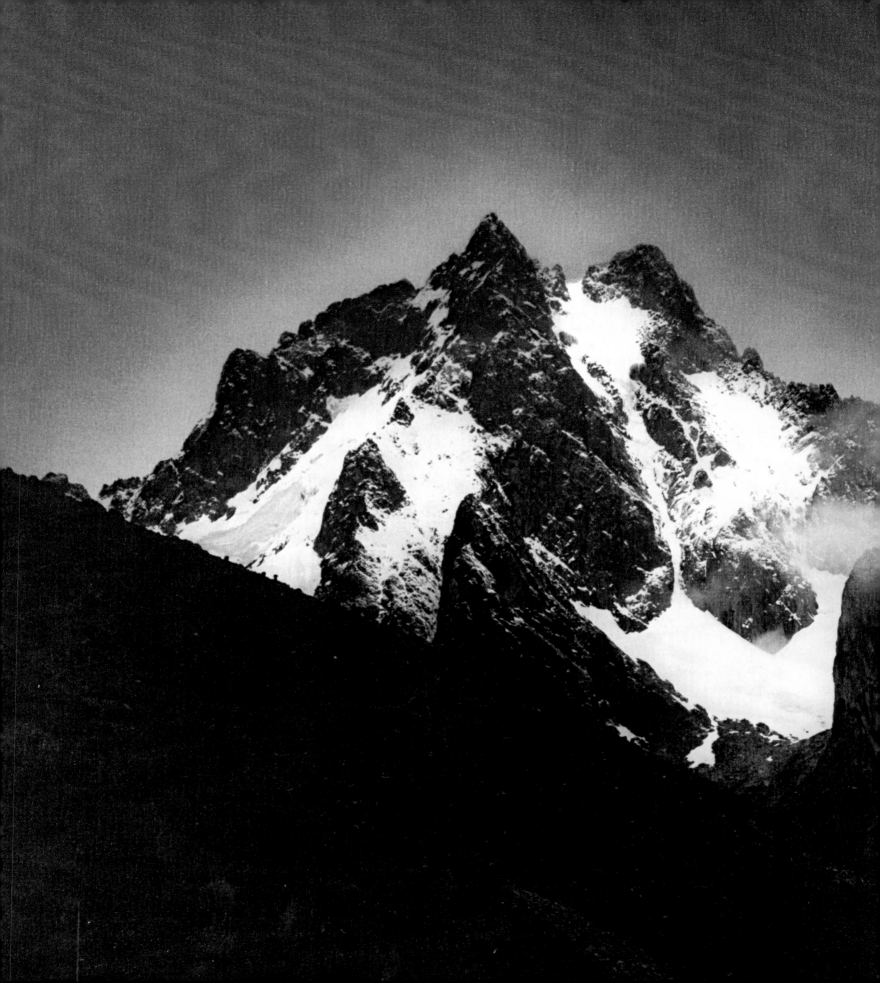

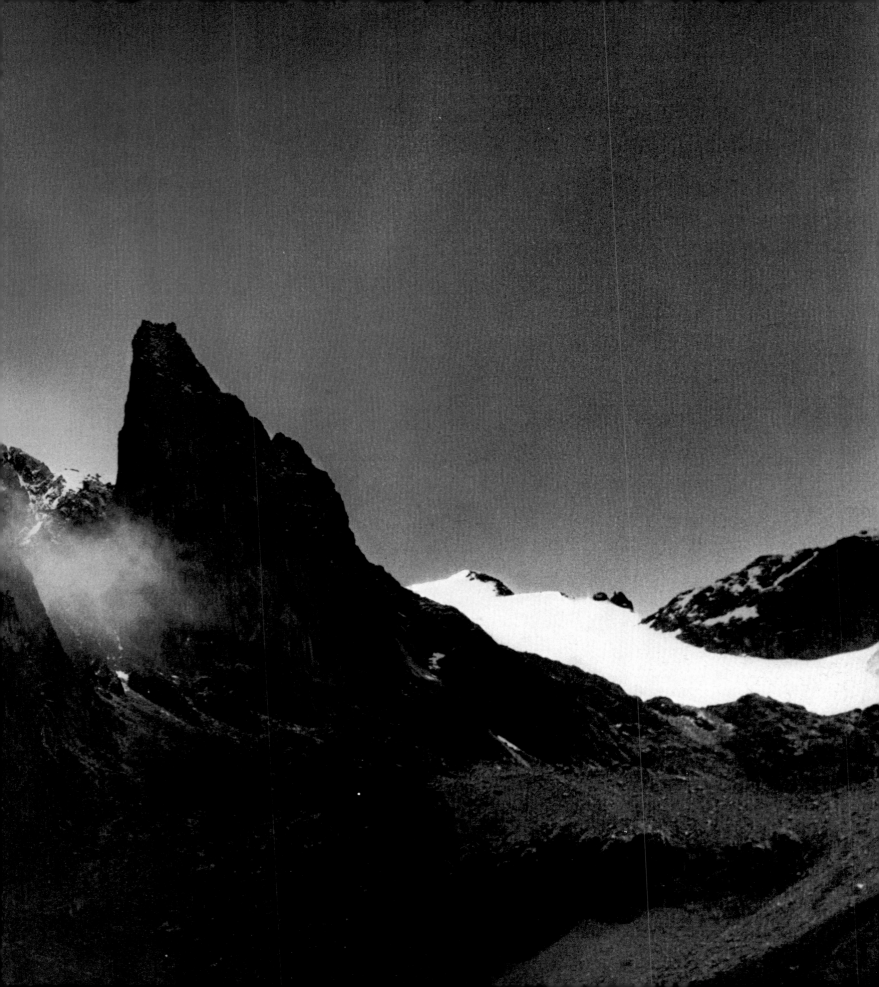

should have gone over an ice-cliff on to the Darwin Glacier several hundred feet below.

"At last we reached the stone again, and almost exactly at noon set foot on the summit, which is like a low tower rising out of a heap of ruin, for the lichen-covered rock is vertically and horizontally jointed. On the top were three or four little turrets close together, and on these we sat. A small platform a few feet lower adjoined the south-east corner of the crag, and from this I got two shots with my Kodak of the summit with César and Joseph upon it.

"I read the aneroid twice, throwing it out of gear between the readings, then ascertained the boiling-point, and took the temperature with the swing thermometer. There was a light north-north-east wind. The second peak bore 135 magnetic and we estimated that it was about 30 feet lower than that on which we stood. I broke off a fragment of the highly crystalline rock. The delay on the glacier had allowed the midday cloud to gather round the peak, but the sun shone through from above, and there were great rifts in the drifting mist through which we looked down onto the glaciers and aretes beneath, and away beyond into the valleys radiating from the peak. We remained about forty minutes on the top.

"Then we scrambled down into the col between the peaks. The temptation was great to make an attempt on the second, for the way up from the col did not appear difficult, but a storm was threatening and we were not equipped to spend another night on the mountain. We therefore returned over the hanging glacier, clearing the freshly fallen snow from our steps. It was fortunate that we had cut them deep. By 6 p.m. we had reached our resting-place of the previous night. There was still the treacherous face of the arete to be negotiated, but we continued down by the light of the half-moon and the sheen from the glacier below, throwing most of our gear over the precipice before-hand. It was not until 8:20 p.m.— for we were all tired—that we set foot on the Lewis Glacier, and not until 10:20 p.m. that we arrived back in Camp 22, hungry and weary, but triumphant.

"Our times indicate a slow descent, and I was the chief cause of this. Beyond a spoonful of soup at night-time, I had nothing to eat for nearly thirty-six hours, except a few meat lozenges and an occasional bite of Kola biscuit. Starvation seemed the only remedy for the lassitude I experienced in our first attempt. The remedy succeeded admirably during the ascent but naturally had to be paid for during the later hours.

"The light effects were wonderful that evening. On the hanging glacier we had frequently been enveloped in the cloud, which shielded us from the equatorial sun, but at sunset we came again into the clear air on the top of the southern arete. All the eastern horizon was glorious, with a deep purple belt rising like a wall from the end of the landscape. Three hours later, as we trudged home over the Lewis Glacier, the great features of the mountain stood out as though boldly sketched in black and white crayons. The upper end of the glacier rose in snowy billows to the point of Lenana on the one hand, and on the other skirted the foot of the cliff by which we had descended, now black in the shadow cast by the moon. Below was the white expanse of the cloud roof flowing dreamily beside the solid texture of the ice. Most striking of all were the sheens and jetty blacks on the pinnacle of the Lion's Tooth, Jackson's Peak today.

"The midnight scene as we supped by the campfire I shall never forget. The sound of the Nairobi torrent, swelling suddenly from time to time as the breeze changed, and even the occasional hoot of an owl, made no break in the silence of the great peak standing brown and white in the glare of the setting moon. The Pleiades twinkled over the centre of the Lewis Glacier, but overhead the stars in the black vault were steady and without twinkle. Our camp was on the broad floor of a deep valley, shut in by steep slopes to north and south. To the west was a moraine of great blocks and tree groundsel. To the east were the red cliffs, and to the north-east the Lewis Glacier and the peak. Those evenings, this the most wonderful of them all, were spent monosyllabically, warming our hands and feet at the fire amid the mysterious shadows of the tree groundsel and the white gleams of the creeping groundsel. Our thoughts and our words were divided between our conquest and the red cinders which spoke of home,

Noon, September 13, 1899 —
Joseph Brocherel and César Ollier at 17,058 feet,
the summit of Mt. Kenya (then unnamed)

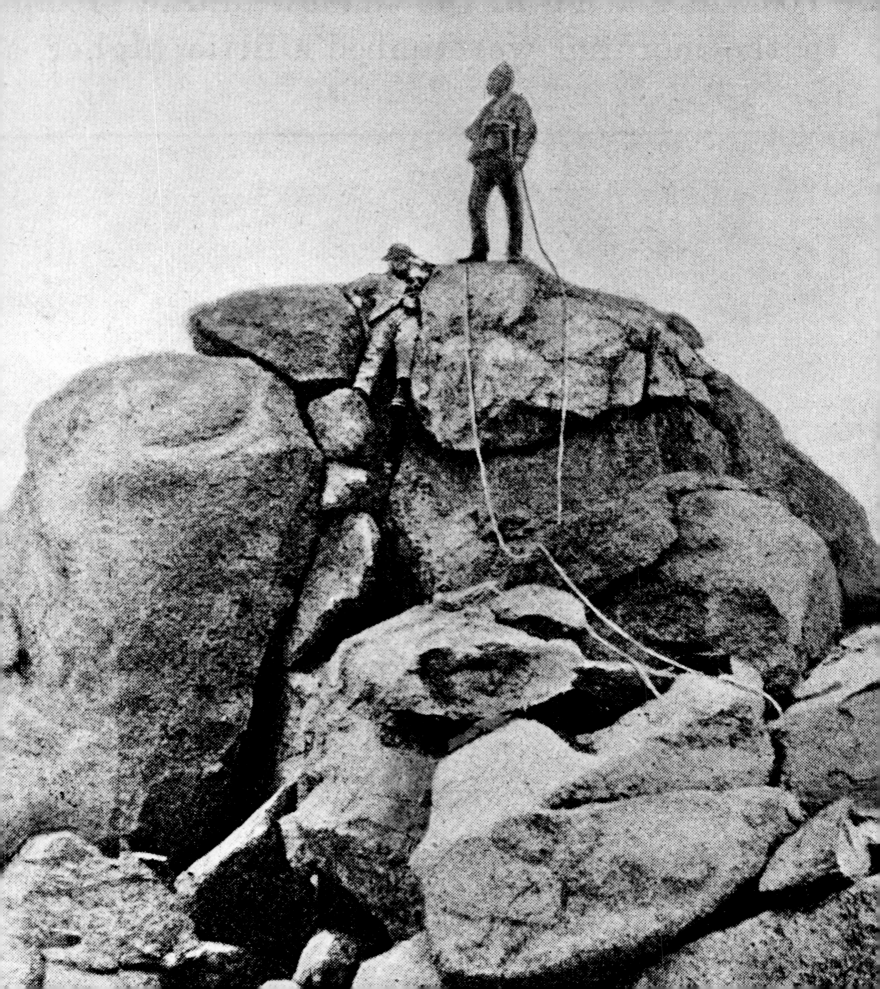

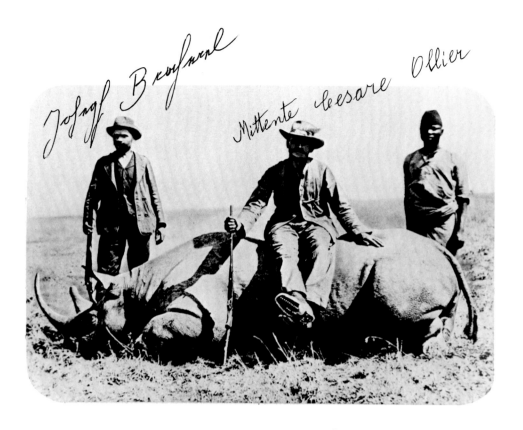

until presently the scene around broke slightly into our dreams, . . . as the fire dulled and our feet grew chilly the bark of a leopard ranging the hillside opposite reminded us of the early rise on the morrow, and with a drink of the cold water from our camp spring, we rolled ourselves up in our blankets without undressing, for warmth could not be wasted at Camp 22."

For the first time in the history of the world, a man had stood on the summit of Kenya. The ravaging cold and splintered icy rock had at last been overcome, but the mountain would retain its ancient mystery: though he had pierced the mist, Mackinder had not dispelled it.

The world paid little heed to Mackinder's conquest of the home of Ngai. In time, however, the story of his ascent became part of the mythology of the mountain, obscuring his later distinctions as geographer, Member of Parliament, and civil servant.

So as not to break faith with his sense of history,

Mackinder named the peaks after two celebrated Masai brothers, both *laibons* and chieftains. The higher peak (17,058 feet) he called Mbatian, after the son of Supeet, son of Sitonik, son of Kipepete, son of Parinyombe, son of Kidongoi, son of E-Sigiri-aishi, son of Ol-le-Mweiya, the first Masai, who came down from the heavens to sit on the top of the Ngong Hills, beside Nairobi, "place of cold water." Nelion was Mackinder's name for the second peak (17,022 feet), which was to resist conquest for another thirty years. (Eric Shipton was the first to climb it in 1929.) Mackinder's reports of inaccessible valleys, altitude sickness, and hostile natives were the fodder for tall tales and served only to burnish Africa's greatest mountaineering legend. But for the natives, the mountain—and the world it symbolized—had come to grief.

One item, incidental to history, in Mackinder's account became the occasion for a popular poem: the buffalo skeleton he saw at 14,200 feet in the Gorges Valley, "a full-grown bull and king of all."

82

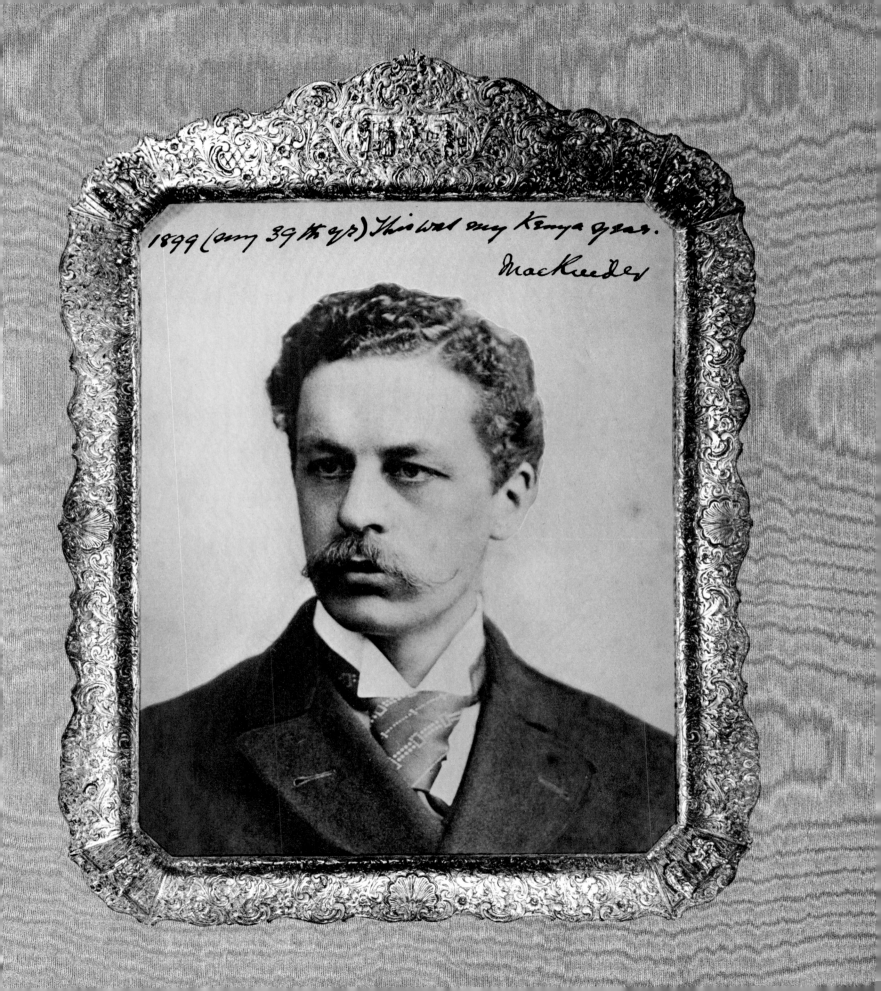

1899 (my 39th y/s) This was my Kenya year.

MacKeedley

from the snowline above Mackinder's Camp.

"Under the Mists of the Kenya Snow" by Brian Brooke captures in both its Parnassian tone and its idiom, irretrievable now, the wonder of a far-off mountain when Mackinder was its only conqueror.

Many hundreds of years have passed away,
Since the grand old Monarch has held his sway,
But he lies asleep in the snow today.
Hundreds of years he has lain alone,
Guarding it all from his lofty throne
Under the mists of the Kenya snow.

When the game has passed from the realm he held,
And the waterless plains are fenced and welled,
When the forests are ploughed and the trees are felled,
As a monument to the Bush and Plain,
Where in ages past he was wont to reign,
There the Buffalo Bull will still remain
Safe, in the mists of the Kenya snow.

The white men who know it perhaps are few . . .
'Tis only of late that the white men knew;
But the fact remains that my story's true;
You can go and see if you want to know,
Climb up the cliffs till the sky and snow
Appear to be one with the peaks on high,
And there in his pride does the old bull lie,
Safe, in the mists of the Kenya snow.

Mbatian's people would in due course be conquered by the white man. The great chief had a premonition of this. Even as he lay dying of plague in 1890, he summoned the elders of Matapato, the subdistrict in which he lived. "Do not move from your land," he told them, in warning and farewell. "I am about to die and I will send you cattle from Heaven. If you move you will die from smallpox, and your cattle will die and you will have to fight with a powerful enemy that will come up from the coast in the form of a snake." After his death, from his grave at Donyo Erok, Mbatian returned to the spirit world of Eng-ongu e-'m-bagasi, or ol-doinyo loo-'l-Aiser. And, as he had foretold, plans for a railroad were drawn up in England and steel tracks shipped out to Mombasa on the coast so that what would come to be called "The Lunatic Line" could begin its sinuous, convoluted, 580-odd mile incision into Kenya and Uganda.

84

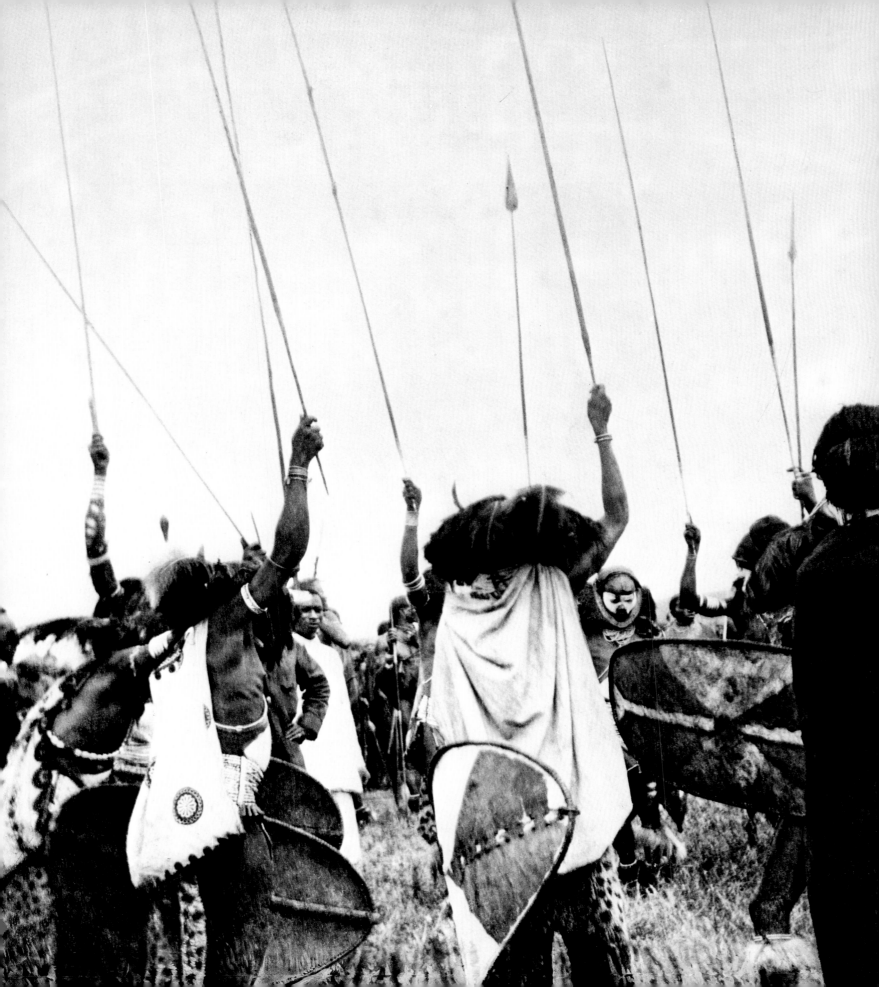

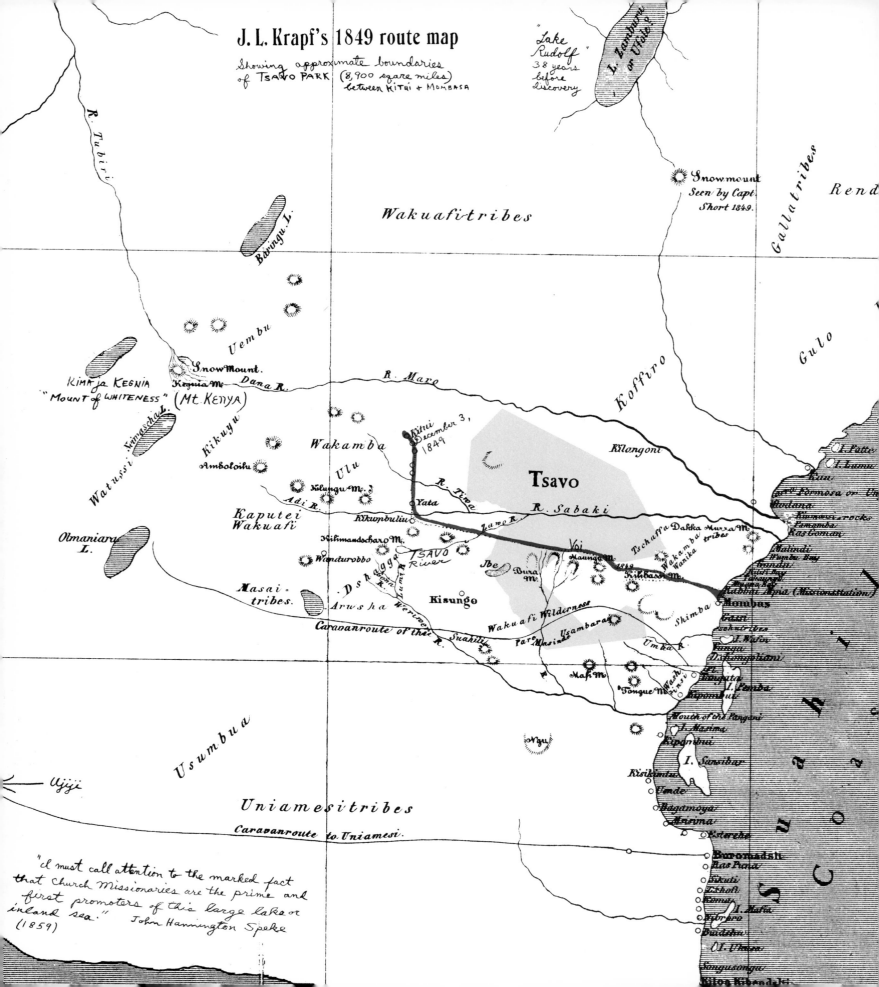

J. L. Krapf's 1849 route map

Showing approximate boundaries
of TSAVO PARK (8,900 square miles)
between KITUI & MOMBASA

"Lake Rudolf" 38 years before discovery

Snow mount Seen by Capt. Short 1849.

R. Tubiri

Baringu L.

Wakuafi tribes

Gallatribes *Rend*

Uembu

Gulo

Koffiro

Kima ja KEGNIA "MOUNT of WHITENESS" (Mt. KENYA)

Snow Mount.

Dana R.

Kegnia M.

R. Maro

Watussi Naimaschai

Kikuyu

Ulu

Wakamba

Kilongoni

Kitui December 3, 1849

Amboloihu

Kilungu M.

Tsavo

Adi R.

Yata

R. Tina

R. Sabaki

I. Patte
I. Lamu

Kaputei Wakuafi

Kikumbuliu

Tava R.

Garl Pomosa or Un
Bodana

Olmaniara L.

Kilimandscharo M.

Tschaffa Dakka Mura M.

Kumou rocks Pamamba Ras Goman

Wandurobbo

TSAVO River

Voi

Maunga M.

Wakamba tribes

Wanika

Malindi
Wumba Bay

Ibe

Dura M.

Mbubassi M.

Abbai Rqua (Missionstation)

Masai-tribes.

Kisungo

Arusha Werinei Juma R.

Dshagga

Wakuafi Wilderness

Shimba

Mombas

Caravanroute of the R.

Suahili

Pare Masin Usambara

Umka R.

Mafi M.

Usumbua

Nzu

Tongue N.

I. Sansibar

Ujiji

Uniamesi tribes

Caravanroute to Uniamesi.

"I must call attention to the marked fact
that Church Missionaries are the prime and
first promoters of this large lake or
inland sea." John Hannington Speke
(1859)

Kiloa Kiband.

2

A Snake from the Coast

I, Roshan came to this country of Africa,
and did find it indeed a strange land;
many rocks, mountains, and dense forests
abounding in lions and leopards;
also buffaloes, wolves, rhinoceroses,
elephants, deer, camels, and all enemies of man . . .
Now from the town of Mombasa, a
railway line extends into Uganda.
In the forests on this line there are
found "man-eaters." . . .

Day and night 100's of men fell victims
to these savage creatures whose very jaws were
steeped in blood.
Bones, flesh, skin and blood, they
devoured all and left not a trace behind them. . . .
The lion's roar was such that the very
earth would tremble at the sound. . . .
On all sides arose weeping, wailing, and
the people would sit and cry like cranes.

Where was there a man who did not feel afraid?
And now I will relate the story of the engineer
in charge of the line:
. . . After seeing what the animal had done,
the Englishman spoke, and said,
"For this damage the lion shall pay his life."
Patterson Sahib is indeed a brave and valiant man
like unto those Persian heroes of old—Rustem,
Zal, Sohrab and Berzoor.

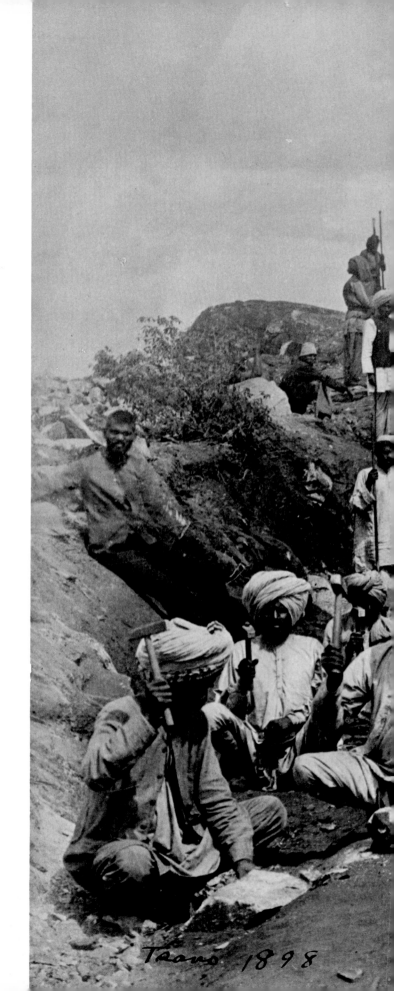

Tsavo 1898

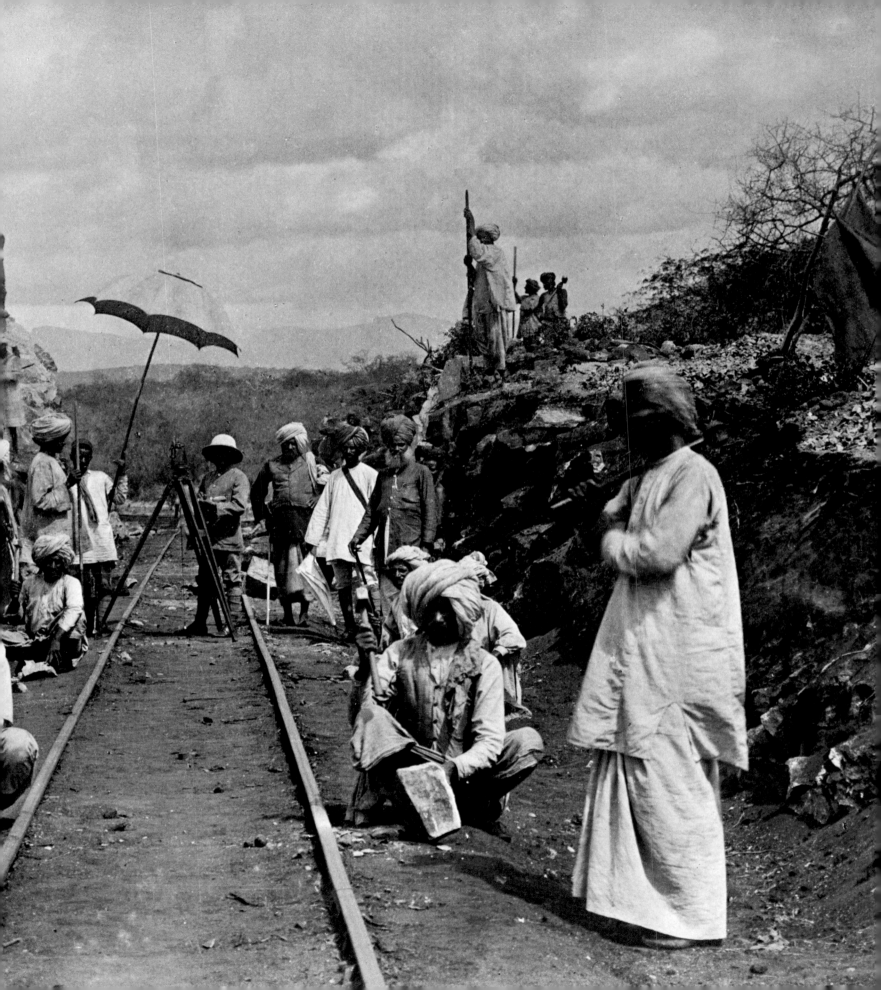

J. H. Patterson

Friday 9 (343-22)

Early in morning Swahilis came & told me lion had tried to break into their camp but they had frightened him off & at last he took a donkey from close to boma & was eating it. I went & arranged a drive; lion came within 10 yards of me & I fired point blank at his head—cartridge missed-fire & lion bounded by me into bush growling — saw no more of him.

Patterson's Tsavo diary

90

Slowly winding its way over the ravines at Mazeras and through the Taru desert, winding its way two thousand feet up the Rabai escarpment, the iron snake made inland from Mombasa and Kilindini during the summer, winter, and succeeding summer of 1896-1897. But at the Tsavo River area, having grown to between 120 and 130 miles, it was suddenly stopped by two "devil-lions."

"Ye who have beheld the blood-seeking monarch of the forest but in crippling captivity, immured in a cage barely double his own length, until his brawny sinews have become relaxed by irksome confinement, have seen but a shadow of the lordly savage that wields the sceptre of the jungle!"

The "blood-seeking monarchs" of the Tsavo bush were large, maneless, and, above all, man-eating; since March they had been feasting with brazen regularity on the occupants of camps near the railhead. Regarded as the spirits of native chieftains protesting encroachment on the land, they induced panic in the Indian coolies upon whom construction of the railway depended. (The sparsity of the native population, as well as its complete disclination to work, had made it necessary to hire these Indian workmen.) It was the coolies who called the lions "devils," for they believed that the animals could not be killed. Hysteria built to such a pitch that on December 1, 1897, thousands of workers threw themselves across the railroad tracks, interrupting work indefinitely.

The chief engineer at Tsavo, J. H. Patterson, was a tall, lean, stooped young Englishman with a moustache, who happened to have been raised in India. He knew how to build every kind of railroad—except this one. Night after night, in an attempt to trap the lions, Patterson crouched in trees near their most recent kills. But the lions invariably chose other railhead camps to prey upon. Changing his tactics, he tried poison. The lions avoided the bait. When he had a trap built, it remained empty. The renowned white hunter, Frederick Courtney Selous, expressed utter amazement that Patterson had not been rewarded for his daring by being seized from behind. In *The Man-Eaters of Tsavo,* Patterson

himself recalls: "The terrible thing was to feel so helpless. . . . I have a very vivid recollection of one particular night when the brutes seized a man from the railway station and brought him close to my camp to devour . . . the sound of their dreadful purring filled the air and rang in my ears for days afterwards." Another time, he had constructed a special trap of wooden sleepers, tramrails, telegraph wire, and heavy chain—which he then had baited with live human beings. When the door suddenly slammed shut, the armed "sepoys" inside froze in fear and there was an agonizing interval before they could be prevailed upon to fire. When at last they did fire, it was with such vehemence that the door shattered, releasing the captive demon. "Whitehead and I were at right angles to the direction in which they should have shot . . . yet their bullets came whizzing all around us." Another night, during a "stalk," so many men swarmed into one tree that it fell resoundingly down, hurling terror-stricken coolies to within a few feet of the waiting lions. ("Fortunately for them, a victim had already been secured and the brutes were busy devouring him.") On one occasion, the two lions fought over a victim ("They've taken him, they've taken him!" the coolies screamed) under the heavy fire of a visiting inspector.

These two man-eaters of Tsavo had transformed the sun-drenched, tangled jungle landscape of weirdly shaped baobabs and dense commiphera into a waking nightmare for every worker within ten miles of the railhead. Nobody—white, black, or brown—knew when the abominated jaws might seize him and drag him down. What he did know with a dreadful certainty was that once he had been dragged into the bush, the lion with its coarse tongue would lick off his skin, drink his blood, and then, leisurely, usually starting with his feet, eat him. Most of the labor force had fled to the coast, scattering their tools and supplies along the way like the toys of careless children. The few who did remain built shelters. And Patterson continued to maintain his grueling 24-hour watch.

On the night of December 10, from his rickety ten-foot-high platform, Patterson fired four shots at a dun form. The next morning he found on the spot

Monday 10 JANUARY, 1898.—

Sign Agreement for Uganda Rly. at Colonial Office 1898

Tuesday 1 MARCH, 1898.—

Arrive Mombasa 1 P.M. Like appearance of place. Chief Engr. away, no one knows anything of my movements here.

Scaffolding for public executions, Mombasa 1898

Monday 7 Ember Day.

Visit Mombasa. Take photos. Am officially informed that I am posted to Tsavo — Prepare "chop boxes" for 3 months at Tsavo — draw kit from Stores; Call on Dr. & Mrs. Hinde —

Tuesday 8

Leave Kilindini for Tsavo at 5=20 A.M. Have a hot & unpleasant journey thro' the Taru Desert. Dr. McCulloch shot an Ostrich from train — we pull up & take it with us. I have some of the feathers — arrive Tsavo — 7 P.M.

91

Tuesday 6 Go on Quarry all masons mutiny & threaten my life — send for Police — See trouble brewing with coolies — coolies strike work.

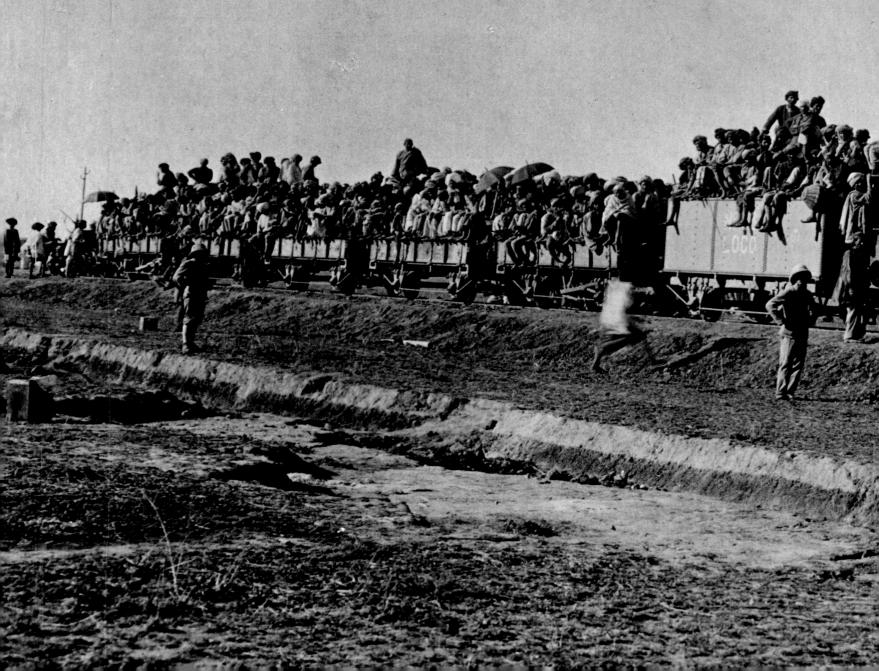

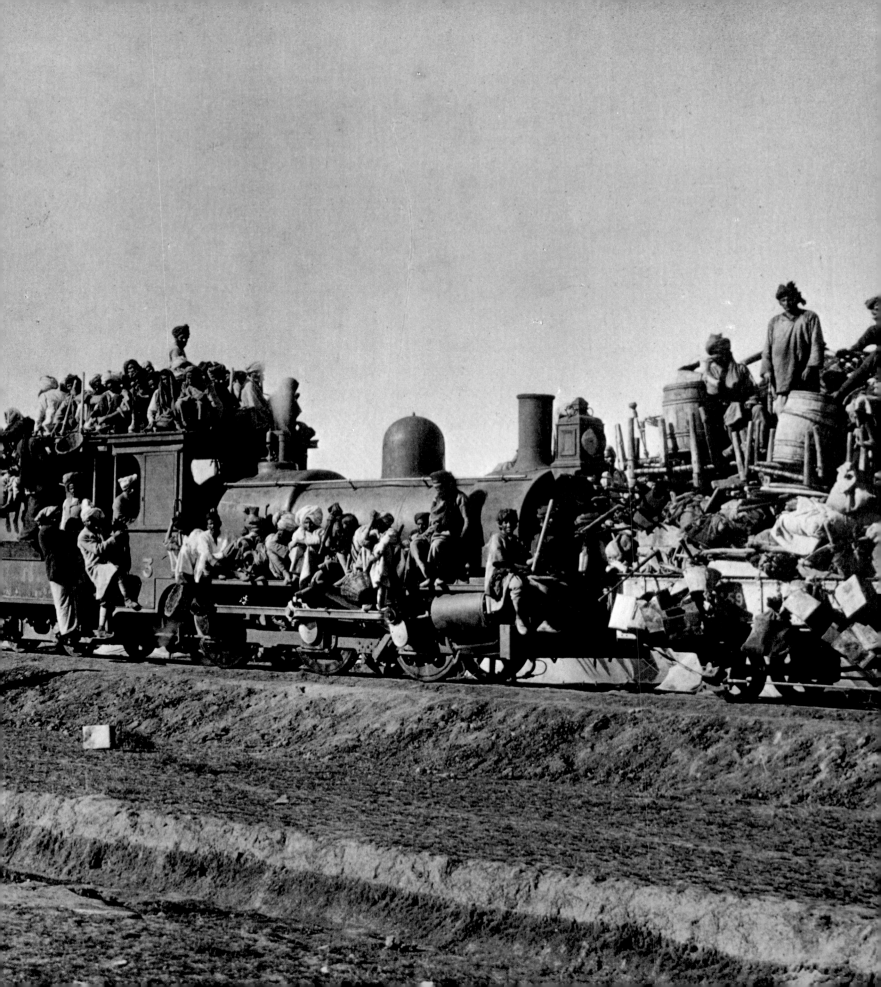

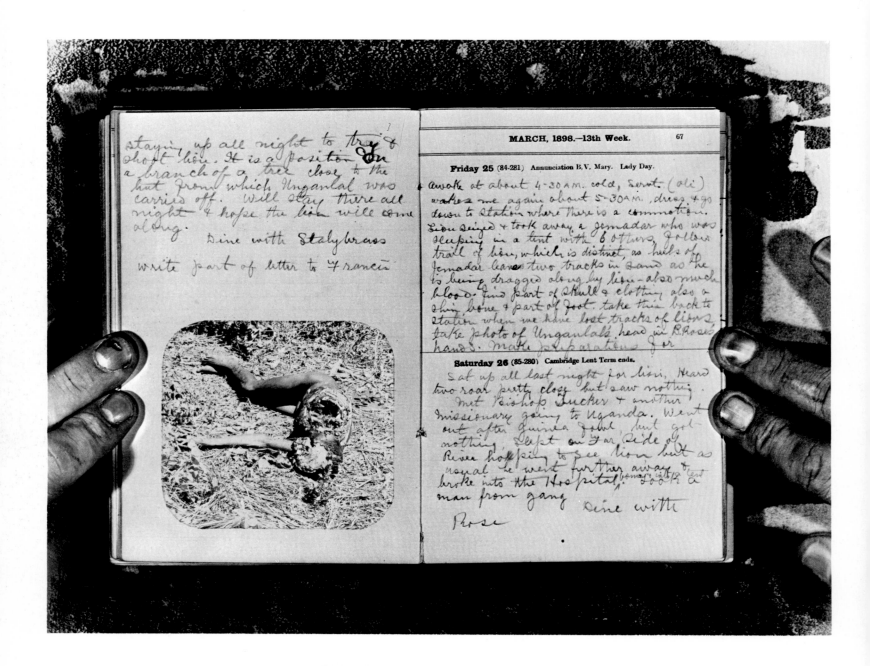

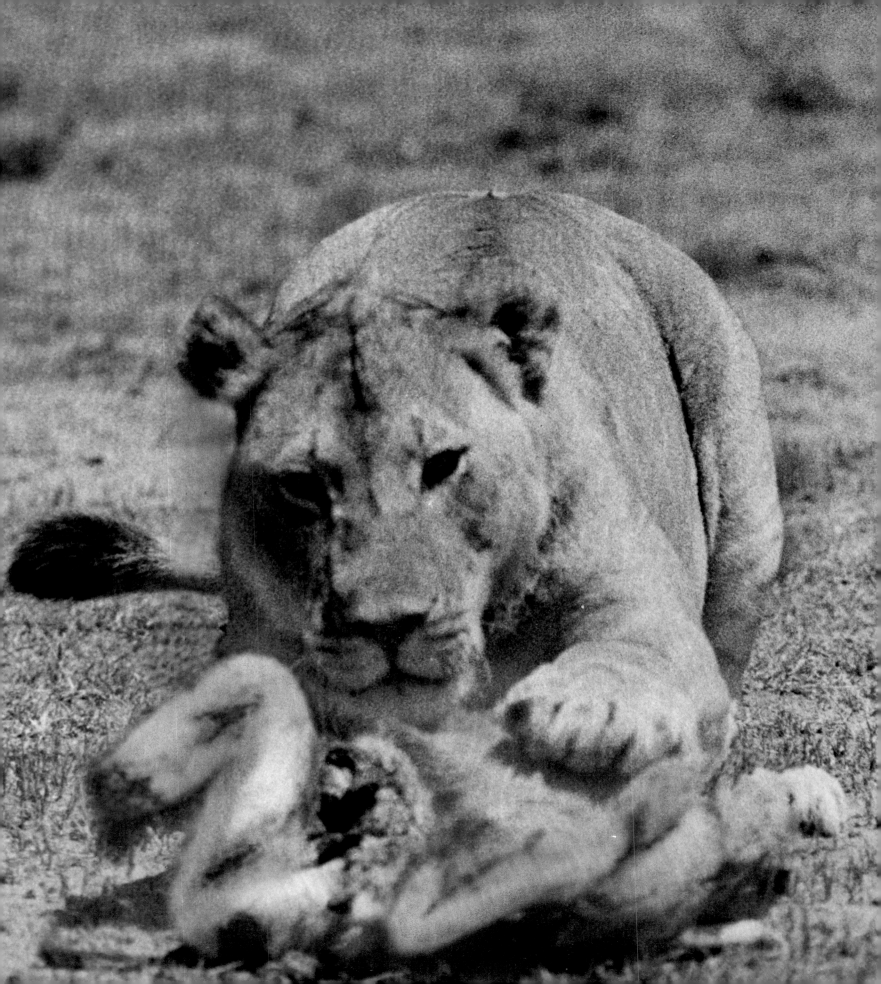

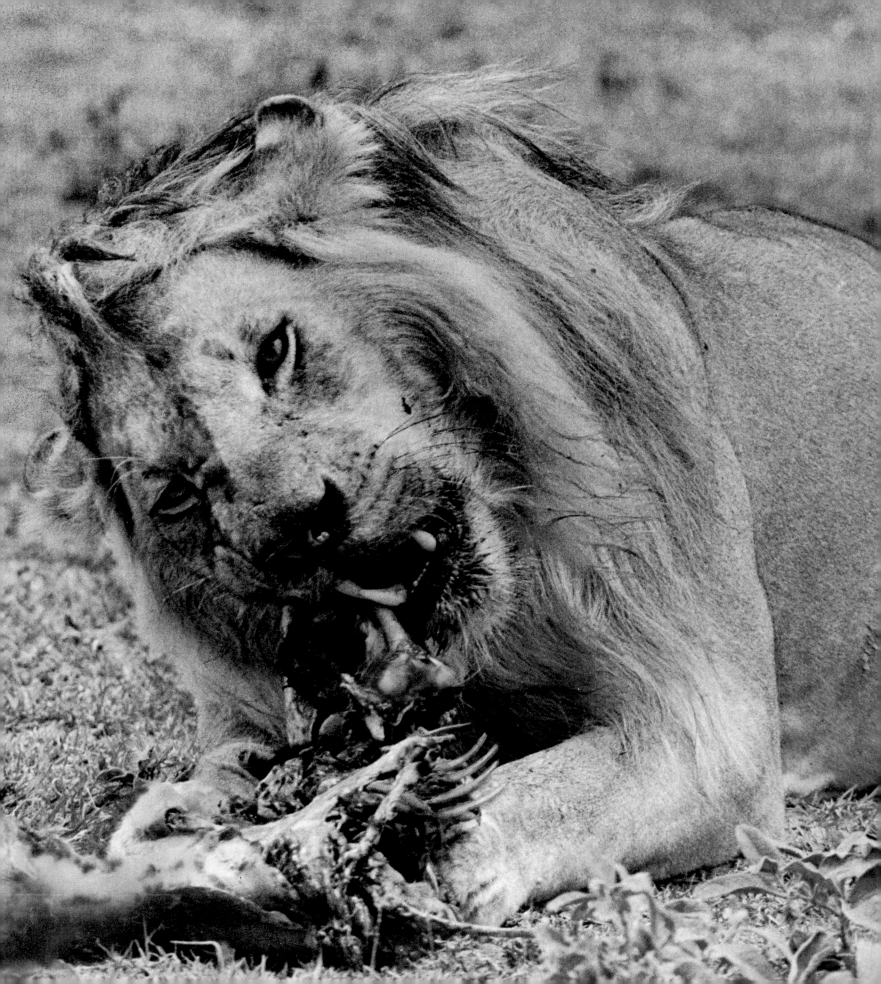

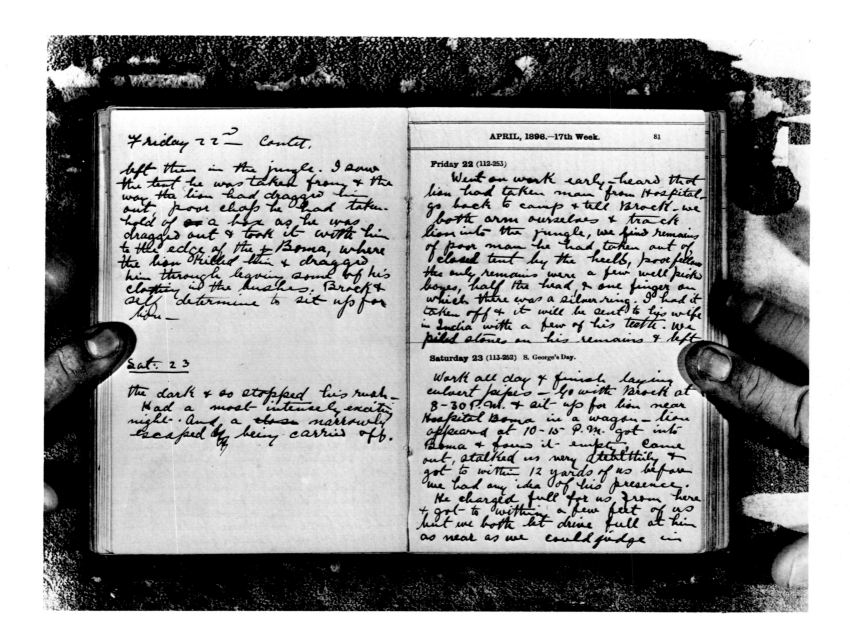

Friday 22ⁿᵈ Contd.

left them in the jungle. I saw the tent he was taken from & the way the lion had dragged him out poor chap he had taken hold of a box as he was dragged out & took it with him to the edge of the Boma, where the lion killed him & dragged him through leaving some of his clothing in the bushes. Brock & self determine to sit up for him—

Sat. 23

the dark & so stopped his rush— Had a most intensely exciting night. And a narrowly escaped being carried off.

Friday 22 (112-253)

Went on work early—heard that lion had taken man from Hospital—go back to camp & tell Brock—we both arm ourselves & track lion into the jungle, we find remains of poor man he had taken out of closed tent by the heels, poor fellow the only remains were a few well picked bones, half the head, & one finger on which there was a silver ring. I had it taken off & it will be sent to his wife in India with a few of his teeth. We piled stones on his remains & left

Saturday 23 (113-252) S. George's Day.

Work all day & finish laying culvert pipes—Go with Brock at 8-30 P.M. & sit up for lion near Hospital Boma in a wagon—lion appeared at 10-15 P.M. got into Boma & found it empty, came out, stalked us very stealthily & got to within 12 yards of us before we had any idea of his presence. He charged full for us from here & got to within a few feet of us but we both let drive full at him as near as we could judge in

"... one particular night the brutes seized a man from the railway station and brought him close to my camp to devour. I could plainly hear them crunching the bones, and the sound of their dreadful purring filled the air ... They had doubtless indulged in the man-eaters' habit of licking the skin off so as to get the fresh blood ... On two half-eaten bodies which I subsequently rescued, the skin was gone in places, and the flesh looked dry as if it had been sucked."

March 1st—

One man killed by lion last night, and one badly mauled. Indian shot thro' temple by accident last night—fear he will die also. Have seen mauled Swahili in Hospital, do not think he can possibly recover.

Am busy most of day writing up diary—Very hot day. Have a slight attack of fever—Wish I were back in Old Ireland— Go & visit surg. capt. Haslam & see several of his animals dying of bite of Tsetse fly— Dr & Mrs. Hinde arrive from Mombasa.

I procure a goat & walk a mile to a tree where I sit all night in wait for the lion— Lion takes man from out of Railway-truck at Engomani (Ogilvie's servant)

Sit up all night for lion. Mosquitoes appear & are troublesome — Two more coolies taken by lion from Railhead.

Sat up all night. Lion turns up & tries to get one of my men out of tree— Dr White drops in half dead; he had just finished a long march from near Ndi (about 20 miles)—Learn a little Swahili —

Laid out found S. of Tsavo Bridge — at last— Sit up all night on girder — See a kind of "Ingoma" — Lion seen during night— Mr. Whitehead Dist. Officer Ndi was coming to my camp at about 7 P.M. when quite close, lion jumped on him from bank, Knocked him down & mauled him slightly; left him & seized his sergeant & ate him about 20 yards off. Develop photos at night.

Complete iron trap for lion. Sit up in lion trap all night. Lord Delamere passes through... Uganda Rifles march into Tsavo.

Last night went to bed for 1st time since 20th & was disturbed by a leopard breaking into goat shed & killing 29 of my goats.

Shot leopard at 7-45 P.M. in goat shed.

I sit on tree— and saw nothing of lion—

Lion got into trap last night & 3 sepoys there fired 21 shots at her—
blew out a bar & the lion escaped, badly wounded however—
followed for a long time — got a growl once. Lion that escaped
from cage went up steps & into verandah of P. W. D.... tried to get in,
but having failed, killed two goats — Sat up over dead goats all night—
lion came & I wounded it badly—gave both barrels of slug.
Follow up lion, see lots of blood but no lion — Develop some photos—
Whitehead goes to meet Sultan of Zanzibar—

Friday 9 Sat up over donkey, & lion came at 6-30 P. M. & saw me:
prowled round growling until quite dark & I feared he was
going to charge my temporary staging— just then an owl came along
& without any warning struck me full on the back—
I was startled as I feared twas the lion had jumped up from behind
& I could not see as it was pitch dark; as soon as I moved
the lion growled close in front of one & I knew what had struck me.
at 8-15-P. M. the lion came up to carcas of donkey & I gave him
a shot through the lungs & he died roaring & plunging in a terrific
way— All my men came pouring down, with lamps but there
was no lion & I did not care to follow him into the bush.

Saturday 10 DECEMBER, 1898.— Cambridge Michaelmas Term ends.

Up at 5 A.M. & went after the lion—to my joy I found the enormous
brute quite dead 20 yards from where I had shot him —
He measured 9'-8" by 3'-8" & was a most powerful beast in every way.
All my men were most highly delighted & hundreds visited me to see
the last of the famous tsavo man-eater. coolies who had struck made
abject submission— Sat up all night for the female;
but saw nothing of her. Send off skin to Rowland Ward.

Sunday 25 (359-6) Christmas Day. Sat up for lion—she came in dark & took 4 goats tied
to 1/2 iron rail from under my nose did not get a chance to shoot —
Whitehead returns, brings me 400 carts .303...a cow & calf, cake, beef...
very drunk.

notice that one of the lion's claws have been stolen —

one dead man-eater. Eighteen nights later he put six slugs from a .303 into its mate. And as if by magic, life returned to the rail camps.

Out of the infernal silence came voices and lights. Torches twinkled, lanterns swung to and fro in the fine night air, and all around him danced Patterson's men: Africans beating drums and laughing, Indians rising and falling and prostrating themselves before him, chanting all the while in a voice at once sad and joyous, "MABARAK, MABARAK, MABARAK! Savior, Savior, Savior! God be praised. God is good." They had lived for so long in the prison of terror, and now, thanks to *Sahib,* they were free again. They had to be forcibly restrained from shredding the carcasses of the lions, the oppressors that had shredded the bodies of many and the spirits of many more, and that had almost succeeded in stopping the iron snake.

The celebration, like all good celebrations, continued into the next day, with deserters streaming back, and telegrams arriving, and visitors converging from all along the line to see with their own eyes the carcasses and the badly scarred skins. A month later, Patterson's men presented him with the sweet laurels of victory: an inscribed silver bowl from Baboo Purshotam Hurjee Purmar, "Overseer and Clerk of the Works," dated January 30, 1899, and Roshan Mistari's commemorative poem translated from Hindustani.

Now this was the night of Shab-i-Kadr, a Muslim festival:
And at night when all had retired to rest, the lion came in a rage,
And Patterson Sahib went forth into the field to meet him. . . .
And everyone began to shriek and groan in their uneasy sleep, jumping up in fear, when unexpectedly the roaring of the lion was heard.
The lion roared like thunder, and fled for his life, but the bullets nevertheless found a resting-place in his heart.
And after he had covered a chain's distance, the savage beast fell down a corpse. . . .
My native home is at Chajanlot, in the thana of Domli, which is in the district of Jhelium, and I have related this story as it actually occurred.
Patterson Sahib has left me, and I shall miss him as long as I live;
And now Roshan must roam about in Africa, sad and regretful.

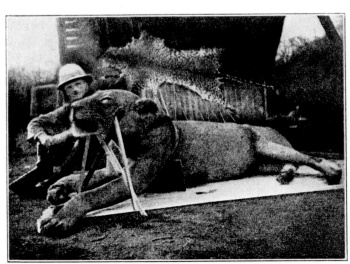

December 11, 1898: Patterson and the first man-eater

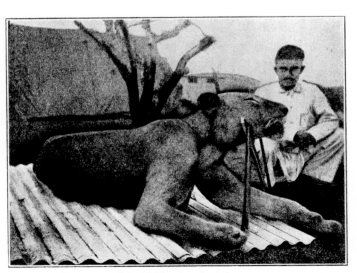

December 29, 1898: the second man-eater

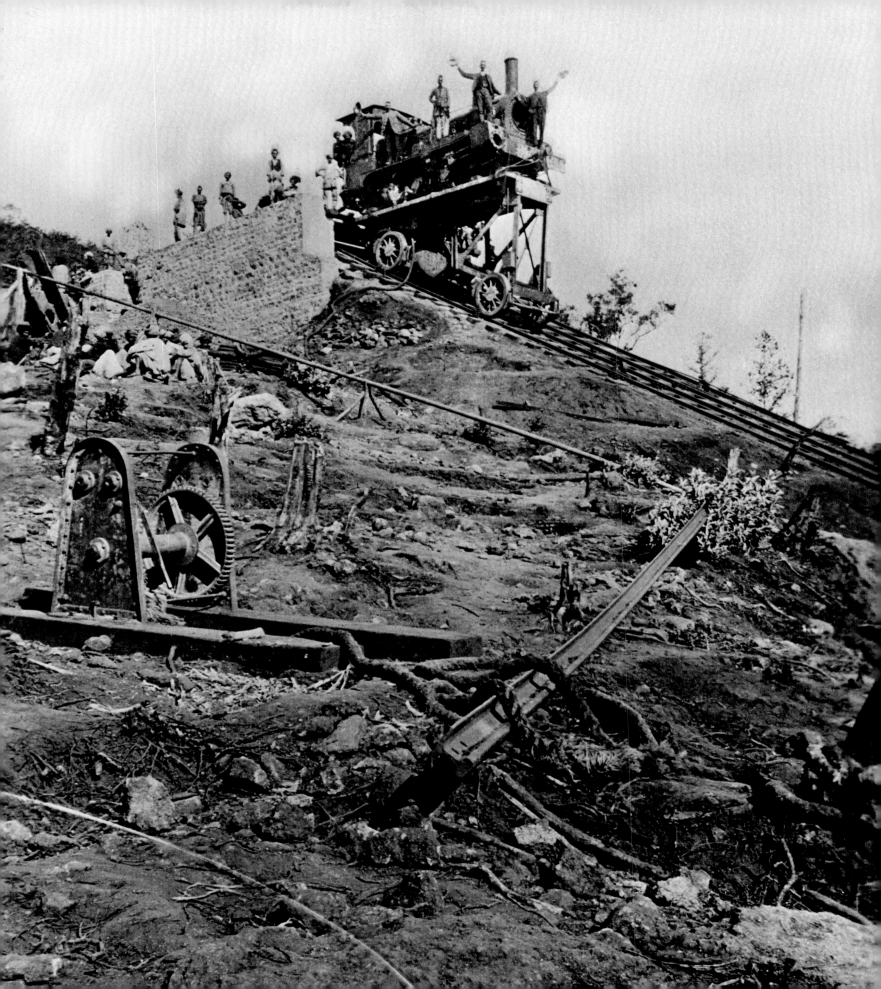

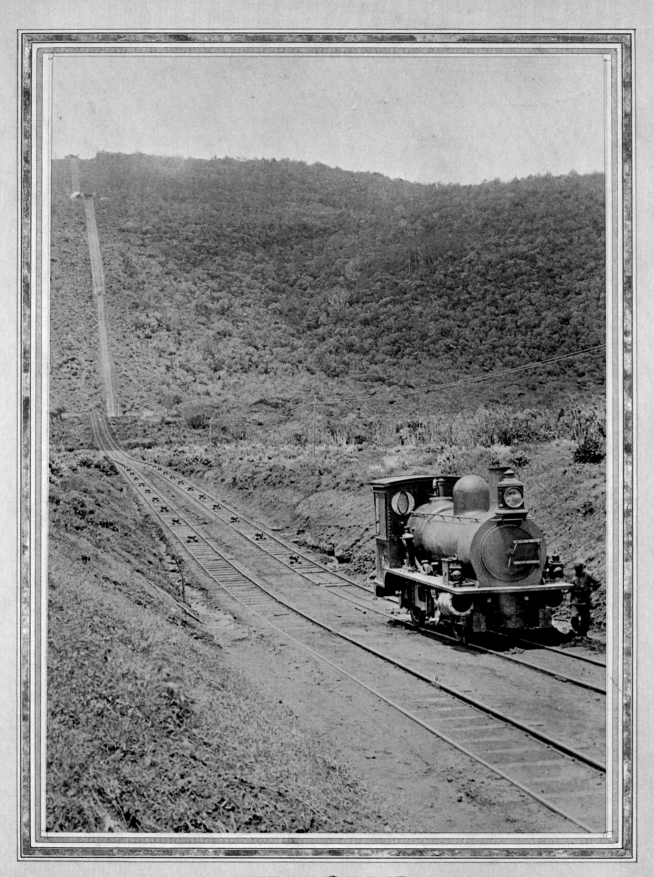

At long last, the engineer was free to turn his attention and skills to the railroad, and his thousands of men could once again work and sleep in the open. The lions' den had been discovered and would stand always as a reminder to them, for marking its entrance were the human bones, metal bracelets, earrings, and assorted trinkets of scores of natives, all of whom had been eaten long before the arrival of the iron snake.

There exist several photographs of the "devils," their swollen heads propped up by sticks, their long cylindrical bellies nourished on a hundred or more human bodies. For years, the prize of 100 rupees was awarded to anyone who shot a lion within one mile of "The Permanent Way." As *The Spectator* put it in 1900, "Mr. Patterson must have realized in no common way what it was to have been a hero and deliverer in the days when man was not yet undisputed lord of creation, and might pass at any moment under the savage dominion of the beast."

Killing the Tsavo man-eaters was the end of only one episode in that long-playing adventure, the construction of the "Mombasa-Victoria-Uganda" Railway. Begun in 1896 and completed six days before Christmas, 1901, it was built by the British through a curious mixture of altruism, practicality, and political expediency. England was obligated, under the Act of Brussels (1890), to fulfill her responsibilities to help end the sea-borne slave trade. She was also interested in maintaining Uganda as a "sphere of influence." Then too, there was the hope that the railroad would insure her strength at the headwaters of the Nile and thus protect her interests in the Sudan and Egypt. And, not least of all, she was worried by the threat to her tenuous position in East Africa posed by the railroad the Germans were planning to build from Tanganyika to Lake Victoria. By means of tracks and telegraph lines from the coast to the lake, she assumed she could impose order on the interior.

In characteristic fashion, the English did not proceed with very great haste. The wheels of Parliament were spoked with cogitation and rimmed with red tape, and progress was made only by the combined effort of individuals against the weight of a cumbersome bureaucracy. Lone men of courage and initiative had to overcome not only the land but the Establishment as well. When the idea of a railroad was broached, Gladstone's government did nothing; neither did Lord Rosebery's. Finally, reluctantly, under Lord Salisbury, a commission was established in September, 1895, monies granted, supplies ordered, papers signed, and—after more bureaucratic amending of emigration regulations—arrangements were made to import the Indian workers.

Various methods were used to induce the native Africans to work but, despite the pressure of the 1897-1899 famine, none were successful. Indifferent to money, impervious to change, they could see no advantage whatsoever in contract labor over slave labor, nor, indeed, in any labor at all. To excite the Africans' curiosity and awe, the British would sometimes leave hurricane lamps burning at night. A solitary African would approach, stare wide-eyed at the magic lamps, and work for a few days or even weeks until his curiosity was satisfied; and that would be the last that anybody would ever see of him. With the passing of the 1896 Emigration Amendment Act, the Indians arrived by the thousands; 35,733 between 1896 and 1903 alone, mostly from the lower castes of the teeming cities. In 1897, an outbreak of bubonic plague in Karachi stemmed the flow, but not for long. When weather, sickness, or a holiday interfered with his work, the Indian was not paid a thing. He had to buy food out of the pocket of his own knee-length sari, and medicine was portioned out to him sparingly, and only in the case of accident, plague, malaria, and cholera. Even so, he cost the British an average of £361/3/10 per annum— four times as much as he cost in India; 2,493 of these Indians died, 6,454 were permanently invalided, and 25,259 were otherwise incommoded.

Many of them became disoriented wandering only a mile or so from the track and ended up dying in the wilderness. There were other problems as well: they rioted over religion; they got on poorly with the natives; they fought constantly among themselves and with the railway bosses. There was always the threat of insurrection: two serious attempts had been made on Patterson's life by the same Indians who were later to give him the silver bowl. Frederick Jackson, Commissioner of Uganda

Hear that poor Haslam has been murdered & mutilated
by natives of Kikuyu —

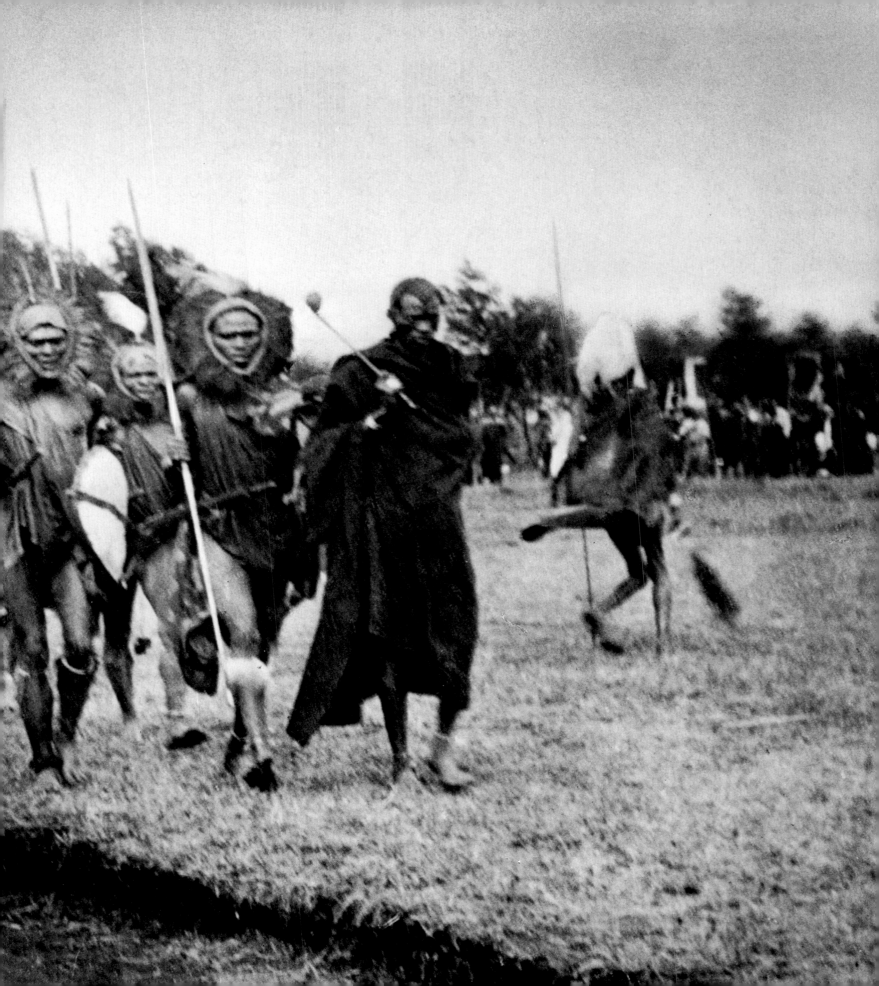

in the late 1890s, described the Indian camps as squalid enclaves of "prostitutes and small boys and other accessories of the bestial vices so commonly practiced by the Orientals." In their turbans, flowing shirts and leggings, and followed by tribal women, the Indians were moved down the line in open cars —a crazy, teetering mass of men, mattocks, shovels, bundles, trunks, tent poles, bedding, flies.

All would have been well if, after their work was done, they had returned to India. Many, however, remained in Africa, living in poverty and disease in native villages and city bazaars, selling anything they could find to anyone who would buy, disdained by the blacks and loathed by the whites—the eternal middlemen. *What to do* with them? What kind of rights to grant them? These were the incendiary questions that eventually erupted into the bonfire of political crisis—the Indian Problem of the 1920s and 1930s.

The coolies built the railroad in five years. With three survey parties never more than 140 miles ahead of them, the Indians laid 582 miles of permanent track, weighing 50 pounds per yard. They moved over nine million cubic yards of earth and excavated nearly one million more cubic yards of rock. For every mile of track, they built eleven feet of bridge, a total of 162 bridges. They dug and set 326 culverts and more than a thousand drainpipes. They erected 41 stations, of which the two major termini were situated at Mombasa and Port Florence (now Kisumu) on the lake, with engine-changing houses at Voi, Makindu, Nairobi, Nakuru, and Muhuroni.

These impressive statistics are distinctly at odds with the conditions under which the work was performed. Disease rotted the coolies' teeth and scarred their bowels—diseases they had known before, and many they had not. The jigger pest and tsetse fly infested and infected their mules and horses, which swelled up in the sun and burst like fetid balloons. The 1899 smallpox epidemic went hand in hand with her gaunt sisters, famine and drought. From mile 38 to mile 100 (Voi River), there was not a drop of water to be drunk. Then, after three years of drought, when the rains did come, they came in torrents. The Stony Athi bridge

collapsed nine times in five months. In 1900, at mile 151, a twenty-foot earthwork bank washed out, and later a passing train was swept 150 yards from the track as its crew splashed to safety.

The natives were hostile when the line invaded their territory. The Wakamba and Kikuyu, celebrated for their cunning, dipped arrows in a poison that would be lethal within a matter of seconds. And one night, Kikuyus cut the telegraph lines for the wire that made handsome ornaments, so that, not knowing that the other was on the track, a train from Mombasa crashed head-on into a train from Voi. Big game and small plagued the workers. Rhinoceros charged, as if out of nowhere, even at trains going under full speed; and even some of Africa's humblest creatures, the tiny caterpillars (*Toredo navalis*) got into the act, riddling bridge timbers and making heavy repairs necessary. The caterpillars also had a habit of crawling over the tracks. Whenever a locomotive hit this sea of ripples, the engine could get no traction and the wheels would spin and whine and splatter gore in every direction. And then there was the incident at mile 254. A policeman named Ryall and his two companions were dozing in the eight-by-seven foot compartment of car number 102, when one of Ryall's friends, in a lower bunk, started up to find a lion standing on top of him. From above, there came a plangent scream, and the lion made off through the window with Ryall in his mouth.

But it was not the beasts that dined on human flesh with fine impartiality, nor the resentful natives, nor even the ever-grinning presences of famine and disease and drought that most impeded progress. It was Africa, willing herself unknowable, impenetrable. Here I am, she seemed to be saying, with my thorny deserts, Taru and Kibwezi, extending for 70 miles without water; here I am, in the low gray bush country, where a man can drink or cook only when the daily engine from the coast arrives with water, and where no man can ever wash.

Men had to cut through forests, slice through volcanic rock, move it in chunks, and traverse miles of warm, stinking mud and black cotton soil. Outside Nairobi, a major station and patchwork quilt of laborers' shacks, administration buildings, and loco-

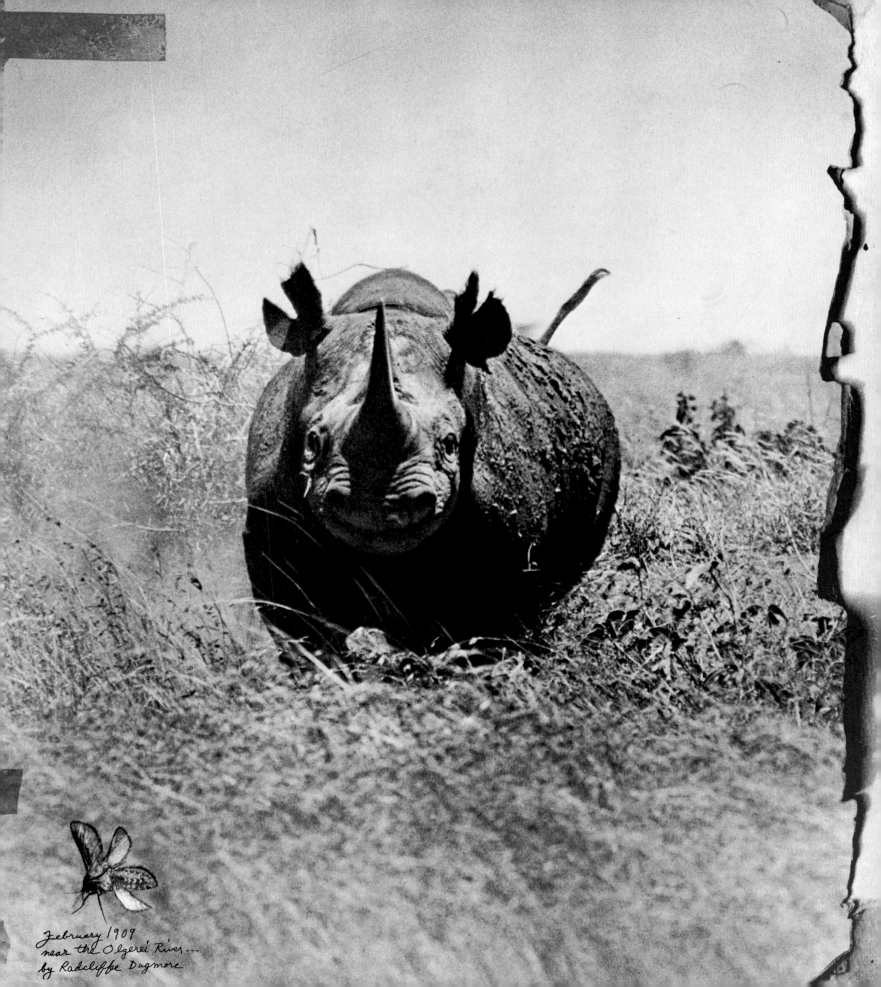

February 1909
near the Olgeré River...
by Radcliffe Dugmore

"There was a collision at Rail Head at about 7-30 P.M. one Killed &
4 seriously injured Horrible to see them being lifted out of the Van
some with a foot off others with arms off etc...

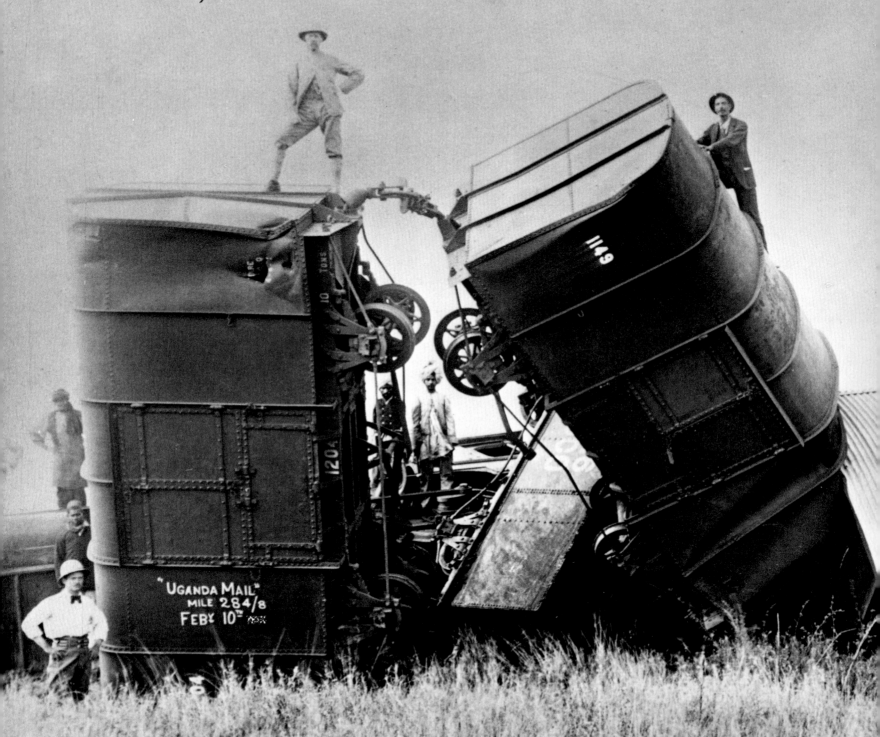

"UGANDA MAIL"
MILE 284/8
FEBY 10TH

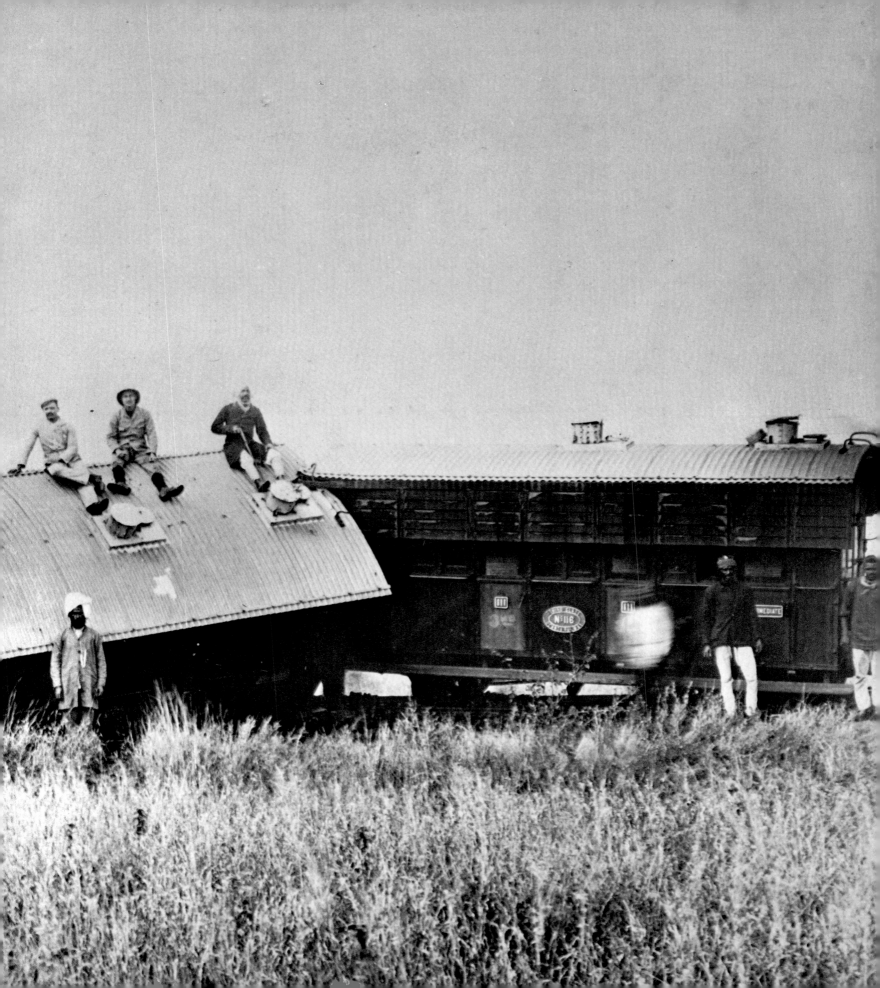

"Teach the native to want."

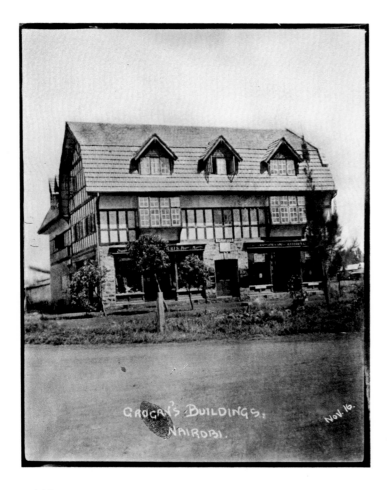

GROGAN'S BUILDINGS, NAIROBI. Nov. 16.

motive sheds, the land was green and rolling; but the grades were often so steep that the track barely crept forward. Eighteen rivers were crossed, but most of the bridges and viaducts had to be built over two jagged mountain ranges and the Great Rift, a gash in the earth from Egypt to South Africa, which separated them.

The Great Escarpment, summit of the Kikuyu range, only 50 miles from Nairobi, is 1,523 feet higher than the town, 7,600 feet at the summit. There is a long drop, over gorge and crevasses, into the Rift Valley, and then another rise across the Mau Escarpment, 8,300 feet high. And rails had to be laid on this course. By a system of four incline stages as steep as 50 per cent, and a double track allowing cars to pass or be fastened with clips to the tracks, the work could proceed up the Kikuyu summit. Eight viaducts, ranging up to 770 feet long with over 85-foot drops, snaked their way down the other side. From mile 320 to 449, across the Rift, the track had to be laid in volcanic rock. Here the workers' principal problem was the steam vents in the valley floor. But it was from Nakuru (just over 6,000 feet), mile 449, to the Mau summit (over 8,000 feet) and down to Port Florence on the lake, that some of the heaviest work was done. In 73 miles, 11,845 running feet of viaducts were built. In all, there were 27 viaducts, up to 881 feet long and more than 110 feet above the earth, crossing the escarpment to the lake.

On December 19, 1901, a gray afternoon, the wife of the head engineer, Mrs. Robert Preston, wearing a billowy white dress and matching hat, drove in the last spike as her proud husband and four of his engineers, all attired in white shirts, ties, jackets, pith helmets, leggings, and boots, looked on. The railroad, which had cost England £9,500 per mile, had been completed, achieved; the efforts of more than 40,000 Asians, Africans, and Europeans had borne fruit. Against tremendous odds, over a land whose extremes are unmatched anywhere on earth, these men had carried out the major pioneering venture in the history of settlement. The decorous ceremony and the atmosphere of restraint at the shore of Lake Victoria on that December day were in notable contrast to the nature of the five-year-long

task. Perhaps, on the shores of a lake named for the Queen, certain standards had to be maintained.

The Uganda Railroad ran east and west. But there had also been a plan for a railroad running south and north. This was the dream of Cecil Rhodes, who saw it as the spine of a great British Africa, connecting the Cape and the Mediterranean, bringing commerce and settlers and civilization into the heart of the continent. His vision inspired a young Cambridge graduate named Ewart Scott Grogan to survey the continent and gather information. Grogan is said to have been spurred on by the father of a girl he wanted to marry who did not consider him sufficiently "outstanding." "If I were to walk from Cape Town to Cairo," Grogan asked, "would you reconsider my worth?" The older man hesitated; no one had ever suggested it, let alone done it; one would need a "small army" to fight off the hostile . . . And Grogan was off.

In February, 1898, he and a young companion, Arthur Sharp, began a history-making trek down the whole length of Africa. For Grogan it was the beginning of a career in African affairs that would end only with his death in 1964, the year of *Uhuru* (independence). In his lifetime, he had gone not only from Cape Town to Cairo, but also from one extreme of African history to the other, from cannibalism and slavery to *Uhuru* and *Jamhuri*. For all that, he was forced to wonder if he had come so very far after all, if he had made any lasting contribution. He shared these doubts with his old friend Karen Blixen, who had written hauntingly in *Out of Africa*: "If I know a song of Africa—of the Giraffe, and the African new moon lying on her back, of the ploughs in the fields, and the sweaty faces of the coffee-pickers, does Africa know a song of me? Would the air over the plain quiver with a colour that I had had on, or the children invent a game in which my name was, or the full moon throw a shadow over the gravel of the drive that was like me, or would the eagles of the Ngong hills look out for me?"

Like Mackinder, Patterson, and John Boyes, Grogan crossed hitherto uncharted territory, taking measurements, making maps, and naming mountain peaks (one of them after his fiancée). He made peace with natives, bartered with them, and even

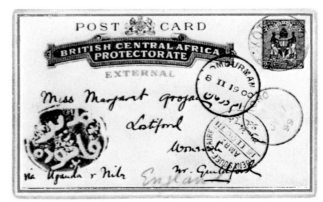

The postcard which Grogan mailed his sister from Kota Kota, the Arab slave trading center, during his "Cape to Cairo" walk

Ewart S. Grogan 1874—1964

111

healed them. In the blazing, lava-covered Mashuri district, he saved a local tribe from the ghastly incursions of the Barekas, wandering cannibals of the Congo. And, like the early hunters, safari leaders, and railroad men, he shot food for everyone, quelled mutinies of the hired help, and fended off innumerable hostile attacks.

Grogan encountered many tribes never before seen by white men. He walked through the old Arab slave centers in Tanganyika; he met the fabled seven-foot Watusis, their serfs the Bahutus, and their neighbors the forest pygmies. He even tackled a thief who had greased himself up in the mistaken belief that if he were slippery, he could not be caught. "The following morning he was handed over to the chief, and suffered the usual penalty of convicted thieves, his head being cut off and placed on the path as a warning to others." On one occasion, he barely managed to lead his party to safety in the wake of an ambush by the six-and-one-half-foot, stark-naked Dinkas.

The hardships he endured are difficult for us to imagine in a world so very much altered from Grogan's—a world in which native porters never remained loyal for long, where there was never sufficient food or water, where the natives were rarely hospitable, where the terrain was, at best, uneven, and where dysentery and malaria were constant companions along with ticks, flies, army ants, and in the Nile area, mosquitoes. (During the week Grogan spent with the Baris, who had been driven by the Dinkas to live on the islands of the Nile, he had to encase himself every night in mud as protection against mosquitoes. On the third night, one of his porters felt too ill to apply the mud to himself, and was bitten to death.)

Grogan's walk from one end of Africa to the other, in 1898 and 1899, was that rare thing—an act of pure courage undertaken in the spirit of expansion and exploration. It was yet another in the list of adventures on the part of white men for whom Africa was at first a challenge, and then a home. In the introduction to Grogan's *From Cape to Cairo,* Cecil Rhodes congratulates the Cambridge youth "for having succeeded in doing that which the ponderous explorers of the world have failed to accomplish. . . . Everyone supposes that the railway (north

and south) is being built with the only object that a human being may be able to get in at Cairo and get out at Cape Town. This is ridiculous . . . the railway will pick up trade all along the route. . . . Your success has given me great encouragement in the work that I have still to accomplish."

As the century turned, Africa began to emerge from a Dark Age stretching as far back as life on earth, into all the years that lay ahead—years of Renaissance, Enlightenment, Industry, and, if you will, Anxiety. It is fitting that Grogan made his symbolic trek as a survey for a railroad, the means through which foreign capital, the paraphernalia of technology, and foreigners themselves would enter. But because an incision is also a wound, the railroad was also the means through which the old life suppurated and poured out of Africa.

This, then, is the tragic paradox of the white man's encroachment. The deeper he went into Africa, the faster the life flowed out of it, off the plains and out of the bush and into the cities, vanishing in acres of trophies and hides and carcasses. The coming of the white man, who imposed his steel tracks, his brains, and his will, on the great continent was attended by glory and courage, ennobled by sacrifice, enriched by science and medicine and law. But it marked the beginning of the end in a land where nature herself had always been sovereign: at once sickness and cure, crime and punishment, beginning and end. Not the least of the signs of decay and dying was the gradual, remorseless end of the wild game.

*The man-eaters of Tsavo in their glass case
at the Field Museum of Natural History, Chicago 1977*

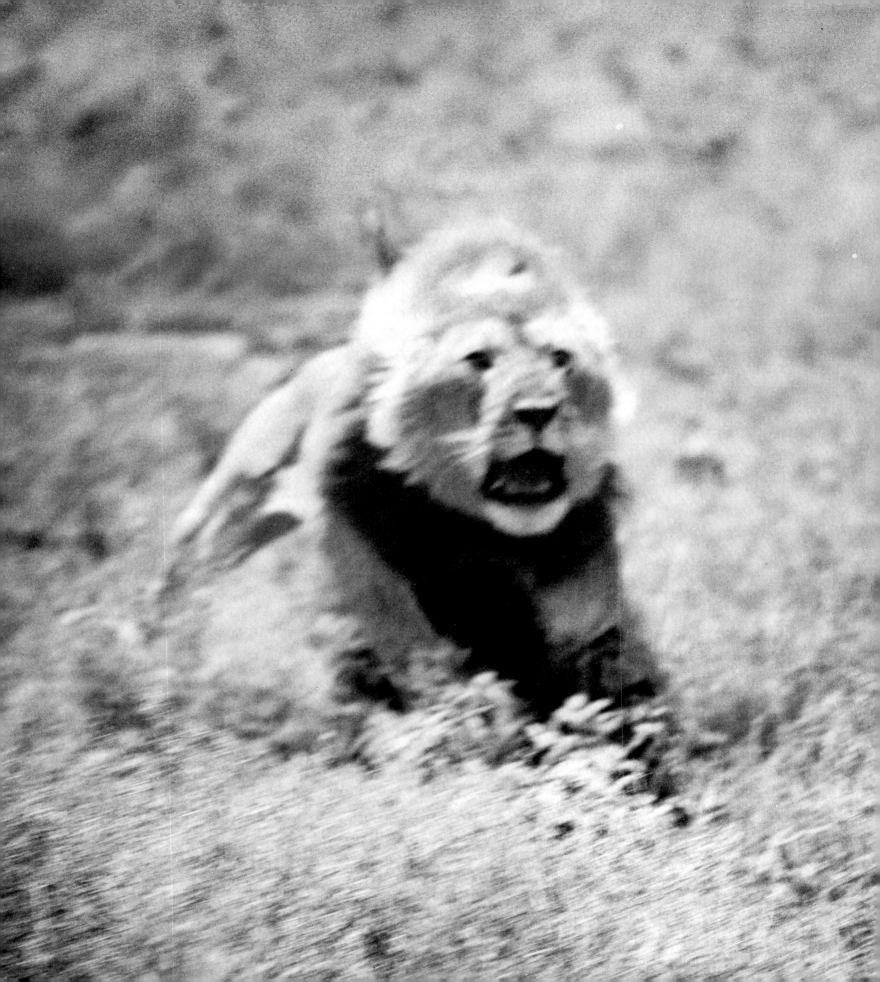

Go to Voi, leave Tsavo at 6-45 a.m. arrive voi 9-30 A.M.
leave Voi for Tsavo at 7 P.M. — Arrive at 11-30 P.M.
Felt all on the alert — as it was pitch dark &
I have a lively recollection of the lion.

a 1976 photograph of Patterson's RR route between Tsavo + Voi
along the border of Tsavo National Park (left)

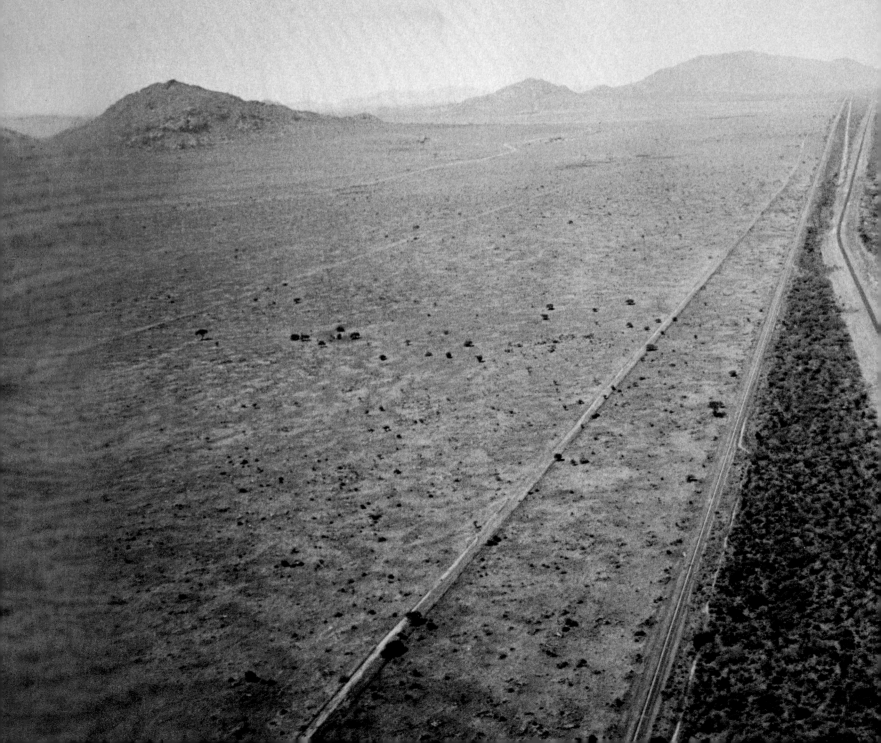

3

In the Glare of the Game's Eye

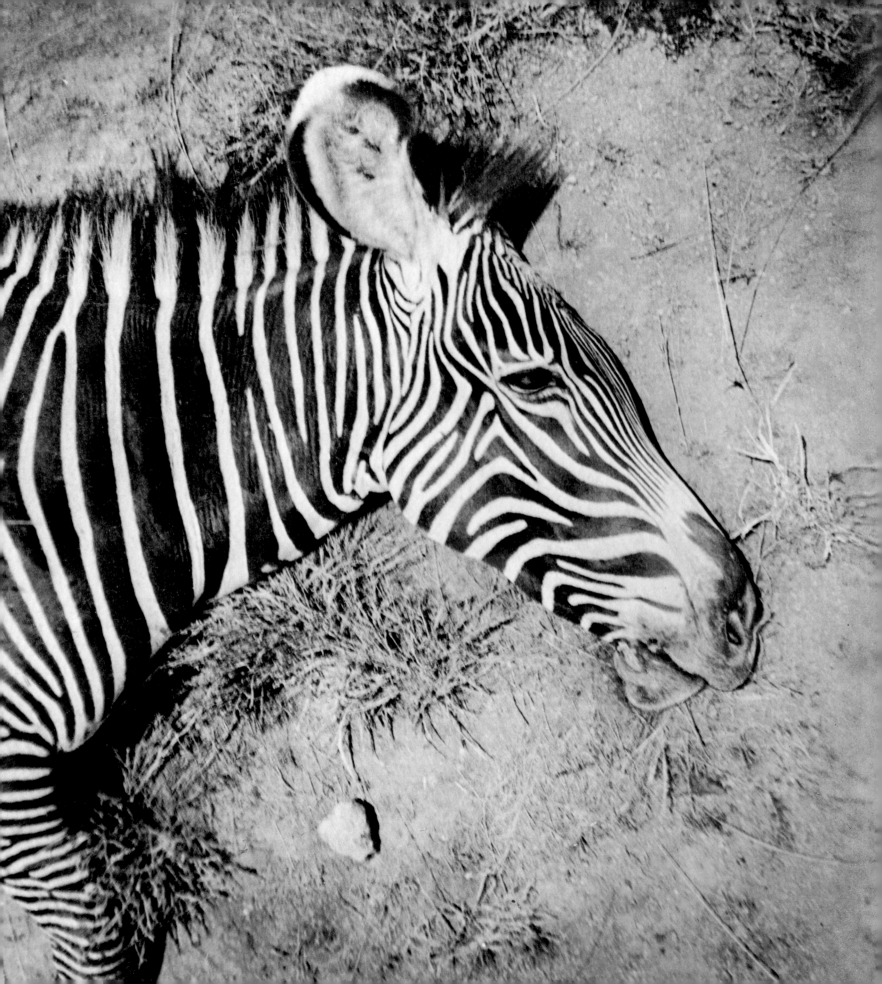

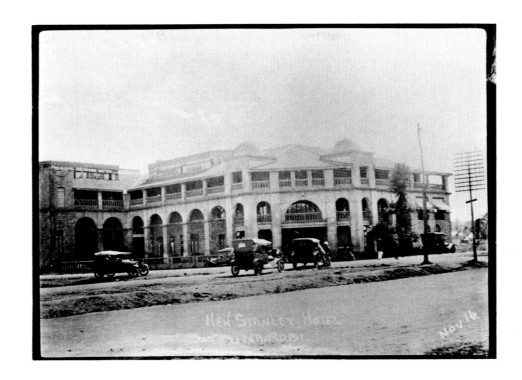

NEW STANLEY HOTEL NAIROBI. Nov.16.

*"In British East Africa you may either elect to shoot
big game from the second floor of the hotel,
or to plunge pluckily into the jungle and engage the
wild beasts on a catch-as-catch can basis."*

*Mr. David Garrick Lonqworth,
The Globe-trotter*

In Masai, Nairobi means "place of cold water"—an image that is a far cry from the railhead it turned into, with its phantasmagoria of tin huts and lean-tos, and an even farther cry from modern Nairobi, with its population of almost a million. Like the black and white ostrich, like Ke'nyaa, like Africa herself, the city is a definition in contrasts: native slum sections straddle the marshy land where, in the Africa of long ago, Mackinder gathered his forces for the assault on Mt. Kenya; nearby gleams every chrome and cultural convenience peculiar to twentieth-century man.

Golf courses, swimming pools, "football" clubs—the high points of any tourist season—all abound. For the art-minded, there are the Coryndon (National) Museum on Ainsworth Hill and the Sorsbie Art Gallery in Karura Avenue as well as four libraries, a puppet theater, and a ballet society. The presence of God is attested to by the more than twenty churches, of which All Saint's Cathedral and the Jami Mosque are particularly handsome; and there is always the Theosophical Society at Nairobi Lodge.

In some respects, Nairobi *is* like almost anywhere else: the post office closes at five, parking is free on Sundays and holidays, and loading zones are reserved for commercial vehicles. Of the many bars and night clubs, the four-star New Stanley Hotel's Thorn Tree Café is perhaps the most popular, a haunt of airplane stewardesses, secre-

119

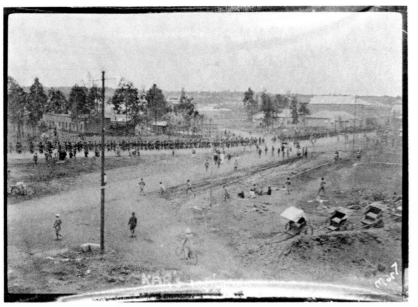

D.O's Office
NAIROBI
Nov 16.

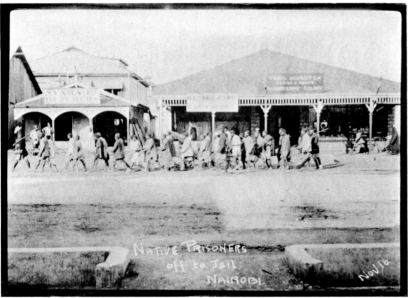

Native Prisoners
off to Jail
NAIROBI
Nov 16.

Kings African Rifles
July 7

Nairobi Roads
July 7

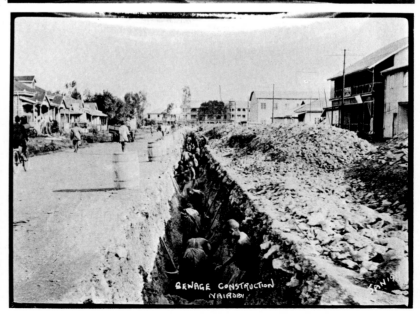

Sewage Construction
NAIROBI
Jan 19.

taries, and white hunters in varying stages of employment. Here the second-generation settlers, that saddest stratum of any immigrant group, being neither here nor there, spend much of their time disparaging the way of life ushered in by *Uhuru* while extolling the European pioneer world only a few of them can ever have known. It is true that what their fathers fought for more than half a century ago is about to be lost. The echoes in the club—of regret, distaste, and false nostalgia—commingle and grow louder, and the sense of futility becomes ominous.

On my first evening in the New Stanley, in June 1960, I met Douglas Tatham Collins (known, unaccountably, as Ponsumby) in the Thorn Tree. He was reputed to be one of the most colorful characters in Kenya, and a great hunting guide besides. I was therefore delighted when he offered to help me find a Land Rover (fourth-hand and with its odometer turned back), and then decided abruptly to throw in his lot with me. Together we drove off into the surrounding wilderness or "lesser shag," as he casually called it—my car loaded with food, his with native skinners, trappers, gun bearers, and a cook called Morengaru. Our goal was far-off Somaliland, where he had once been District Commissioner. Thanks to our hand-written Somali visas, we were to have a small footnote in history: these were the last visas of their kind ever issued by the Italian Consulate, Somali having declared her independence the next day. As *Uhuru* could always be counted on for a certain amount of mayhem, everyone to a man urged us to bypass the new nation—which was yet another incentive for us to reach it.

Our first stop was at Donya (Old Dionya) Sabuk, a giant mound of tropical vegetation not far from Nairobi. Major Ray Mayers, who had made a name for himself fighting Galgail warrior tribes in Somaliland in the '40s and founding the redoubtable Ray Regiment during the Mau Mau Emergency of the '50s, had invited Doug to spend a few days at his coffee and sisal plantation on the old Northrup McMillan estate, where Karen Blixen had learned to grow prize peonies and Theodore Roosevelt had shot hippopotami. The Major hoped that we would be able to help his

"NAIROBI HOUSE."

WATER CART. NAIROBI.

men contend with some marauding leopard that had been snatching livestock as well as dogs.

It was sundown when we drove up to the house. A big, aproned Kikuyu with a meat cleaver in his hand came out to welcome us. This was Kariuki, the cook, an "oathed" Mau Mau who from time to time still slipped away to conduct various rites in the forest. During the Emergency he had contrived to buy a controlling interest in the plantation and had the Mau Mau won, he would have owned it. But they lost and he went to jail. When he got out, the Major rehired him. *Plus ca change, plus c'est la meme chose.*

Kariuki led us to the back of the house, where he showed us some leopard traps that had to be reset before dark. Two leopards had been caught during the past week, but there was another still at large. We lifted a small lamb into the far section of a double-wire mesh trap, rancid with the half-eaten remains of her predecessors. The sooner that last leopard was caught, the better.

We discovered that meat had been promised to 300 plantation workers, forbidden by government decree to hunt the animals they had once depended on for food. If their life with the game was over, ours was not, and it was now up to licensed gun-holders like us to provide for them.

When on our last morning at Donya Sabuk, we saw that not enough *nyama* had been collected, we determined to take a hippopotamus. Struggling out of our blankets a little before five, we ran along the red cement floor to shut the windows. Petrolax lamps which the houseboy had placed on the table reflected eerily in the window panes so that everything outside seemed blacker, colder, and more forbidding than it was. We might have slipped back among the pillows, but there was coffee in the next room.

A gibbous moon shone through the double glass doors to the porch. The wire mesh on the doors and windows were leftovers from the Emergency when Mau Mau gangs used to sweep down from the hills at night. With our boys and guns in the Land Rover, we proceeded on the rough ground to the river. Buno, our gunbearer, with his thin black hand began gesturing to the trees by the pool, where he said he knew of *"mingi kibokos"*.

We too had been told that a trophy-sized hippopotamus bull and his family might be lurking there.

Easing ourselves out of the car, we heard a gurgling, as if large bubbles were being pushed up from the center of the earth. Then a rumbling snort, another gurgle, another rumbling snort. Then silence.

We huddled near the water's edge, hardly breathing. We were trespassing in another world and we knew it—ours would not take over until daylight. There was a blueness to the air, and across the river the moon had gone below the stronghold of the hills.

Buno and Morengaru—two heads and a body —were just visible on our left. They babbled softly in Wakamba that this morning the bull was not there in the pool but that there were five other hippos there. The bull would come back late in the afternoon or early in the evening, they said.

Then the hippos surfaced, just breaking water, snorting and grunting. From time to time there was an extra-big splash, an extra-loud grunt. Birds hopped to within a few feet of us, chirping, jumping about from branch to branch.

We heard waterfowl skidding down the river— all blurred flight when we looked. The hippos were finishing up last night's feeding. They surfaced less often now, and when they did, showed only two small ears, bulging eyes and nostrils alternately flared and shut tight; an instant later, they would be submerged again. Soon enough, they would be showing up clearly in our sights.

I took the .375 from Buno, and from a well-chosen tree-rest began sighting in the ears and eyes as they surfaced. It wasn't going to be a difficult shot, but it had to be done right, within about two inches of the left ear. We could no longer afford to wait for the bull with the magnificent tusks.

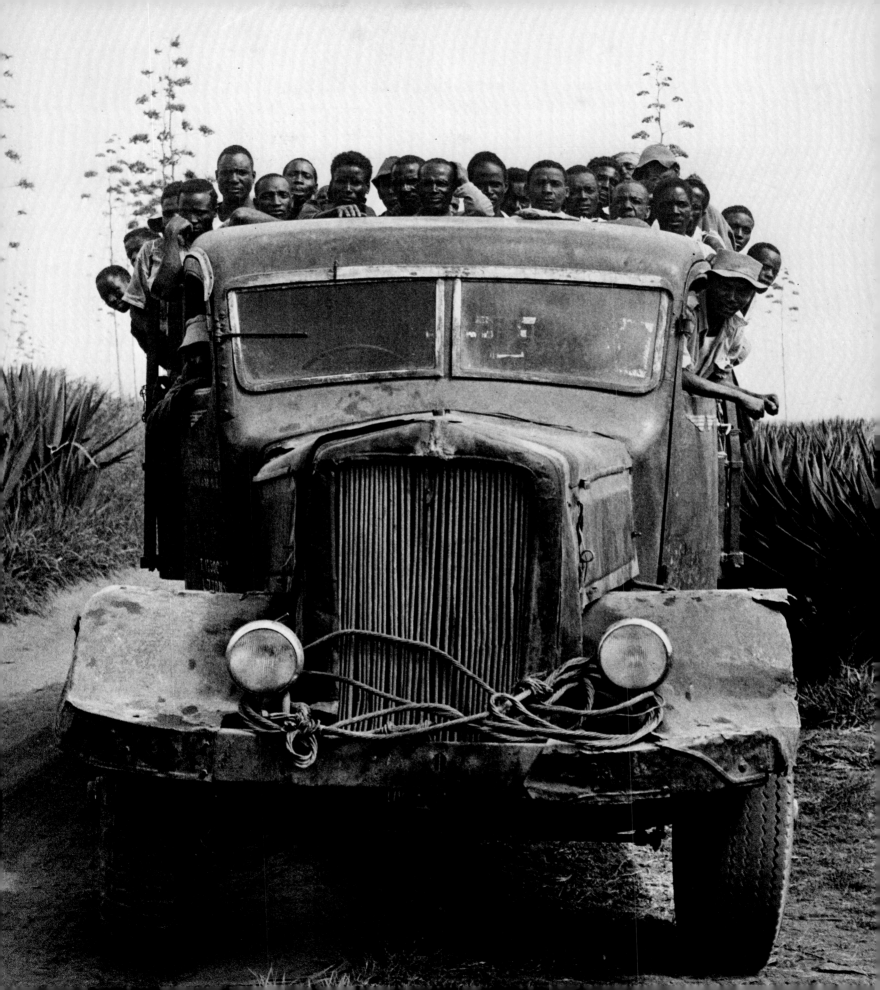

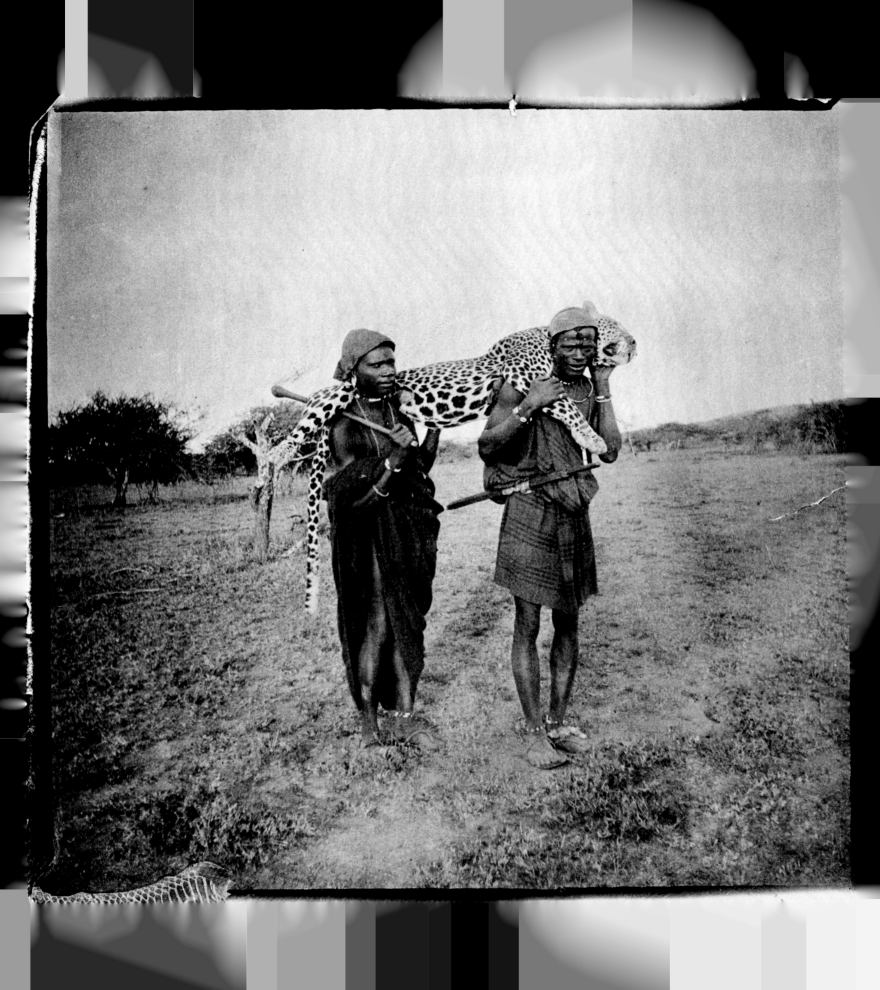

There were 400 people to feed at the plantation.

Up came the head of the cow with her distended eyes. I fired. Not a bird stirred as she sank. We stood up and wiped the splotches of wet off our clothes. It would be hours before the gases from the *kiboko's* stomach expanded and the great body floated upside-down to the top. This was my first shot in Africa and I had expected a great deal. But it had been so quickly done, I still didn't know what I felt.

We were eating lunch in the shade of the porch when Buno came up and announced that the *kiboko* was "on the water" and that we could "come now and let the meat be cut."

There must have been a hundred pair of hands helping us there at the river's edge. Many dogs, too. (The mixed blessings of canine company.) We hauled the hippo against the current into shallow water and hacked the two tons of meat into portable chunks. We made out, in the middle of all the slimy waste, the rubbery form of a fetus, unfinished, never to be born. The dogs worried it as if it were a great delicacy, but the natives disdained it as spongy and tasteless and left it as food for a nearby column of army ants.

While we were butchering the meat, a garden boy at Donya Sabuk had speared a python between a row of cabbages and, when we returned to pack up, presented the skin to us as a going-away present. Stretching to almost twenty feet, it was wide and beautifully patterned. This turned out to be an extravagant day for trophies, after all, for a few hours later the last leopard was taken in Kariuki's trap.

Except for a session of buffalo hunting with spotlights on a besieged estate in Mweiga, our sojourn at the old McMillan estate had provided us

Dividing up a 4,000 lb. hippopotamus

"Triumph! The ancient pigtailed-monster — shadows from the ages gone and perished"

from *The Gardeners of Eden*
Alistair Graham

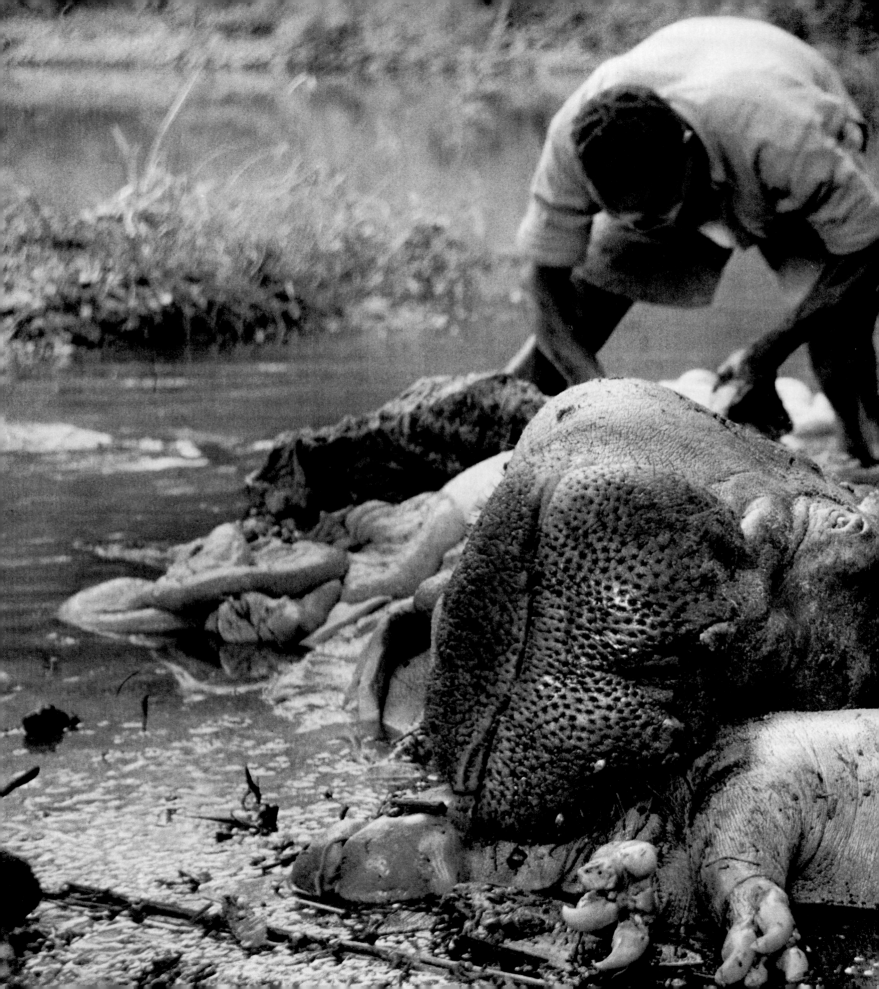

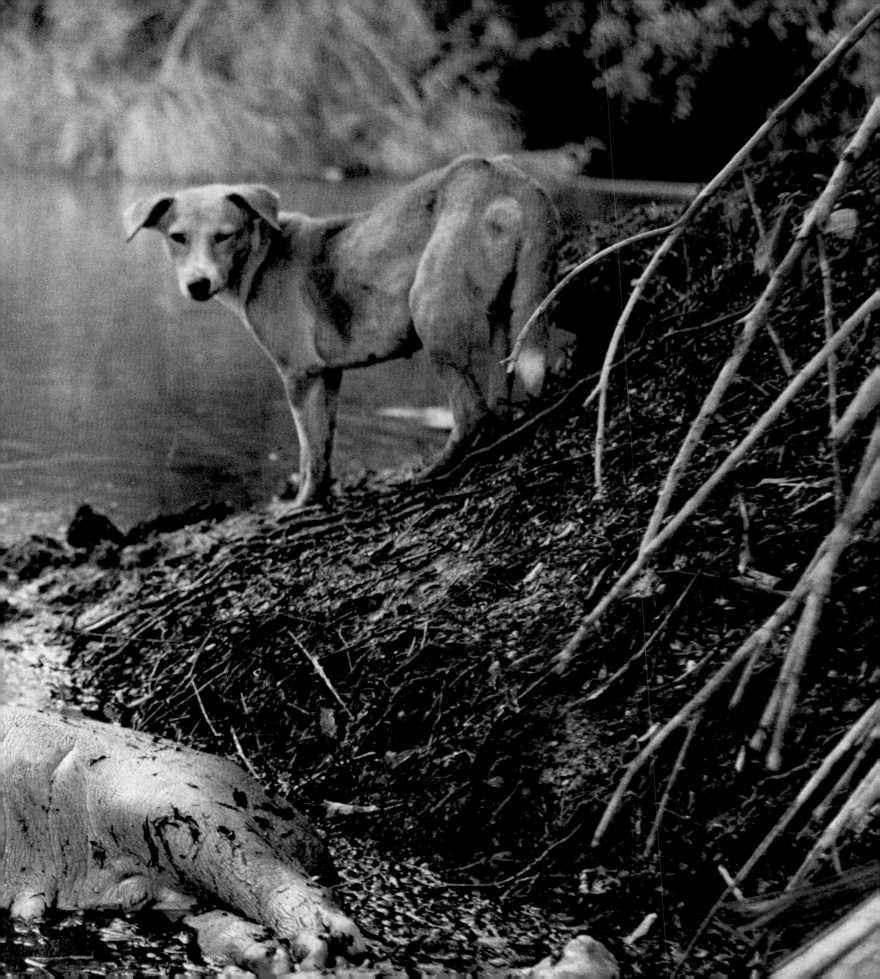

with the only hospitality we were to receive for some time. We were on our own now—in the glare of the game's eye, interlopers in the shag.

It was a hundred miles to Amboseli, thousands of square miles of game country lying below the startling peaks of Kilimanjaro. My Land Rover —Doug's was nowhere in sight—bumped along the Mombasa Road through barren plains and up barren hills, punctuated by boulders with their hatchet features. From out of this silent expanse a lone Masai stepped off the Namanga track, bunching his blanket around him and shifting his spear. I came to a stop. For whole minutes we simply stared at each other. He didn't seem at all surprised that a twentieth-century chariot had pulled up beside him. When I motioned him to the back of the car, he was just interested enough to gather up his blanket and spear and climb in, trailing a cloud of sullen flies.

The gas needle lay almost flat on its side. The transmission was giving off a disturbing amount of heat. In fact, every mechanical organism in the car seemed to be at stake. The unflappable old Masai looked a little desperate now, all hunched up, feet braced, holding on to the gun-racks with both hands as if it had just dawned on him that this new system of going from place to place had its drawbacks.

And then it began to rain. The rain beat down on the tin roof and the car shook. The windshield wipers did what they could. Anxiety gripped me, and going around a curve I almost hit a station wagon carrying a bunch of nuns, eight or nine of them. At the wheel, under a white pith helmet, sat an august-looking missionary. Namanga River petrol station was just up ahead, he assured me. The sun was trying to show through—a gateway to better luck, I hoped. Perhaps the nuns had brought us luck.

Now that the rain had stopped, my passenger had a new air about him of having been casually won over. A small following of his fly friends had regrouped around him and, very pleased with themselves, were eagerly crisscrossing his sad face.

Doug was waiting at Namanga, shagged with fatigue. We practically inhaled the *wompo* and lashed right into a Beefex tin. I felt strangely well. We decided to bed down for the night along the road rather than drag ourselves all the rest of the way to Amboseli.

It was time to take leave of the old *Mzee*, who was clinging to his place in the car as tenaciously as the flies were clinging to him. Ponsumby was going to have to explain to him in Swahili how sorry we were to be depositing him short of his destination—and on the eve of his conversion to the machine age—but here was a Beefex tin for being such good company. Ponsumby delivered the message, and then presented the Beefex with a flourish and a little bow. But the Mzee had got used to his seat and had no intention of giving it up. In the end, Ponsumby was compelled to improvise a method of persuasion. *Then* the Mzee saw in a flash what was expected of him and, without so much as a word for either of us, relinquished his seat, took the Beefex, stashed it somewhere in the endless folds of his blanket, and stole off.

We laid out our bedrolls in the tall grass. A sky of stars stretched over Africa from one end of time to the other. They were the same stars that had watched over the travellers, traders, and engineers who 60 years before had slept fitfully among the wild game as the Mombasa Railroad was being pushed through, who had shot the rhinos that charged the trains, and who had earned their living selling in Nairobi for a pound apiece the lion skins they had risked their lives collecting.

The mornings at Amboseli were among the most beautiful I had ever known—cold, opaque mornings when Buno or Morengaru would murmur some friendly Swahili and bring in the delicious *kahowa*. This was the country of the Masai— herdsmen, aristocrats, warriors, carriers of tall spears, drinkers of blood and milk, lion-killers. Isak Dinesen harnessed their character and their plight in a few sentences:

> Fighters who had been stopped from fighting, a dying lion with his claws clipped, a castrated nation. Their weapons have been taken from them, their big shields even, and in the Game Reserve the lions follow their herds of cattle. . . . Sometimes they may be capable of gratitude, but they can remember, and they will bear a grudge. They will bear us all a grudge, which will be wiped out only when the tribe is wiped out itself.

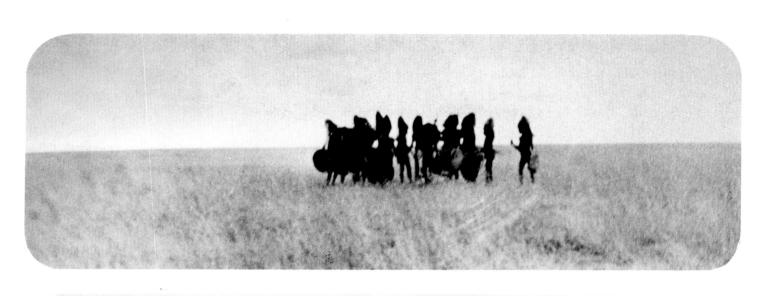

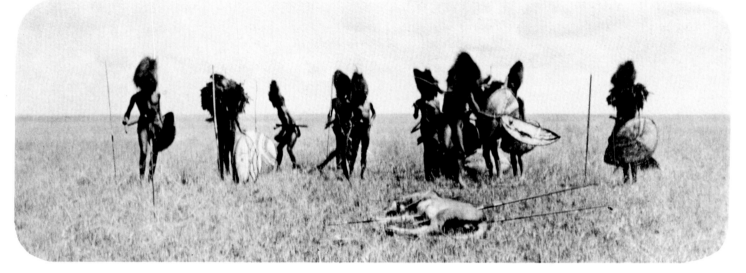

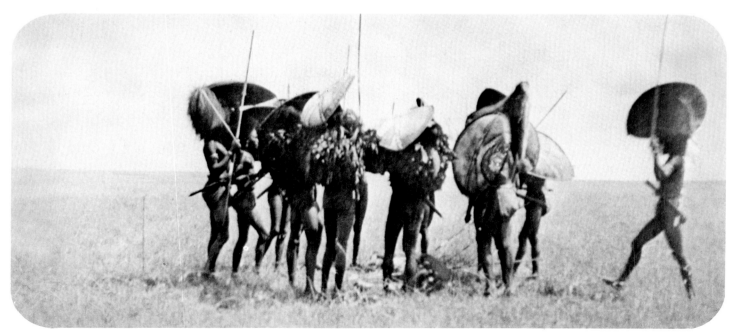

A Masai lion hunt, 1914

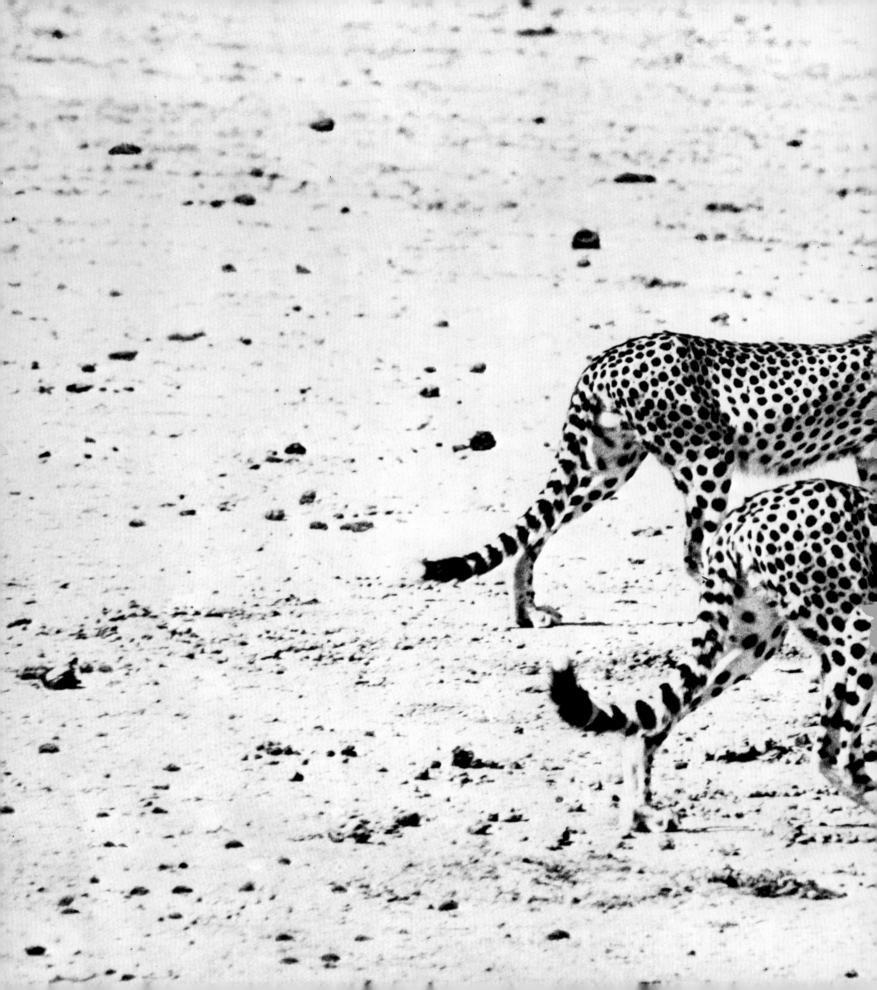

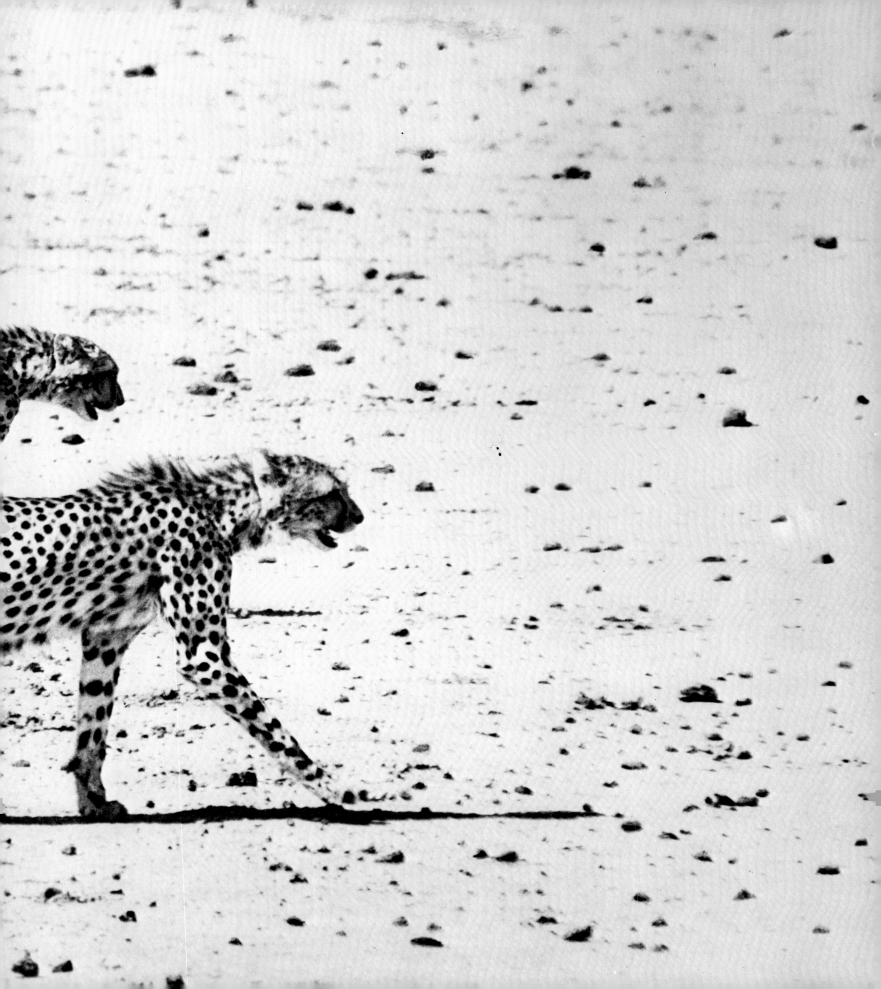

Doug and I would often come upon the Masai as they drove their cattle. We would throw spears with them and watch them drink blood from the necks of their cattle.

One afternoon, as we were driving along through the acacias, we heard, then saw, vultures flapping in a tumult through the trees—hundreds of feathered witches shaking out their rugs. Death had called them—on some infernal, uncoded telepathy—from every corner. Only an elephant carcass, I thought, could command such a large congregation. As the day slowly died, they rummaged about—there were probably a thousand of them by now—crashing into each other, obscenely screaming.

Through the trees I could make out the outlines of a Masai encampment. All the fires were out, but the waist-high huts looked freshly slabbed together. The odor of death hung thick and close and unmistakable in the air. Around the village a wall of thorn branches encompassed a circular *boma* which had been constructed to protect the cattle and their owners. I was able to find an entrance and, once inside, began running, as if to shake off the stench and the flies.

I ran around the deserted huts. A small fireplace stood in the center of each one. The half-charred remains said that the owners had left in a hurry. When I kicked at a pile of powdery ashes, a last ember glowed. At the end of the *boma* I saw the thing that had fouled the air for so many miles around, the thing that was keeping the flies and vultures in their heaven, the thing that had caused the Masai to flee for their lives.

The soggy blackened bodies of two cows and a calf lay all close together. To the Masai, the presence of death within the circle of the *boma* is a portend of great evil. Bits of the decomposing carcasses had dropped down and become indistinguishable from the black cotton soil. The slimy gray excretions of the vultures had formed a patina of mud and flesh. The cattle's skulls lay intact, their sockets gaping where the eyes had been pecked out.

The air was solid here. You could taste the atmosphere. When the symphony of flies became unbearable I retreated through the thorn gates. Doug was waiting and we raced off, flies hanging on against the air .wash of the speeding Land Rover.

Even in a land where life and death come and go casually, what I saw in the Masai camp shocked me in its extremity. I had discovered on this first journey through Kenya that every creature born has its hyena or vulture waiting to consume it.

So too was our life at Amboseli and in Africa a life of extremes. At the close of a hard day we would bathe in canvas tubs in water that Morengaru had boiled up specially for us; and then we would go and sit with our drinks and listen to the living things of the night take over—the cicadas and peeper frogs, and the distant zebras of the harsh, lonely barks. We got easily into the habit of expecting to be surprised.

Our encounters with black rhino came when we least expected them. Although they constitute a threat to one's life as well as—far more important —to one's Land Rover, they go about their demolition work in such a scatter-brained, bull-headed way that it is hard to take them seriously. No one has better described the rhinoceros' propensities for making a pass for the grandstand than Colonel Steadman in *Wanderings in Africa*:

> Whilst the native hunter pursued and wounded one of these formidable creatures, his horse was killed under him by one lunge of the terrible long horn. Before the rider could release and shoulder his gun, the beast came thundering at him again, and thrusting his horn into the chest of the dead horse, threw it and the rider who still bestrode the saddle, clean over his broad back. And then, with a triumphant grunt, trotted off into the forest's impenetrable depths.

Neither the strength nor the temper of a black rhino when he is annoyed should be underestimated. He is the extrovert of the animal kingdom, prepared to charge headlong into oncoming trains. Perhaps such enthusiasm for so futile a cause is a measure only of misguided gaiety on the part of this highly animated relic.

At Amboseli we took on a guide by the name of Ketabi, whom we eventually succeeded in teaching to drive—or so we thought. One morning, with

Ketabi proud and intent at the wheel, we mistakenly roused a rhino from his bed a hundred yards away. Shredding the tall grass like a bulldozer and making sounds thoroughly appropriate to the beast it was, it charged the car and our instantly frozen driver, who proceeded to rev up the engine for a flying escape—only to stall ignominiously. The rhino bore down, pinpointing the front seat whose doors, in the name of improvised air-conditioning, we had removed and left in camp.

From my safe standing position in the back, I could enjoy pretending I would trade places with the rhino to see Ketabi's bright, petrified face.

The animal was now upon us. In the hope of frightening it off, we banged the side of the car with a spare steel mainspring. A ghastly snort issued from somewhere inside of it, and it veered sharply to the left, its hind legs pelting us with bits of mud and stone. Through the rear window of the cab I saw the face of the most terrified native in all Africa, with its earlier, happy look restored to it. Ketabi, his heart beating madly, his head thrown back, was laughing hysterically, and these bouts of laughter were to recur throughout the day. It was laughter as heartfelt as it was wild. In all the years that have passed since that morning, I have never heard its like.

Ketabi found us equally curious specimens. Sometimes, in the middle of a motorized stalk, we would ask him to stop so that we could photograph a piece of driftwood, a pile of bleached bones, or a rare angle of landscape. Shaking his head in puzzlement, he would apply the breaks—and, of course, stall. If we saw a rhino and I signaled for him to make an approach, he would sigh and shake his head no. Then, satisfied at having disobeyed us, he would carry out our insane wish. But he accepted our daily bribe of oranges and other loot with the most charming innocence, and so we got on famously.

Long after Ketabi left our service, the rhinos kept after us. Up in the Northern Frontier, we often came upon them sniffing and snorting in the dawn and later, during our game control days, they sometimes charged us from heavy brush. Never unmindful of them, whether they were there in our field of vision or not, we took some consolation in agreeing with that hunter of the old days who had observed:

The head of the rhinoceros is so thick, there is little use in firing at it. Should it be penetrated, it is a great chance that the bullet will not find the brain as it is very small and confined to a chamber about six inches long by four inches high. On filling this receptacle with peas, I found it to hold barely a quart.

In the way of supplies we were now down to spaghetti and passion-fruit squash. Morengaru was sure we would starve, and he with us, so we set off to restock at the Asian duka near J.A. Hunter's retreat in Makindu.

We had some difficulty finding our way there, as the signpost at the driveway of his lodge was down. It was the rhinos, after us again: we later learned that a disgruntled beast had knocked the sign over on three successive occasions.

Although his armed expeditions on behalf of the railroad, the government, and various safari companies have no equal and many of his trophy records stand to this day, there was nothing in the least self-conscious or death-defying about J. A. Hunter. Larded with legends, he showed himself open and courteous—and a fine host. It struck me

that what he was a host to was nothing less than the past, his own and part of Africa's.

J.A. gloried in rekindling the old days for us: the time he shot a leopard right off a Turkana's back; how he had hunted in uncharted areas with Karen Blixen and Denys Finch-Hatton; how he took movie stars and the like on safari. Once, out in the bush with the very ample Maharaja of

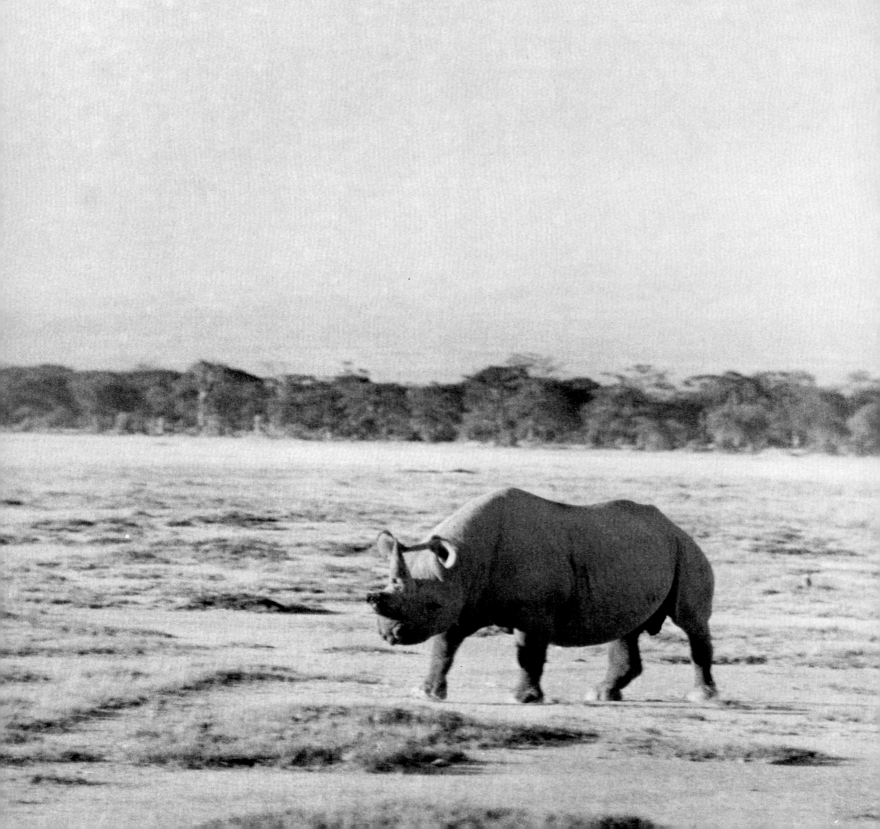

Saguia, he had spotted a leopard feeding among some vultures. The cat, sensing danger, moved off, a vulture flapping in its jaws. The Maharaja took aim and knocked it down. Congratulating Himself on a fine heart shot, His Highness repaired into the low bushes to examine His trophy, J.A. and a second hunter following close behind. But the trophy had disappeared. Then J.A.'s rifle exploded and the leopard fell from midair a few feet from the astonished Indian prince. "A wounded leopard can come at you from nowhere, through the air like your own bullet," J.A. told us. "When I heard a thwomp instead of a thud I knew the prince had only wounded it in the gut."

During this visit we came to know another side of J.A.—his intimate relation with nature, which he saw not as the fuzzy home of lion cubs and baby giraffes but as a world as brutal as it is bountiful, as inchoate as it is ordered.

J.A. had always had Makindu in mind for his resting place. Long ago he had been asked by the local game department to shoot off elephant herds that were tearing down *Wakamba* shambas. Without telling anyone what he intended, he decided simply to sting the elephants in their rears so that, a little scared, a little sore, they would move away only temporarily. Had he used his regular guns on them, they would never have come back, and he had a vested interest: this was where he hoped to build his lodge. His solicitude paid off mightily. Every evening and early morning, he could sit in the blind he had built with his own hands and watch his friends feeding in the swamp out back.

The morning we set off for the Northern Frontier, he came to bid us goodbye, saying that not many years before he would have joined us. Then he caught sight of Morengaru peering with his hazy, enigmatic eyes through the rear flaps of our Land Rover.

"What's your old *Mzee* called?" he asked us. "He used to cook for me when I was with *Safari Land*. We would go all the way to Rhodesia for the sable hunting." He looked closely at Morengaru. *"Jambo Mzee?* Remember me?"

"Ndio bwana," Morengaru nodded.

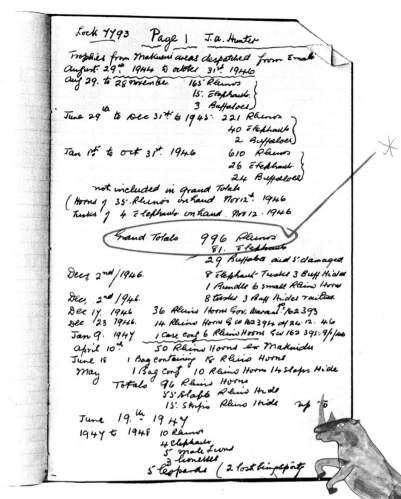

And so our own Morengaru was revealed to us as having cooked for one of the great old hunters of early Kenya. Those were the days when Masai and Nandi warriors openly hunted lions, when elephant tusks weighed over a hundred pounds a side, when a few months' hunting for the Game Department could bring down 600 rhinos or 100 lions. I could suddenly see in the manifold wrinkles of Morengaru's face another face: that of history. His eyes were clouded by the smoke of a thousand campfires, and in the head that had never learned to count the passing years was a totally vanished world, one I would never really know first-hand.

"Ndio bwana," Morengaru nodded, answering the questions of his old Safari leader as if they were both back in Rhodesia, or in the frontier town of Nairobi, packing up the wagons.

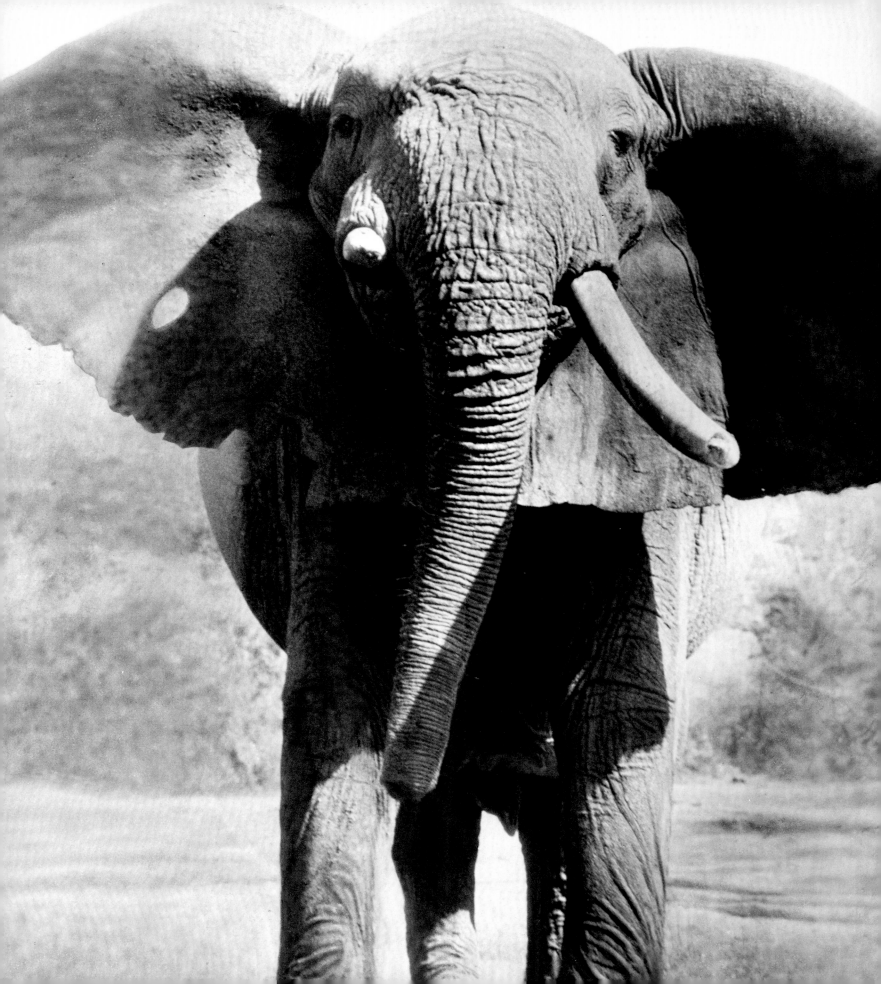

J.A. Hunter
Kenya.
June 23. 1960.

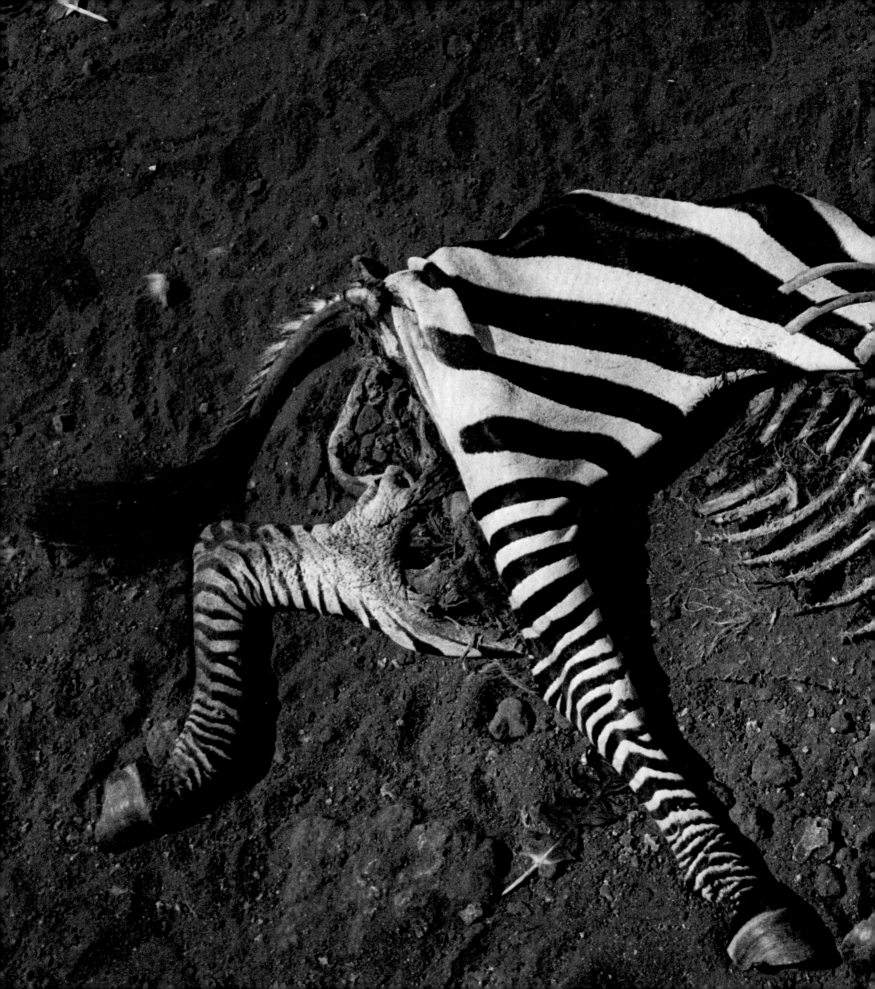

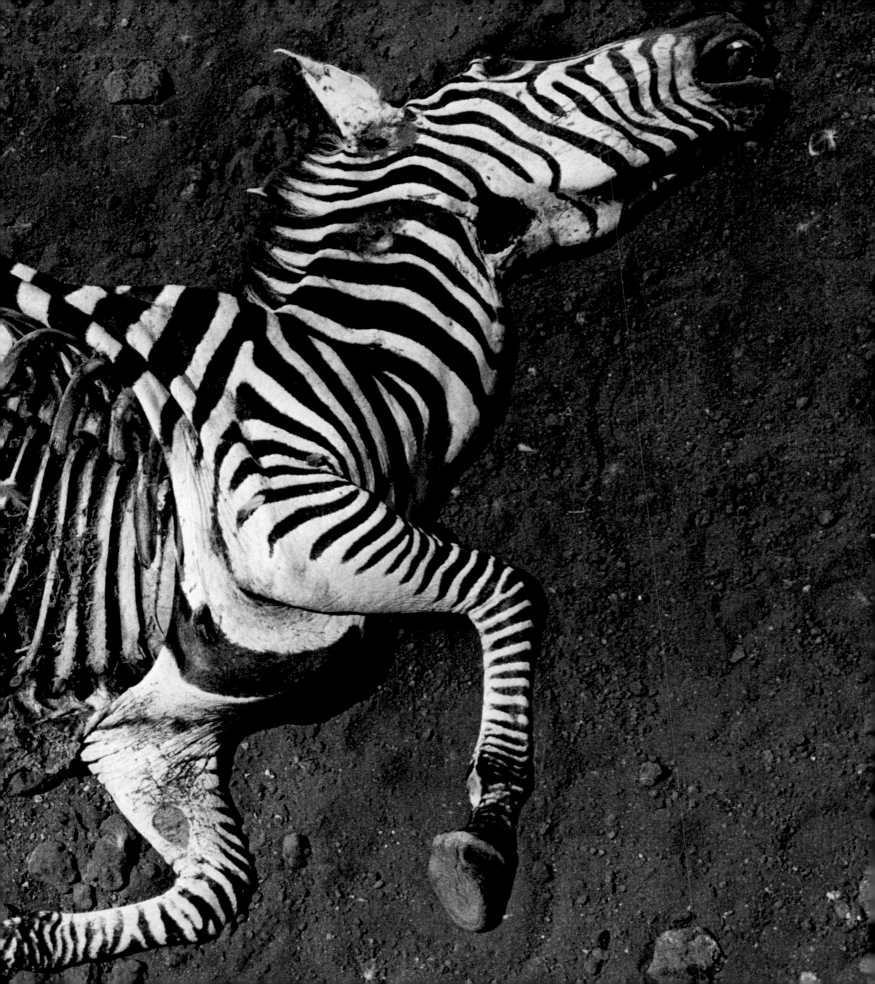

A savage shore receives thy tread, companions thou hast none,
While thorn boughs blow above thy head, erect thou wanderest on;
Weaving through tangled wild-wood drear, piercing the desert glen,
Until at last thou drawest near the haunts of lonely men.

We entered the Northern Frontier District, known to hunters as "the greater shag", on the road through Nanyuki and Isiolo, where British troops had just been called in to stifle another outbreak of Mau Mau-style oathing ceremonies.

We came unexpectedly on the sands of the N.F.D.—just around a slow rise of grassy hills. Ahead lay hundreds of miles of desert flatness. Ponsumby was back in his element. All pink and large, and positively shagged with merriment, he gave out a few verses from his old Gendarmerie Marching Song:

There's a house that is painted bright blue
Near the back streets of Mogadishu
Where in days long ago when we ousted the foe
It was well stocked with whores ninety-two.

Ten years had passed since Douglas Tatham Collins, District Commissioner, had seen the sands of Somalia, but the memories reverberated within him. When someone lives for years without seeing another of his kind, when he has to talk to his mirror to keep from going " 'round the bend", a strange and lasting relation is born between the environment and the stubborn man who has overmastered it. Apart in his triumph he stands, a lone friend of the "Furthest Shag of the Never-Never Land." Now Ponsumby was racing north like a child—like a child of the shag—toward the country that for him was still attraction and enigma. In ten years not a single one of his safari clients had ever been "fargone" enough to ask to be taken all the way into this nowhere. But with a fargone

143

shagbag from the Thorn Tree Café, he was going all the way.

> *Now they've all gone away,*
> *They say to get better pay,*
> *But the Lido is new*
> *And they have some there too,*
> *So the hell with the house painted blue.*

In the full heat of the day the only game to be seen were mirages of camel caravans—those ships of the desert steering their course for infinity. When the temperature hit 100°, we approached a passing Somali for camel's milk. I expected Ponsumby to handle the Somali dialect with perfect fluency, but there was clearly an understanding beyond language between him and the wanderer of the desert. We lay down under an umbrella thorn and drank the thin, sweet milk—"the staff of life, nectar of the gods"—as our nomad host stood staring at us first on one leg, then on the other—the very incarnation of the old Arab proverb: "The newcomer filleth the eye."

Suddenly Ponsumby's eyes welled up and for the first time since I had met him he seemed at a loss. "Amiina," he wailed, "blooming flower of the desert . . . time stands still as I drink thy beauty, Amiina. . . ." Those great droppers-in, the little heat flies, crawled over his face, and he let them— a bad sign, I thought. He lay on his side, his eyes half shut, and traced a pattern in the sand with his finger. Then he began humming a Somali love poem. Slowly the words came back to him, "enriched from the vaults of his dungeon."

> *I long for thee as one*
> *Whose dhow in the* khorif
> *Is blown adrift and lost*
> *In the gray and empty sea.*
> *If I set myself to write*
> *Of the love that holds my heart*
> *A wondrous great book*
> *Could not contain it all.*

Ponsumby got up and went over to the Land Rover where he fished up out of the pile under Morengaru a small, worn leather satchel bulging with poems, letters, impassioned scribblings, and the stuff of a novel begun ten years before. Most of the writings were addressed to Amiina. While

fighting in the desert during the *haggai,* the hot season when the *khorif* winds tatter the land, Ponsumby had met her on the beach at Alula, near Guardafui, where his dhow was moored. He knew of her as *jiradah,* princess, daughter of Mohammed Boghor, Sultan of Mijjertein; she knew of him as Abdi Melik ("the bastard"), which is what he was called by the Somali tribes whose warriors he had fought and hundreds of whose Galgail camels he had confiscated.

As the *khorif* mourned to the world outside, they became lost in each other on a shore more isolated than the desert. From Amiina, he learned the folklore of the Somalis, of the legendary figures of the race, Darod and Issak from Arabia, from whom she was descended.

Doug's book would tell of the people he had come to love, of their fierce warrior men and delicate women, of their savages and poets. It would tell of the beauty he had found, in himself and in others, during his ten years in the desert. So enchanted was he with these people that when the war ended in 1951 and he was recalled from his post, a special detachment had to be flown north to Mogadishu to fetch him.

As lovely as a dhow at sea
Thy young beauty is to me,
Tall, with all the gerenuk's grace
A daughter of the Darod race.
Black hair, fine as gossamer thread,
Eyes that speak of things unsaid,
High cheekbones with straight nose,
Of thy mouth—the desert rose.

Our friend with the milk supply, still standing in the sun like a stork, with his right leg folded up and resting on the left knee, offered us more milk. Doug stood up and explained that we had to be on our way but that he was writing a great *kitab* about him and his people. Then they shook hands in the Moslem tradition, pressing thumbs and bringing to mind the haunting refrain from the Hhudur legend: "I will not let thee go except thou bless me."

"*Nadad golyo, Sahib,*" the Somali herdsman said, salaaming.

Leaving him to his camels, we bounced along

Buffalo Springs scorpion

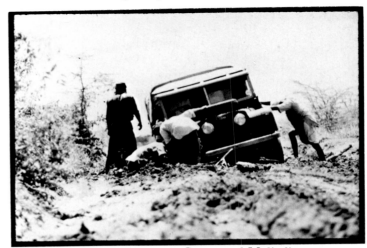

The road between Garsen and Malindi

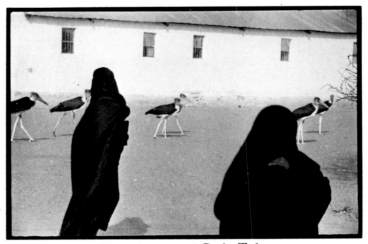

The main street of Garba Tula

145

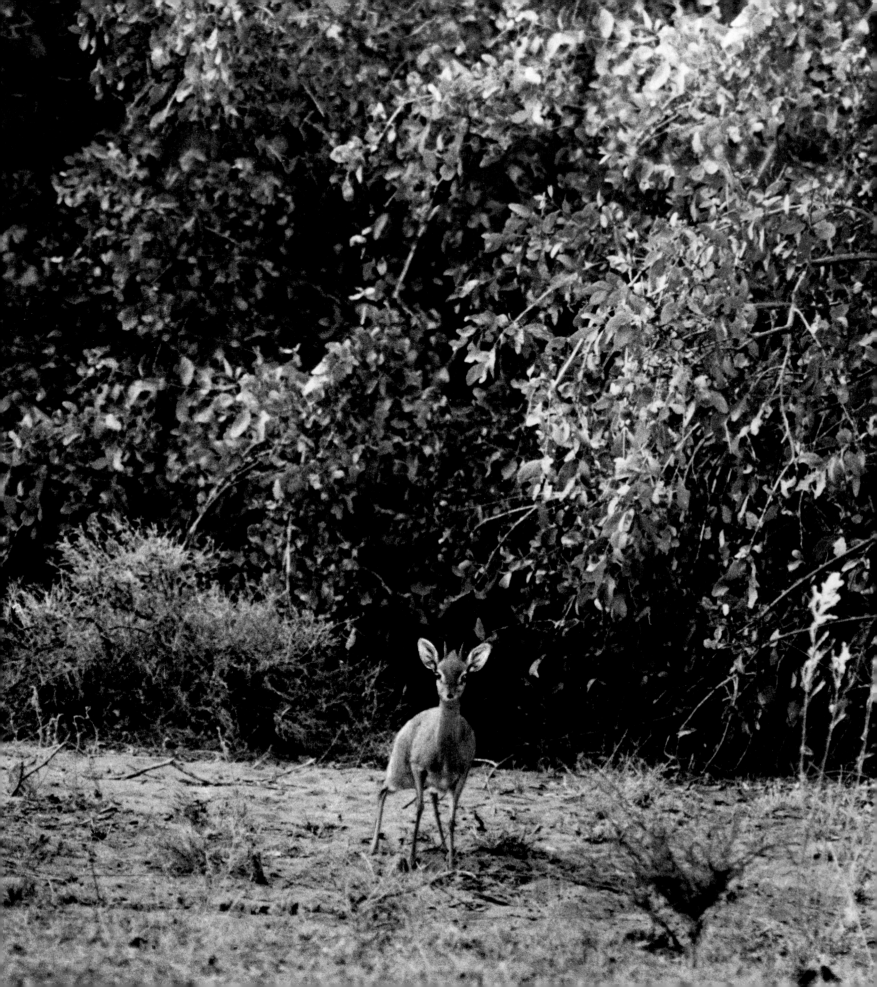

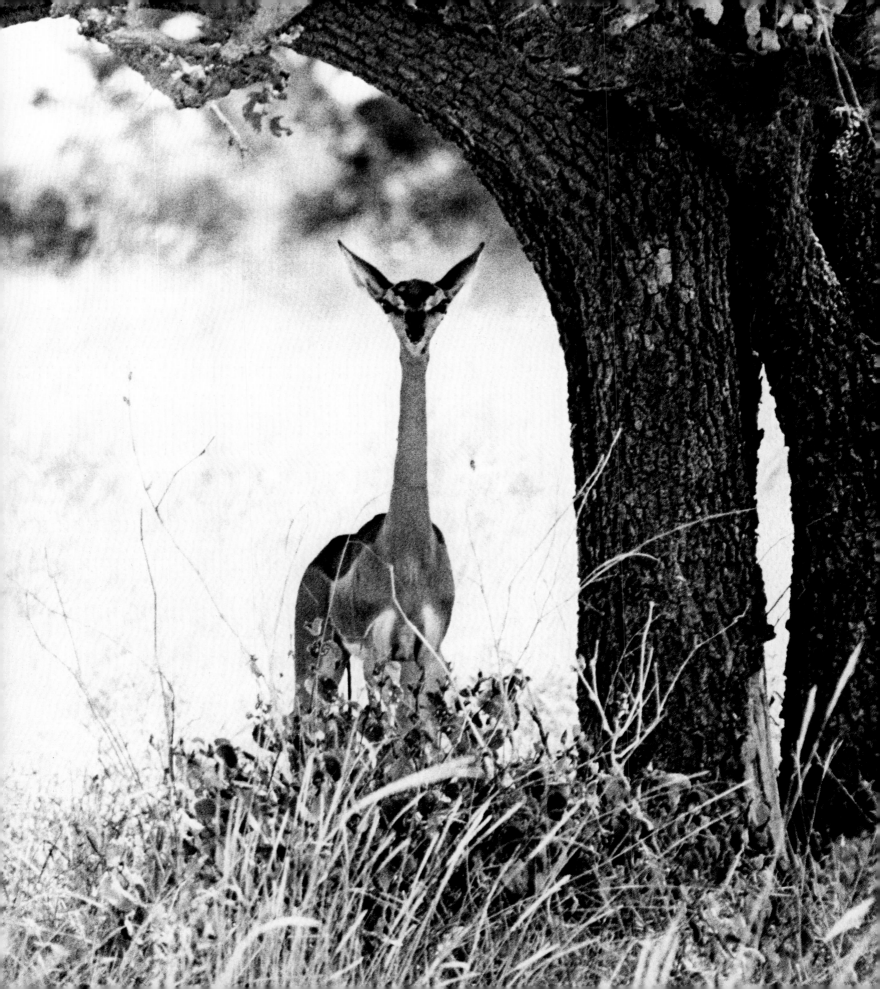

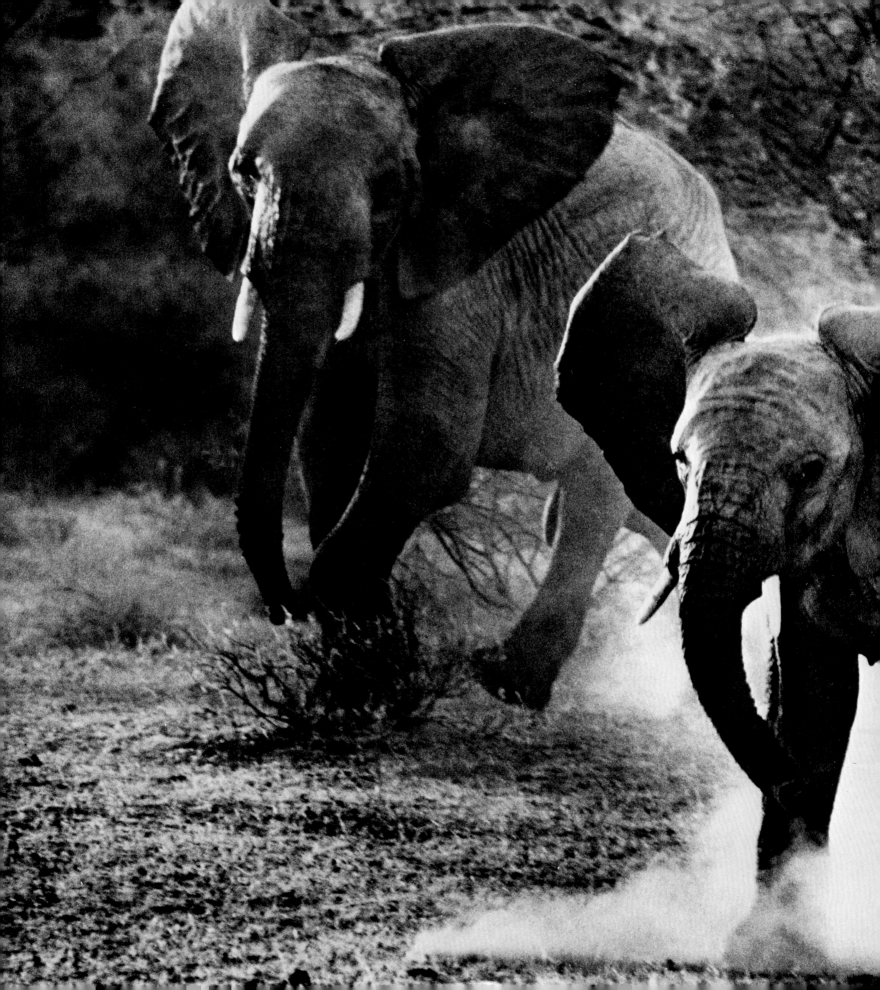

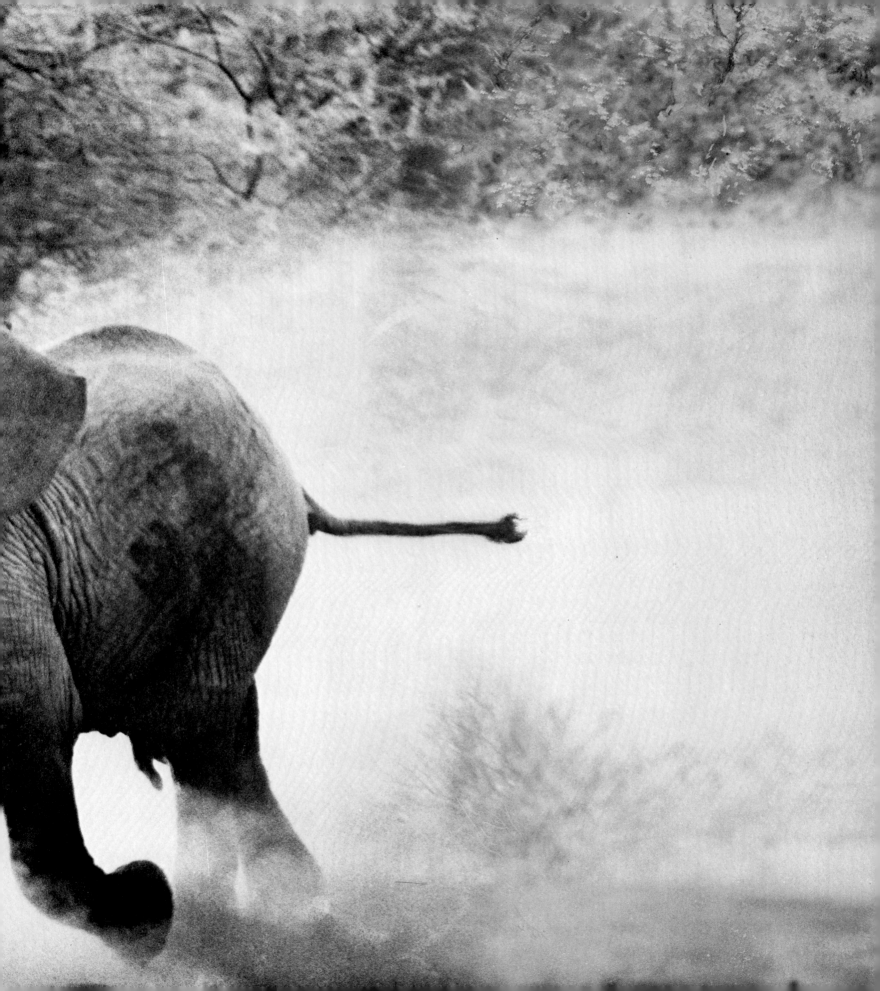

FEMALE

MALE

until we reached Buffalo Springs, a pool of clear water deep in the desert floor and an oasis for game from many hundreds of miles around. We set up our camp in a light that seemed hand-painted, a mix of dusk and a gathering desert storm. After wallowing in the spring like contented hippos and eating a meal of guinea hen and sand grouse beautifully prepared by Morengaru, we began building a blind of palm branches near the waterhole, downwind from the prevailing northerly breeze. As we worked, the storm vanished over the horizon. A three-quarter moon came out and we discovered on the bank of the pool a name chipped in stone: "James 1932."

In the early dawn we woke to elephant screams. At least Buno and Doug agreed that it must be a cow-elephant herd coming to water and that if we could get up to the blind in time, we would see something amazing. In his army shirt and patched black trousers, wearing the brown and white fez that Doug had given him as we crossed the border, Buno preceded us through the trees around the springs. From there we could see the herd far off, shuffling along in a great mass. It was impossible to take a count.

Some of the biggest elephants were browsing along the landscape of thick bushes and trees near the springs. The rest of the herd lingered behind. Many of the young calves nuzzled the tough hide between their mothers' legs and, as each leg moved in step, followed with scampering maneuvers.

It was some time before the leaders of the herd reached us. A gap in the center of their formation allowed them almost to pass by on either side before picking up our scent. Then all at once they caught it, and they turned around with a startling grace and agility, filling the air with a collective scream that spread to the rest of the herd. In the moments of confusion that followed, there was nothing for us to do but keep down. We didn't have to understand elephant-language to understand that 50 or 60 mother elephants wheeling in panic and screeching to their young were devoutly to be avoided. The ground shook from the pounding of those monumental feet as the herd bunched together in a circle, the babies huddled in the middle,

searching the air with their trunks. We were completely surrounded by elephants, ears back, heads up straining for the wind, trunks going rhythmically up and down. The very air around us vibrated to our nostrils.

We doubled up low in the bushes until the older cows began to retreat. There were calls between those who edged back and those who held the tight circle. Presently, the last of this hard core shuffled away and when the herd came together again in the distance, there was a trumpeting exchange of triumph and relief: the world's biggest land mammals had got away again. For the time being.

We were still lost in the beauty of what we had just seen. Even Buno had a look about him. And as for me, I could see that I had used up a 36-exposure roll of film but I couldn't remember taking a single frame.

On our way back to camp we saw two rabbit-sized creatures with big eyes, standing statue-still except for their little noses twitching in the air. These were dik-diks, an elusive species of antelope so sensitive it is nearly impossible to photograph them. I crawled through the bushes and saw one of them busily covering a few of its droppings with its back feet. The law of the bush required that it do its job—scratch, scratch, scratch. At the mere click of my camera, the febrile forms disappeared into the underbrush.

Ponsumby was so shagged at my luck in getting a photograph of them that as we walked off he told me an old native fable about dik-dik droppings.

Long, long ago, the king of all the dik-diks was running along, unmindful of where he was going and, being the king, without a care in the world, when he slipped and fell in a huge deposit of *ndofu* (elephant) dung. Whereupon he summoned all his subjects and ordered them to trip up a *ndofu* in dik-dik dung. Ever since then, the dik-diks have been toiling to collect a pile big enough for a passing *ndofu* to slip in.

"One of these days the little bastards will do it too," Ponsumby declared.

The natives had many such tales to tell—of the desert and the river, of snakes that could run as fast as men, of elephants with tusks so big they had

to walk backwards. Underneath all their imagination and wit, underneath the mystery and seriousness, lay a gift for mischief and a gift for fun. Buffalo Springs, doorway to the greater shag, meeting place and source of life, was an ideal place to be initiated into their lore.

Here, as in any terminus, animals and people kept dropping in. On hot nights I walked over to the sandy grass plains around the waterhole to stalk the zebra and waterbuck herds that had settled in. I could often sneak up to within ten or twenty yards of them. This nighttime stalking had a special excitement to it that cannot be compared to any stalking I did in the day. It had something to do with the African night, which is so easy to be enveloped in. Even keeping to the flat plains along the springs, I often *felt* lost, and hurried back to the reassuring flickering of our Petrolax lamp, which went on at seven each evening.

In the dull light of an early morning we left Buffalo Springs and headed east to Garba Tula. Some strangely warped image or other was always appearing in mirage on the horizon—a herd of camels, or reticulated giraffes, or Peter's gazelles, or just a mound of porous rock. Garba Tula was the usual line of heavily shuttered Indian *duccas*: on the outside, blazing white stucco; on the dingy inside, a clutter of wares jammed up against the walls and piled haphazardly on tables and chairs. A fan invariably turned in the shadows, cutting the thick air and stirring up flies. The streets could be counted on to stay empty all day except for an occasional body wrapped up in a sheet on the steps or in the middle of the road. The Indian shopkeepers listened to a whining music on their dusty radios as they checked their merchandise.

Our limited water supply kept us moving along southeastward toward Garissa. The town was a mere splash of white on the horizon but when we got there, the streets and shops were crowded with Somali travelers, most of whom wore their hair piled high and pinned up with porcupine needles. Ponsumby felt completely at home here and was inspired to get back to work on his book, which he had decided to call *A Tear for Somalia*. For hours each day he sat writing at the dinner table as the

natives along the river bank beat their wash and wailed their songs. The air gave off the scent of frangipane trees, and fallen blossoms carpeted the banks sloping down to the river.

We sing to the Leopard River
Flowing through our land,
Providing life for us,
 Our camels,
 Our sheep,
 Our goats,
 Our cattle.
We sing to the Leopard River
Flowing through our land,
Its waters, our crops,
 Our sim-sim,
 Our cotton,
 Our maize,
 Our cassava.

Douglas (Ponsumby) Collins.

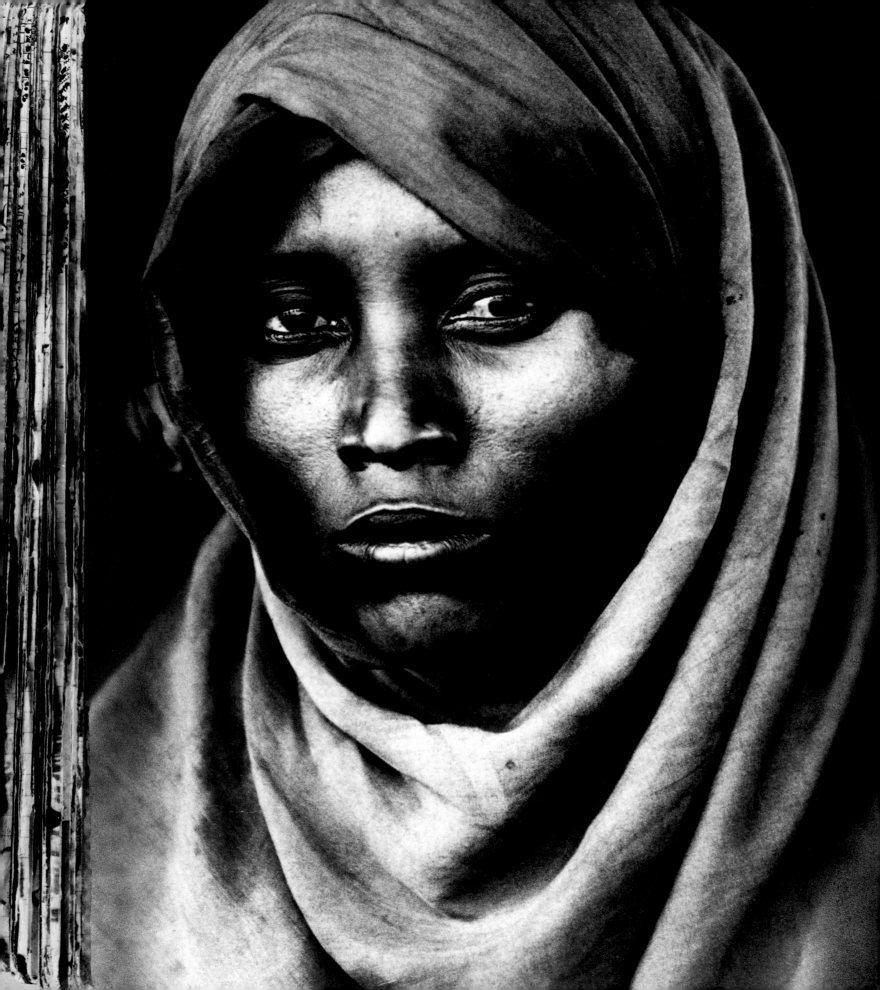

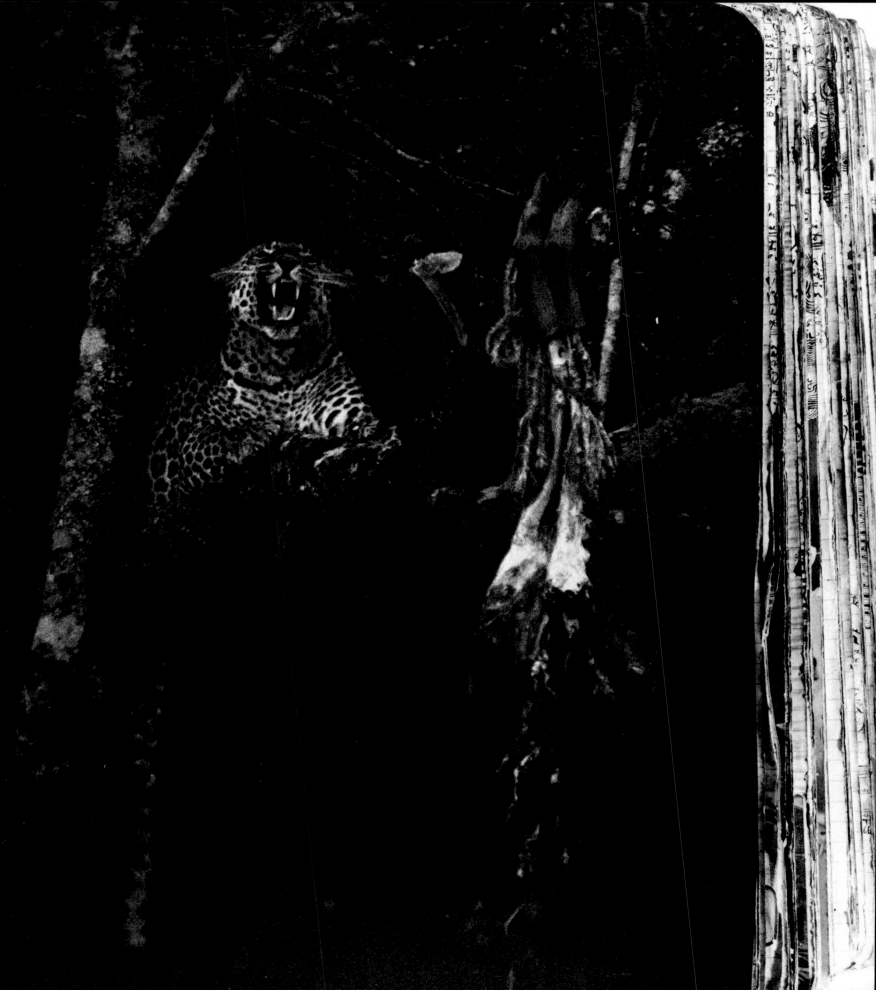

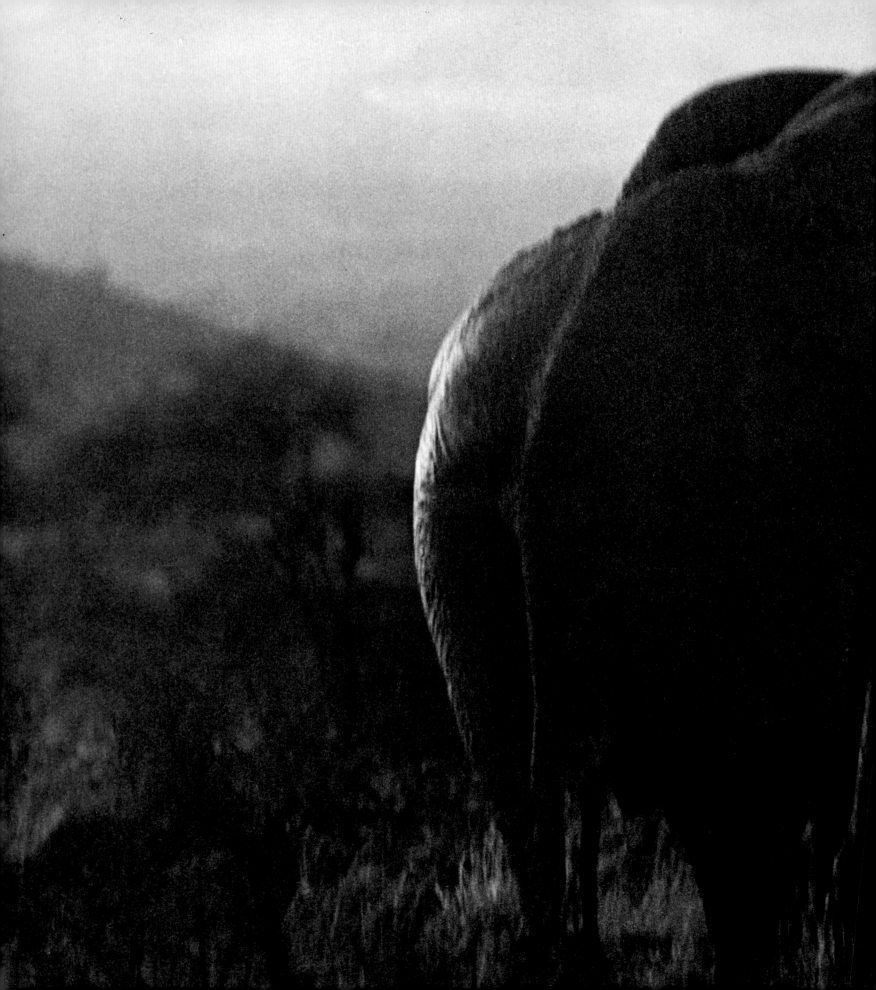

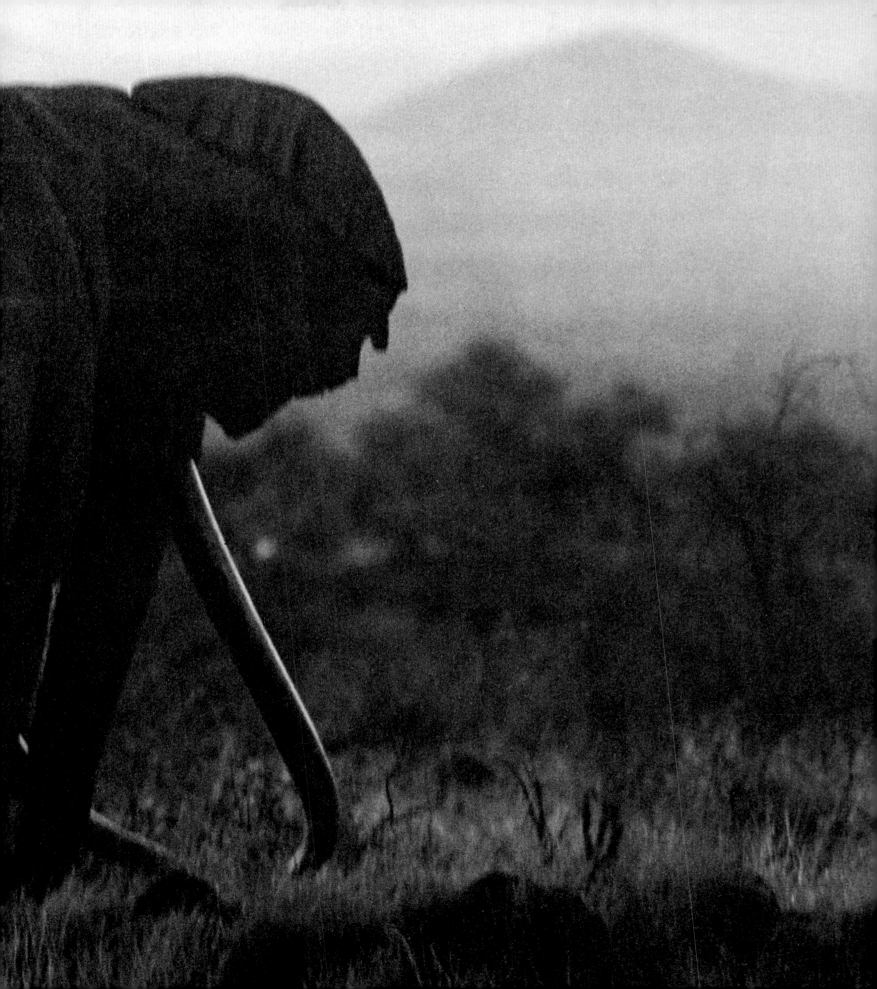

Almost as if Doug's own feeling for the land had conjured it up out of his desert past, a letter, addressed to "Abdi Melik" Collins and sealed formally with wax, was delivered with all due ceremony early one morning by a native clerk from the District Commissioner's office. We were startled to see that it came from the residence of the Prime Minister of the new Somalia. The clerk in Doug's office when he was D.C. in Mogadishu, one Abdi Rashid Ali Shermarke, was now Prime Minister! Doug was as shagged as he could ever be shagged.

The letter overflowed with salaams and invitations. The Prime Minister was putting his palace at Doug's disposal, and, of greater interest to us, all the fine hunting areas as well. Although he had officially closed the new nation to hunting for a few months, he invited "Abdi Melik" and his friends to take as much ivory and as many trophy skins as they wanted. Within minutes we were all packing to leave. Three hundred thousand square miles of unspoiled hunting lay before us—and the chance to clear a profit from trophies!

Halfway through my packing I had the desolating feeling that our reconnaissance was going to take at least four months, and I simply didn't have that much time.

"Not to worry," Doug reassured me. "You and Morengaru bash on to Nairobi. I'll map out a route for you. Bryan Coleman, my second hunter, is a good chum. Here's where you'll find him when he's not slogging down *wompos* at the Thorn Tree. Get him to take you along on his game control

Elephant asleep

work in Laikipia. He needs all the help he can find and you'll never get photographs like that again."

I asked Doug what game control was.

"You'll find out," he said cryptically.

Doug then gave me all his surplus equipment to deposit for him at *Kenya Safaris,* an elaborate map, and a note of introduction to Bryan Coleman. Then, slinging himself behind the wheel, he made his familiar *Uhuru* sign and chugged off. Buno, still wearing that funny little fez of his, waved goodbye from the back. I shouted goodbye to him in Swahili and, wonder of wonders, he smiled—it was as if a stone had cracked. And a small cloud of dust swallowed them.

Morengaru was helpless to understand why *Bwana* had gone and left us. I was feeling a bit bereft myself, and let it go with a few shrugs.

From the map I saw that we were going to be taking a circular route toward the coast, arching up again northwest to Nairobi.

For this part of the safari I put my camera away and concentrated on having a good time. Whenever we ran out of food, I took up the shotgun Doug had left me and came back with some guinea hen and sand grouse. But at a way-station called Garsen, on the road below Mazabubu, a stretch of black-cotton soil played havoc with our plans. We had to wait two weeks for it to dry up before proceeding.

At least there were dik-diks and warthogs to look at, and a few superb lesser kudus, and an unforgettable old buffalo bull. One day with a crash and a snort it emerged from the bush onto the path that Morengaru and I were taking down to the river. From the refuge I had found in the nearest clump of trees I watched incredulous as Morengaru, standing where I had abandoned him, made little shooing motions with his long arms. "Shoo, shoo," he said, flicking his wrist as if warding off a fly. And sure enough, giving the turf a last pawing, the bull spun around and disappeared into dense cover.

"*Bwana, bwana,*" Morengaru called, "*Kuja hapa* (Come here)." I went up to him and congratulated him on his courage. "*Ndio, bwana,*" he agreed, bursting into laughter, and we continued on our way to the river.

At nine every night the B.B.C. broadcasts reported how European mothers and daughters in the newly independent Congo, only a few hundred miles away, were being violated by regiments of native soldiers. An airlift, operated 24-hours-a-day by Sabena Airlines, was evacuating thousands of these terrorized refugees, but many others had had to flee on foot and by car. (Most of them ended up in Nairobi, where relief camps had been set up to accommodate them.) Now I could understand as never before what the years of the Mau Mau Emergency must have meant for the isolated white settlers.

As soon as the road dried up, we set off for Malindi. One evening at our camp there, a Belgian refugee in a small station wagon stopped by. Jacques had left his plantation in the Congo before the real trouble began, and was prolonging his holiday here until everything calmed down. He had complete confidence that his elderly parents, whom he had left behind, would be safe.

Our camp was on the opalescent Indian Ocean, and local fishermen saw to it that we were supplied with more varieties of fish than we could name. In short, the perfect place to relax after an exhausting stay in the shag.

Jacques and I would come back from our fishing trips in the lagoons to have to face the real world in the form of evermore detailed B.B.C. reports. Each refugee plane was full of passengers staring blankly into space, and there would invariably be five or six of them who had to be removed in straitjackets. And no wonder: when Congolese soldiers descended upon the Belgians who had not been able to escape, they often gang-raped wives and daughters in front of their families and then mutilated the witnesses.

In Malindi, Morengaru contracted malaria and had to be confined at the clinic there. If he was always sad, he was sadder still about his "very great illness." Thinking to cheer him up, we recorded his voice on Jacques' tape recorder—which both pleased and bewildered him when it was played back "Where voicy in five-minuti radio-box come from?" he asked with a deep frown.

"Morengaru," we said, "We have to be off now. It will be rough going without you, but we'll see you

back in Nairobi as soon as you feel well again."

"Goodie byu." He squinted up at us from his pillow as intently as if he were afraid we were leaving him forever, leaving him to die.

"*Kwaheri.*" Goodbye.

Morengaru at Ngulia

The roads out of Malindi were badly washed away. Turning off on one of the shortcuts Doug had mapped out for us, we came on a truck flipped over on its right side amid scattered nuts and bolts and bits of metal.

"*Jambo, bwana, jambo,*" came a cry from behind the rolled-up windows of the cab. Three black heads were pressed against the windowpane. Jacques had to shout at the top of his lungs in Swahili because they just wouldn't roll that window down. They said that they had broken an axle. We could see that they had, since it was lying there on the ground. They had broken down three days before and were famished. Opening the window a crack, they described how on their first night lions had walked around the truck and roared at them.

"You can come out now," Jacques assured them. "There are no lions here now."

"*No bwana, mingi sana, simba, mingi, mingi!*"

This was probably their first experience in the bush and they were too far gone to be reasoned with. To absorb a leftover sack of Morengaru's *posho* and a bunch of bananas, they did roll the window down about halfway. We promised to call Mombasa for them from Voi. They managed a collective forced smile, waved goodbye, and rolled the window back up.

It was at Voi that Denys Finch-Hatton had

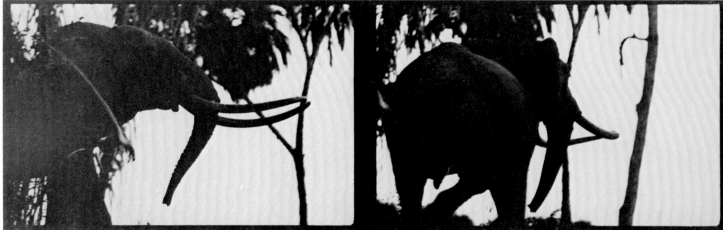

crashed his small plane in May 1931. J. A. Hunter came down to help retrieve the body and bring it back on the Mombasa train for burial in Ngong. Isak Dinesen wrote in *Out of Africa*:

> The morning air was so cold that it bit the fingers. . . . We walked together for a little while talking of the mist. . . . The day was like a rainy day in a northern country. When the boys began to work, I heard that there was an echo in the hills. It answered to the stroke of the spades, like a little dog barking. Denys' friends from up-country, who had had news of his death, came driving from Naivasha, Gil-Gil, and Elemteita, their cars all covered with mud from the long fast drive. Here in the hills I had seen him only a short time ago, standing in the afternoon sun, gazing out over the land, and lifting his field glasses to find out everything about it. He had taken in the country, and in his eyes and his mind it had been changed, marked by his own individuality, and made part of him. Now Africa received him, and would change him, and make him one with herself.

We telephoned Mombasa for help for our friends and then pressed on to Masongaleni. We were down to *posho,* biscuits, a bottle of passion-fruit squash, and six fig newtons. In reserve we had some large nuggets of black-market gold which Jacques had brought with him from the Congo.

We arrived in Nairobi on a Sunday when everything was closed—everything except the Thorn Tree Café. In the streets, we saw groups of dis-

placed Belgians talking among themselves or arguing with Indian merchants over the price of the automobiles they were forced to sell.

Jacques sold a nugget and we headed for the Thorn Tree. Ruth Hales, the secretary at Ker and Downey Safaris who had helped arrange my trip, came up to our table. She had spent the last few weeks working tirelessly at the airport and in the refugee camps, and she was terribly cast down. But when I told her that Ponsumby had finally made it back to the greater shag, she brightened up and we all drank to his happiness.

First thing the next morning, Jacques and I went to Barclay's Bank on Delamere Avenue across the street from the New Stanley. There, two of Jacques' old neighbors from the Congo came hurrying up to him; their plantations had been overrun, and they had barely managed to escape with their lives. They sagged with the rest of the news they had for him: his plantation too had been burned and—they looked down at their feet—his parents had been killed, tortured to death.

Jacques turned quickly and left the bank. I thought I should leave him alone at this desperate moment; I did not think that I would never see him again. I learned later that he sold his car that afternoon to some Indians and left for Mombasa to take a boat to South America and beyond. He was obviously obsessed with getting as far away as possible from what had happened in the Congo. But I wondered if the second-bestness of travel was the answer for him—or for any of the rest of us, for that matter.

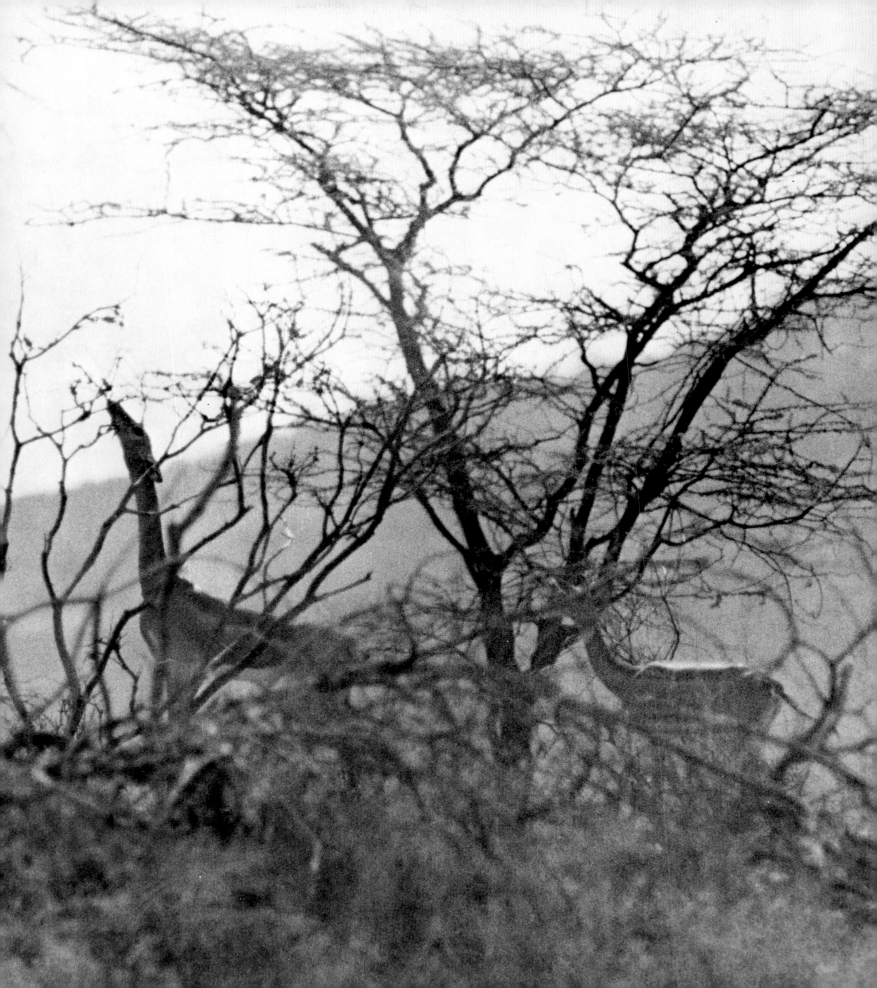

4

Game Control

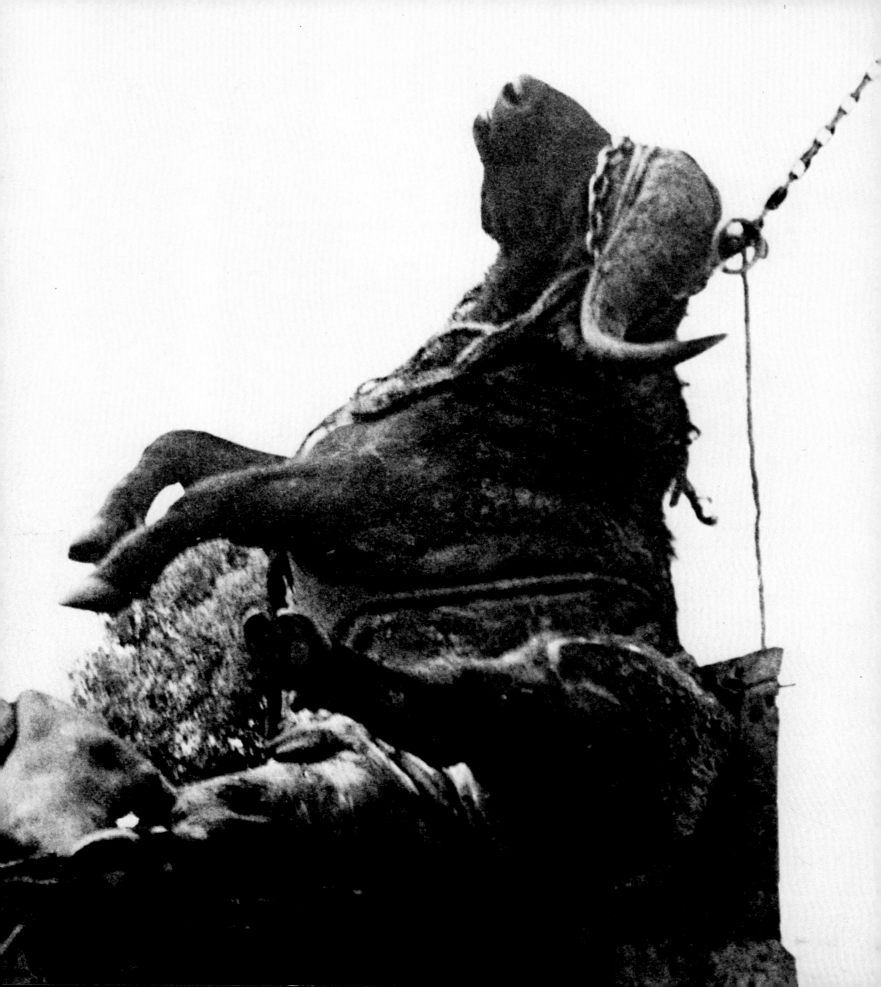

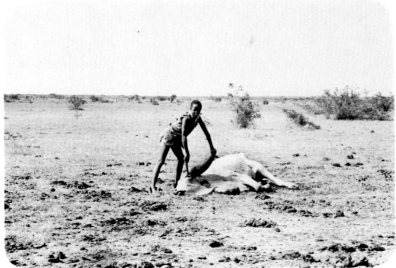

In the same way that the word "Paradise" is often interpreted as boundless primordial fecundity when it really stems from the Old Persian word for enclosure ("walled-in royal garden"), so "Game Control" conjures up images of management and order while what it really means is extermination. Game Control officers such as "Samaki" Salmon in Uganda, J. A. Hunter in *Ukambani,* Bob Foster at Voi Sisal Estate and later in Kiunga, worked for the Game Department gunning down big game on a full-time basis—in order to accommodate expanding numbers of taxpaying human beings in various stages of starvation. Reasons could always be found for whatever government required, with the possible exception of the Ground Nut Scheme which hired control officers to eliminate several hundred thousand wild

animals from a vast area in Tanganyika which was then bulldozed flat, creating a dustbowl where no ground nuts (peanuts) ever grew.

With an interloper's enthusiasm and sense of curiosity, toward the end of summer eighteen years ago, I joined Doug's friend Bryan Coleman on his control scheme on the 172,000-acre Boran Cattle estate belonging to Gilbert Colville in Laikipia.

It took us less than a day to drive the 200-mile journey north to Lariak, Colville's estate, which had taken its name from the area itself.

On the way to our campsite at Ol Morani, eleven miles from Sipili, an old Masai gathering place, we came across a great many cows and calves suffering from rinderpest. From their eyes and mouths drooled the white fluid characteristic of the disease. It seemed certain that they were all dying. It had been a particularly bad year for rinderpest; despite massive inoculation programs, more than 250 of Colville's cattle had perished. Waiting patiently in the bush for the emaciated

163

bodies were hyenas and their sidekicks, the fox-like jackals. The atmosphere of inevitability and slow disease could not be easily shaken off.

But rinderpest was not the most acute concern at Lariak. The estate, vast as it was, was stocked to capacity, and the grazing needs of ever-increasing herds were fast depleting it; moreover, thousands of zebras of the plains and water holes were reducing the potential size of Colville's domestic herds. To divide the land into measured and controllable paddocks of about 5,000 acres each, 365 miles of expensive fencing had had to be constructed. But when the Cape buffalos came out of the forest at night to graze, they would invariably knock the fencing down, and passing elephants, taking offense at the wire, would calmly pull up a few miles of it so that in the morning it looked as if a trick of inversion had been played. About $6,000 a year were earmarked for repairs.

The problem has always been that there is no easy way to raise stock on the same land as wild game. When space becomes a problem, as eventually it does even on estates as large as Lariak, the value of each acre increases, and the only course of action left to profit-minded farmers is to exterminate the wildlife they have been protecting.

When lions used to hunt on Lariak, it was still possible to feel the old spirit of the *nyika* when you heard them roaring in the distance. Now their roars are mutinous—signals to prepare the dog pack for an early morning. The lions have replied by learning to kill silently and to retreat after a quick feed. When they fell cattle instead of the

usual zebra or antelope, their behavior is almost preternaturally cunning. Not long before Bryan Coleman was hired, six lions at Lariak killed 75 head of cattle within a six-month period. (The average lion in the wild probably makes no more than twenty regular kills a year. Everything about Lariak was outsized.)

Other cautions at Lariak were *rhipicephalus appendiculatus* (Eastcoast fever), which is carried on wild game by nine different species of tick; *anaplasmosis* (heartwater sickness), and *babesiosis* (redwater disease). It is thought to be from wild game that these diseases travel and spread to domestic herds, and the manager with whom we worked lamented that game could not be put through tick dips or chased away.

We set about arranging the small tent where all seventeen of us would be living for the next months: skinners, trackers, two Wa-Ndorobo-Masai gunbearers, Tereri and Larsili, and two horses. There was also a pack of wild-looking mutts that Bryan had been using for lions and buffalos. By the manager's house, eleven miles from our camp, there was a cage containing a large lion on which the dogs, with a certain ceremony, were being trained.

Zebra and plains game occupied our first days. This kind of hunting, by definition unsensational, takes on a new dimension in a game-control area. The animals do not offer themselves in the open. The large zebra herds have split up into smaller groups that can sense danger at once, scatter, and disappear. The slightest sound, the least change of wind, and they are off—sometimes for several miles. From the sound of their hooves and the sight of their flashing stripes, their desire for freedom cannot be misread.

Stalking them required hard work and strategy. The stalks were long and low-crouching, the approach slow, and the shooting had to be quick and usually from a considerable distance. For every zebra or buffalo, we had to walk about four or five miles. Relief lay in the daily bag counted up at dusk, and these totals ranged up to eighteen. The day of that triumph, I got sunstroke.

We had the horses to help us round up zebras, but they were far from imperial specimens. Their

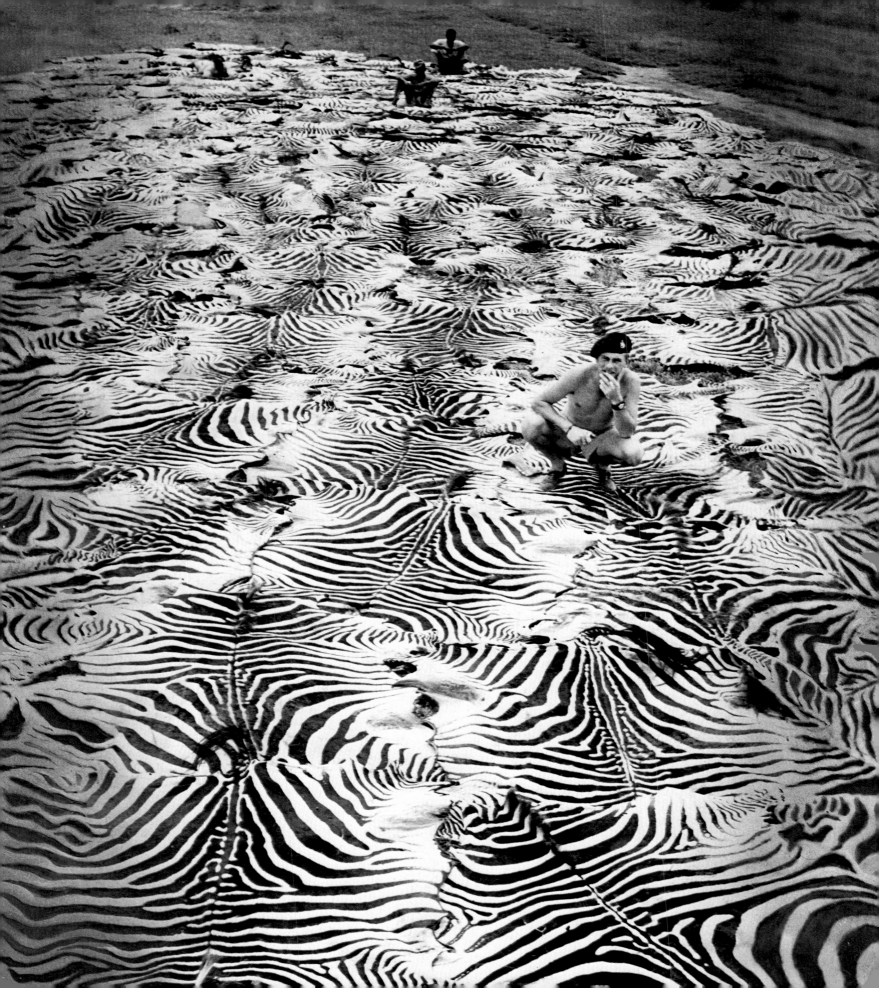

makeshift saddles had the annoying habit of slipping under the bellies at full gallop. If you fired from their backs, you would be certain to fall off; if you took the time to dismount, you probably wouldn't get the chance to shoot. Only on two occasions—and they were flukes—did these miserable horses manage to run zebras to a standstill. My horse was handicapped by having only one eye, but this infirmity served me well enough: it meant we galloped at a diagonal toward—but really away from—the herd until we could "tack" or "come about," riding diagonally at it from the other side. The zebras, which never ran in a straight line (probably a learned reaction against ambushes), would often tend toward the direction in which we were tacking. There were hazards too. Sometimes my one-eyed beauty would skid at the last minute into a tree, its head jammed back against mine, making a bloody pulp of my nose and lips.

The unpredictability of this kind of hunting had a tonic effect on us. When we started out each morning in the Land Rover, only a reckless prophet would have dared to estimate where exactly we would end up. We would drive until we came upon a group of zebras, elands, or oryxes, then proceed with a difficult circular approach until we had the herd surrounded and could close in on it almost without moving. As soon as a shot rang out, the whole herd would charge off, stampeding into the distance, the survivors barking shrilly to each other. The tracking genius of our Turkana skinners would lead them to kills we had not even suspected were there. The speed with which they were able to use a knife, their uncanny ability to read signs and to stay their course in the thickest bush, made them invaluable. Whenever we dropped ten or fifteen zebras, we left much of the meat for the hyenas and leopards. On our return to the area, we stayed on alert in case we should happen on a leopard standing guard over a carcass.

The most affecting moment of our control work came when a long shot fired randomly into a herd happened to bring down a female zebra. The rest of the herd ran off, leaving her to die. A young one stood in sudden terror nearby. The "toto" was too small and unweaned to last long on its own, and we had to kill it. There

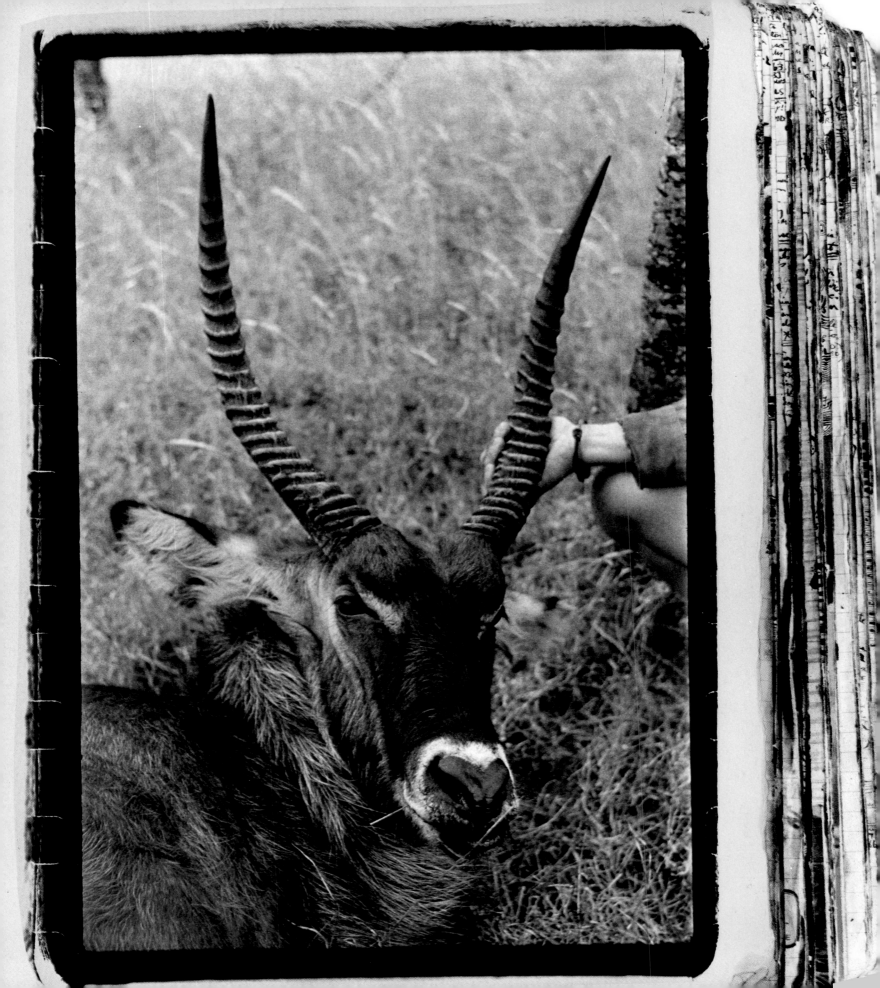

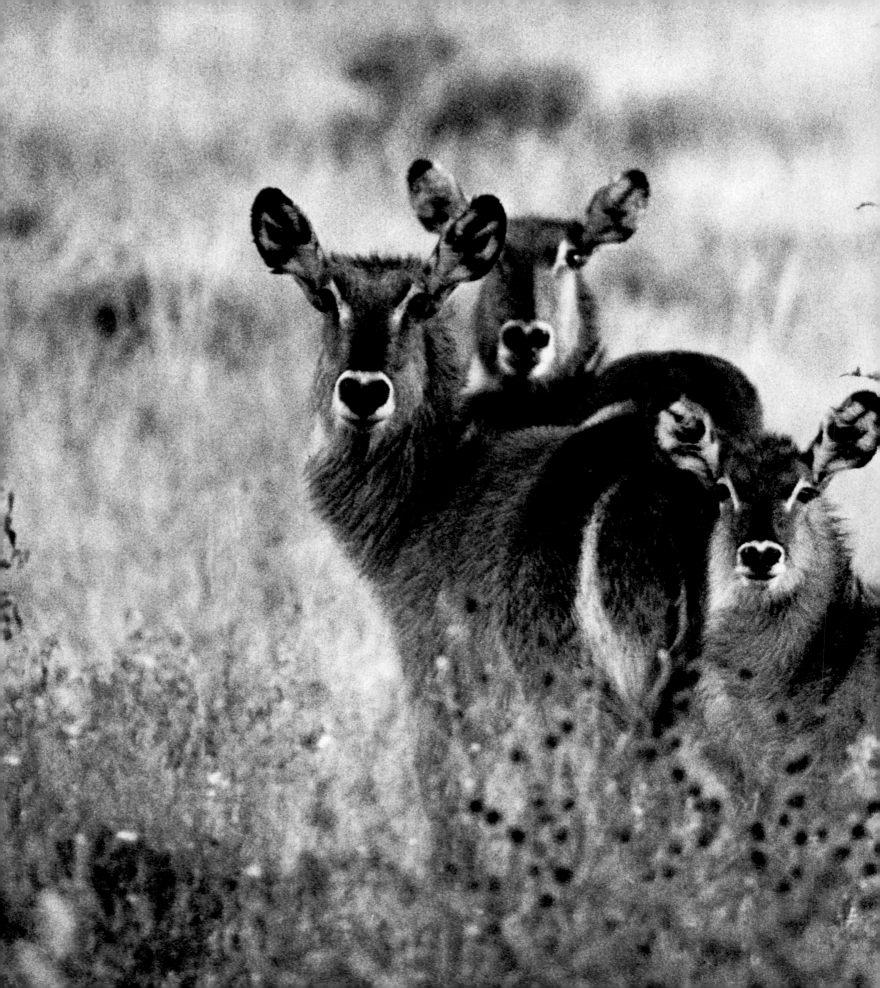

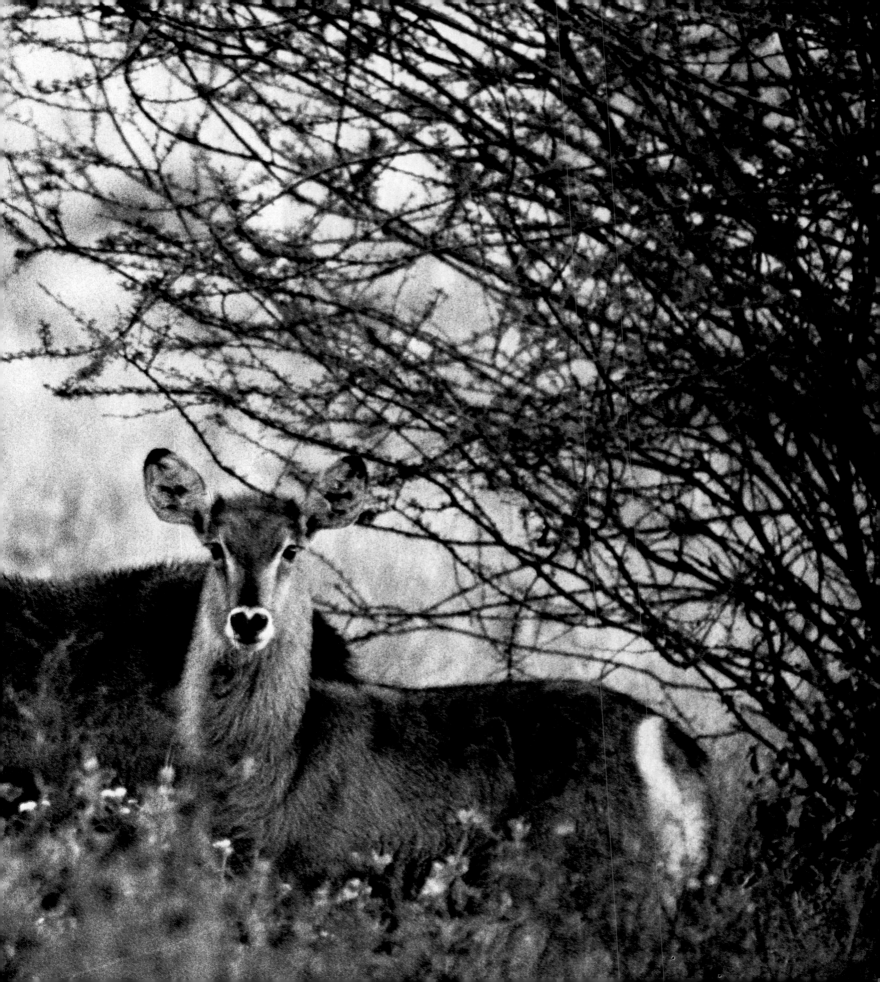

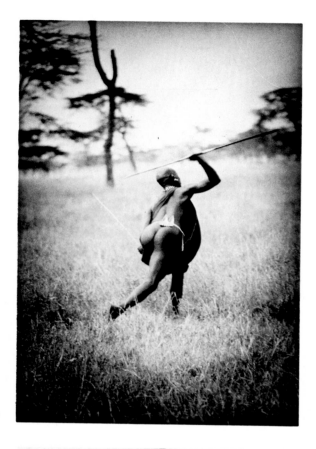

was nothing we could offer it that would be as nourishing as its mother, and we felt cast down and utterly superfluous.

At sunset we would regroup through long, hooting calls or gunshots and make final pickups on the skins and meat we had concealed in branches during the day to feed the dog pack and the caged lion. Then, slowly in the failing light, we would make our way back to camp, where the longest ritual of all awaited us: pegging down the skins for salting, and stacking the ones that had already dried.

There were diversions: tracking down stolen cattle; hunting lions that had made a cattle kill; driving in the pre-dawn dark to hunt buffalo in the heavy forests outside Sipili.

We would load the dog pack into an open trailer behind the Land Rover and drive leisurely over back roads, looking for the wet hoof marks of buffalo that had come out of the forest at night to graze in the open.

Larsili and Tereri would ride on top of the Land Rover until they spotted the spoor of a bull. They were interested only in bulls; where 50 cows had crossed the road they could barely bring themselves to look. *"Eko ndumi kubwa kabisa,* (It is a bull, big to the extreme),"* Larsili, who could read the open plains like a book, would exclaim. The dogs, whimpering and fighting among themselves as they expelled the foul gases of their zebra-meat diet, were pulled out of the car. Heads held high, they parted the tall, wet grass, then disappeared, free to the morning air. Larsili and Tereri too had disappeared in search of the circling spoor.

When we reached the dark wall of forest that divides the buffalo's nights from his days, Larsili and Tereri took over completely. They could divine that the bull had crossed the borderline at a fast pace about an hour and a half before and that it had already reached the all-enveloping safety of the forest. We bent over and started tracking, slowly, in the dark tunnels. We were as wet from the dew as if we had been out in heavy rains for days. Vines got in our way at every turn and the wait-a-bit thorns detained us, sometimes a whole arm at a time, and beads of blood ran out of the thorn pricks onto the wetness.

At about noon we stood full up in a small open-

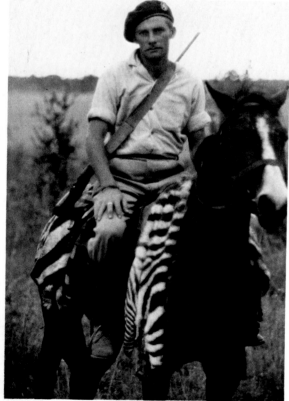

Bryan Coleman

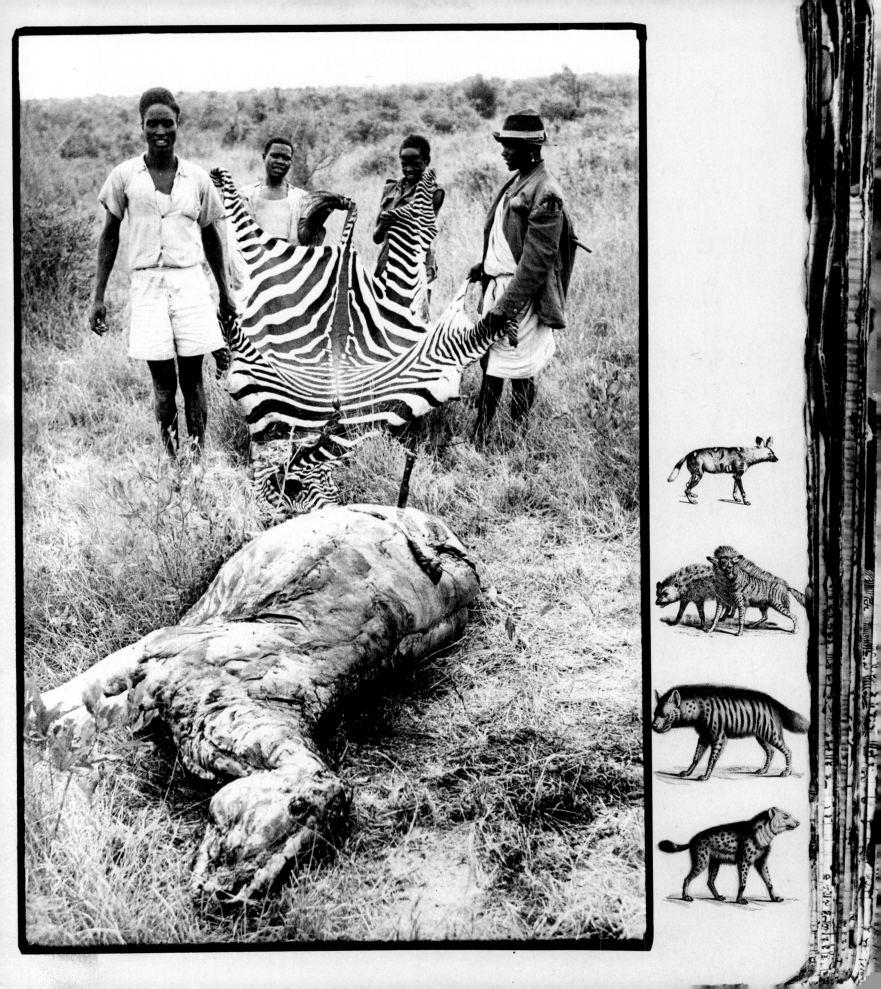

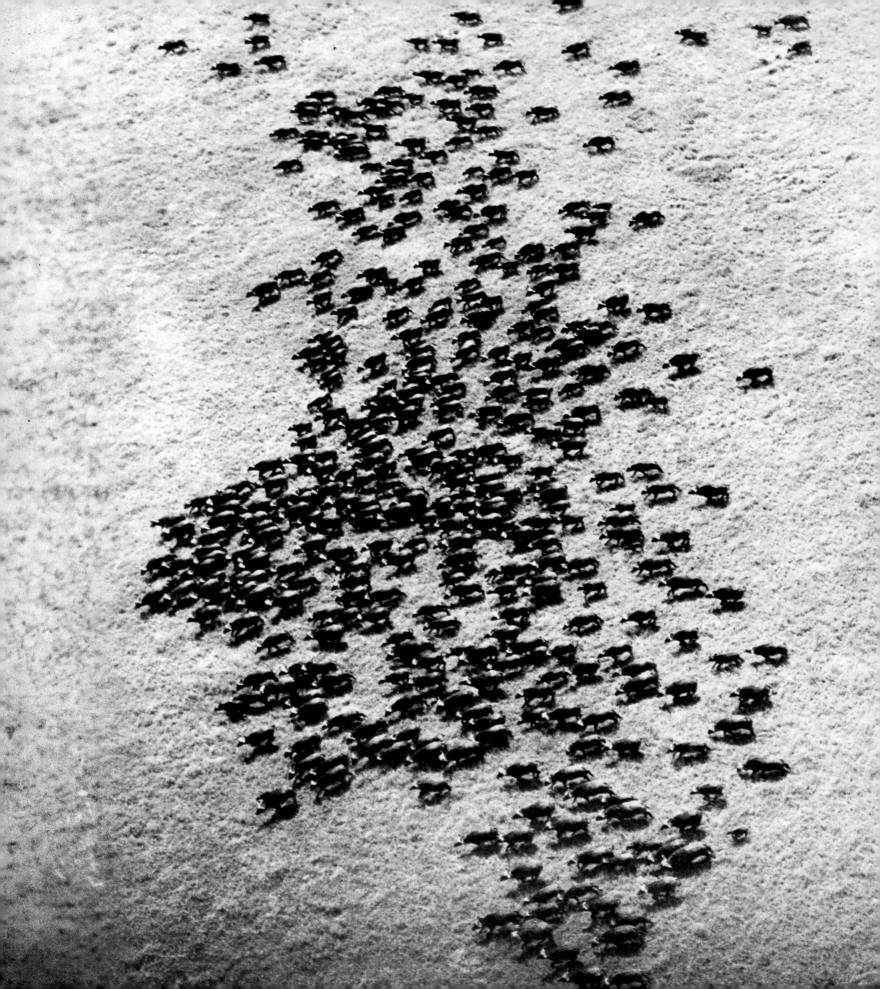

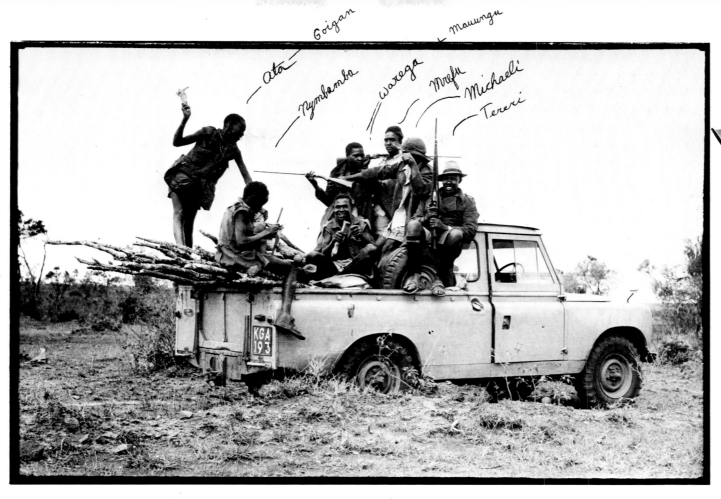

Ata — Goigan — Nymbamba — Waraga — Mrefu — Michaeli — Tereri — Mauungu

ing to collect ourselves. All I had seen so far were three of the bull's giant footprints, a bent branch or two, and some half-liquid droppings which Larsili alone would be able to interpret.

The morning chill had given way to a dull, humid heat, as sun streamed down through the thick foliage. We wondered how far we had come. We also wondered how we would ever get back. It wasn't possible to tell whether the buffalo had picked up a steady direction or was making its way at random. Then, suddenly, twenty dogs exploded on the left with the kind of wild yelping that meant special circumstances ahead. The leader of the pack had scented a small steinbok and made a flying dash for it and was now ripping it apart. Each dog tore into the hunks of meat with convulsive, indiscriminate vivacity. When the commotion was over, we doubled up again behind the panther-like Larsili.

We recognized the spoor groupings of other buffalos, mostly the abominated cows, and passed them by. Then, all at once, everyone broke into a run behind Larsili and Tereri. The dogs streaked ahead, yapping, howling. We were running full out with our heavy guns—Bryan with his fourteen-pound .577, which could stop a buffalo by sheer impact, and I with a Husquarua 9.3 mm that I had bought from an elephant-control officer in the Long Bar of the New Stanley for fourteen dollars.

There was a new and quite thrilling feeling now as we ran faster and faster, through the narrow, thorny tunnels—snapping branches, pushing at vines. Soaked through and through with sweat, we wondered how long the dogs could bay that bull, how it was going to look, how far apart its horns would be, how big, how black. Nothing could hold Larsili back now. He knew the ways of the animals he stalked; he was able to take note of their most intimate signals as if their very life went on behind his eyes. It did not matter that he was not a very good shot; for him it was the stalking that made the difference. On buffalo and lion he always used a shotgun with SSG (special shot), so that after he wounded an animal he was soon in position to fire again. Sometimes, on wild, running stalks it took three, four or even ten shots to fell a buffalo.

Now the dogs were on the buffalo just up ahead;

173

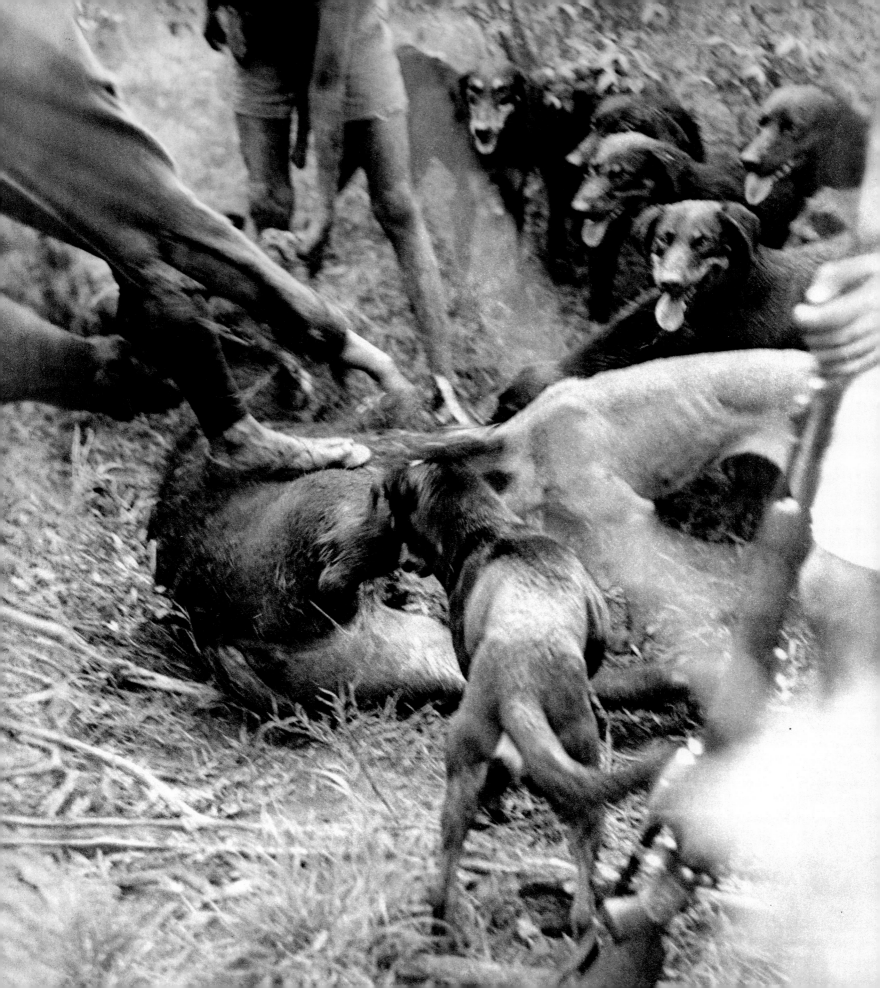

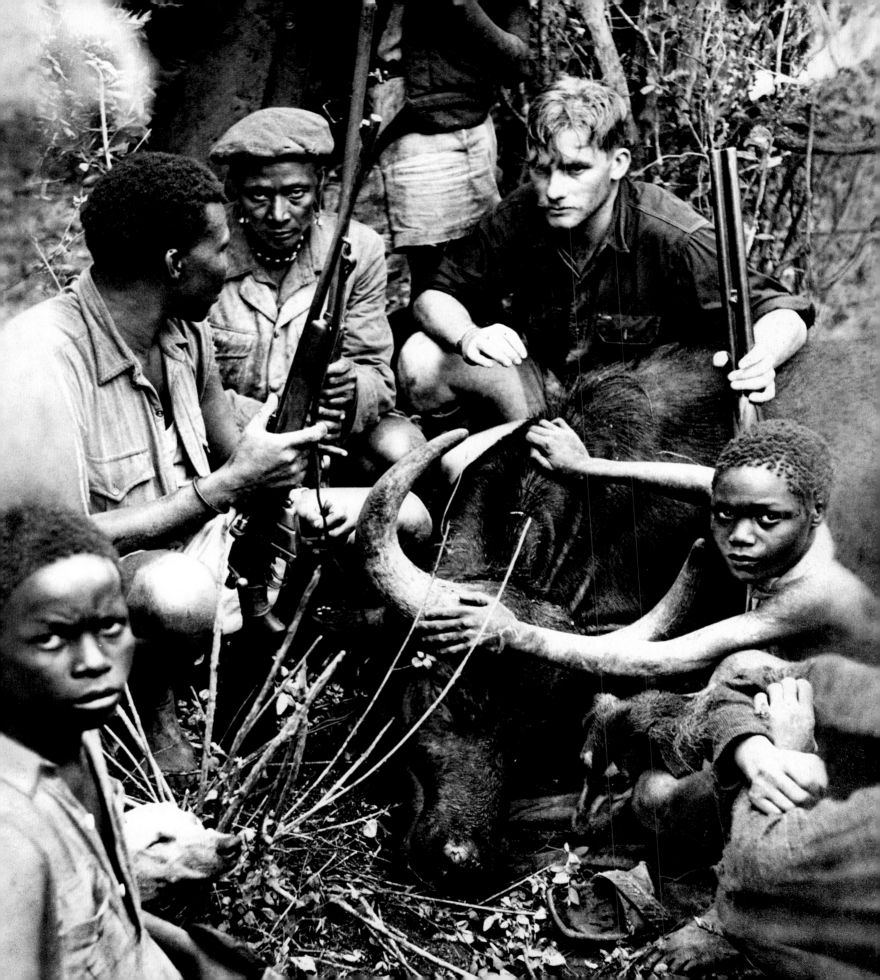

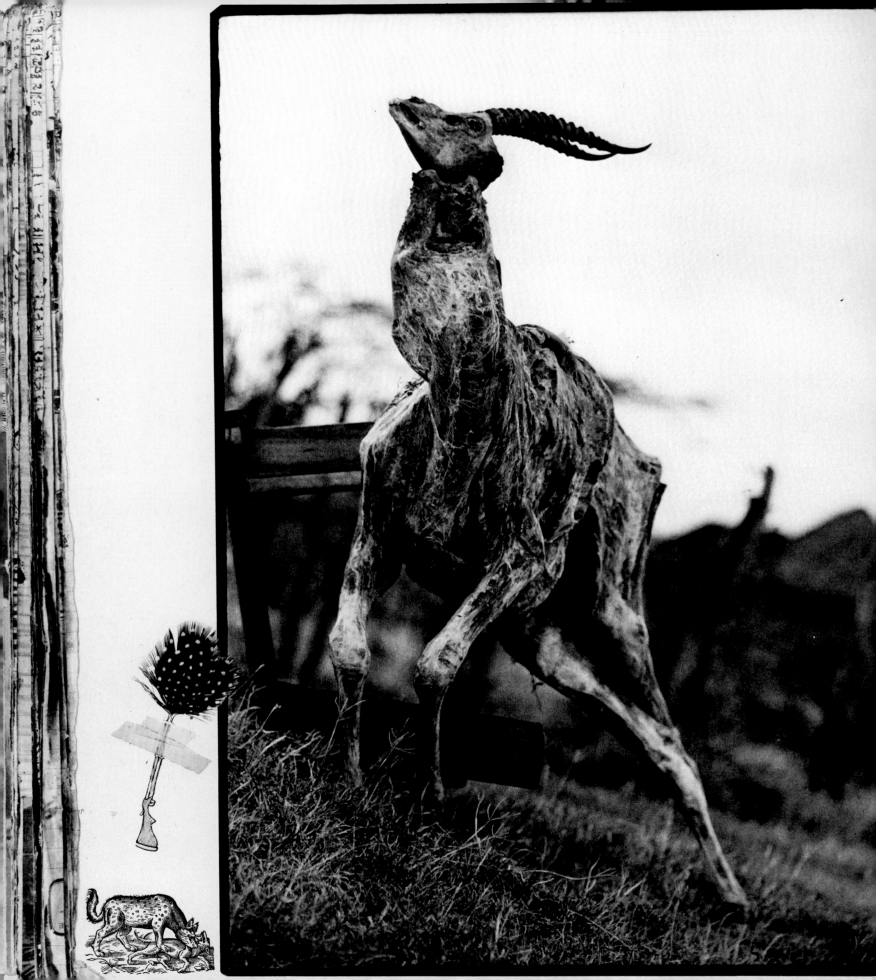

we heard them. The sounds seemed very distant, coming from a world outside, but we kept pace and suddenly felt the discharge of Larsili's single-barreled shotgun and the tree-crashing explosion of a buffalo travelling at full speed. The dog boy, Michaeli, was five feet up a tree located on the bull's trajectory; as it passed, he plunged his spear hard into its back beside the bony fins that protrude from the spine. The spear snapped into pieces a few yards later. The forest had come to life; the noise of the chase was everywhere. We passed Tereri coming from another direction; it was a lung shot, he shouted and rushed on. The branches we passed were coated with the bull's blood. A shot had gone in high on the right side. The forest itself seemed to be tracing the bull's wound, reproducing it on the broad margin of our clothes, our right arms and shoulders were smeared red. Every now and then, foamy sponges of blood clotted the soft rug of the forest floor. Sooner or later, the loss of blood was going to catch up with the buffalo. The spoor was now beginning to circle at random. Larsili and Tereri said that this meant the bull was looking for a place to lie down. *"Karibu kufa* (Nearly dead)," Tereri pronounced.

It was getting late and the blood was drying. The others fanned out to help Larsili. We had gone perhaps ten miles after his shot. It was good just to sit down. The dogs that had stopped with us lay panting, practically docile now, the strongest scene having already been played. One of them had its leg twisted out from its side at an odd angle. It seems that a buffalo had tossed it through the air and it had come down so hard on its legs that one of them would never be right. It, too, lay there panting, biting at the air whenever it caught sight of a fly.

The spoor must have continued circling, becoming less and less distinct, because the others were far ahead of us. But then the dogs were up again and cutting straight into the deep grass on the left. Two shots went off. We froze, the leaves pressed tight against us. A huge, black thing burst through the branches. Turning, we let off several shots from the hip. Just behind was another buffalo, down on its front knees and circling with its hind legs. It wasn't long before it collapsed in a quivering heap. Now

I could see Bryan lying in the dirt between the buffalo and me. He had been mowed down by the first wounded black bull. As he tumbled over, a cow with her head down crashed through and he got off a perfect heart shot as she turned.

There was more barking up ahead. When we reached the yapping pack, we saw a calf being pulled apart. We were too late to do anything for it and had one of the dog boys put a spear into its heart.

The meat of a young buffalo is highly prized by the natives, and not a scrap was left behind. It was after six when we finished loading up the liver, heart, and two legs of the cow buffalo, and all but the head of the young one. We were left to wonder in the darkness if anyone knew the way home. But Larsili and Tereri both knew Lariak. As for Larsili, there was something so authoritative about his manner that we felt safe, whether we were or not. After a day on foot he could go back at night in the Land Rover, sometimes ten or fifteen miles, and pick from each bush and tree the meat and skins

Gilbert Colville and Lariak buffalo head (57¼ inches)

only the lions, after they had made kills that not even an estate on the scale of Lariak could sustain. But then the hyenas came in, and they too had to be eliminated. With the destruction of the hyenas, the plains game began to proliferate. And so on until even the most delicate zebra foal might have to be passed sentence on. An anti-vermin fence on the nearby Fletcher estate had been so effective in protecting Thomson's gazelles that 7,000 of them had to be shot. And when a couple of years later they replenished themselves and began crowding their limited areas, another 7,000 rounds of ammunition had to be bought—and used. On another estate, the owners had to shoot their giraffes not only because they spread rinderpest, but also because their height and keenness made it difficult for control hunters to work. But there was a danger in eliminating them, which the owners of the estate had not reckoned on: the acacia thorn trees, without the giraffes to nibble from them, became so thick that the movement and grazing of cattle was seriously impeded. Bryan Currie of Rumuruti, having made a private and natural assessment of the giraffes' value, had spared a number of them in each of his paddocks. But his giraffes are no longer part of nature's scheme; fenced in as they are with cattle, they stare stonily at mankind each day, their numbers controlled by the guns of their landlords. Even when wild game is allowed to exist in limited numbers, without the freedom they once enjoyed their private glory is absorbed and compromised.

he had hidden from both vultures and local Turkanas. That was how well he knew his jungle.

It was therefore a surprise to no one when the next day—we were back at camp for zebras—Larsili returned to the forest, and with the help of the ever-circling vultures, found our buffalo rolled over on its side, foam standing out in white whorls from its nostrils. He severed the head, which weighed over 70 pounds, and carried it six or seven miles back to the road—the same route he had led us on the night before. His back and legs were stained with the bull's blood. He would be providing his family with soup enough for a week.

Larsili shot his buffalo with an old single-barreled Spanish shotgun. Gilbert Colville, who used to go buffalo hunting with Larsili, once shot what would have been a world-record bull buffalo had its right horn not been broken at the tip; even with the break, the spread measured 57¼ inches. But buffalo can also be hunted successfully with spears. John Dugmore, a local Kenya hunter, more sporting than most, spent two years in the Marmet Forest overlooking Lake Baringo, a few miles from the Lariak, practicing this difficult sport.

It was only as a last resort that Colville, himself a great sportsman and trophy hunter, turned to game control. At first he tried to eliminate

The buffalos of the forest seem to be an exception. Shooting merely stimulates their breeding rate and brings new blood into the herds. During the 1940s, Carr Hartley and his brother-in-law Ken Randall once shot a thousand Lariak buffalos to feed Italian prisoners of war. Like war-babies, the buffalo bounced back, with a force all the greater for their obliteration. In this way there continues to be increased opportunity for constructive hunting.

The sport certainly had a fierce hold on us. Once, we moved camp about 30 miles to Ngarari where a pride of five or six young lions was learning to kill. In this desert country we ran out of food. Our camp was in an area where no wood existed

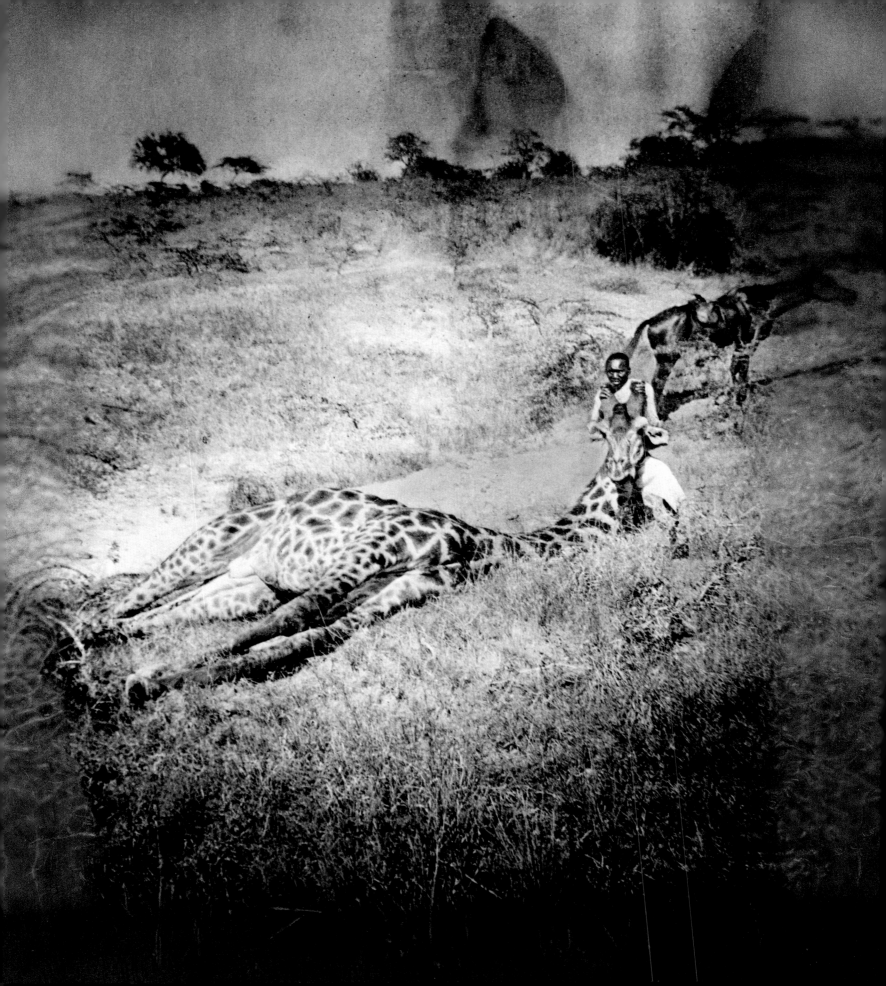

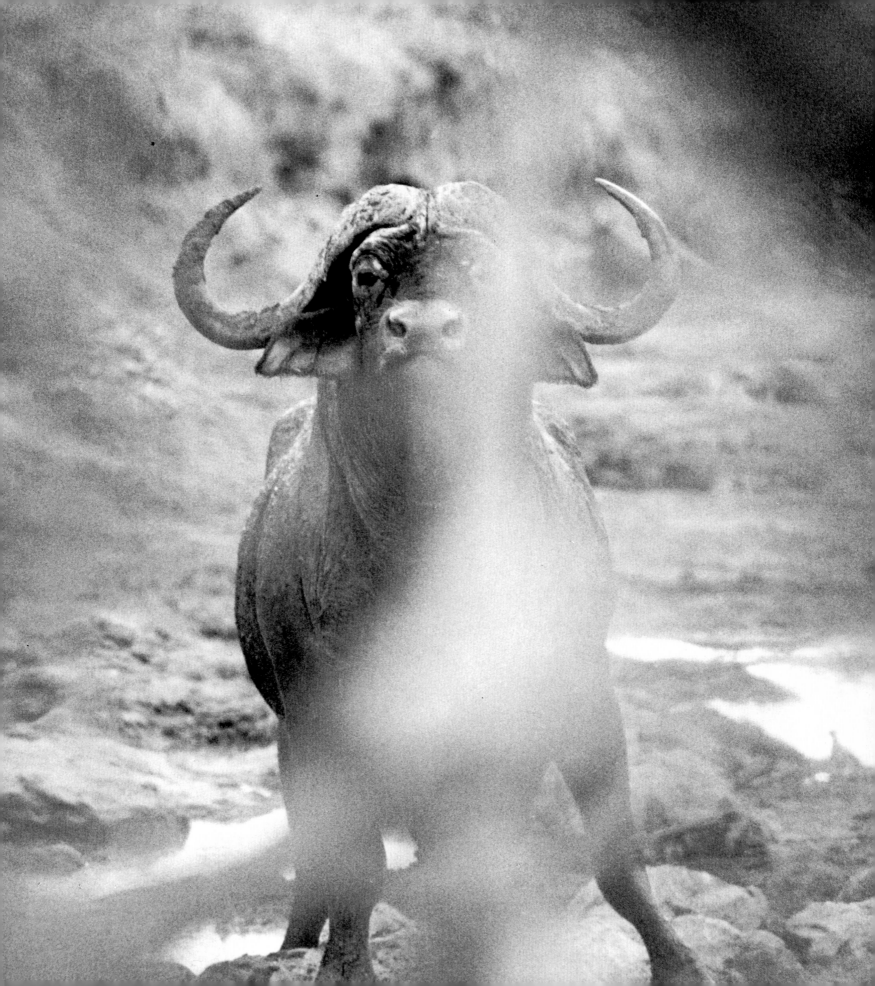

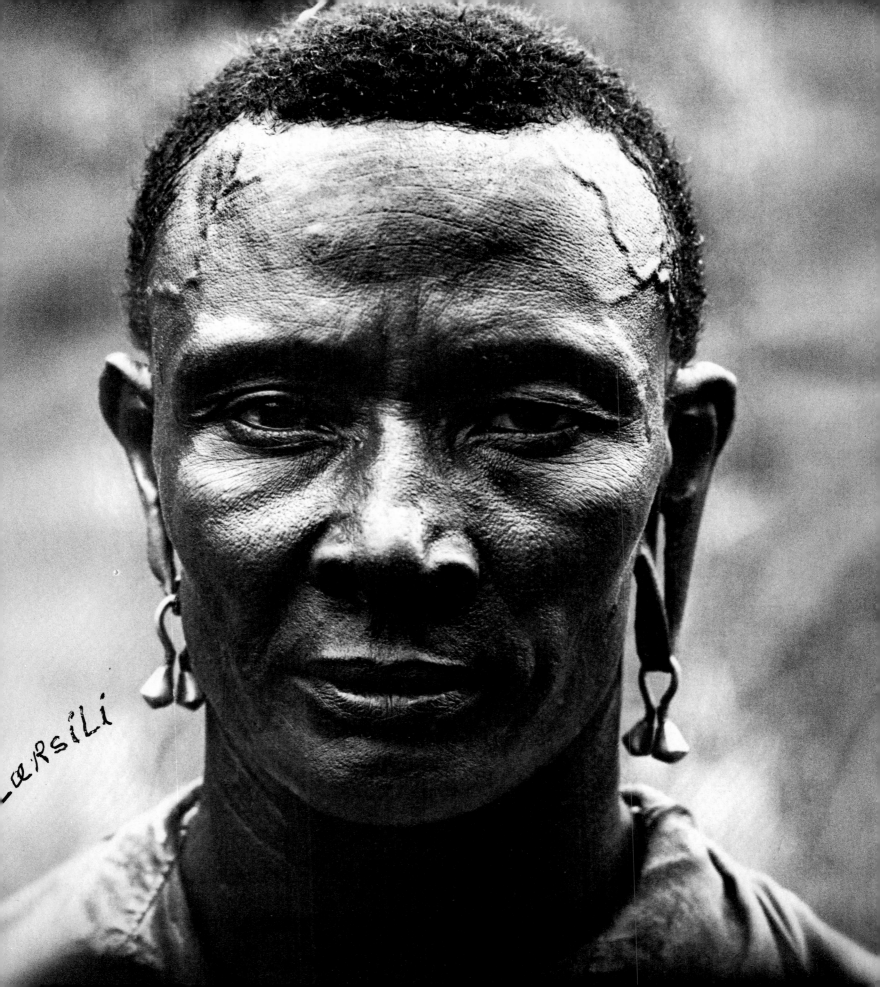

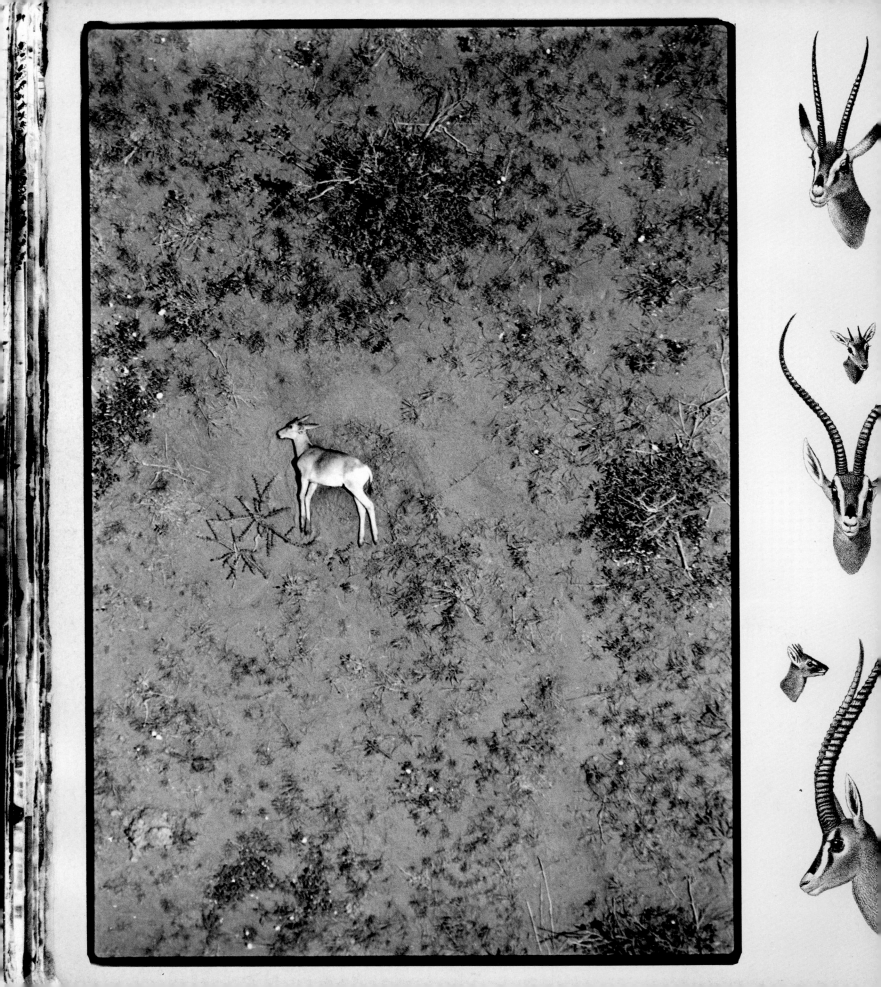

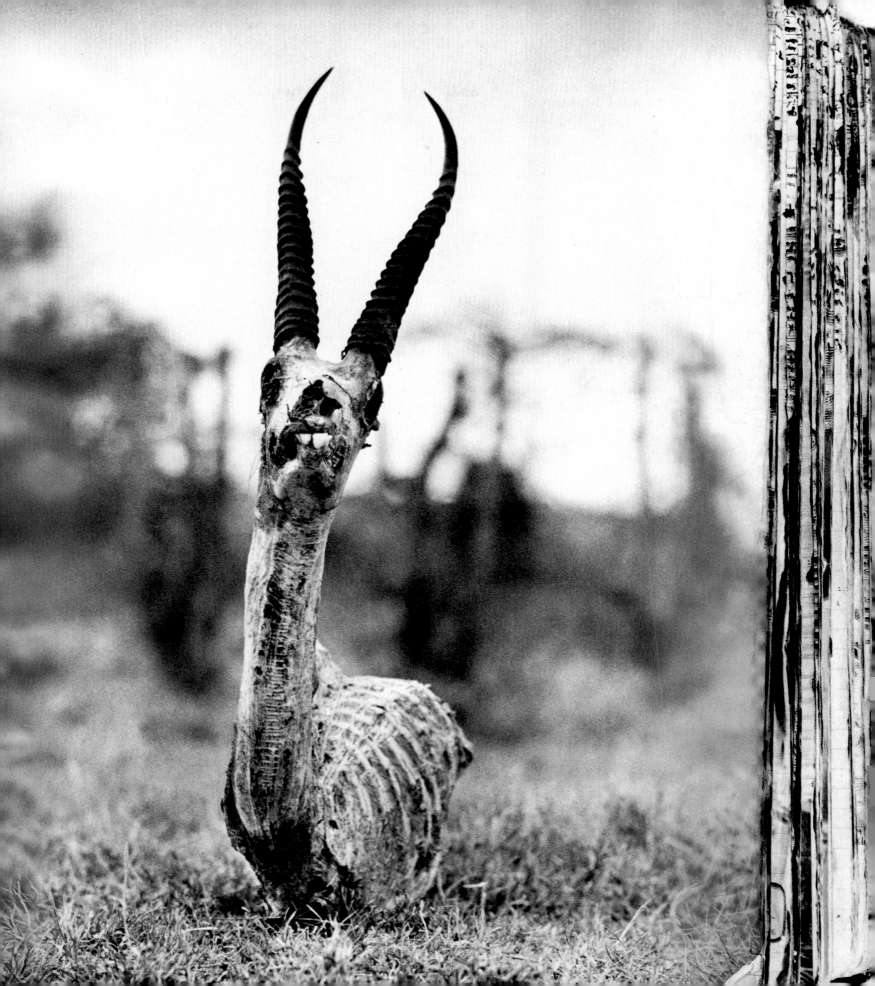

and the thorns did not burn and we had grown weary of trying to cook zebra in a can of sand and gasoline. One Sunday I managed to get off a long shot at an impala and in pursuing it fell into a pig hole and broke my ankle in two places. The impala died nearby and I crawled up to a rise to watch the boys gobble up its heart and kidneys raw and break its bones to suck out the marrow.

On some days we entertained ourselves tracking cattle thieves. To the Turks, Suks, and Masai, this is almost a national sport. No matter how cleverly the Turkana and Suk thieves had disguised their tracks, no matter how far they had driven the cattle the night before, Larsili would find them. He had turned down a large salary as a tracker for the police because he preferred life at Lariak, where he had been born. But whenever the half-covered-over tracks led to the country of his half-brothers the Masai, he would loyally lose the spoor. To the Turks, prison was only a vacation, "Hoteli Kingi Georgei," where they would be taken off their diet of white ants and roots for a few months. Real punishment, which we took ardent trouble to provide, came in the form of a bath and a haircut. (The Turkana ancestral hairdo consists of a big lump hanging down the back of their heads, held together with mud. When a Turk dies, his sons divide this hairdo among themselves.)

Next to stealing cattle, following honeybirds, and watching hyenas caught in a jerry-can trap and crashing into trees, the natives on Lariak liked nothing better than to shoot an elephant. One time, a mother elephant raided the same village each night and had to be shot. We lay in wait all through the night and well into the next day for her young one, weaned and only half-grown, to leave her side. Then we cut out the mother's small ivories and turned her body into a lion bait. For three days I waited in a blind but the lions never came to feed. In any case, the carcass proved not to be a burden to the vultures, hyenas, and jackals.

Long ago, there were many elephants on Lariak, hundreds of which had to be shot. With the advent of cattle and fencing, most of the herds moved away, and now visit only occasionally—a few safari bulls, migrating cows, and, very rarely, what is called in the films, a "rogue". As a single cow elephant can give birth to fifteen or sixteen young during her life, the herds grow at a considerable rate; when their migratory routes are cut off by farms and sometimes towns, the vegetation of a single area is no longer sufficient to nourish them. During his term as a control officer, Samaki Salmon had to shoot more than 4,000 elephants; and in Uganda, the warden Captain C.R.S. Pitman, with the help of natives, brought down 3,992 elephants with 20,328 rounds of ammunition in three years.

But if left on his own in a given area, the elephant would eventually destroy not only its own food supply, but also that of the other animals. Described from earliest times as "the beast that passeth all others in wit and mind", . . . "and by its

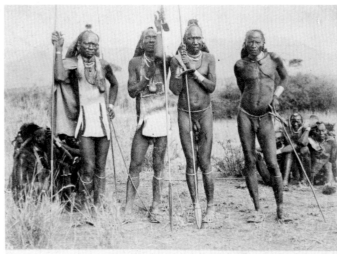

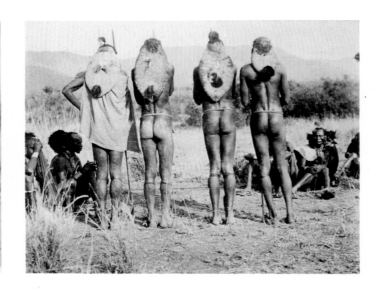

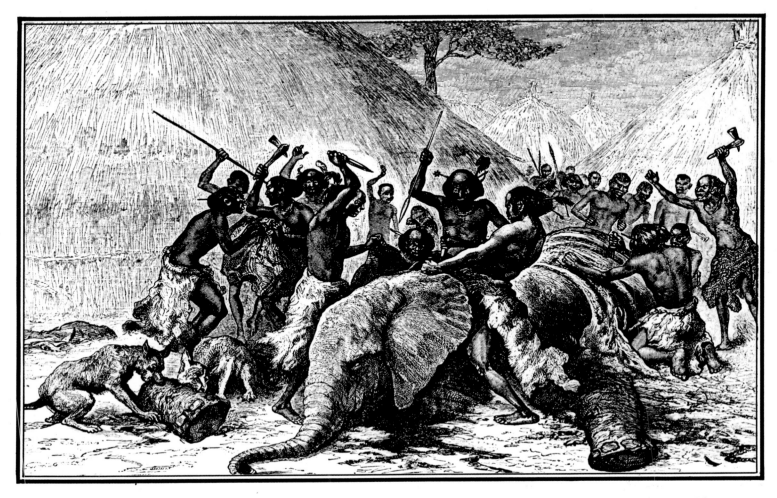

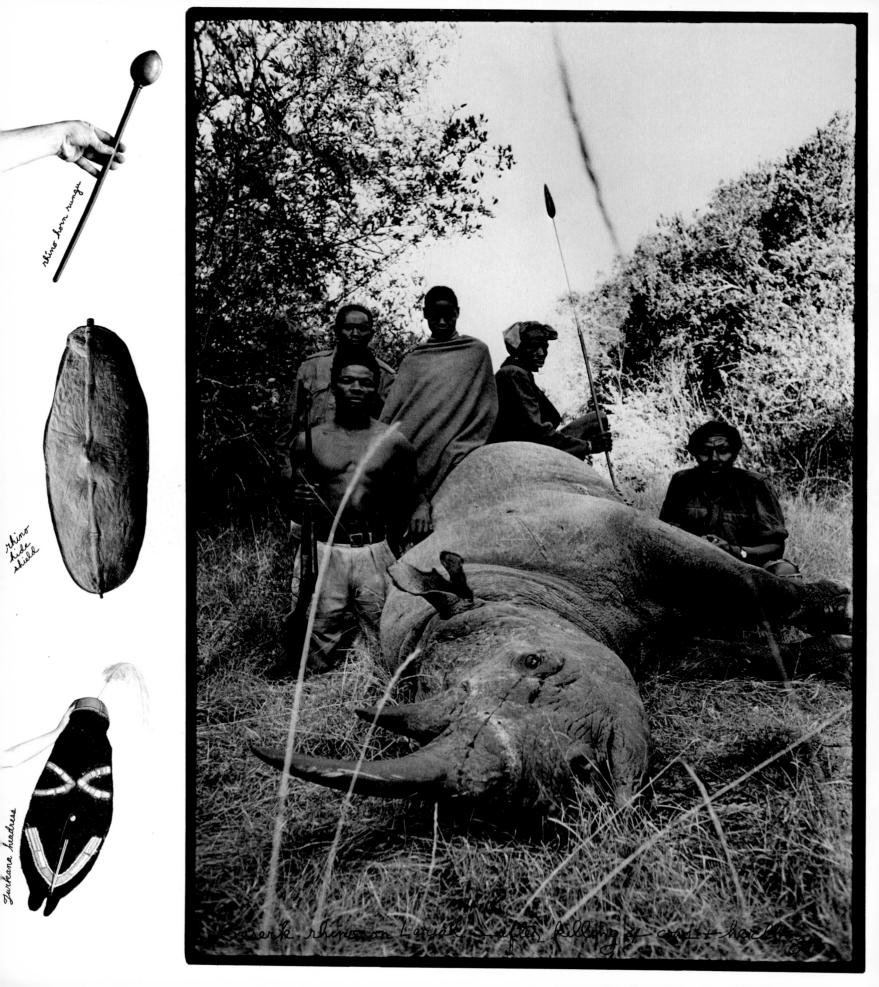

rhino horn rungu

rhino hide shield

Turkana headress

Berserk rhinoceros on Leroghi after killing 4 cows + heolling

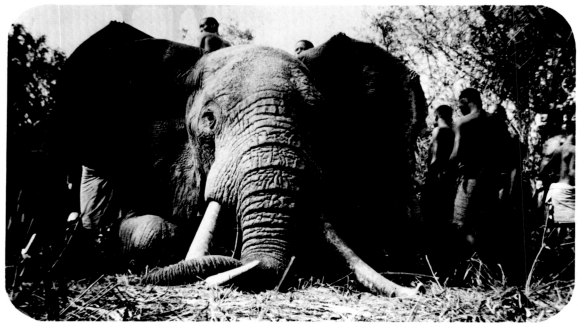

intelligence, it makes as near an approach to man as matter can approach spirit," the elephant has failed to direct its thoughts to family planning. As Frank Melland pointed out twenty years ago in his book on elephants: "If they are to have sanctuaries . . . that can bring them back to living at peace with man, they must be controlled."

The most persistent problem on Lariak was lions. During one ten-month period, 138 lions were killed on the estate.

One morning we were told that three cows (*ngombis*) had been killed by a family of lions that had recently moved into the area. The first *ngombi* we came upon had had its stomach eaten out. While the rest of us went ahead to inspect the other kills, neither of which had been eaten, two boys stayed behind to salvage the hide and as much meat as they could.

Lion spoor, unlike that of hoofed animals, is light, and it takes a keen eye to follow it, especially across hard, dry ground. Larsili, of course, could follow lion spoor across solid rock. After walking around the dead *ngombis* for only a few minutes, he was able to report that a lioness and three cubs had been there. Now it was left to him to find the male. We started after the freshest of the tracks, which led along a paddock fence for several hundred yards and then underneath it, and finally away in the direction of the hills. The lion family was probably ten or fifteen miles off. We got our oranges and guns; it was going to be a long equatorial day.

I followed Larsili closely, knowing that he was bound to be in the right place at the right time and hoping not to be shut out. At about three o'clock, with the sun blazing overhead, Bryan and I were

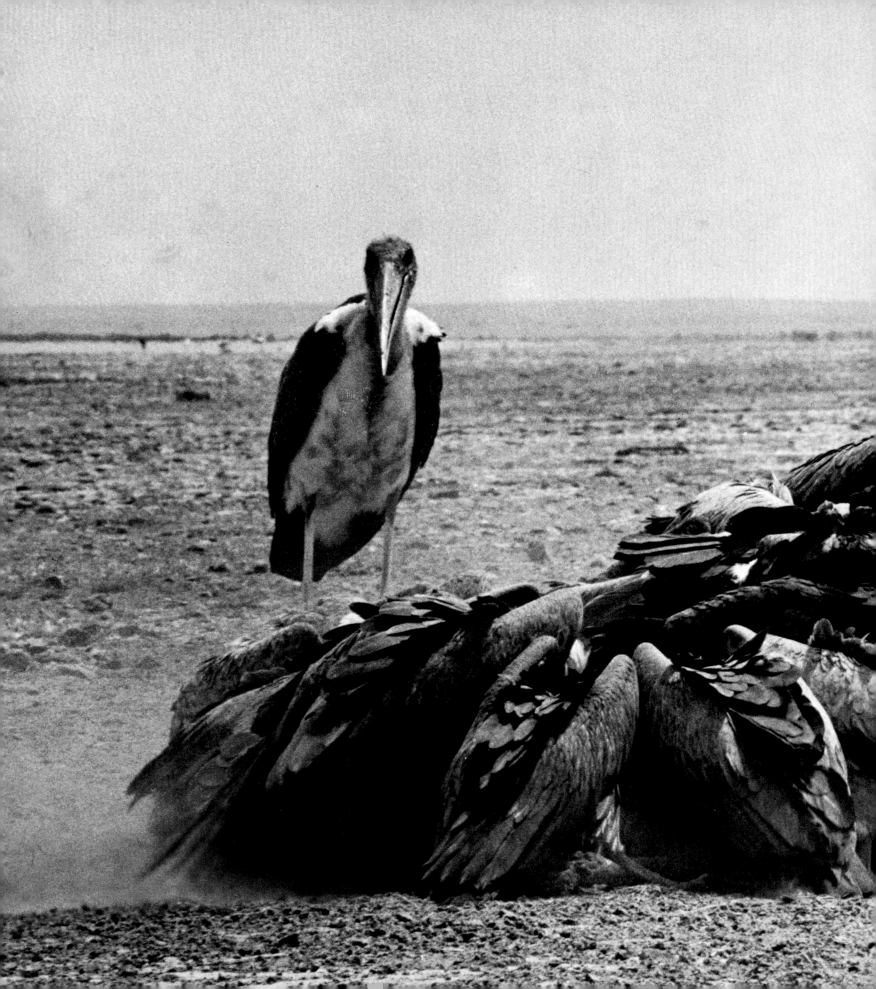

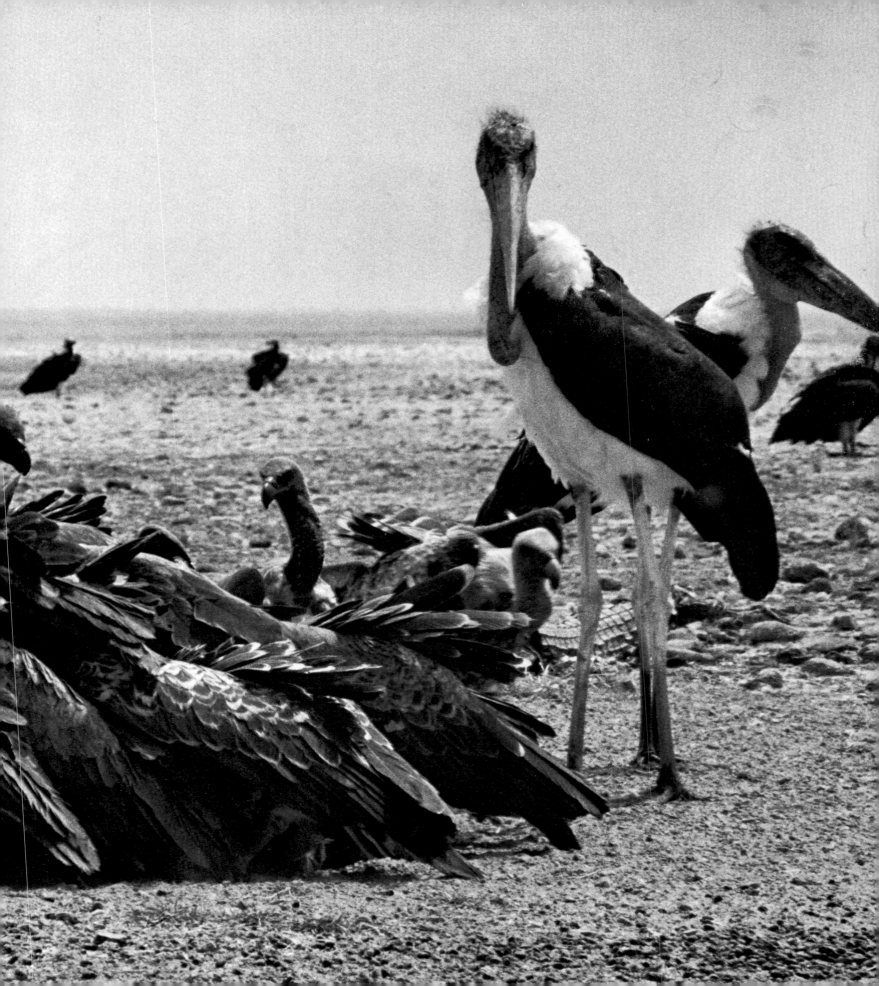

resting on a shelf of dusty rock by an oasis of brambles. Larsili was poking down below in the bush. There was the usual good-natured forgettable talk about how far we were going to go and who would win the extra oranges.

Then there was a great clap of thunder and a crash directly beneath us. Bryan was up with his .577. I pushed a round into the 9.3 mm. From all the thrashing and growling, it seemed as if everything was about to explode. The dogs began to maneuver into position, closing in all around. The skirmishing noises were punctuated from time to time by sharp coughs and the shrill yelp of a dog thrown through the air.

Tereri, to my right, was ready. His .303 went off as I turned to look for Bryan, who had disappeared to the left; it sounded like a miss to me. All the guns were being fired. A full-grown cub streaked past the rock where Bryan had been sitting, an entourage of dogs and natives in its wake. Halfway across the clearing, the cub was struck in the gut and knocked a few feet out of its way—and it never flinched.

Another lion, probably Tereri's, skidded into the ground on the right and then crawled back on its belly for cover. Larsili came up so quickly—as if from nowhere. He blasted the bush, then tore off in the opposite direction. I went over to the bush and found a large cub barely alive, splattered with blood around the head but crouched in a position to spring. It was almost full-grown but on its side retained the brown spots of a young lion. Its eyes were open, but the flies were already crisscrossing.

I watched Larsili track down and shoot the wounded mother. The dogs had the other cub at full bay. Bryan and Michaeli got it—a barrel apiece —Bryan with a heart shot, Michaeli putting a three-inch hole in her back.

The male was still at large. We would probably find it in a week or two, marauding another herd. Not bothering to wait for the Land Rover or for the skinners to finish up, Larsili was off, eleven miles across country to Sipili, his shotgun under his arm—confident about everything and nothing.

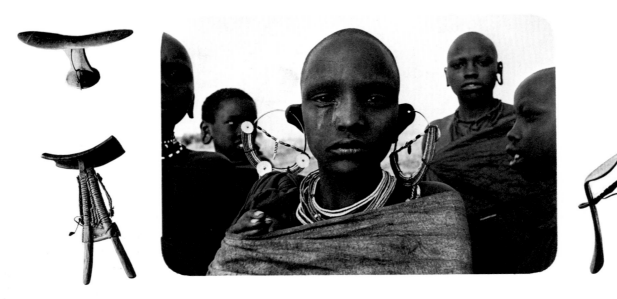

"But past who can recall, or done undo".
Paradise Lost

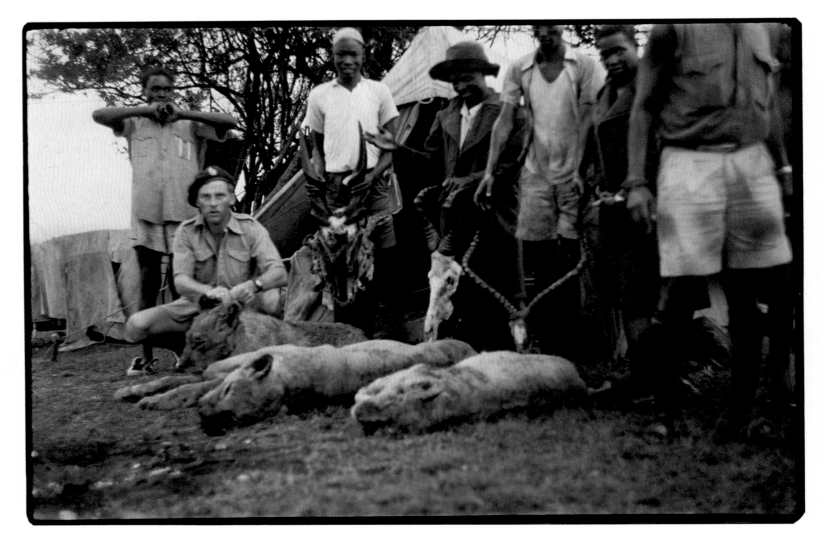

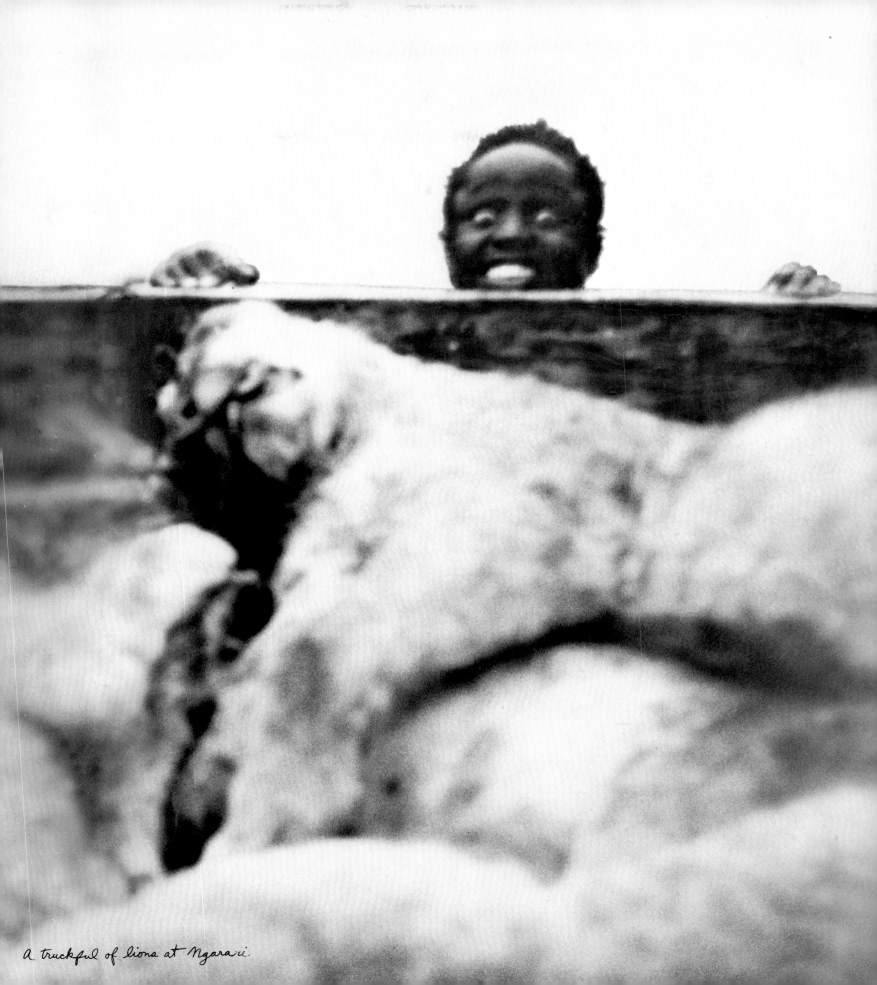

A truckful of lions at Ngara.

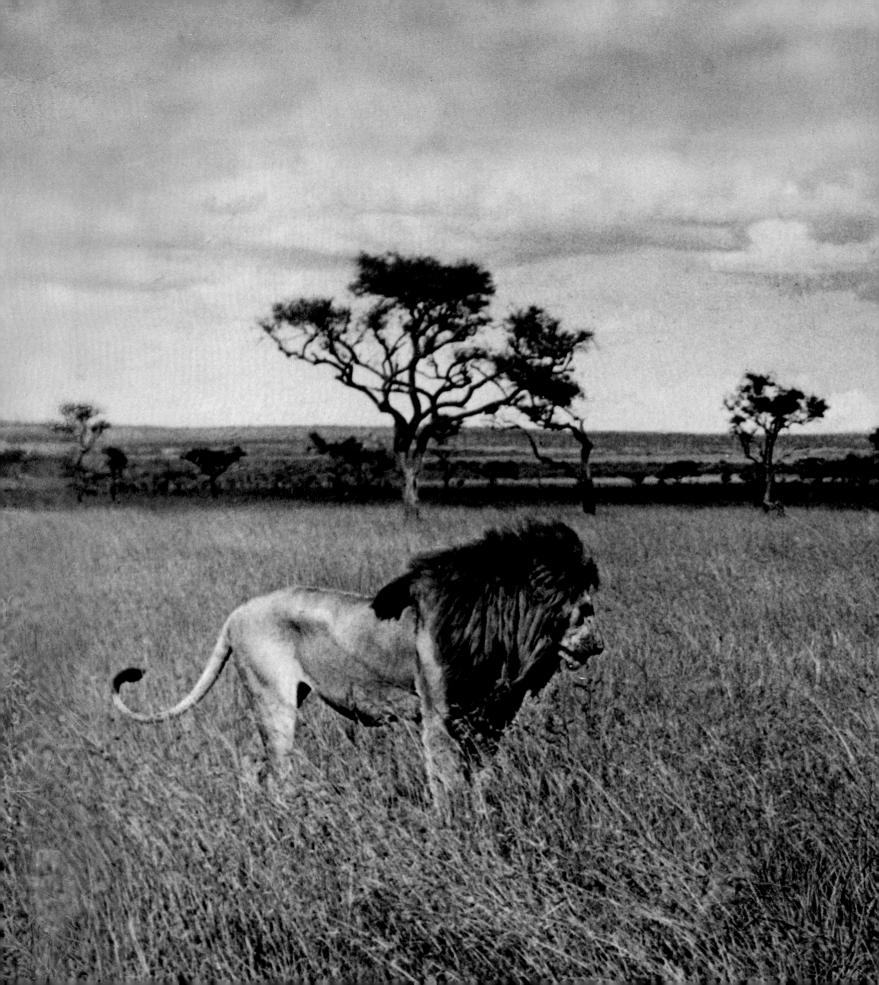

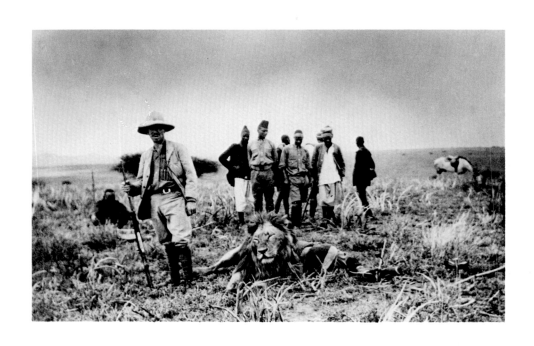

5

Beside the Carcass of a Beast

Philip H Pereira

Sept 1905 - Dec. 5 1961

"We have lived in the best time and seen the wonders of wildlife . . . and belong to a brotherhood the members of which have memories that cannot be matched . . . we have lived on into a new world which I do not pretend to understand."

Sir Alfred Pease

When a school friend and I were planning a Kenya foot safari in 1961, as both a private and published ending to *The End of the Game,* we hoped that it would be beyond the contrived and commercial, in the style of the turn-of-the-century foot safaris, taking neither the side of tearful conservationists nor that of privileged sportsmen. As Theodore Roosevelt wrote, in 1905, with full understanding of how such a trip could be the achievement of a compromise and yet still have its private meaning: "In order to preserve the wildlife of the wilderness at all, some middle ground must be found between brutal and senseless slaughter and the unhealthy sentimentalism which would just as surely defeat its own end by bringing about the eventual total extinction of the game. It is impossible to preserve the larger wild animals in regions thoroughly fit for agriculture; and it is perhaps too much to hope that the larger carnivores can be preserved for merely aesthetic reasons."

I was in Denmark with Karen Blixen, and from that springboard landed in Nairobi at the end of November. Kenya had just endured its heaviest rains in almost a century, and Nairobi, city of the sun, was a foot deep in water. One game warden had seen elephants, some dead and some alive, being washed down the Tana River; another had seen two elephants swept into the ocean from the Sabaki bridge on the Garsen-Malindi road. A pair of hippos, caught out at sea, had to swim over 200 miles to Zanzibar. Rhinos that during the two years of drought dug with their horns and feet in river beds for water, were now drowning. About a million Masai cattle had died during the drought, and half as many more during the rains everyone

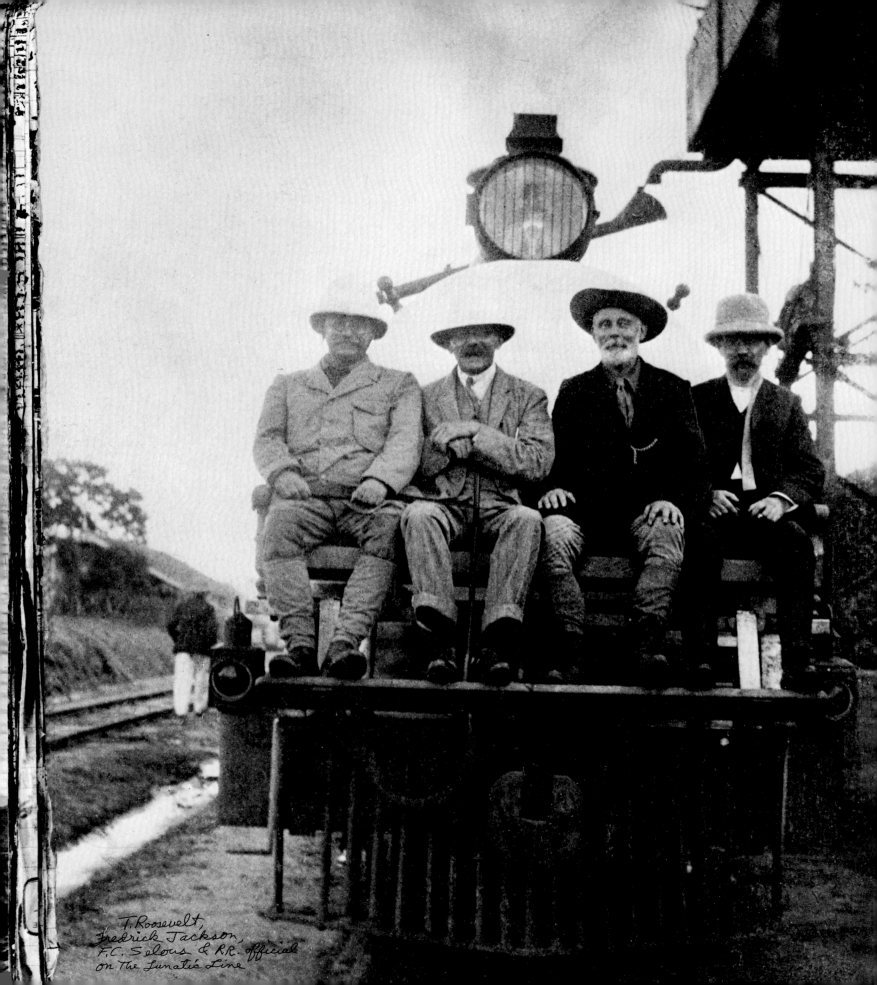

T. Roosevelt,
Fredrick Jackson,
F.C. Selous & R.R. Official
on The Lunatic Line

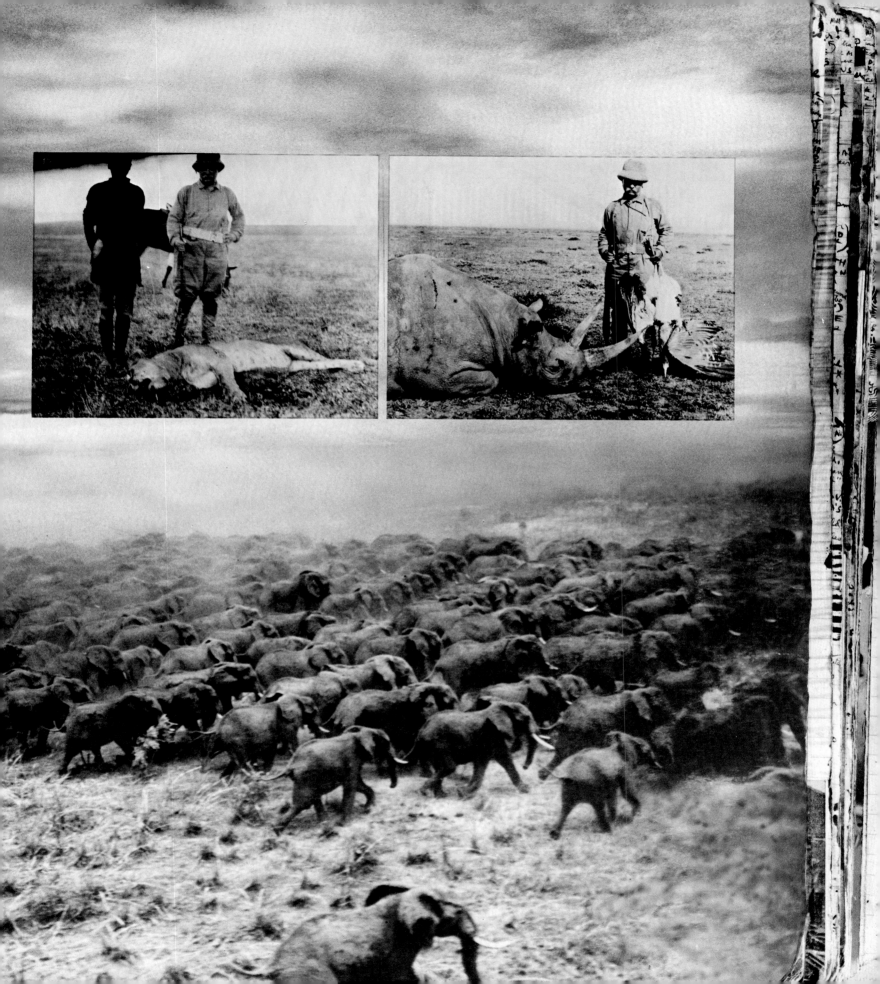

Selous pursuing elephant in Mashonaland, Sept. 1878

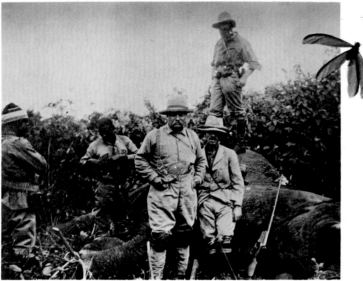

Roosevelt, Percival and R.J. Cunninghame

An elephant being washed down the Galana River

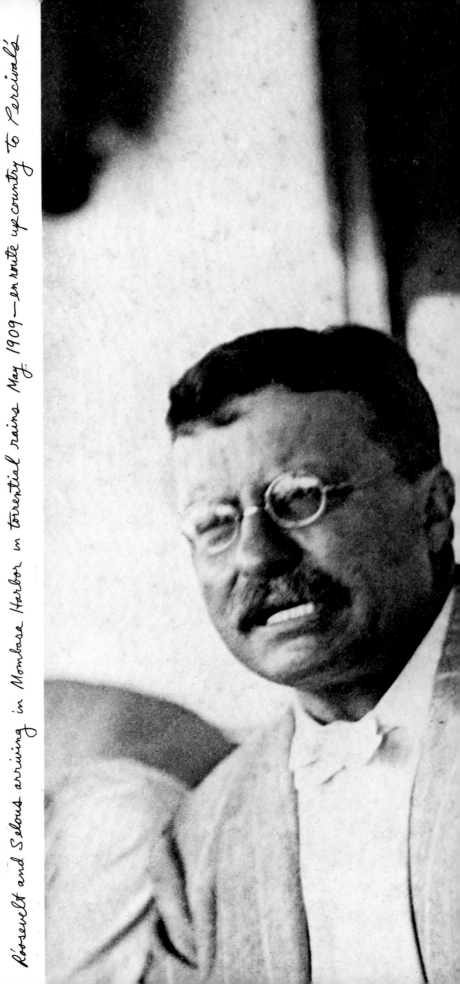

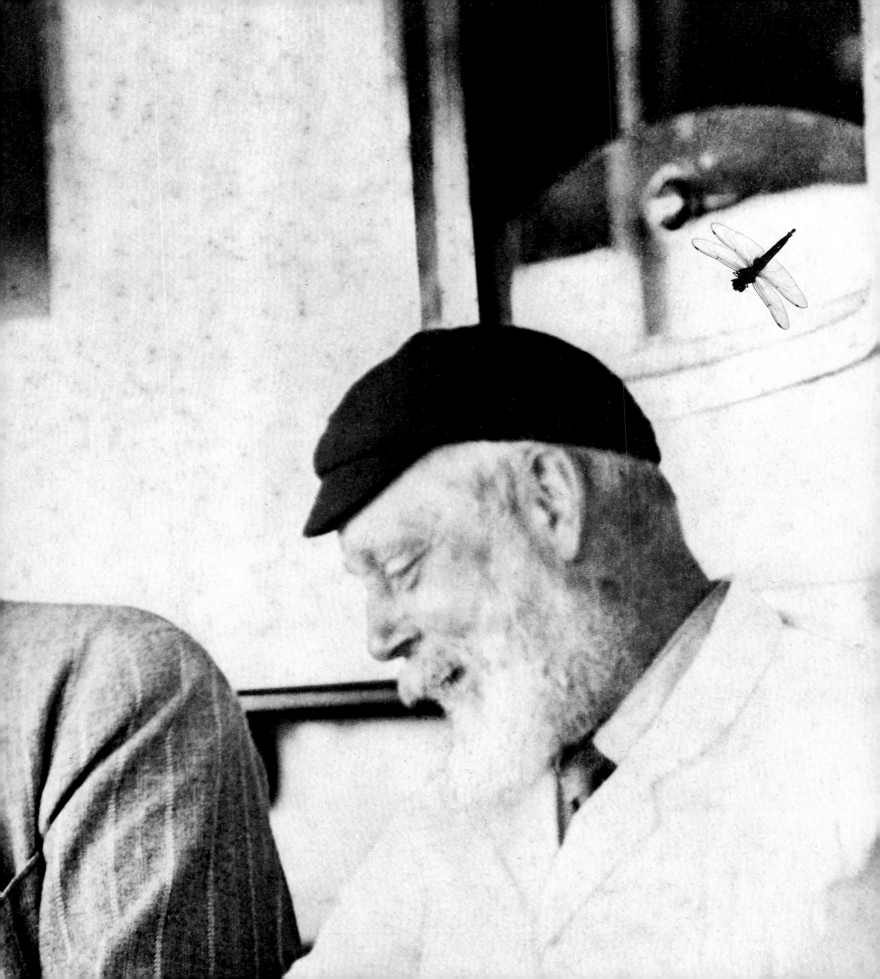

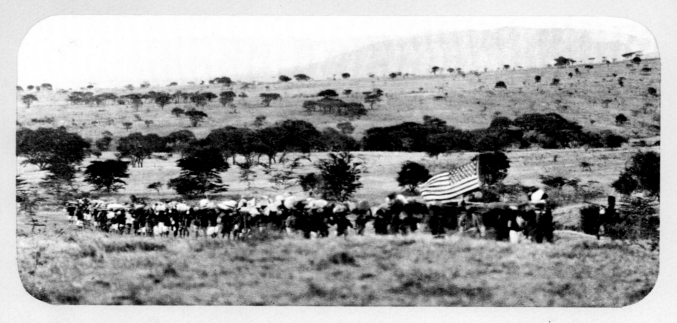

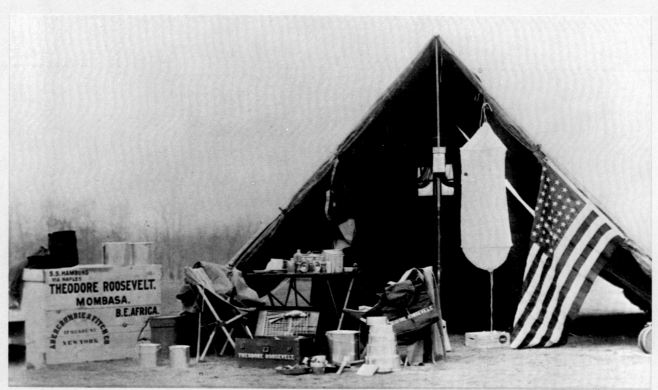

"Game laws should be drawn primarily in the interest of the whole people, keeping steadily in mind certain facts that ought to be self evident to everyone above the intellectual level of those well-meaning persons who apparently think that all shooting is wrong and that man could continue to exist if all wild animals were allowed to increase unchecked."

T. Roosevelt, 1910

had been praying for. Nor was the desolation confined to game and livestock. Twenty-four bridges on the way to Meru on the slopes of Mt. Kenya were knocked down; roads and railroads were washed out, remaining inoperative for months; and two trains on the Mombasa-Uganda line were derailed. Africa, warm-natured as she sometimes appeared, could be a tyrant.

Within 24 hours of arriving in Nairobi, my friend and I had been transported beyond Magadi Soda at the foot of the Nguruman Escarpment, in Masai country, to a grove of fig trees and acacias bordering the Uaso Nyiro River at the edge of a water-soaked plain. We had been installed, and everything arranged, by Harold Prowse, perhaps the only graduate of Harvard Business School to devote his professional life to hunting elephants.

Over the years Harold had assembled one of the surest hunting teams in the business. His four trackers and gunbearers, Ndende, Heekuta, Gala-Gala, and Kiribai were members of the Waliangulu (a Giriama word meaning "meat-eaters") tribe celebrated for its skill in firing carefully made poison arrows into elephants' spleens. Bror Blixen and Philip Percival can truly be said to have discovered this small tribe which Johann Krapf had overlooked when he walked through the Tsavo area with Giriama guides in 1849.

Ndende must have participated in the kills of a thousand elephants. Nothing about their spoor, rumblings, or shufflings was ever lost on him. Where another tracker would probably nudge an elephant dropping with a foot, Ndende would stoop and rub it between his delicate fingers, his head tilted quizzically to one side. He was also skilled in tracking down and spearing leopards through dense bush or over hard ground, and he could squat motionlessly for hours, and sometimes a whole day, in lion or leopard blinds.

In the Mau Mau Emergency, Bill Woodley, then warden of the Aberdares, had initiated the use of Waliangulus—at first, Heekuta and Gala-Gala—to pursue terrorist raiders. Armed with the bows and arrows they had fashioned themselves, they worked like bloodhounds, tracking gangs up to 30 miles from various murder scenes. Heekuta, who had worked for Woodley in the Tsavo anti-poaching

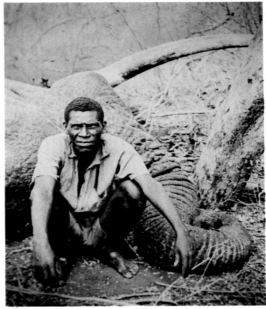

Simba, head gunbearer for Blixen and Percival

Heekuta son of Simba

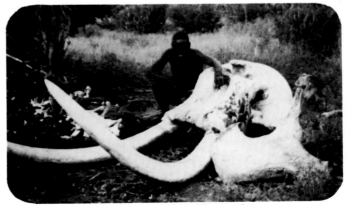

Kiribai and 121-122 pounder

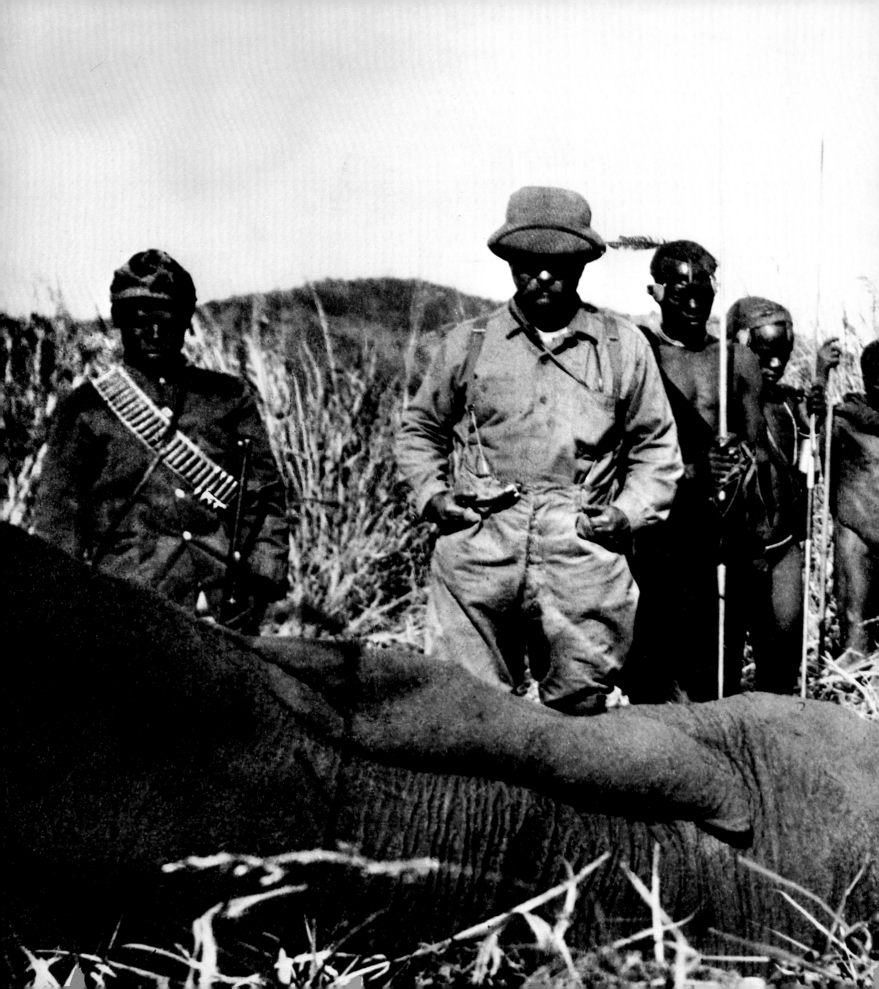

NEC TIMOR NEC TEMERITAS

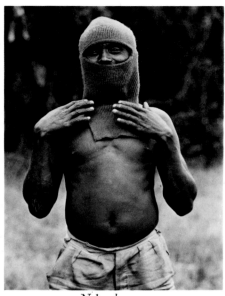

Ndende

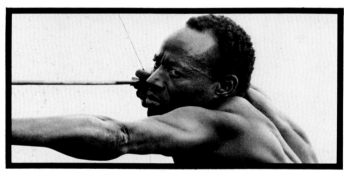

Elui, son of Nzenge

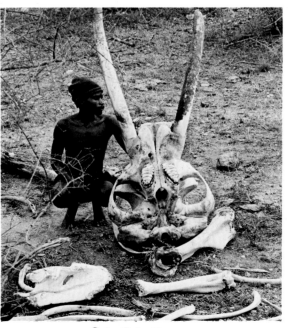

Galo-Galo Guyo

campaign of 1956-57, was often successful in posing as a poacher to get inside information. Better than anyone else he knew the perilous 2,500-square-miles of bush between Daka Dima Hill and the Galana River, where Woodley and his Voi force had come across 117 hideouts and 1,292 elephant carcasses in ten weeks, recovering 444 tusks (8,500 pounds of ivory). Heekuta's father, "Simba", had been Bror Blixen's head gunbearer, earning a reputation as the most cunning elephant tracker in the East African safari world. Heekuta too had hunted with Blixen.

Gala-Gala knew all the tricks of the bush: he could start a fire anywhere without matches, rain or shine, and once, when we ran out of water and had to dig so deep in a river bed that there was no way of getting to the water at the bottom, he improvised a four-foot straw from the thin bark of a few long sticks conjoined with a gummy substance.

Kiribai, from the same village as Gala-Gala (their families had been feuding for generations), was shy and quiet. He was the fighter of the group, although he had been shot in the ankle in Burma during World War II and walked crooked. He was related to the poacher Dabassa, son of Bajabi, who according to reports died of heart failure while drawing his bow on an elephant.

And so, under skies that had unloosed twenty inches of rain since October, our foot safari began on the Uaso Nyro in the area that Philip Percival had preferred to all others and whose attractions he discreetly kept to himself throughout the '30s.

Percival himself flew in and joined us from his old stomping grounds on the Athi Plains—for what would turn out to be his last safari.

At five each morning he would sit down by our campfire, take some tea from Kiete, his Makamba safari helper for 50 years who had taught Hemingway to box on that very campsite, and reminisce with the modesty appropriate to someone who had been elected to 34 consecutive terms as President of the Professional Hunter's Association.

He talked of his brother Blayney, at one time the lone game ranger of Kenya, and of his own days as military game warden of all Kenya, Tanganyika, and Uganda. Most vivid of all was his evocation of that effulgent day in 1909 when he

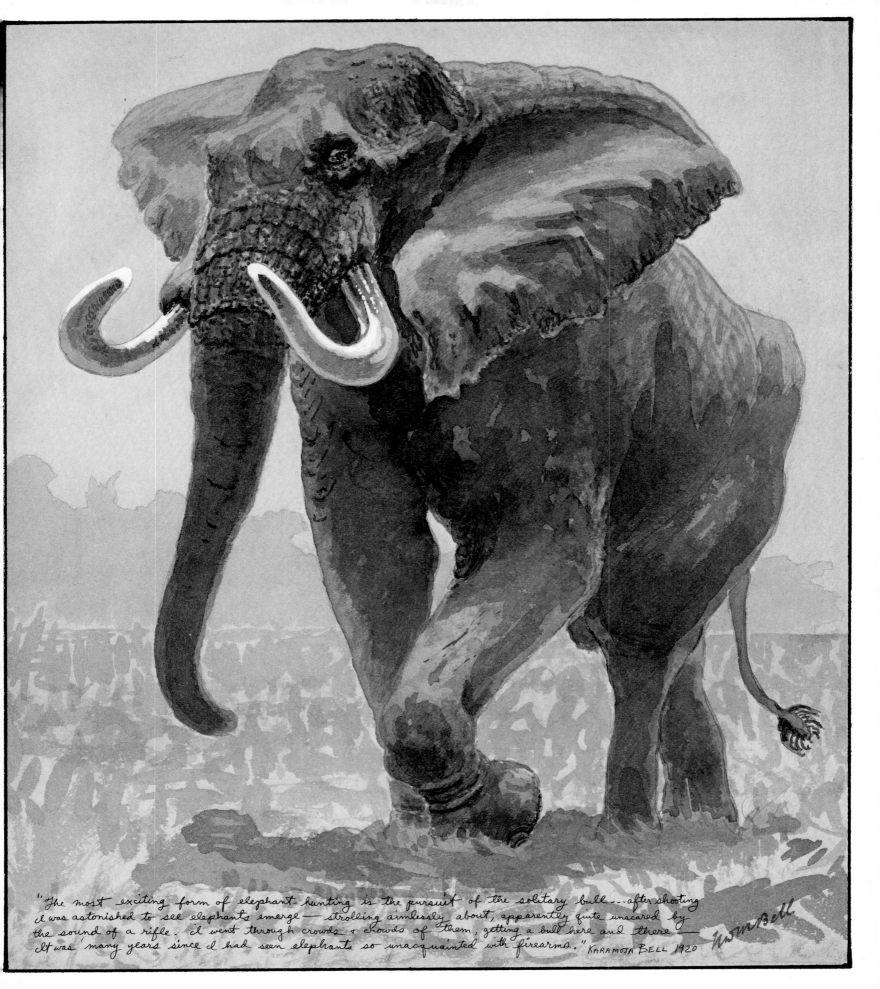

"The most exciting form of elephant-hunting is the pursuit of the solitary bull---after shooting I was astonished to see elephants emerge — strolling aimlessly about, apparently quite unscared by the sound of a rifle. I went through crowds & crowds of them, getting a bull here and there — It was many years since I had seen elephants so unacquainted with firearms." KARAMOJA BELL 1920

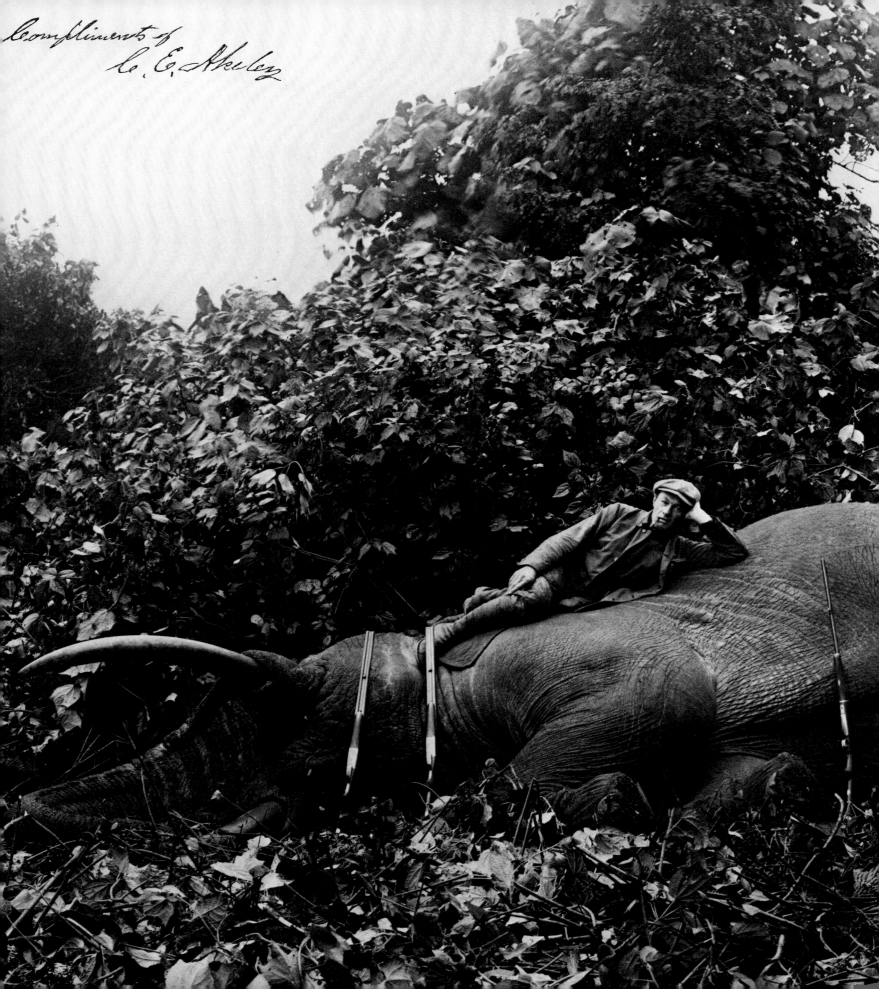

met Theodore Roosevelt with Frederick Courteney Selous, who with J. H. Patterson had arranged a safari for the ex-President. The year before, Roosevelt had had both Selous and Patterson to the White House, and Archibald Roosevelt, T.R.'s youngest surviving child, remembers being treated to incredible stories of early Africa by these experts. Dismembarking at Kilindini Harbor in Mombasa, Roosevelt took the same train that Patterson had taken in 1898 to his Tsavo destination. At Kapiti Plains station Roosevelt found, waiting to greet him, 265 native porters, horses, wagons, and 64 tents (eight for the Europeans, 50 for the porters, and six for the horses). The reporters who had followed him all the way from America were prevailed upon to push off for Nairobi so that he could hunt lions in peace for the next few weeks with Percival, the Hill cousins from South Africa, Tarlton, and Cunninghame.

Ackeley and his elephant for the Museum of Natural History

Sir Alfred Pease, a great friend of Percival's, and his partner in an ostrich farming venture, had also met Roosevelt in Washington the year before and had invited him to stay at his hunting lodge overlooking the Athi Plains, an area which he was in the process of pioneering along with Percival and the Hills. The only problem was that at the time he issued the invitation, he did not have a hunting lodge. But as soon as Roosevelt accepted, he began the construction of one in earnest, and it was completed in time to accommodate its distinguished guest.

209

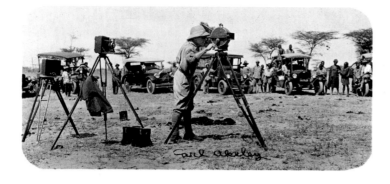

Carl Akeley

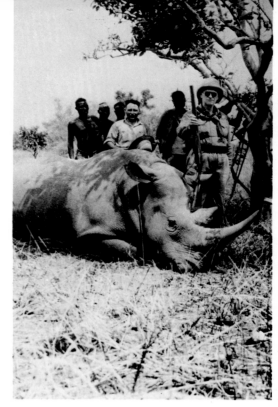

In November 1961, the lodge was still Percival's home, a storehouse overflowing with priceless memorabilia, including an engraving by Millais from the Duke of Orleans; one of the original Eastman Kodak cameras from the George Eastman-Carl Akeley safaris for the American Museum of Natural History in New York; innumerable photos taken by Akeley and Martin Johnson; the skin of a Kapiti man-eater; Sir Alfred's 1911 drawings and diary account of George Grey's fatal mauling on Wami hill, a few hundred yards from where Roosevelt shot his first lion; stacks of letters and books from Hemingway, who was a frequent house-guest; photos of the movie-maker Paul Rainey lassooing all the big game (with the exception of the indefatigable hartebeestes, which were forever to elude him); a photograph of Percival on safari with King George V; a set of horns from the rhino that killed the Hills' foreman; assorted spears, Nandi shields, trinkets, birds, and birds' nests; and probably the world's greatest collection of Turkana rat traps in private hands.

These were all potent reminders of a half-century in Africa that began for Philip Percival in September of 1905 when he came out to Nairobi from England to join his brother.

In his first days in the new colony Percival helped rescue two victims of a severe lion mauling, Lucas and Goldfinch. Bringing the two dying men to Nairobi Hospital on horseback, he heard lions grunting their wicked pleasure all along the way. Lucas had tried to pull the lion off Goldfinch, and most of his left hand and stomach were gone. He was one of the first six men—all of them victims of lions—to be buried in Nairobi Cemetery.

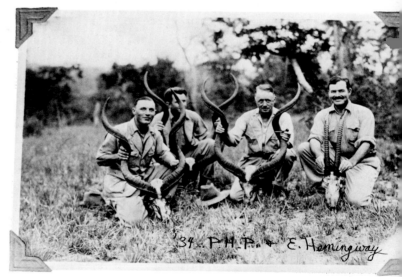

'34 P.H.P. & E. Hemingway

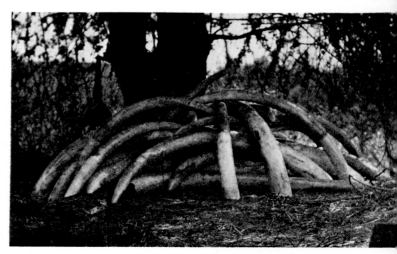

210

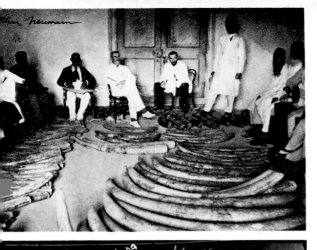

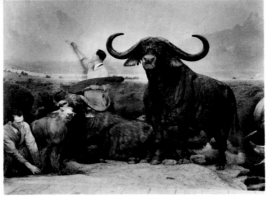

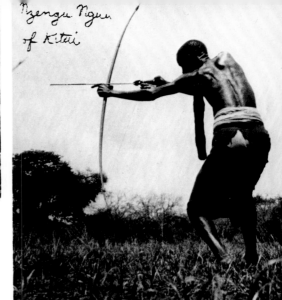

Njengu Ngiu
of Kitui

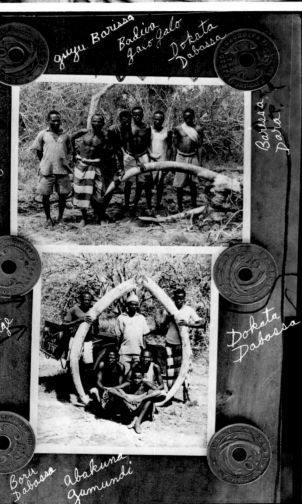

guyu Barissa Badiza
gato galo Dokata
Dabassa

Barissa
Dara

Dokata
Dabassa

Boru
Dabassa Abakuna
Gumundi

The Duchess of Connaught
.. P.H.P. in attendance

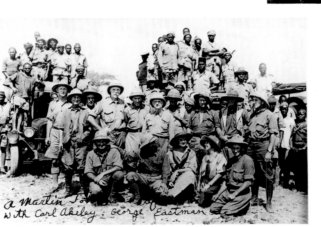

A Martin
with Carl Akeley : George Eastman

Condor Plant

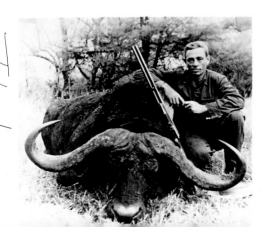

3/6/23

Sitembo Wareo

Game Warden
Mac Arthur

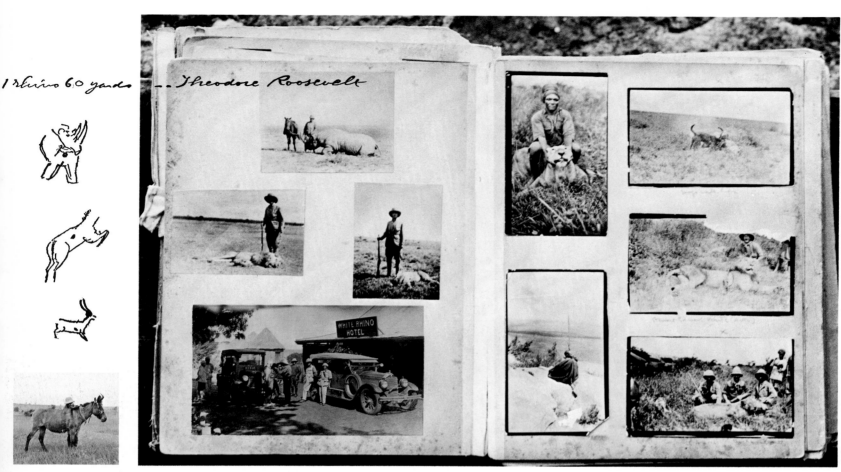

1 Rhino 60 yards

Maned lion; fatal shot on to change, 100 yds

The century was young: Mackinder had just conquered Mt. Kenya; Grogan had just completed his walk from the Cape to Cairo; Dr. Ribeiro, Nairobi's first doctor, was pitching his surgery tent on the site of the present Whitehouse Road Bakery and with packing cases was preparing to establish a consulting room in the bazaar area where he would make his famous diagnosis of the bubonic plague in 1902; and "Pop" Binks, having given up farming, was learning to become Nairobi's first photographer with the chemicals and equipment he had borrowed from Dr. Ribeiro.

In 1961 Philip Percival and I visited Binks, then Nairobi's oldest living permanent resident, in the same corrugated iron house that he had built in a single day with the help of a gang of Indian coolies from the railroad on "plot 28 Kilimani", an open plain adjoining the row of tents that was then the town of Nairobi (the window from which "Pop" used to shoot antelope for dinner now looked out on crowded suburbs along the Ngong Road). Shortly after our visit, on the opening day of the

first of many strikes in the history of the East African Standard, some Africans broke into his house and beat him nearly to death.

Like Percival, Binks deeply regretted the burgeoning hostility between blacks and whites. As for Grogan, he liked to think that in his human separateness he was "complemented by" the Africans and that "there existed a balanced harmony".

But in 1907 the situation was already extreme enough for a British under-secretary of state to report after an African tour: "One would scarcely believe it possible that a centre so new should be able to develop so many divergent and conflicting interests . . . The white man versus the black; the Indian versus both . . . the official class against the unofficial, the coast against the highlands . . . all these different points of view, naturally arising, honestly adopted, tenaciously held, and not yet reconciled into any harmonious general conception, confront the visitor in perplexing disarray."

The visitor was Winston Churchill, and the 70 years that have passed since his tour have only

served to aggravate the symptoms he detected when he wrote: "There are already in miniature all the elements of keen political and racial discord, all the materials for hot and acrimonious debate."

The continent was already in the hands of its destroyers: the railroad had reached the interior, towns were springing up along its tracks, and Europe was marching in. When Sir Alfred Pease inscribed his book *Lion* to his friend the hunter-writer Denis Lyell, he was inscribing it to a witness who, like himself, had known Africa young and who would soon enough be gone: "We have lived," he wrote, "in the best time and seen the wonders of wild life . . . and belong to a brotherhood the members of which have memories that cannot be matched . . . we have lived on into a new world which I do not pretend to understand."

Philip Percival remembered those matchless days as he looked into our campfire and for a moment again the past was no longer consumed and he was as Roosevelt had written of him in *African Game Trails,*

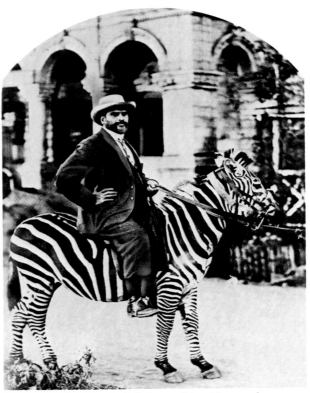

Dr. Rosendo Ribeiro making his rounds

> a tall sinewy man, as he walked beside his 12-ox team, cracking his long whip, while in the big wagon sat pretty Mrs. Percival with a puppy and a little cheetah cub which we had presented to her. . . .
>
> Percival had with him a little mongrel dog and a Masai boy, a fine bold-looking savage with a handsome head-dress and the usual formidable spear; master, man and dog, evidently all looked upon any form of encounter with lions simply in the form of a spree.

Roosevelt had served to situate Percival in history, in passages such as these:

> He was riding through a wet spot where the grass was four feet high, when his horse suddenly burst into a run and the next moment a lion had galloped almost alongside of him. Probably the lion thought it was a zebra, for when Percival, leaning over, yelled in his face, the lion stopped short But he at once came on again, and nearly caught the horse. However, they were now out of the tall grass and the lion gradually drew up.

As the flames collapsed another log, Percival took me rushing through his memories of T.R.

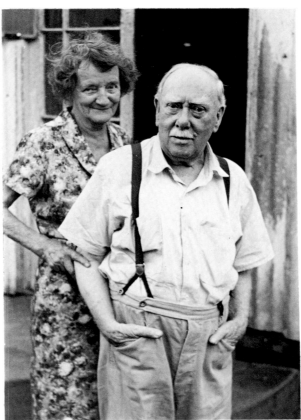

Mr. and Mrs. "Pop" Binks

PERILS OF THE AFRICAN JUNGLE.

P.H.P. 1910

Lucy · Harold Hill · Joyce + P.H.P

Harold Hill 1962

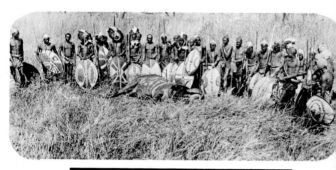

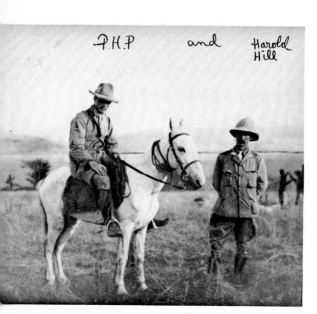

P.H.P and Harold Hill

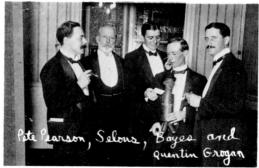

Pete Pearson, Selous, Boyes and Quentin Grogan

Denys Finch-Hatton's camera 1920's

Blayney Percival

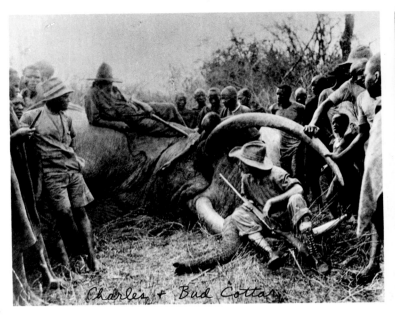

Charles + Bud Cottar.

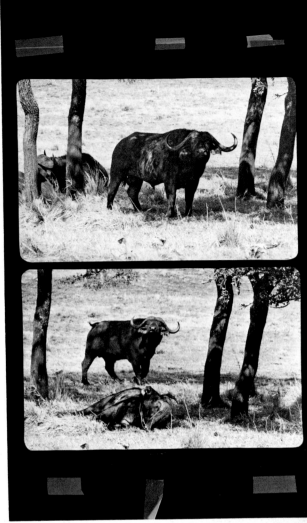

rival of Ex-Pre-
ident Roosevelt.

nding in Tropical Rain.

nner at the Club.

Selous on Peace.

A "RED SEA" NEWS-PAPER.

Distinguished Visitor speak-
ing three Languages Finds Difficulty with Portuguese.

half past three on Wednesday afternoon
O. O. A. L, S.S. "Admiral" under the
mand of the popular commodore, Captain
err, was sighted from the Mombasa
al station. The ship, dressed from bow
ern with multi-coloured flags in honour
our distinguished visitor—Ex-President
evelt—dropped anchor at 5 in the
ing.

he first to go on board after the Port
tor was Mr. Campbell, Aide-de-Camp, to
E. The Acting Governor, Mr. F. J.
son, C.B., C.M.G., bearing despatches
ing Mr. Roosevelt and his son Kermit
be His Excellency's guests at Govern-
t House. Following the A.D.C. was
Cunninghame, F.Z.S., who is in charge of
great expedition which Mr. Roosevelt,
now commencing, accompanied by
or Dr. Mearns and Professors Loring
Heller of the Smithsonian Institute.
large crowd of people collected at the
ndini Landing stage hoping to catch a
pse of the visitors but at 6 p.m. a down-
r of rain, such as is only known in
pical countries, fell and continued all
t being particularly violent during the
ment of Mr. Roosevelt's landing and
le he was entering the train drawn up
he Pier ready to proceed to Mombasa.
y few people realized that a landing had
n effected before the train had steamed
ay. The remainder of the Party stayed
board the "Admiral" for the night.
When Mombasa Station was reached
vincial Commissioner Hinde conveyed
Roosevelt to Government House. Mr.
osevelt although dressed in strong khaki
wearing a mackintosh was drenched to
skin. At 8 p.m. the Mombasa Club,
ed for the generosity of its members,
ertained the Ex-President, among other
sts being Dr. Seaman, F.R.C.S. and Mr.
C. Selous, Captain Doherr, Representatives
the American Press and the Captain and
eral officers of H. M. S. "Pandora."
His Excellency the Acting Governor, F. J.
ckson, Esq., C.B., C.M.G., presided and
ongst other hosts present were the
on'bles C. Sandiford, C.B., M.L.C., G. K
atts, M.L.C., J. H. Wilson, M.L.C., His
onour Judge Bonham Carter, and the
ench, German, Italian, Austrian and
lgium Consuls, His Lordship the Bishop
Mombasa was unavoidably absent through
ness.
The night was one of the wettest expe-
enced in Mombasa and many who attended
re put to considerable personal inconve-
ence, but so keen was the desire to welcome
e ex-President and to do honour to so
stinguished a Guest that not a single chair
s vacant.

The Governor's Speech.

After the health of His Majesty "The
ng" had been drunk, the Acting Governor,

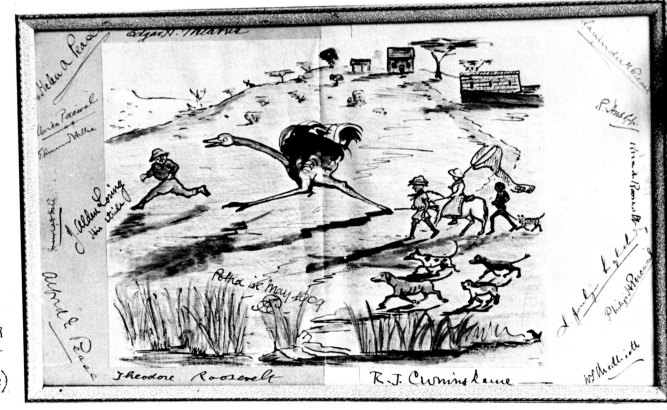

fred Pease's sketch of the
oselt safari on his ostrich
arming estate — Signed by
l members of the expedition
or the N.Y. Museum of Natl. History)

Theodore Roosevelt

R.J. Cunninghame

Potha ist May 1909

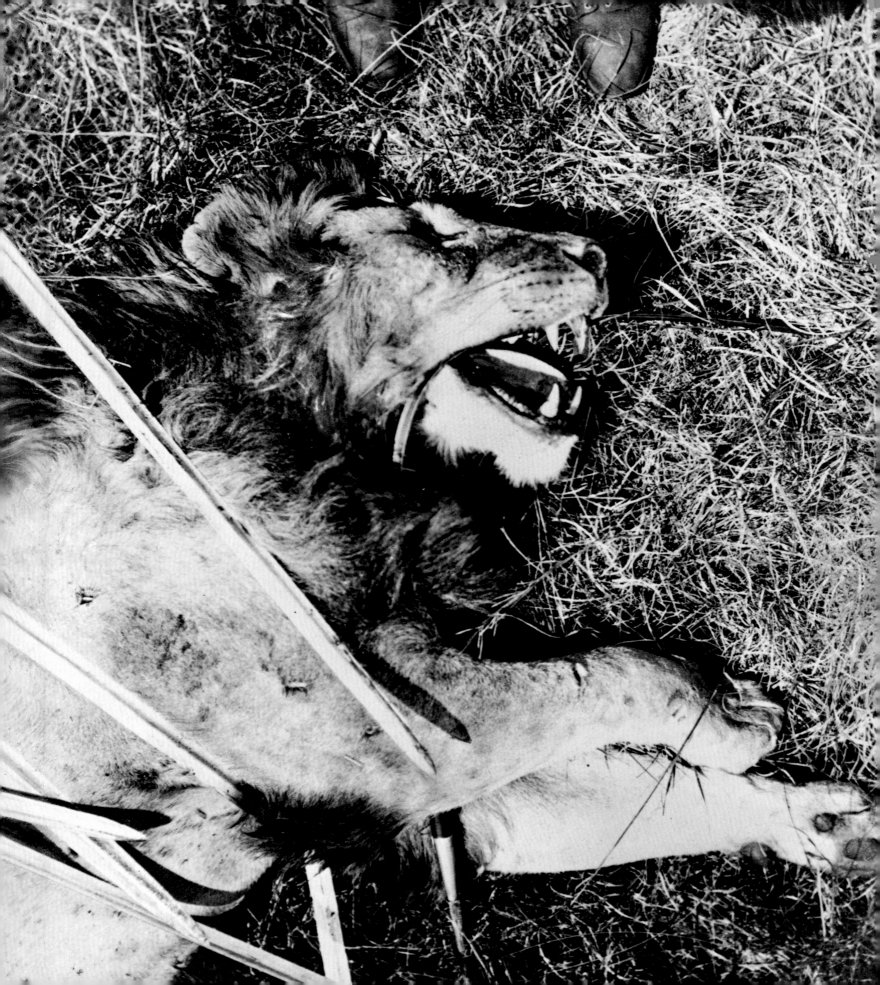

Mombasa RR. maneater shot at Kimaa after eating passenger (Ryell) in upper berth of car 101

When he described Roosevelt's good-luck piece, a gold-mounted rabbit's foot given him by John L. Sullivan, I could actually see him ransacking his mind for the moment he had first seen it, 52 years before.

"The President had a temper," Percival recalled. "I remember once when his son Kermit came back late after dark. . . ." He told us about T.R.'s "pigskin library", the books he had carried by a porter in an aluminum oilcloth case—*Faust, The Origin Of Species, The Odyssey, Huckleberry Finn, Paradise Lost,* and others, from which he would select one for his midday rests under an acacia or on the open plain—in his own phrase, "beside the carcass of a beast".

"He was amazed at the toughness of the land," Percival told us. "Amazed also that anything could survive in it." He was as repelled by the blood-sucking ticks and other parasites that infested the wild game as he was exhilarated by the vast herds of plains game stampeding through the streets of Nairobi under fire of its inhabitants. (He wrote of seeing a zebra shot dead just outside the Episcopal Church.) At the time of his safari, large bands of hyenas were feeding off sleeping-sickness victims in government isolation camps, and he saw one of Sir Alfred's workmen with half his face torn off. There was no moment in Roosevelt's safari when he was not dramatically aware of all that the continent was capable of: lions, buffalos, elephants and rhinos had just taken the lives of over 50 men.

Only a few months after Roosevelt had left for home, Percival, the Hills, and Sir Alfred stood by helplessly as one of their friends was fatally mauled a few hundred yards from where Roosevelt had shot his first lion on Wami. According to Sir Alfred's diary entry for January 29, 1911:

Before relating what happened in the afternoon of the fatal day, I may explain that it was our practice when we had a novice or someone new to "the game" as we played it, to take care that in every dangerous situation our guests, whether they were aware of it or not, had an experienced and deadly shot standing by.

For this purpose no more reliable men could be found than the Hill cousins and our sole object this day was to see that George Grey killed a lion . . . and that Howard Pease [Sir Alfred's son] should get his first shot at one.

Pease and Clifford Hill separated from the rest of the party and eventually found two large maned lions in the direction of Potha, where Percival was about to build his first house with imported wood. They were driving the lions toward Wami hill when the rest of the party appeared on the horizon and complicated matters by interfering too soon:

The newcomers were spoiling our game, for the lions now turned straight up Wami. I yelled and waved but only one of the party paid attention to my frantic efforts. Another, to my horror, I saw was gaining rapidly on the rear lion. Still I never dreamed that he was going to ride it down. . . . Hill yelled, "Shoot! . . . Shoot! . . . Shoot him!" I was off my horse and shouted "Too far—300 yards." Hill yelled "No—200!" and fired. I saw his bullet strike up dust ten feet short of the rear lion which had whipped around and started his charge. The charge started before I got my rifle to my shoulder . . . then it was over. I saw every detail. As the lion charged, Grey leapt from his pony and received the charge in perfect style; fired on the instant at 25 yards; again at 5 yards, as quick as is possible with a magazine-rifle in the hand of an expert.

These 3 or 4 seconds were ones of agonizing suspense. "Is the lion going to drop?" . . . Ping! . . . The lion flying straight on . . . Ping! again; and Grey hurled to the ground, shaken like a rat by a terrier, and I was galloping, as hard as I could to the scene. Only a few hundred yards seemed like a mile. I was conscious that my son was doing the same and by the time he and I were on our feet by the lion, Hill was there too.

As we arrived, the lion stopped worrying Grey for a second and glared at us. Grey was underneath. The other lion crouched in the grass close to, grunting and lashing his tail.

219

Col. George Grey from a photograph taken shortly before his death.

George Grey's mauling as depicted by Alfred Pease

The first lion then got hold of Grey and he could only fire into the lion's body, and even that was risky. We all fired. Hill's .450-bullet in the lungs practically knocked the lion out, and allowed me to put the muzzle of my rifle to his head and finish him. Hill then shouted that his rifle had jammed and urged me to shoot the other lion. I reckoned if I did not kill him dead he would get my son who was nearest, and, thinking Grey was dead, I could not depend on myself to do it with a quick .256 shot. Then out of the corner of my eye I saw the big lion get up and start walking away. We pulled the first lion off Grey, and I knelt down beside him, thinking he was dead.

Grey opened his eyes and spoke very quietly to me. "I am very badly hurt . . . I want to tell you, and you must remember I say it, that I alone am to blame for what has happened." In the same quiet way he told us how we were to move him and how to set about dressing his wounds. I had a water-bottle, and gave him a drink. His face and lips were torn down and one ear nearly off. Hill put half of my bottle of crystals of permanganate into the water-bottle, and we cut off his shirt and clothes from his mangled arms and body. In a few moments, we had washed over his face, head, arms, thighs, and body with the solution. His elbow-points were bitten right through, his hands torn to pieces, and without a syringe all we could do was to put the crystals into the deep punctures and wounds as far as we dared. Later he asked what we had done about the lion. "Have you skinned him?" "No." "Then you must skin him and take great care of the skin."

Harold Hill galloped ahead to wire to Nairobi for a special train. It arrived, with several doctors on board, as darkness closed in. An emergency operation was performed on more than 60 of Grey's wounds in the station waiting room. By two a.m. he was in Nairobi hospital, which he was never to leave. Sir Alfred later wrote:

During the five days in the hospital, he had all the care and skills the doctors and nurses

could give. In those few days his cheerfulness and courage, and that something else about him which cannot be defined, won more than mere admiration from those about him. He passed away quietly on the evening of February 3, 1911. Had he lived, he would have been a cripple, and even if both his arms had been saved, one would have been useless, and he would have been minus fingers on both hands.

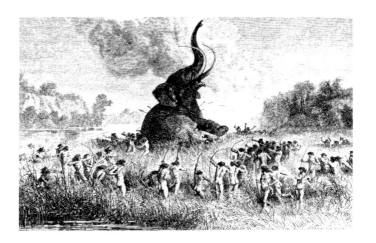

Percival himself was never injured by any of the game he pursued, but many of his friends were not so fortunate. Selous was horned, trod and knelt on by assorted elephants and buffalo. Jim Sutherland, who spent sixteen years relentlessly pursuing elephants and who was considered the elephant hunter's hunter, was once thrown clear into a tree by a large tusker. (He survived, only to die lingeringly of native poisons years later.)

Arthur Neumann, a daring and eccentric ivory hunter who chose the antiquated army .303 for his work, was pinned to the ground by the tusks of a cow elephant near Lake Rudolf. After four months on his back and a diet of milk brought to him by local Samburus, he resumed his hunting. The natives of northern Kenya looked upon him as a kind of god. "Even today," Percival told us, "there are Samburu awaiting the return of 'Nyama Yangu,'" the name they gave him commemorating his skill at marking elephants.

Arthur Neumann

Despite Neumann's reputation, government officials restricted his movements and toward the end of his career he wrote in a sad and desperate letter: "The prospect of giving up the life I love makes me sad. I know well the misery of feeling like a fish out of water with neither part nor lot in anything at home." Shortly after his return to England, he died.

John Boyes, Quentin Grogan, Pete Pearson, Robert Foran, "Deaf" Banks, James McQueen, Mickey Norton, William Buckley, the Craven and Brittlebank brothers, C. H. Stigand, Pickering, and others all hunted, poached, and wandered freely until forced to adapt to the new ways of "controlled" hunting. Professional safaris came into being with early lion hunts at the Hill cousins',

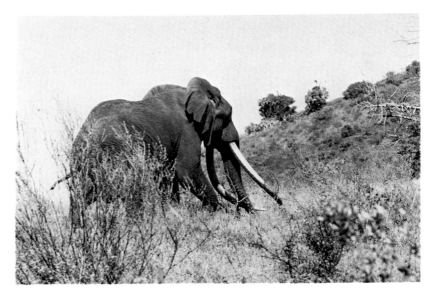

with Percival and Sir Alfred, then with Cunninghame, Alan Black, and A. C. Hoey. Large-scale ivory poaching was over—in Kenya, Uganda, and, after the death of King Leopold of Belgium in 1910, in the Lado Enclave. The era of Adventure Unlimited was coming to an end even as Roosevelt was taking his 1909 safari. In the Lado he must have sensed it ending as he toasted Boyes and Buckley and Banks and the other "gentlemen adventurers of Central Africa" at a party in his honor, at which the last of the heroes he knew from his books were present.

And yet, the damage inflicted on game by the early hunters was comparatively light, as Percival emphasized. What harm they did lay in their hav-

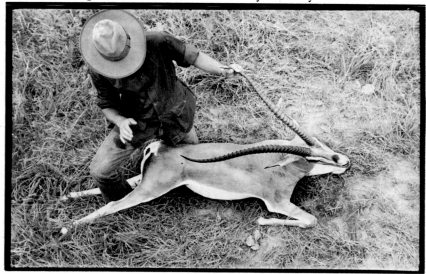

ing showed the natives and Asian middlemen how to kill for profit on a large scale. Larsili, for instance, whenever he needed the meat, thought nothing of hamstringing a wounded eland and leaving it to shift about in agony for days, and during the dry season in Uganda, natives burned elephants in grass fires and shot poisoned arrows into their trunks so that they would bash themselves against rocks and trees and bleed slowly to death trying to get the arrows out. And then there were the Arab muzzle-loaders, which wounded more animals than all the other techniques combined. But if the white hunters and poachers of the early days cannot be held responsible for the end of the game, neither can they be totally absolved, for it was certainly with them that modern poaching entered into the bloodstream of African life.

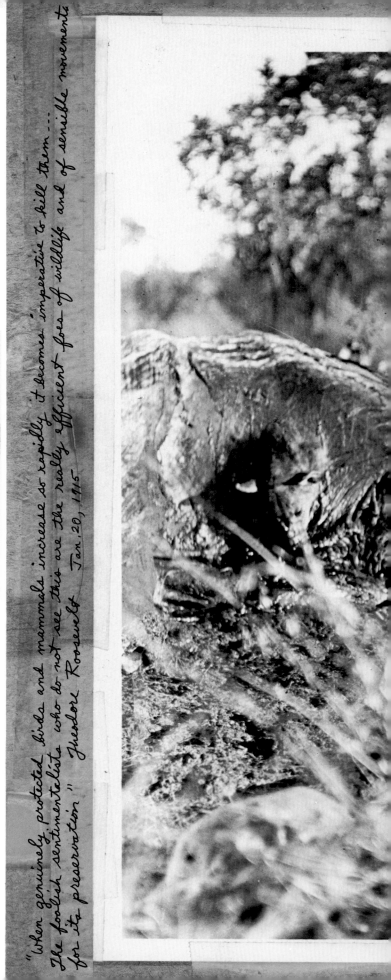

"When genuinely protected birds and mammals increase so rapidly it becomes imperative to kill them... The foolish sentimentalists who do not see this are the really efficient foes of wildlife and of sensible movements for its preservation." Theodore Roosevelt Jan. 20, 1915

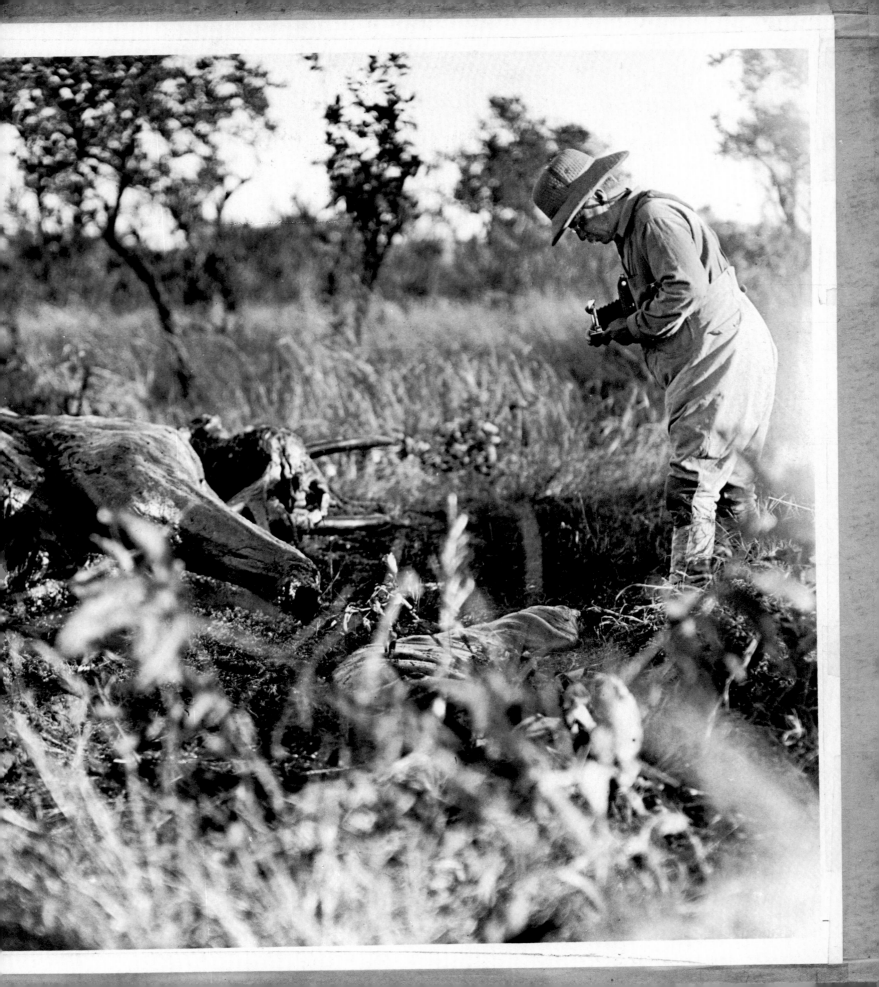

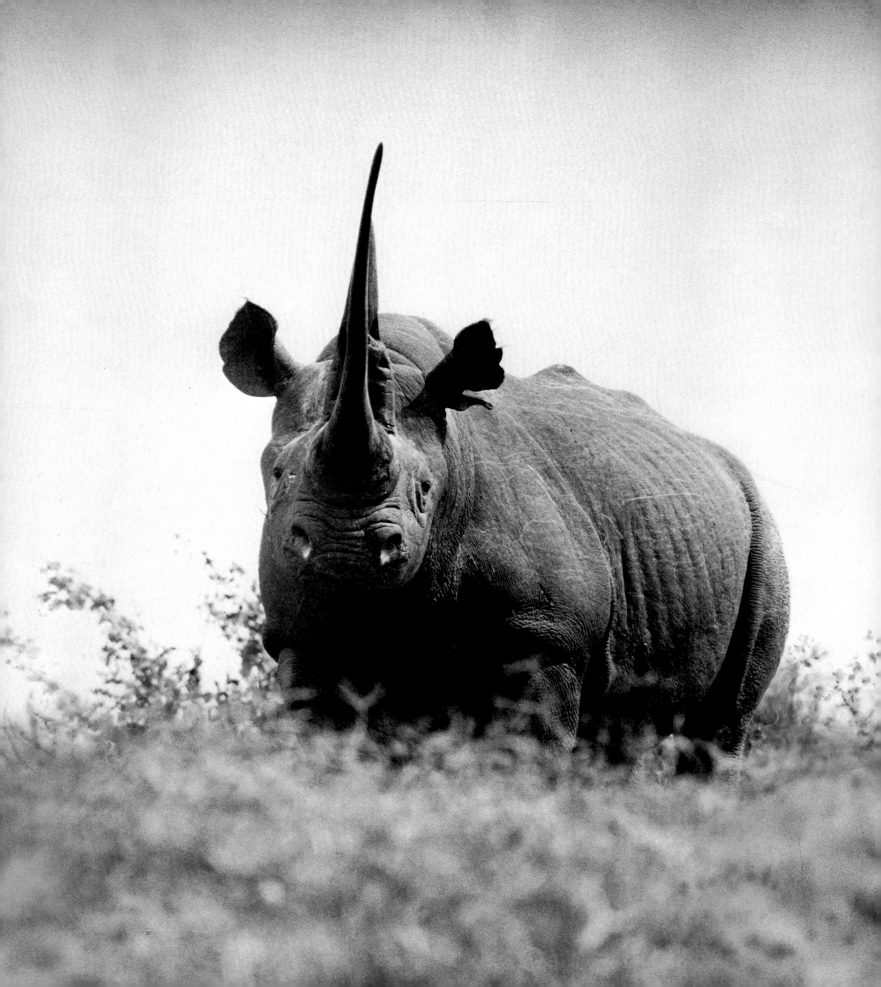

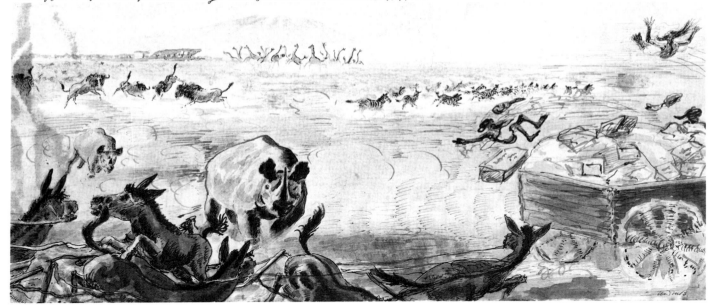

On the morning of the day Percival was scheduled to fly out of our base camp, my friend brought in the first of his trophies: a very old Grant's gazelle buck. Straight-backed, inscrutable, with a sense of his youth, Percival examined this latest example of Kenya's capital and pronounced it the finest gazelle he had ever seen.

"It shows you what you can come up with, if you take the trouble to get out of your car," he said, estimating the length of horn at 30 inches—which would have tied the existing world's record. Without knowing it, he had just given us the private ending to *The End of the Game.*

After an orgy of measuring and photographing, we decided that we would leave history to the historians, that only the living present was real to us. I could tell from the look on his face that Percival

agreed—Percival, who had made history sound as we had never heard it. The next morning we continued our foot safari up onto the Nguruman Escarpment, with the feeling that we were on more familiar terms with the old tyrant, Africa.

When a few months later it came time to think about a published ending for the book, I wrote to Percival in the hope that, just as he had given us an inside look backward, he could give us a look ahead. What could be more fitting than to give the book this extra sense of proportion?

In his replies he struggled to pinpoint the time when he first sensed the end was coming. His friend Alan Black, one of the great hunters of the Athi Plains, had "packed it in" when cars were introduced into East Africa; the cars and the roads that proliferated to accommodate them violated the

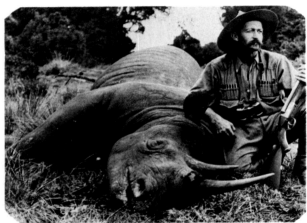

William Judd, later killed by an elephant near Makindu

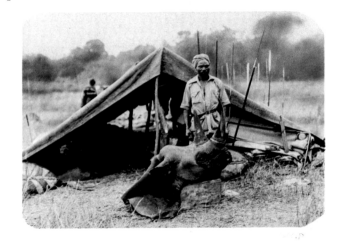

BROR BLIXEN 1930's

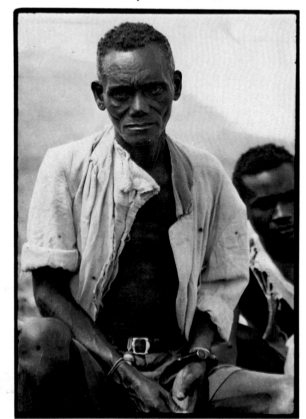

*Major D. L. W. Sheldrick, M.C. Tsavo Warden
inside elephant-eaten tree*

Wambua Mukula, final arrest inside Tsavo 1963

country in a way that he felt was unacceptable. Percival emphasized how gradual it had all been —how the game had almost imperceptibly thinned out wherever settlement came in. For instance, at Wami Hill, after the Second World War, rhinos that had frequented the Kapiti Plains, began to disappear and at some point were simply never seen again.

As a hunter who had never spent more than three nights in any town, Percival found the subtle changes in the whole way of life he had known to be the most telling barometer of decline. As the effort that went into safaris declined, so too did their quality. Local Africans who had once been able to bring much of their own world into the lives of European visitors, had gradually surrendered what is now grandly referred to as their "heritage".

Of all the evolving losses, Percival most lamented the situation of the small Waliangulu tribe which he and Bror Blixen had grown to know—perhaps more intimately than they would their English friends.

"No people could ever have been more compromised in so short a time," he wrote. "A group that coexisted with elephants for hundreds of years, and that in its own way played an important role in the 'dynamic mosaic' of the Tsavo lowlands.

"They were helping to keep the age-old balances— practicing a form of game control, if you will . . . MacArthur and Archie Ritchie could have learned a lot from them."

Percival openly sympathized with the effects of a boundary that the government had placed around their homelands. Discreetly relocated outside this boundary, in a sort of village-reservation near Voi, the Waliangulu became thoroughly accomplished alcoholics.

Speaking of Tsavo as the hidden paradise from which the Waliangulu, Watta, Wasanye, Wakamba, Wondaruma, Wataveta, Wataita, Giriama, despite their natural rights, had been expelled, it occurred to him to mention how the old government had forbidden many Kikuyu and Masai dances, and how his friend and ally Tania Blixen had tried to intercede and, failing, had encouraged them to perform in secret, whenever possible. "You can't just interrupt a whole system of life and expect things to work out smoothly," he said.

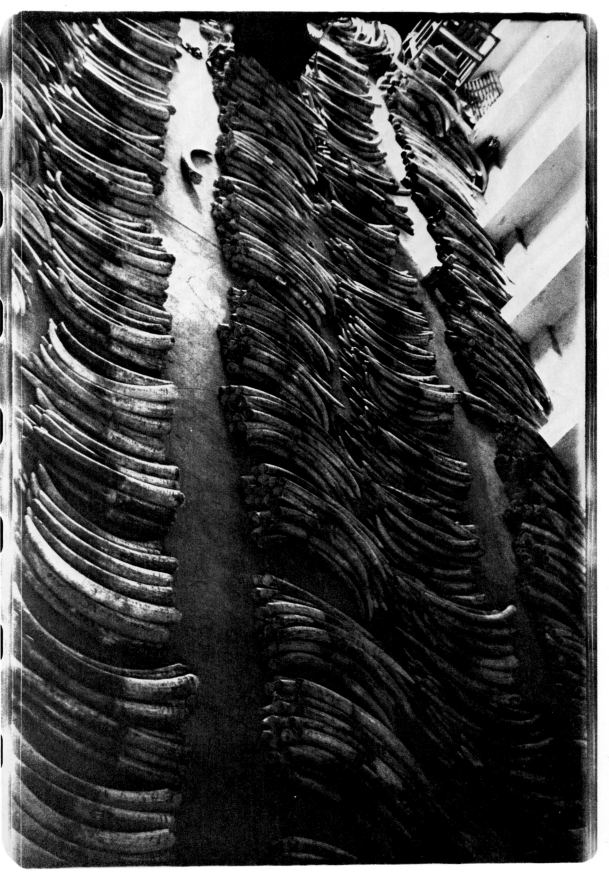
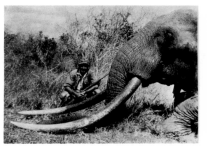
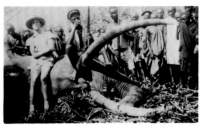
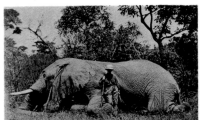

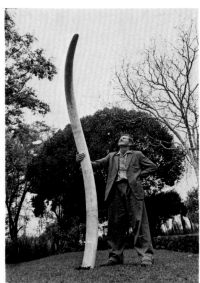

"ahmed" — last photo March '72

1960

1977

bullet in x-ray
of ahmed's tusk

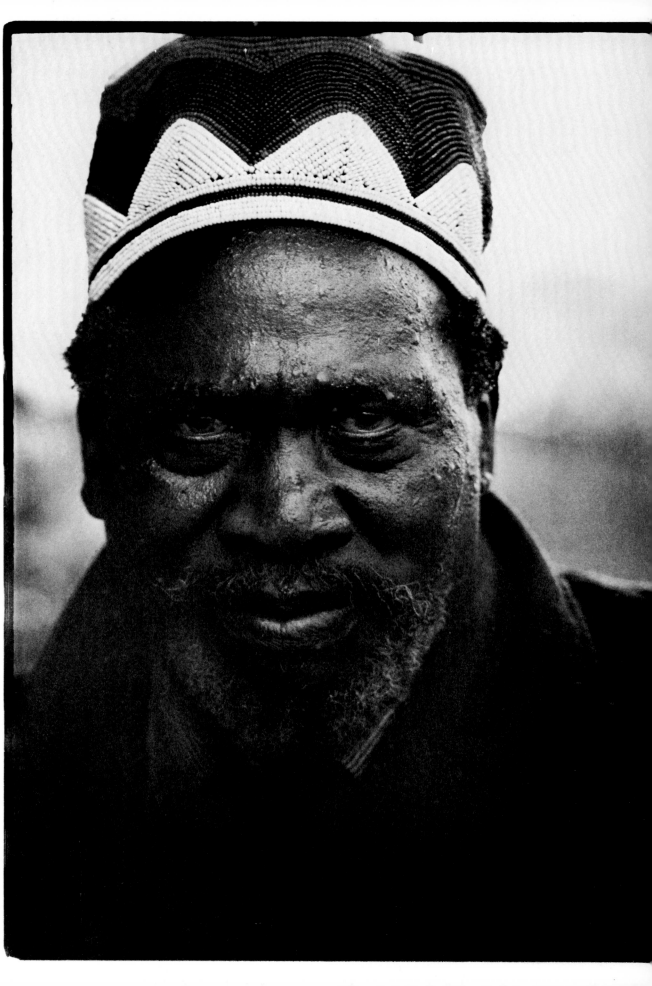

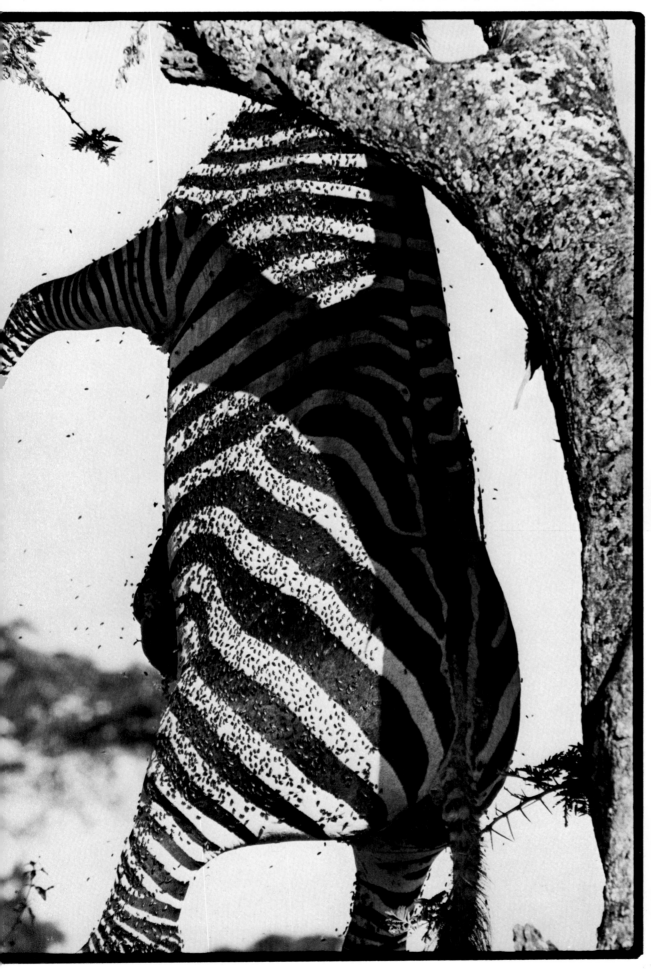

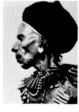

Dedan Kimathi, 1956

He told me how Bob Foster from Voi Sisal Estate had gone to Willy Hale, the game warden in the late '40s, to report a change in Tsavo's dense commiphera woodlands. When Percival himself had had to send his Kapiti Plains Cattle down to the Galana to survive the drought, he had been shocked at the changed landscape. "Nobody seems to know the facts of these things and there appears to be very little interest in finding them out . . . A recent army count of Tsavo elephants has the population at three times that estimated by the authorities and everyone is in shock—my guess is you can multiply that army effort by three times again—how else do all the trees go? . . . You have only to look at Patterson's pictures to see what a jungle that country was when Blixen and I were down there."

He felt that the whole nature of the place was in jeopardy and saw this reflected in the condition of the Waliangulu crowded in their Voi shambas. Theirs had been a life of risk gladly taken—of so few wants, "leisurely and communal, intellectual in ways that are simultaneously practical and aesthetic. And most pertinent to our time, it was a life founded on the integrity of solitude and human sparseness in which men do not become a disease on their environment. . . ."

As Percival saw it the hunting tribes living in harmony with each other and the lands they occupied were in their own way a control factor that could be traced all the way back to the medicines of the missionaries.

"The ways of these hunters are beginning to show us how we are failing as human beings and as organisms in a world beset by a *success* that hunters never wanted."

"Why don't you take a good look at Tsavo," he wrote. "Many of those 'poachers' are out of jail now—they can show you a lot . . . and it's anybody's guess how the overall picture is going to develop— things are going pretty fast down there." He knew that someday there would be a real crisis, that the harmonies and balances of the early days were too far altered, that the interrelationships had been overmanipulated and that the new densities would be unable to support themselves, that the business of saving the game required more than sanctimonious sacrifices on the surface.

230

"Ex Africa semper aliquid novi." Pliny

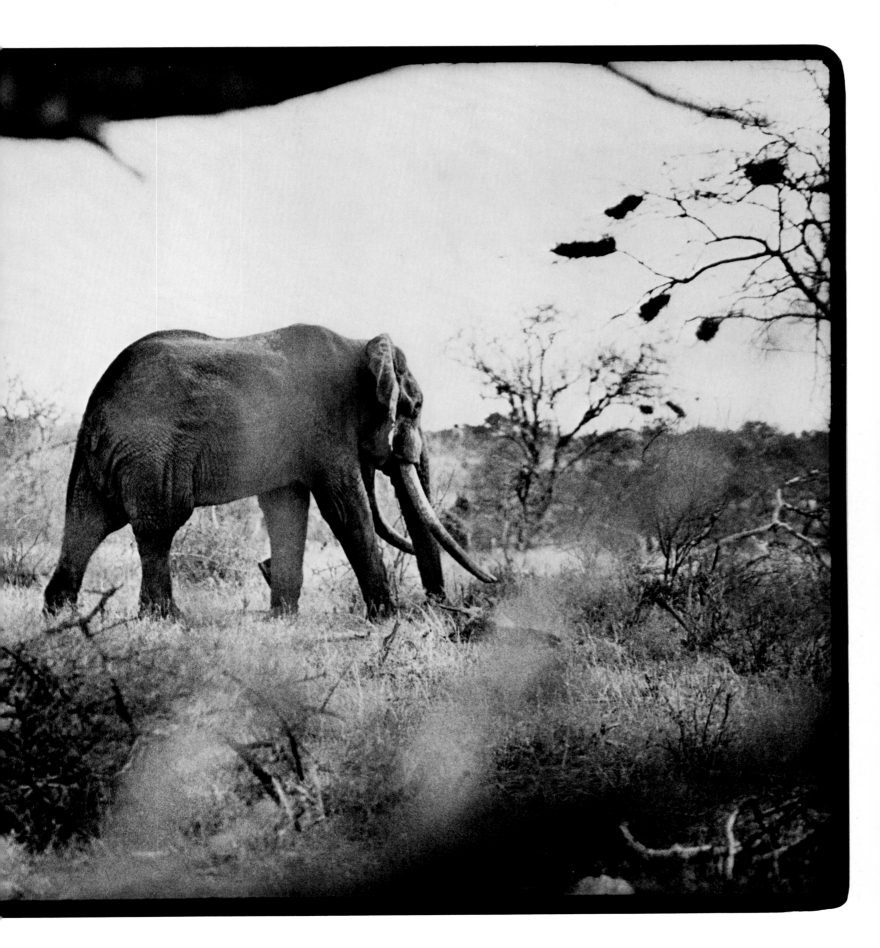

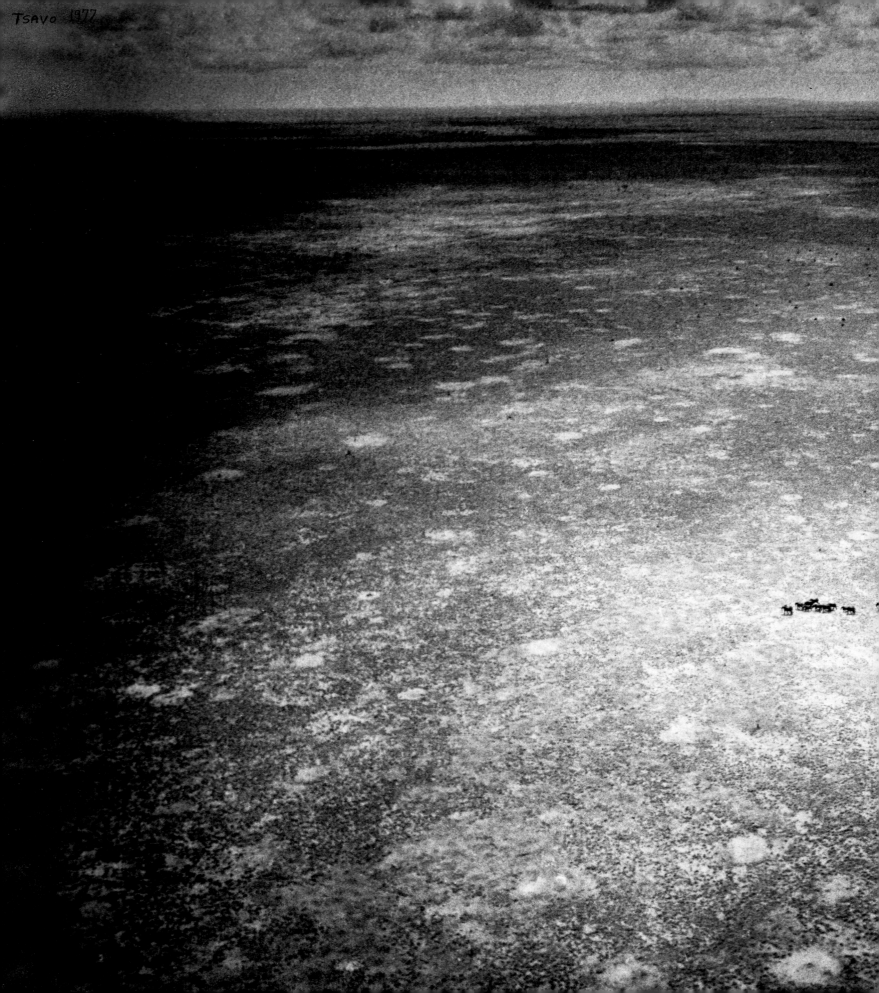

Tsavo 1977

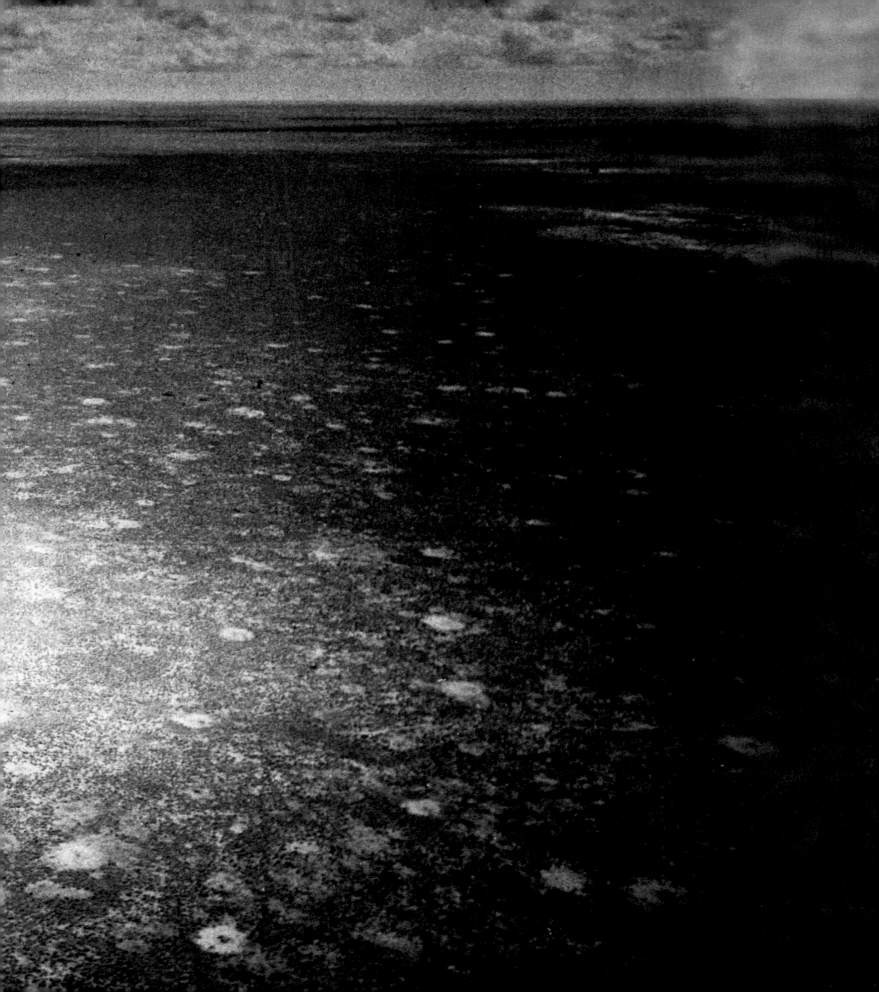

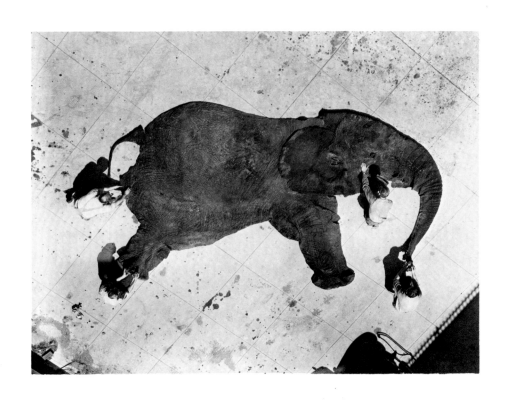

6

Nor Dread nor Hope Attend

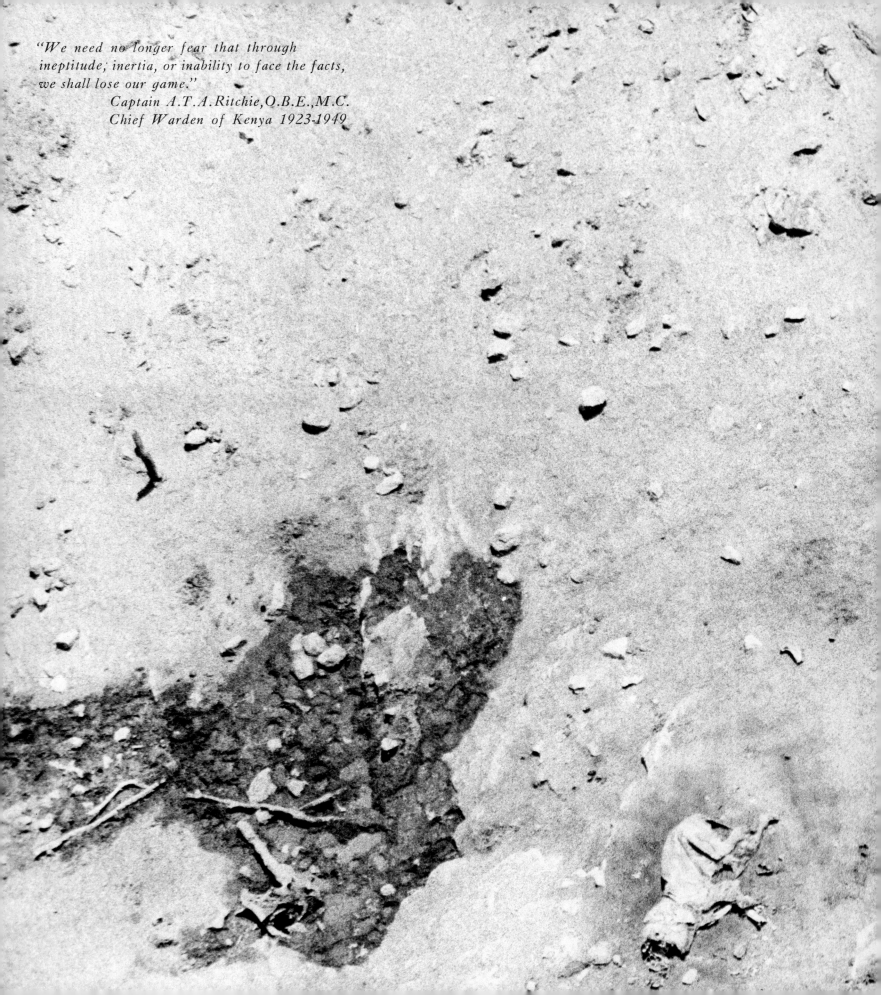

"We need no longer fear that through
ineptitude, inertia, or inability to face the facts,
we shall lose our game."
 Captain A.T.A.Ritchie,O.B.E.,M.C.
 Chief Warden of Kenya 1923-1949

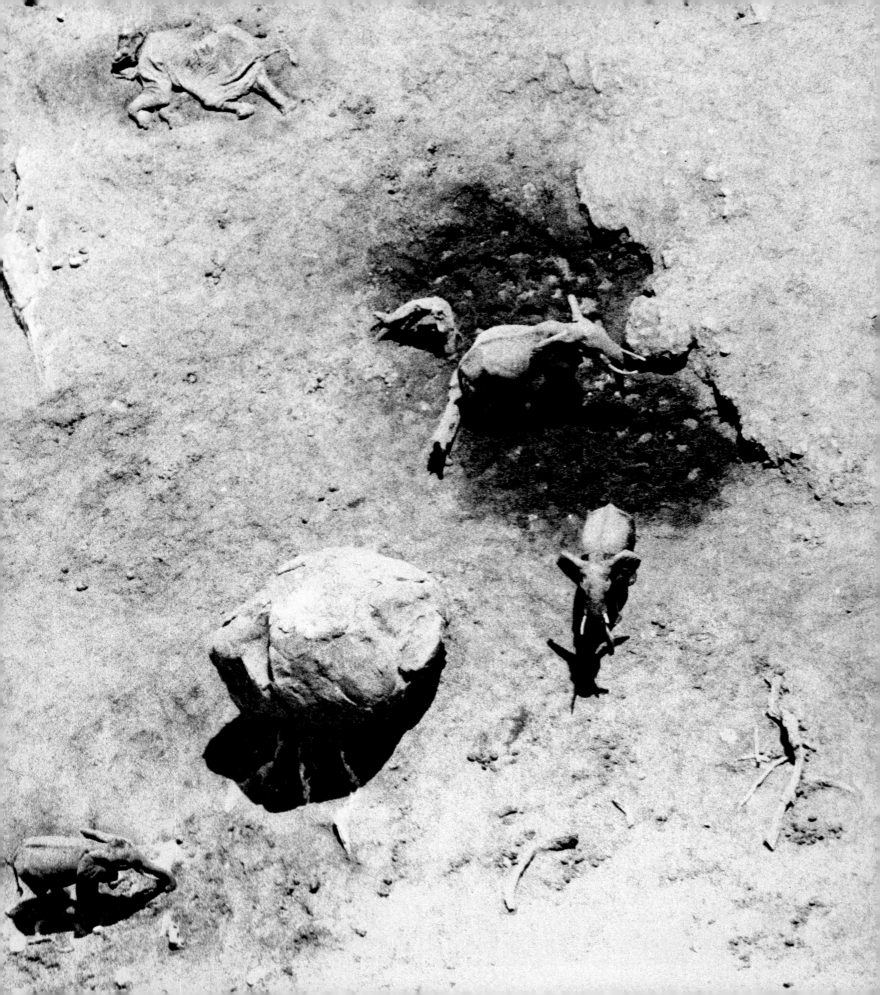

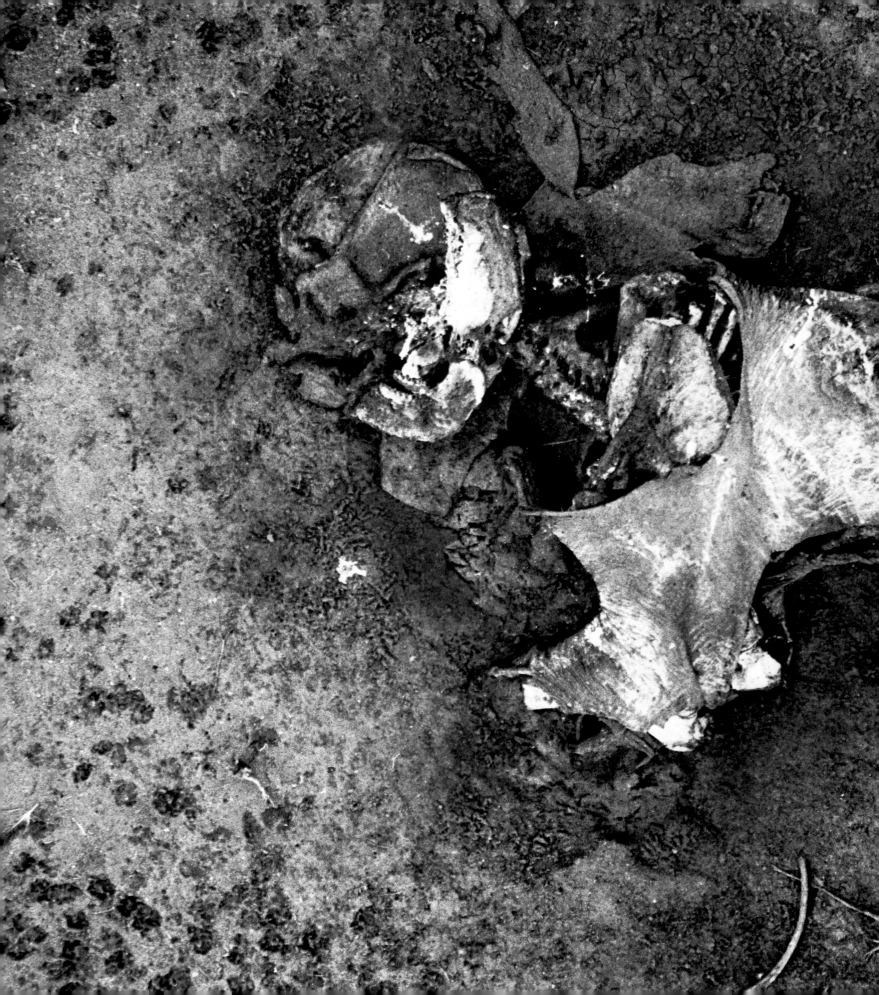

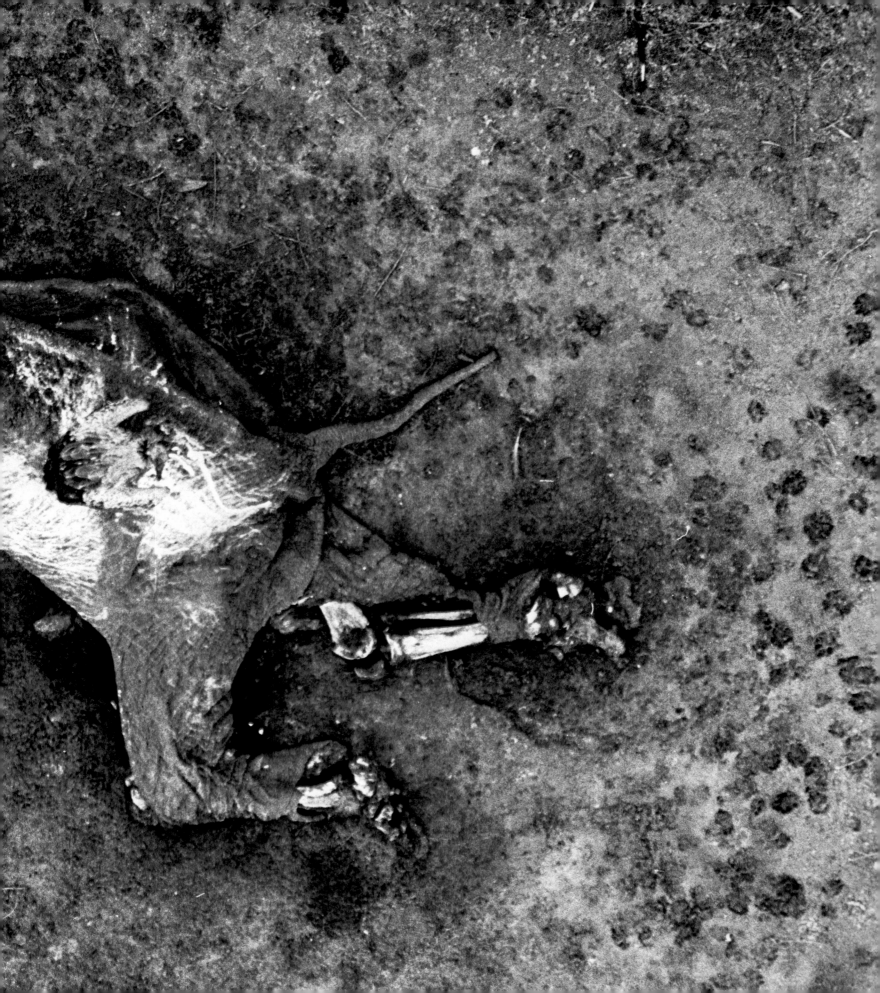

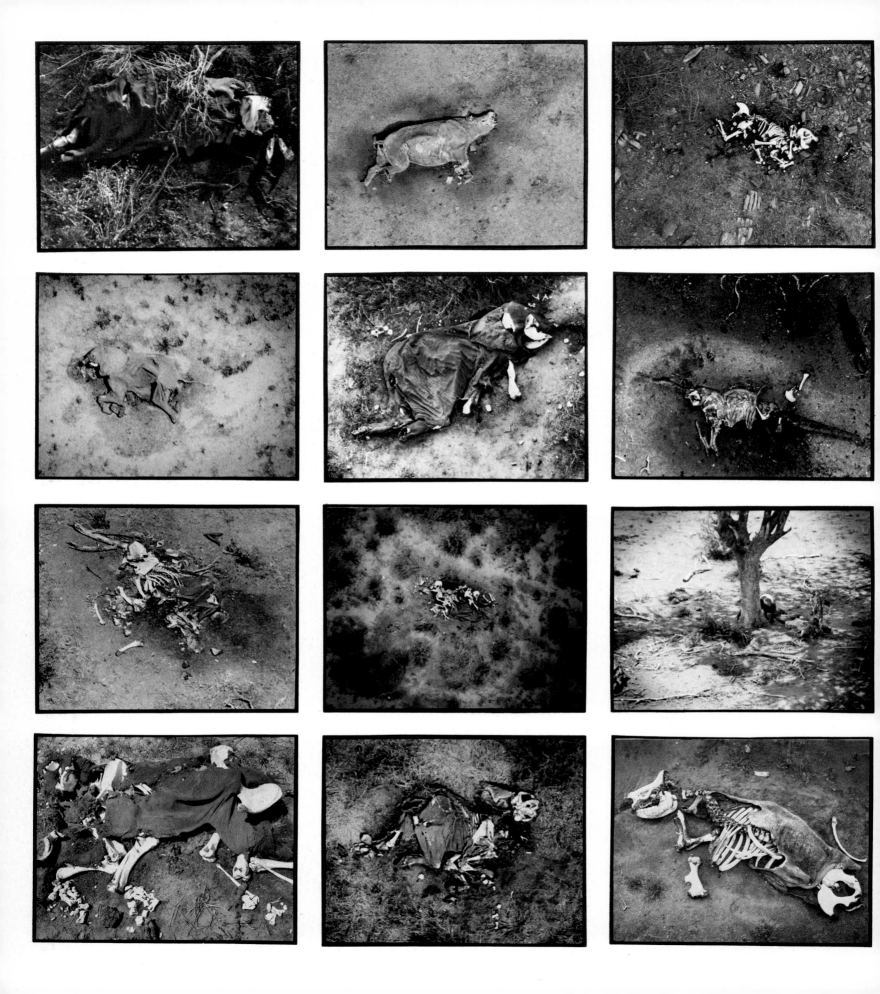

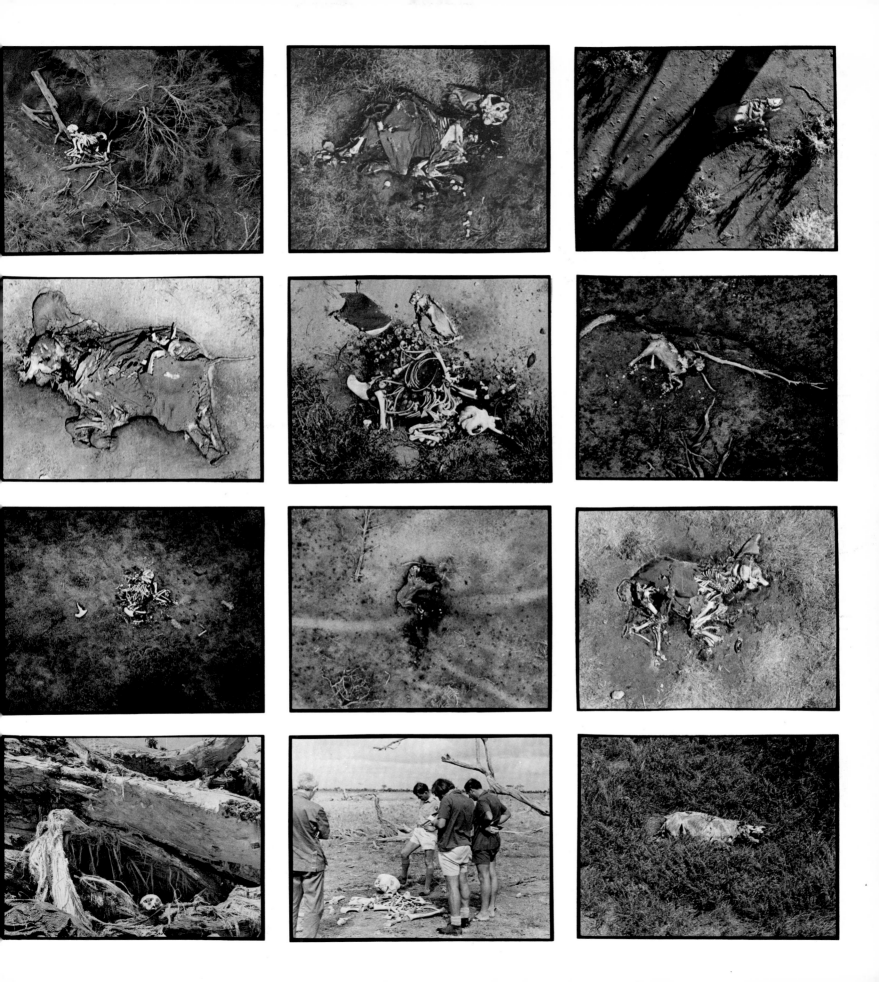

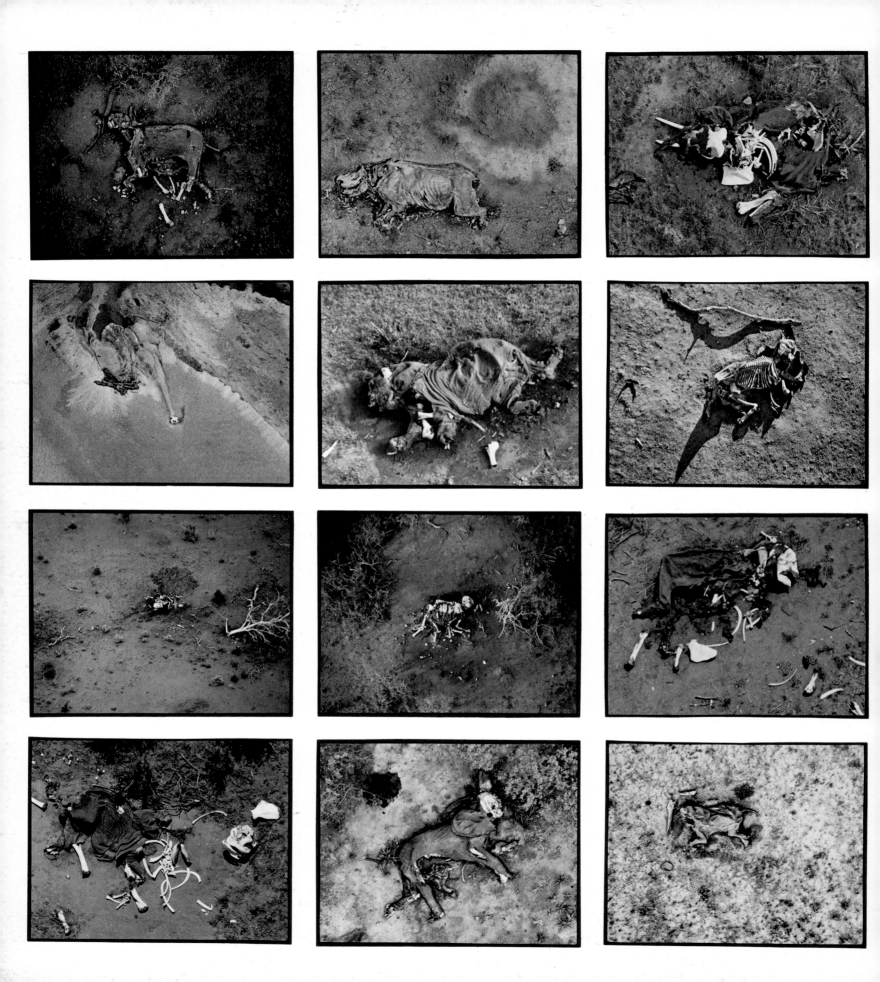

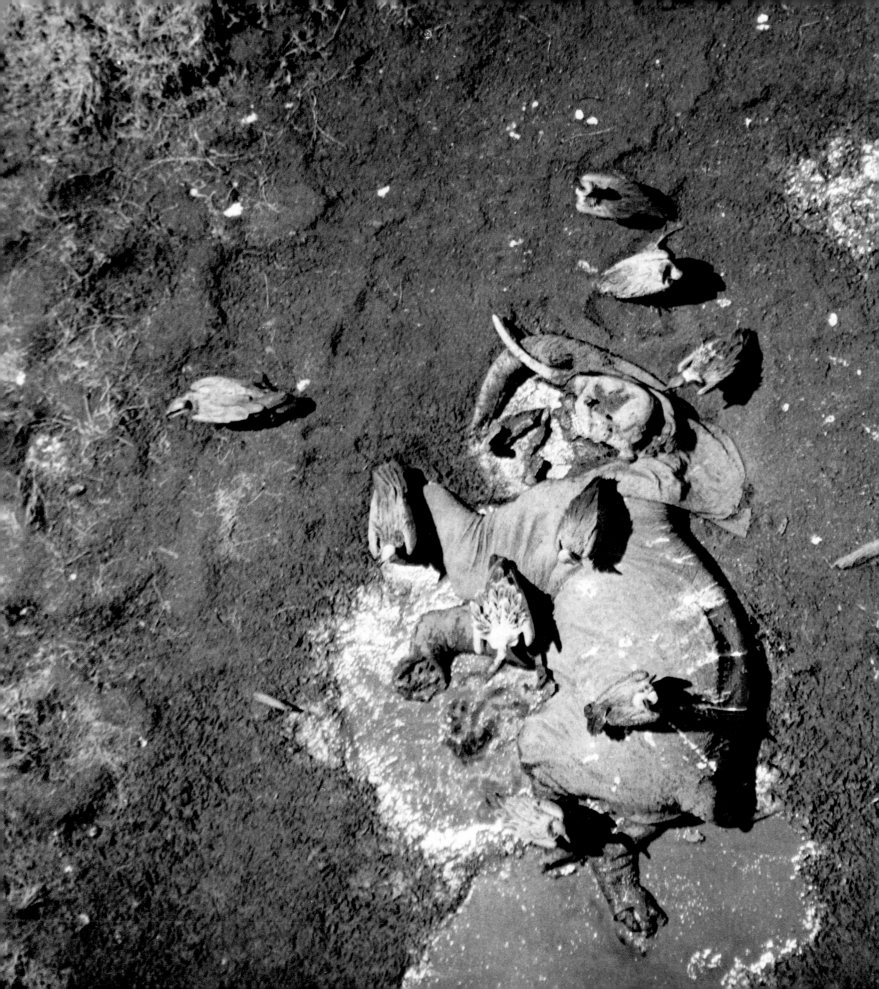

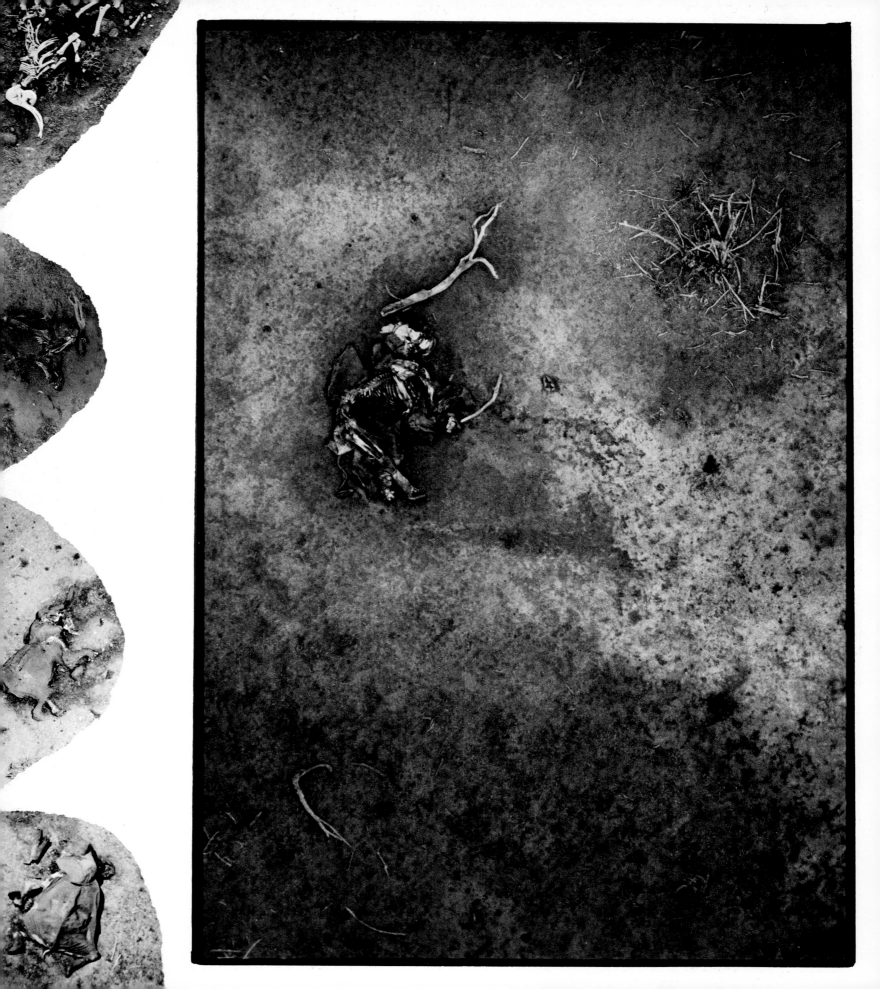

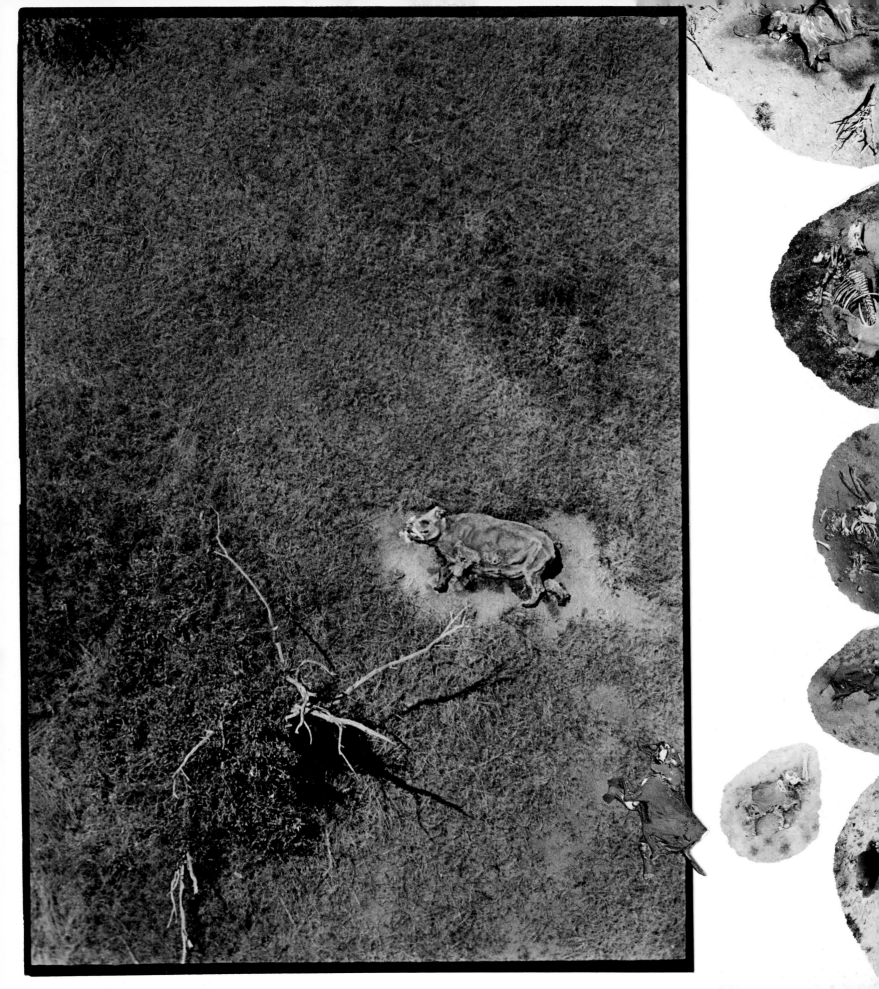

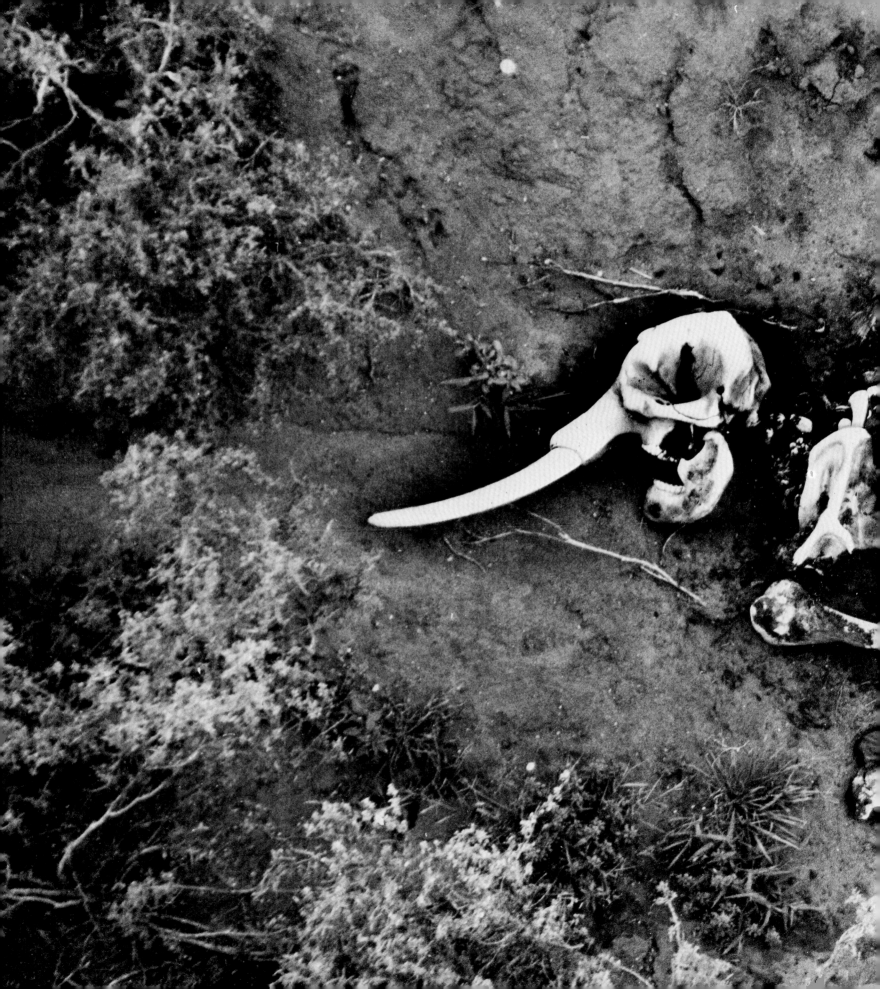

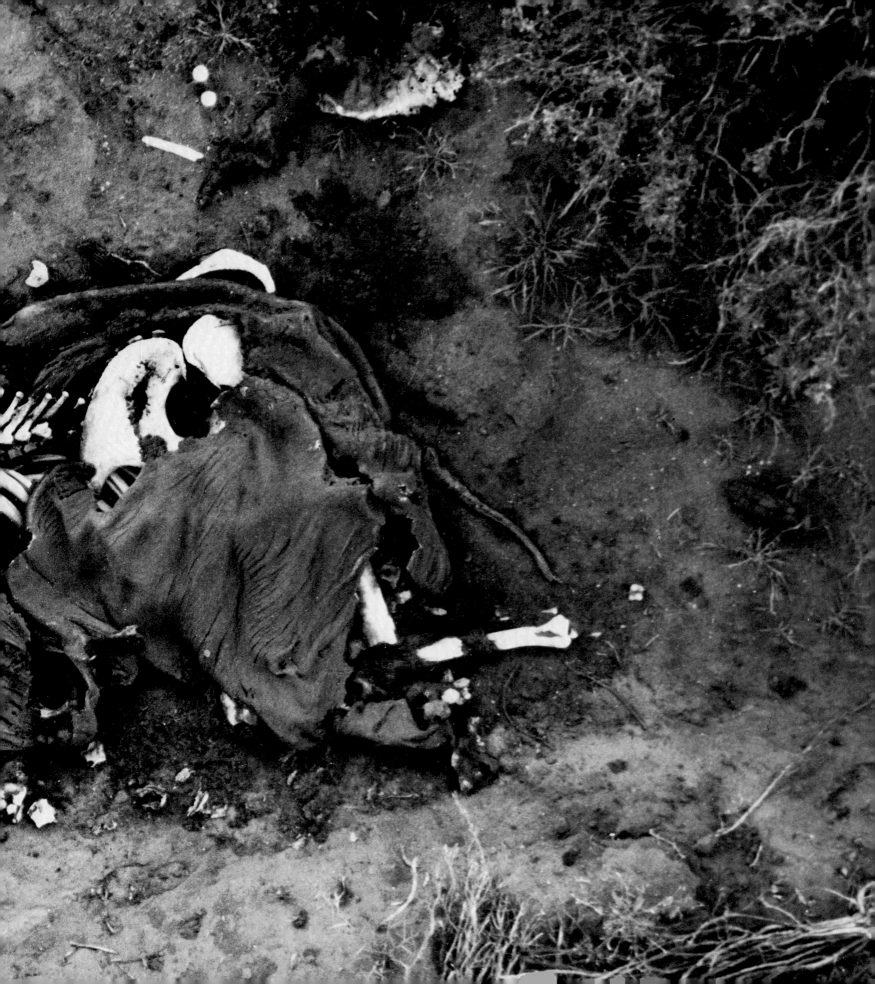

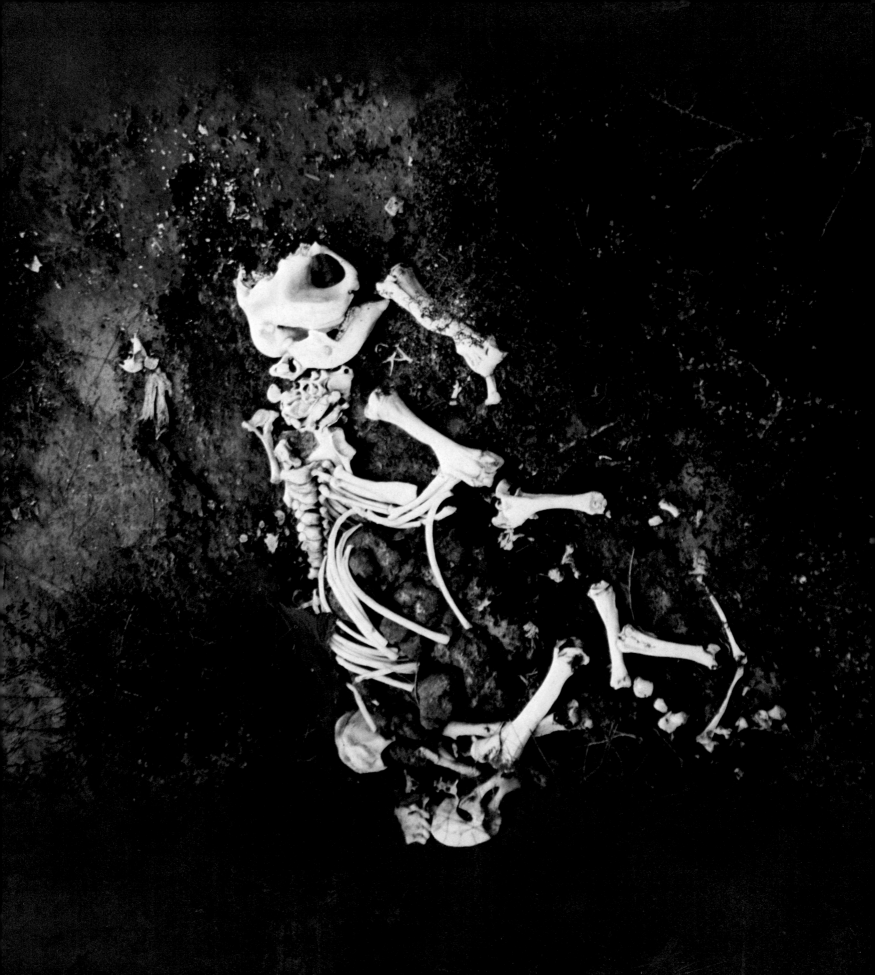

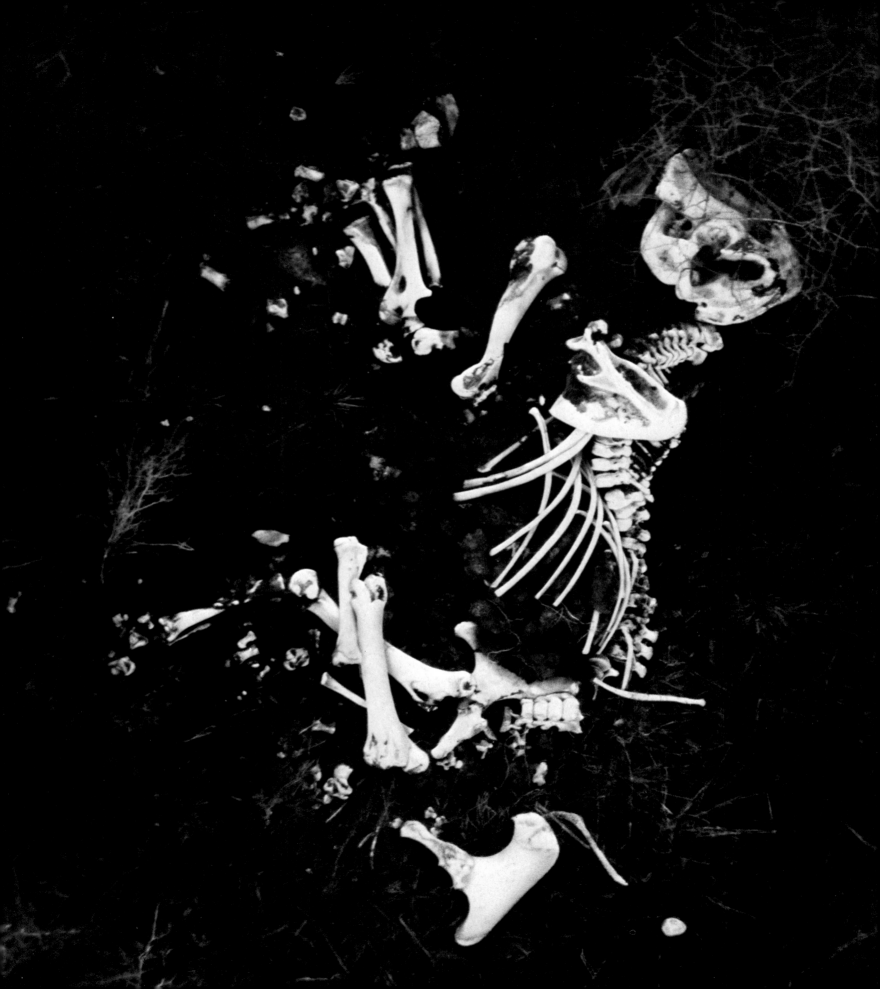

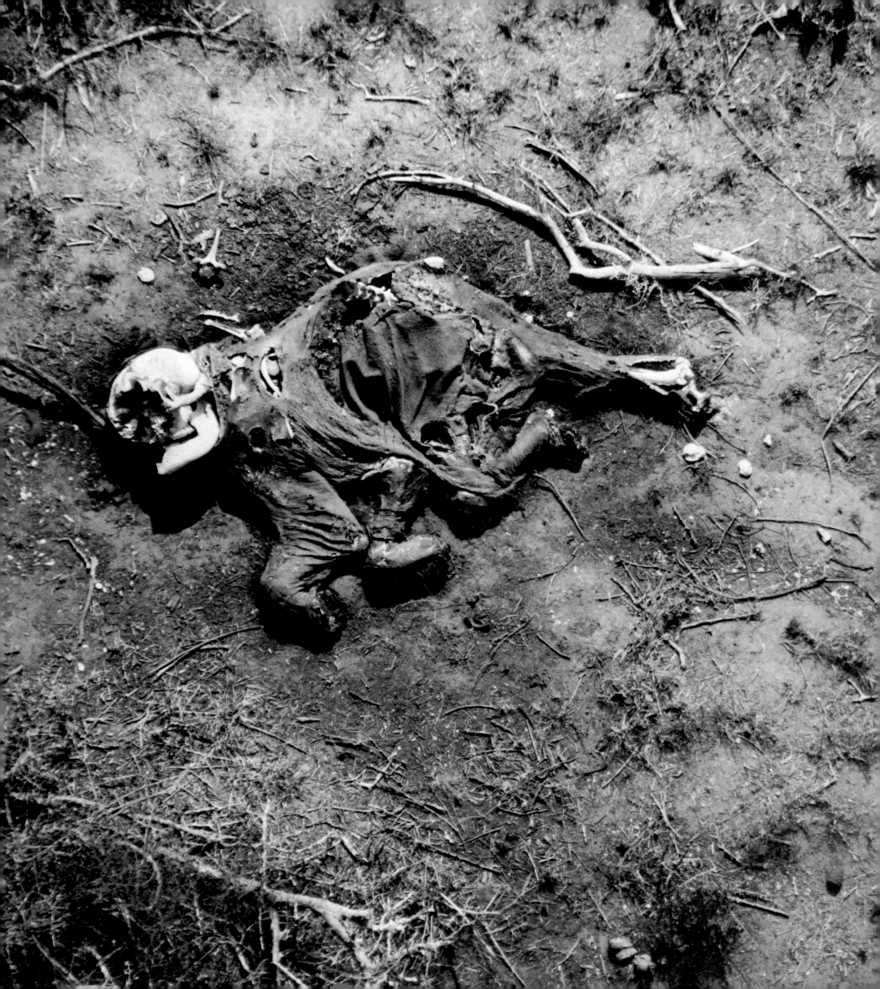

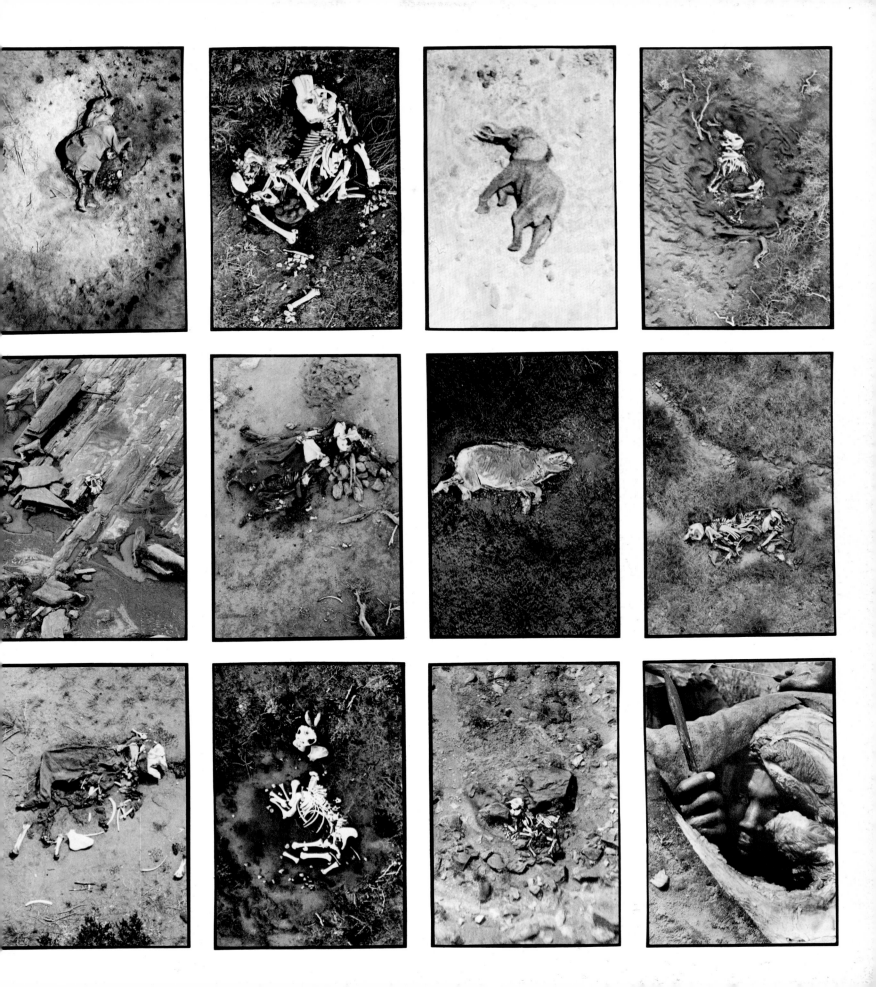

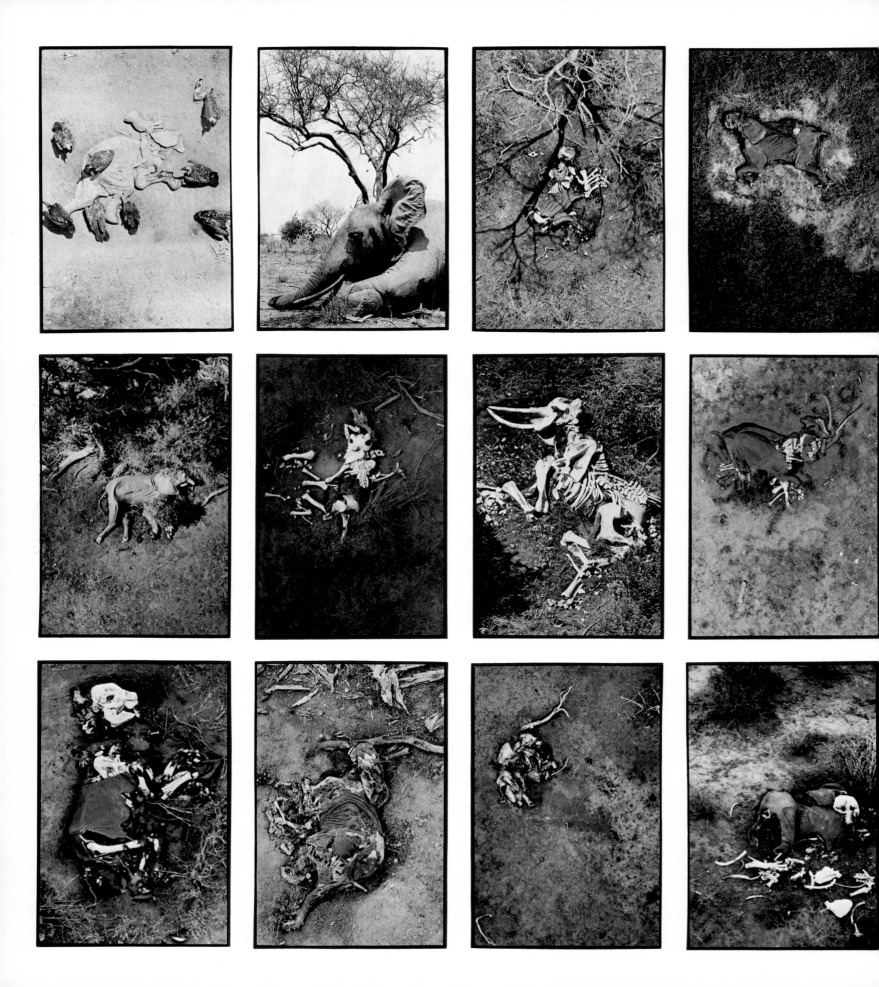

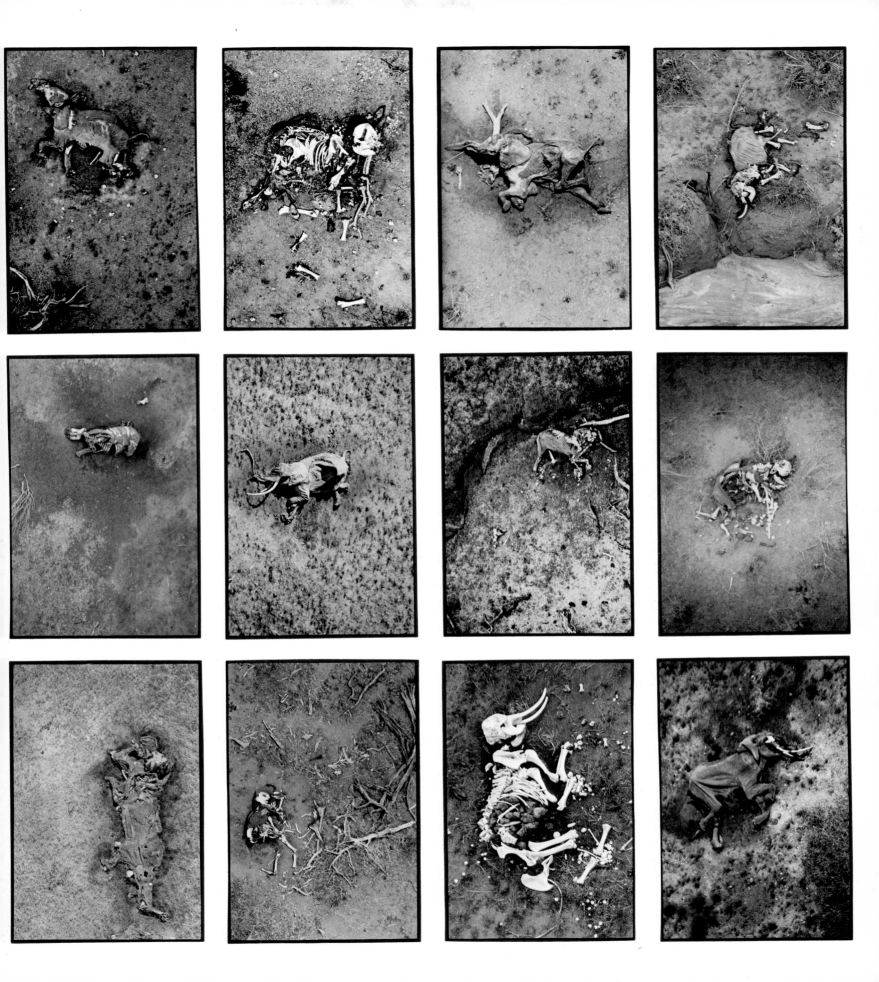

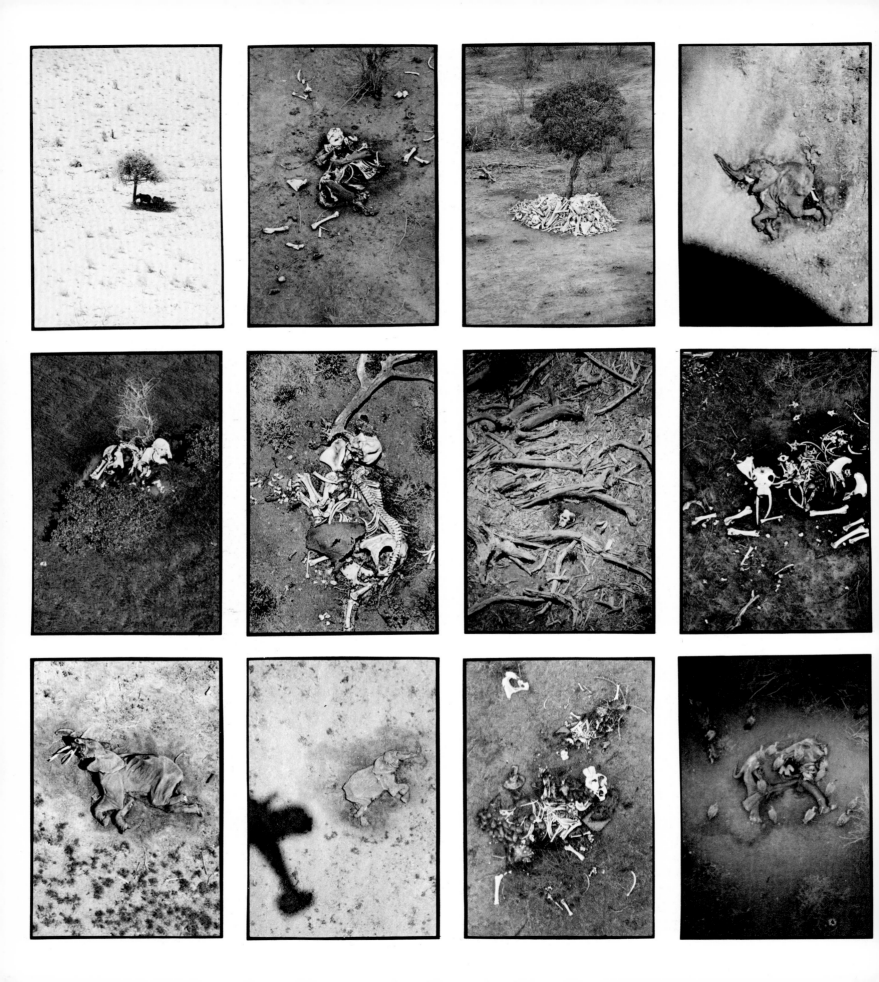

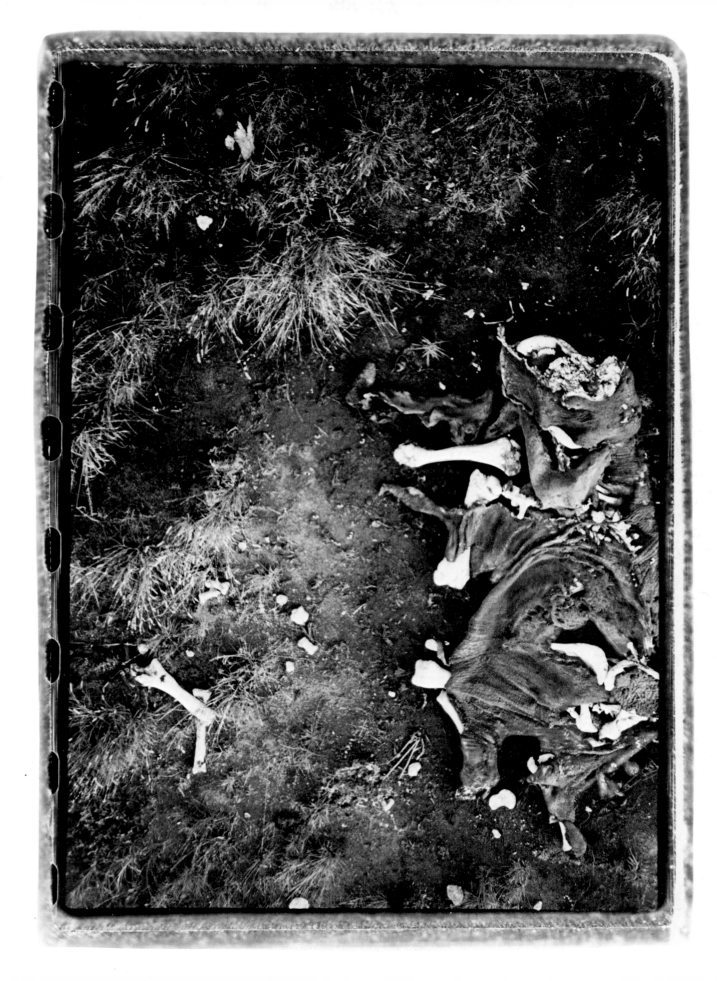

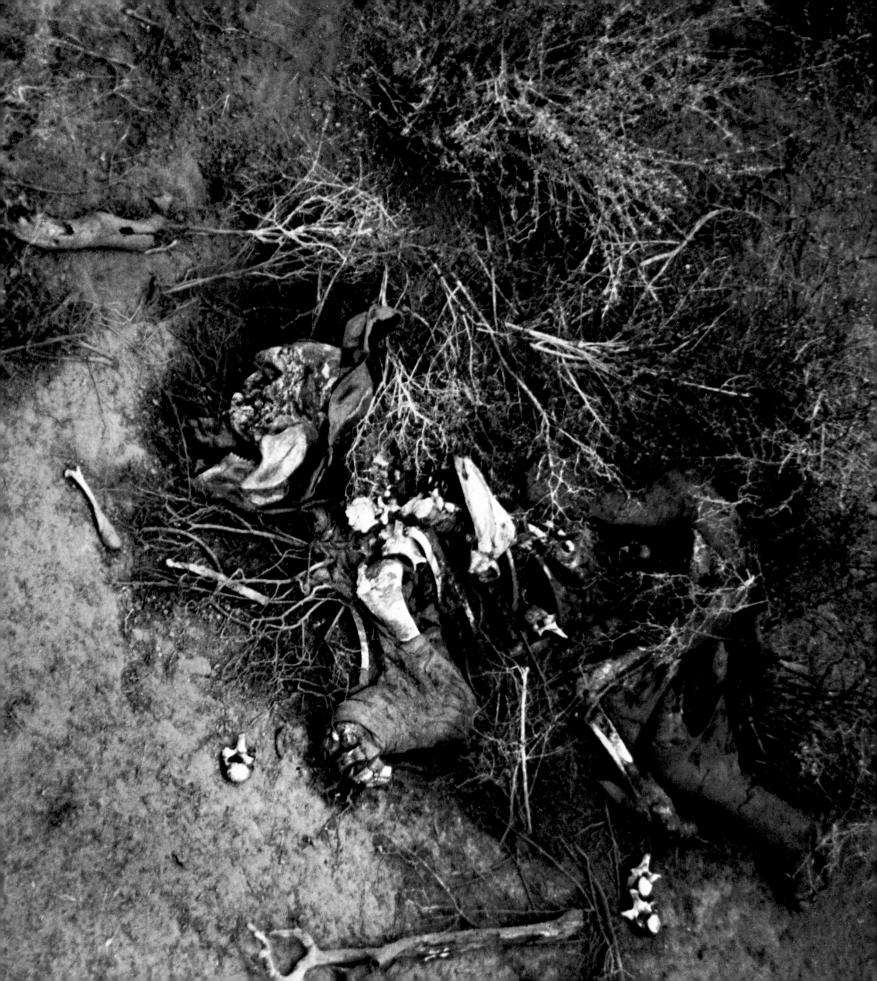

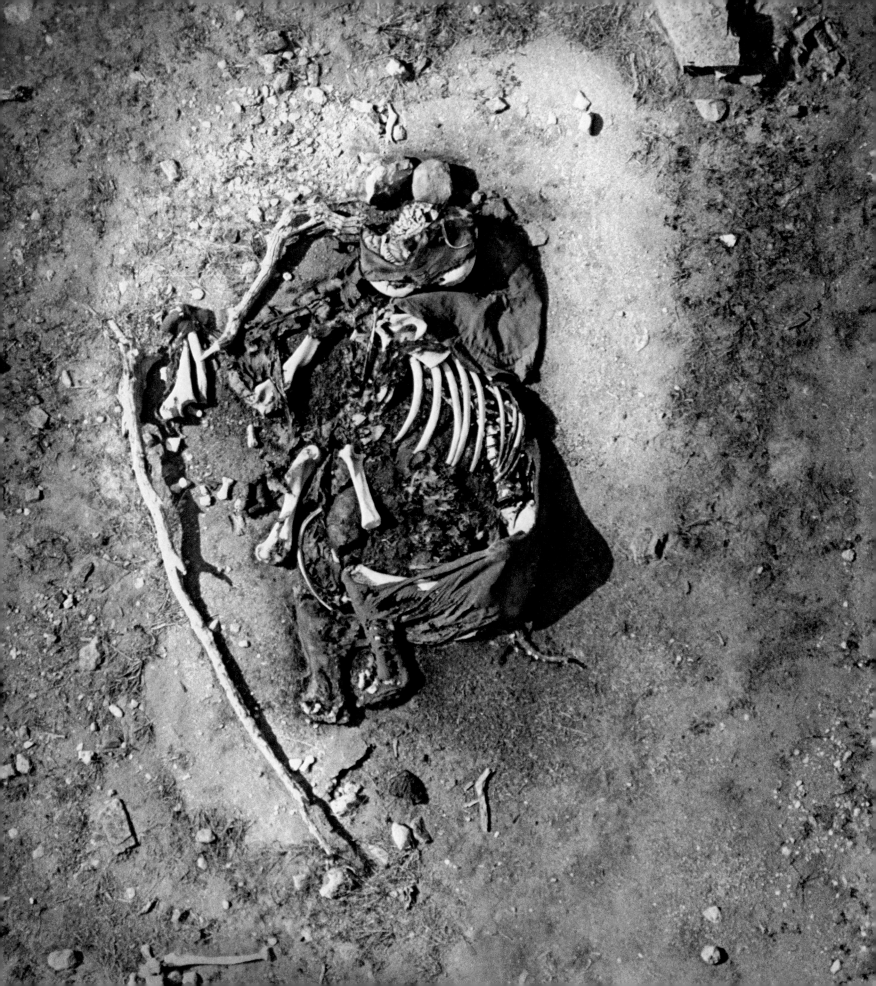

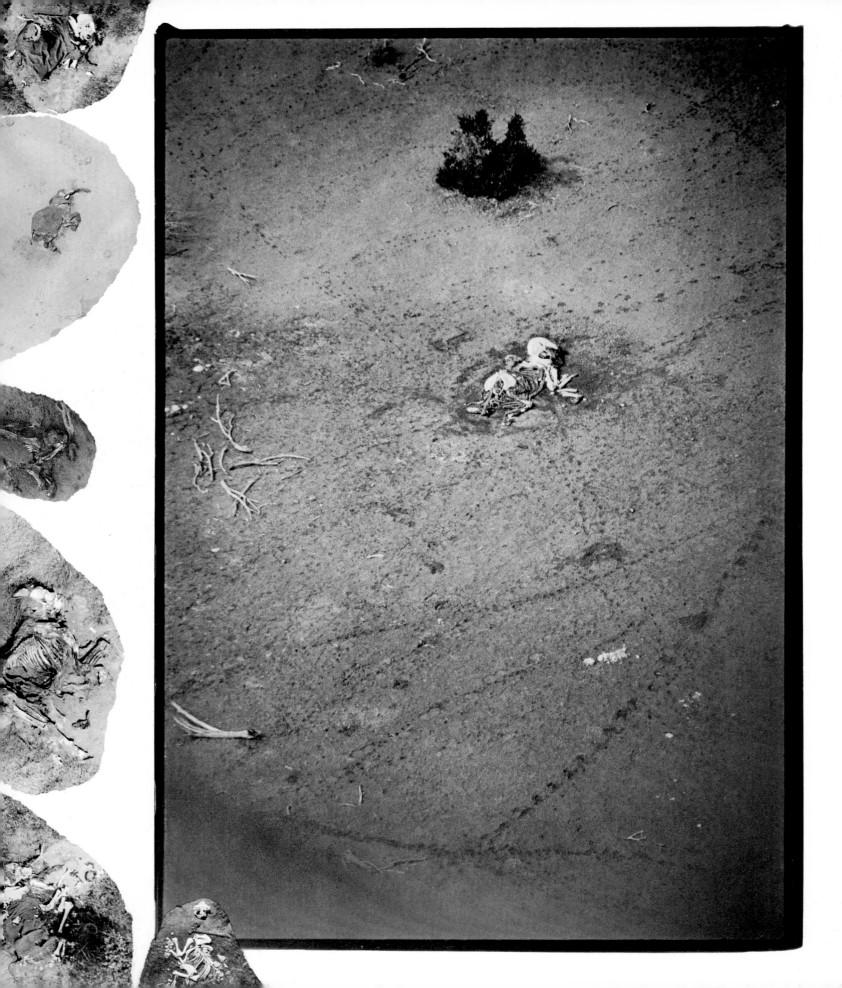

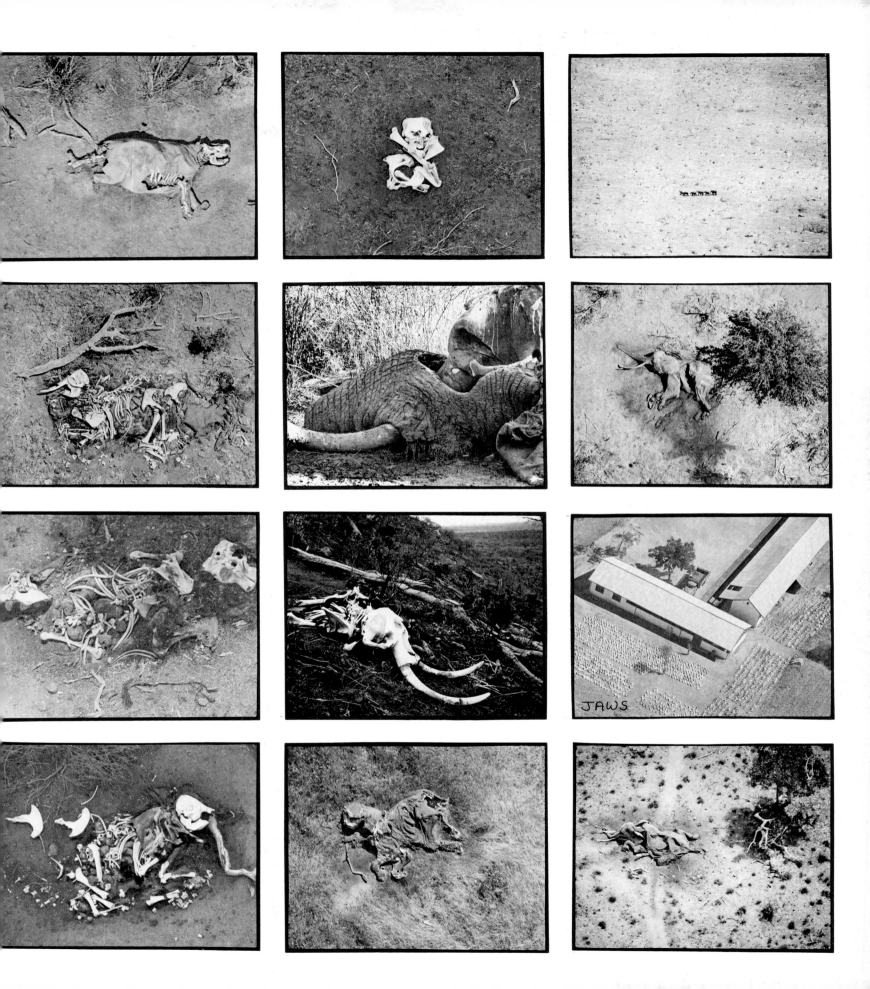

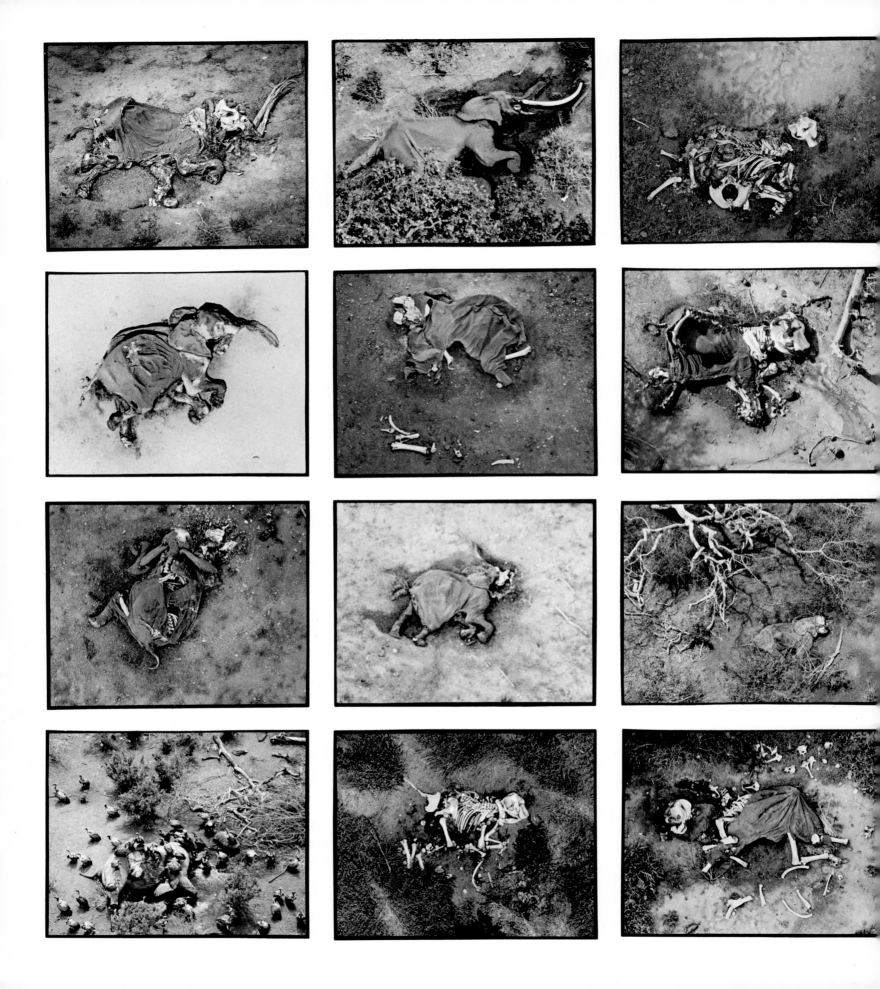

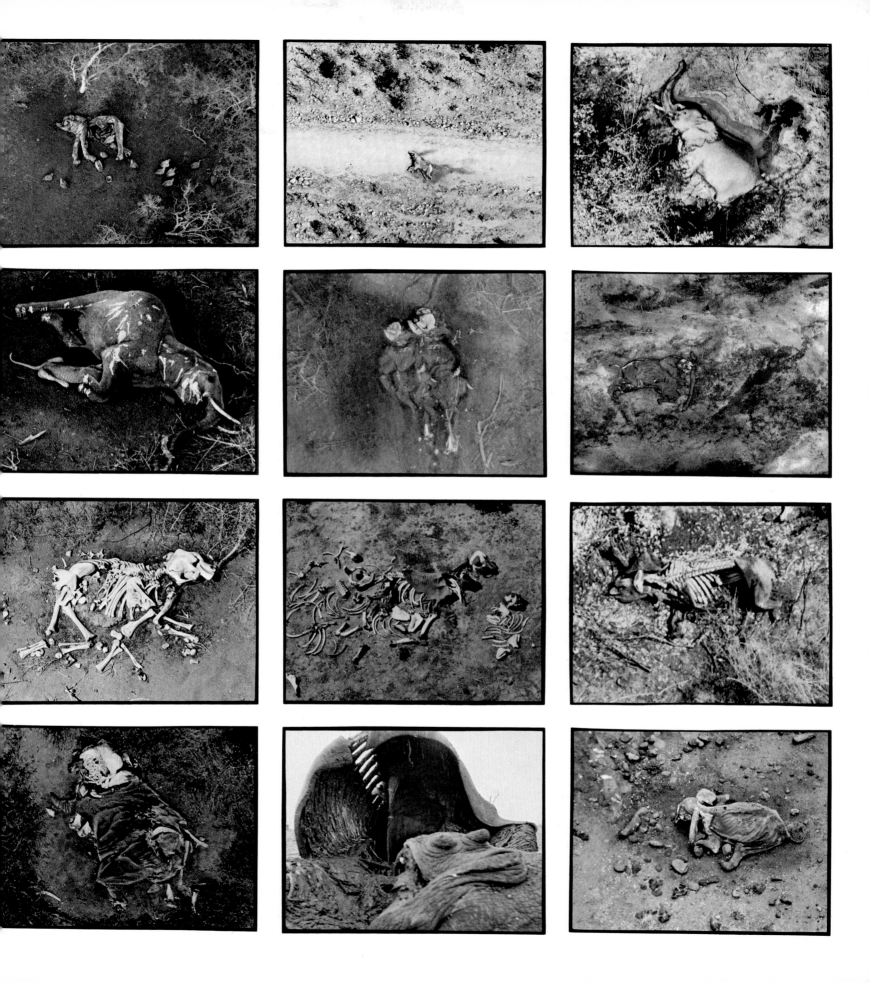

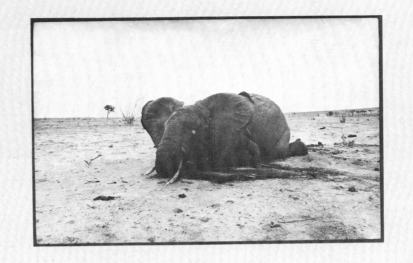

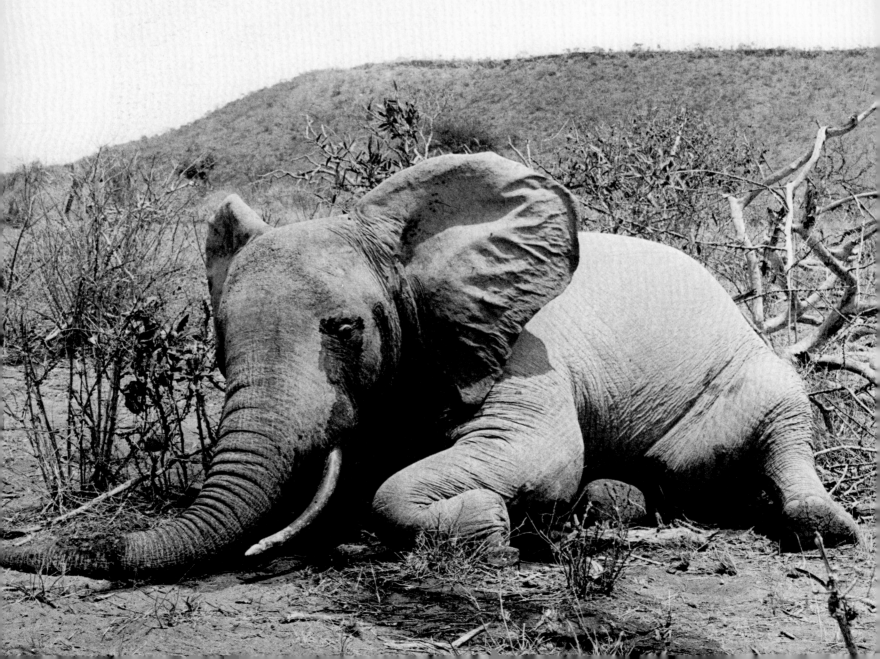

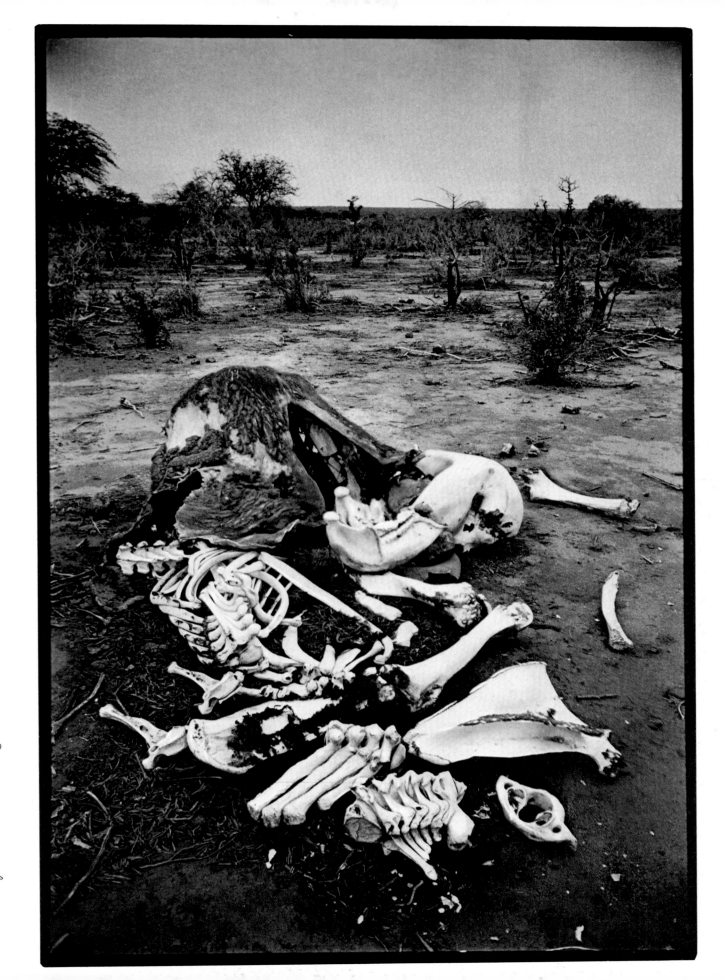

The ruined wood we used to know
won't cry for retribution — the men who have destroyed it
will accomplish its revenge." W.F.

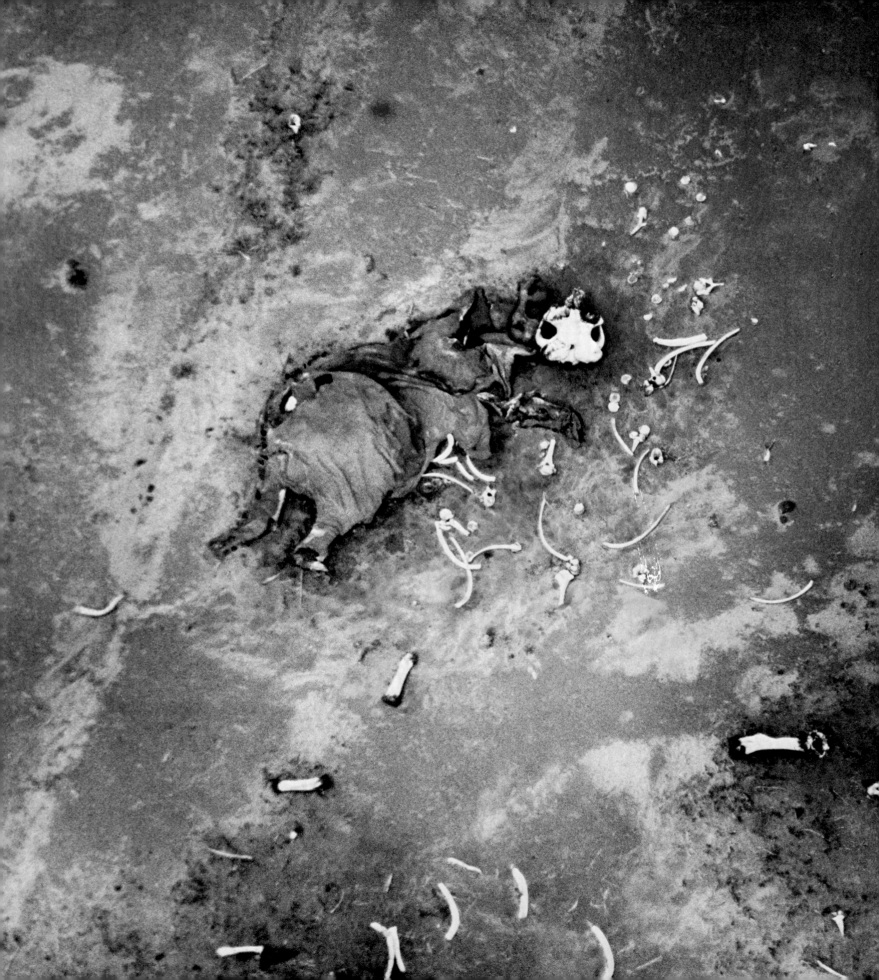

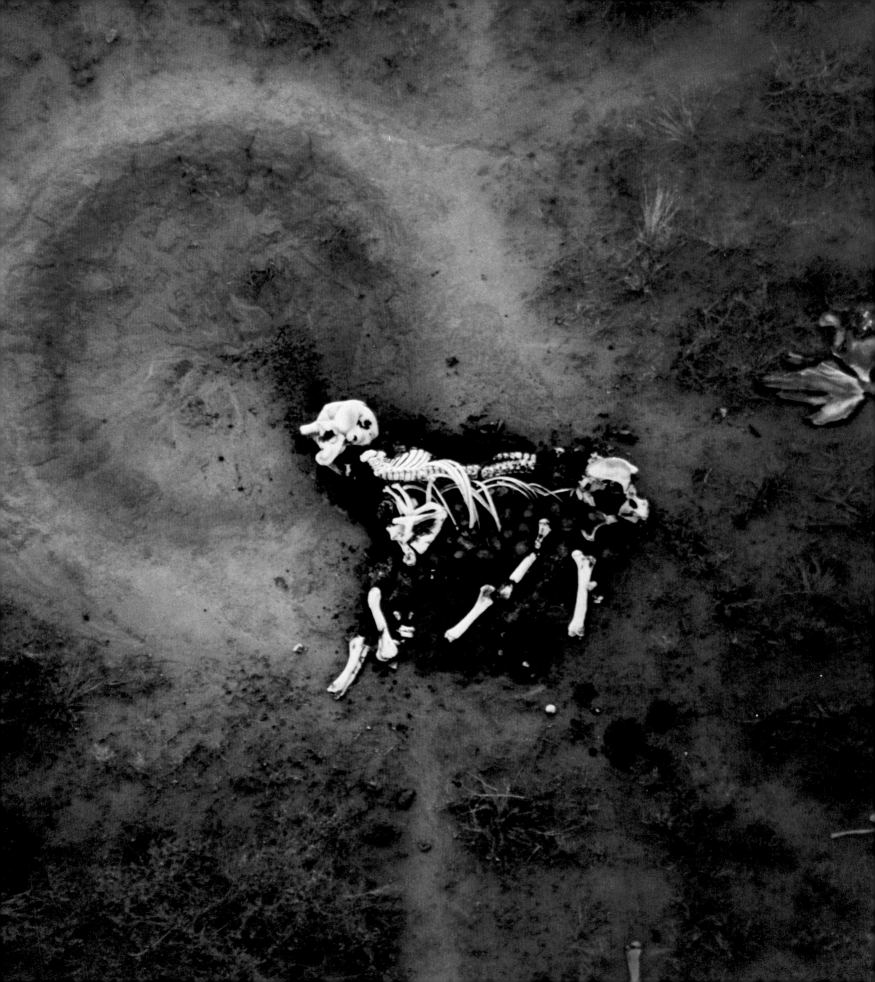

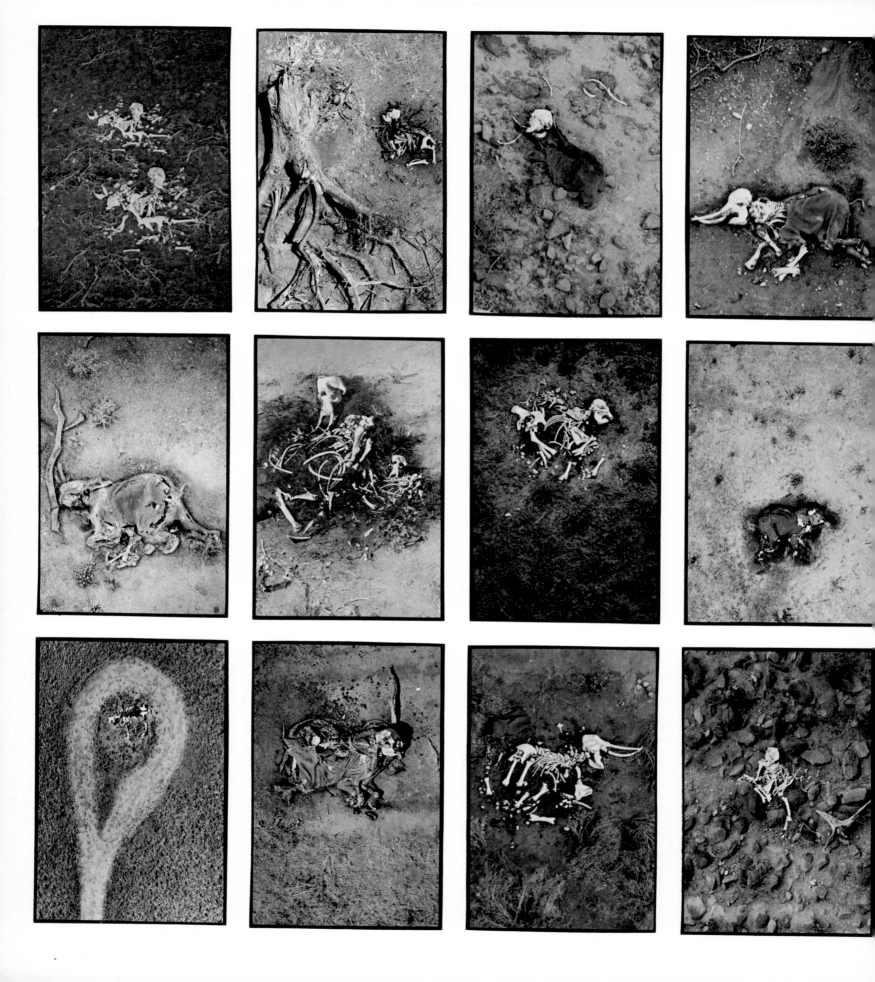

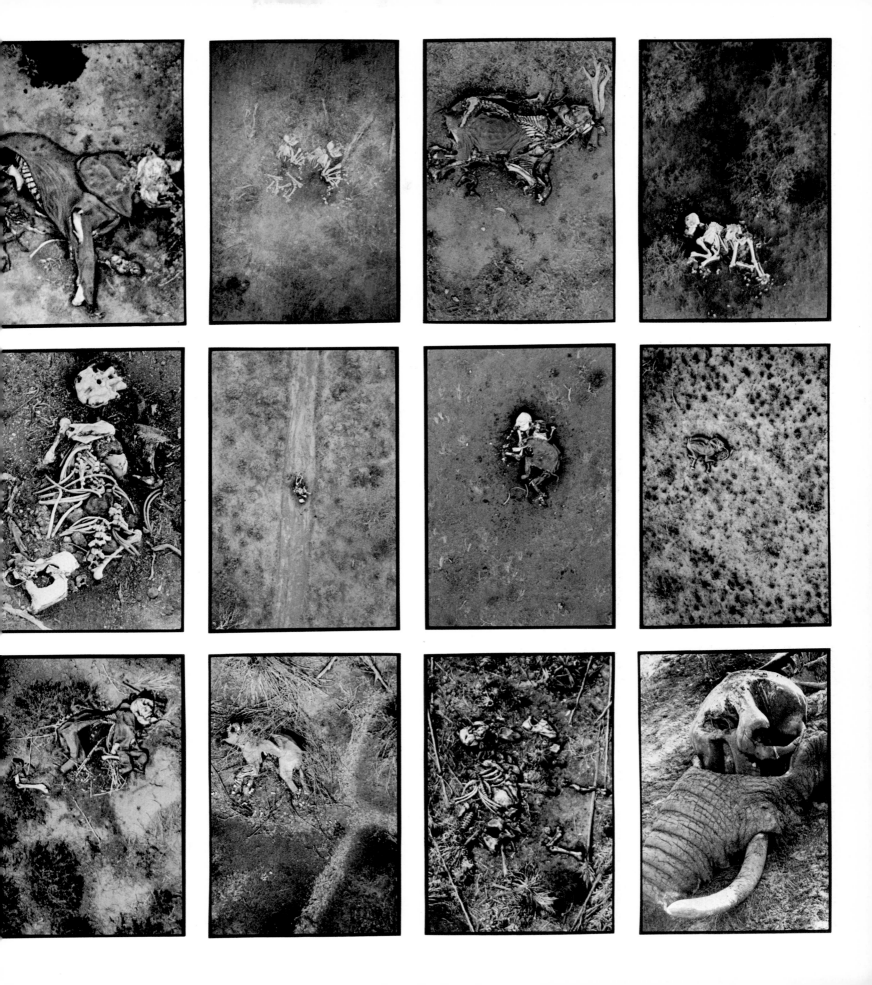

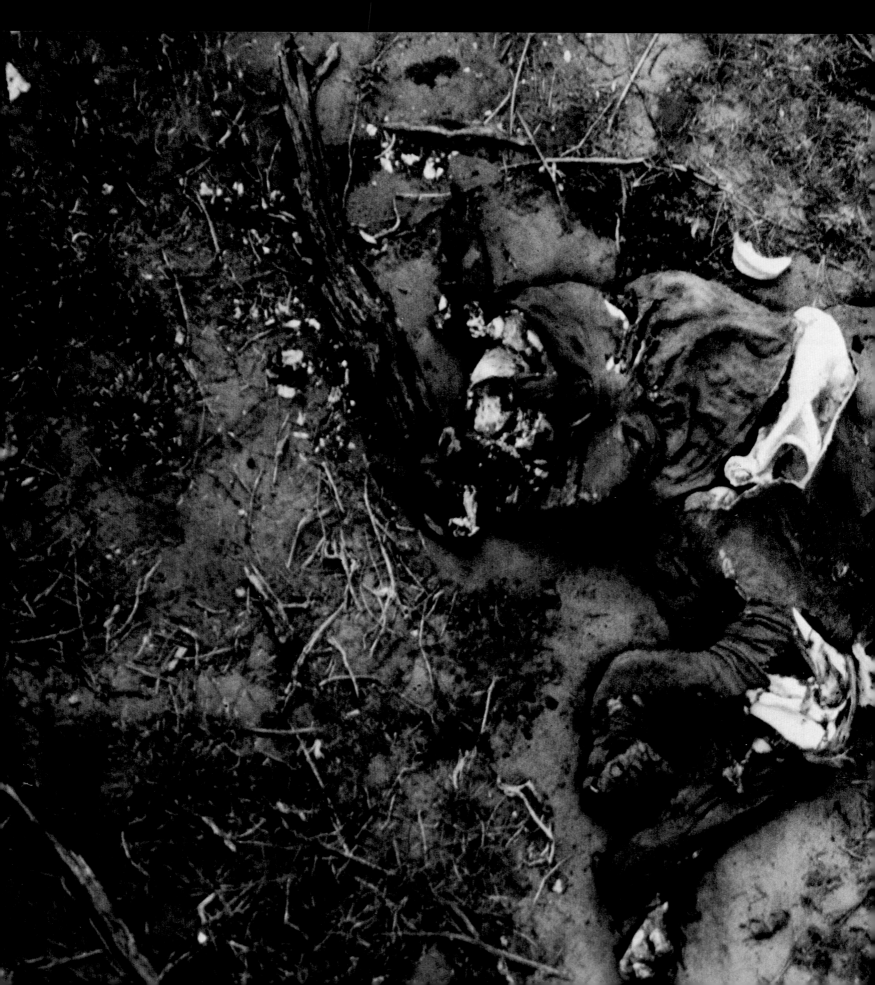

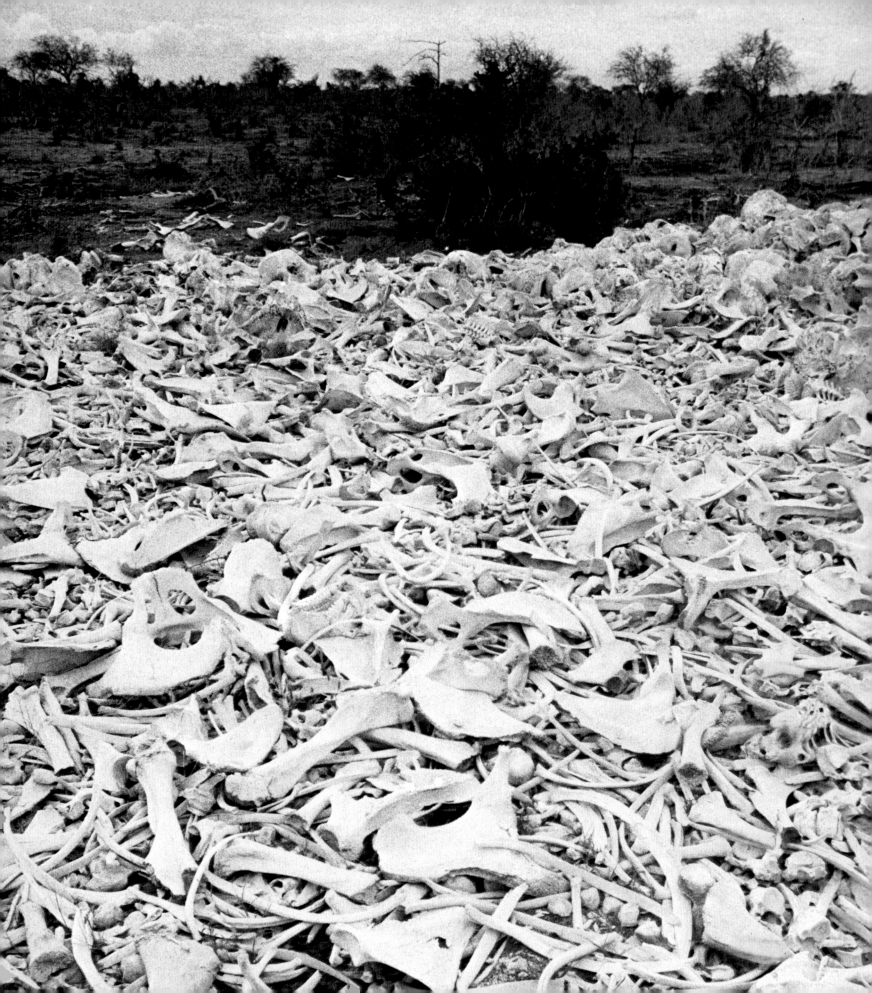

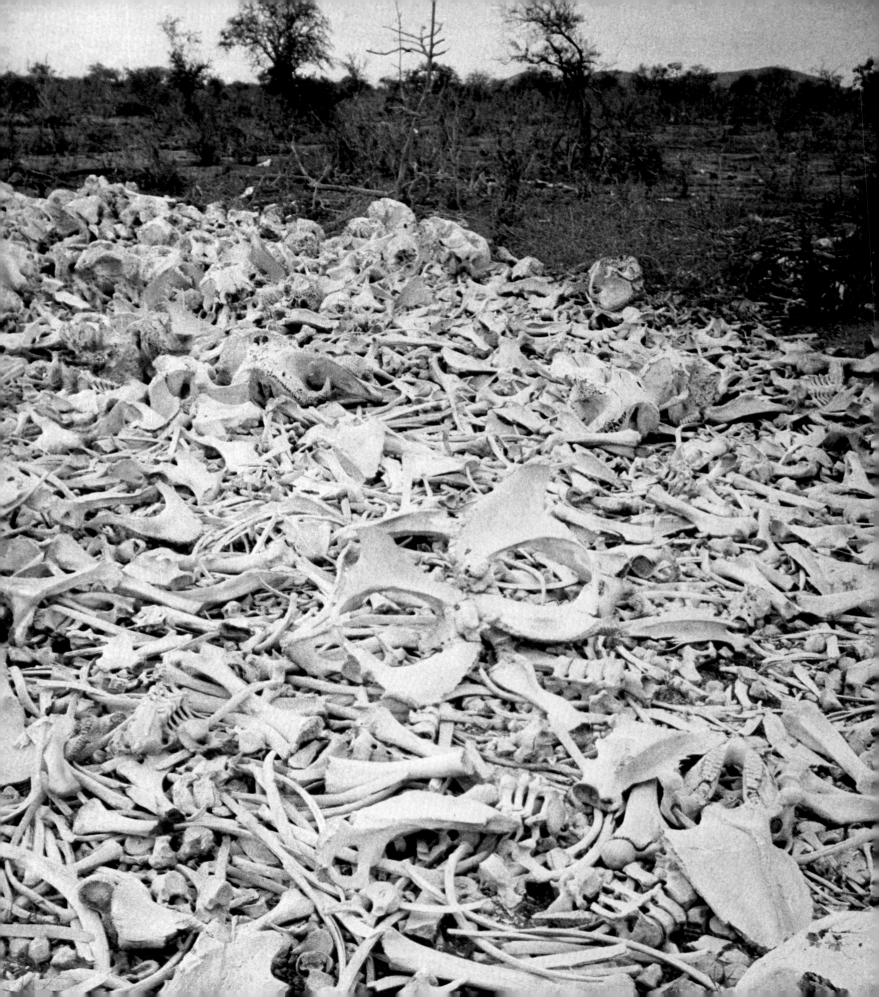

Epilogue

Although the elephant, the whale and *homo sapiens* appear to be very different from one another, these three wide-ranging species share fundamental characteristics. They are all long-lived. Their longevity of 60-70 years accounts for their having not only similar demographic structures, but also an extended period of childhood, in which the individuals have time to form lasting, closely knit families. Elephant social organization has recently been shown to be remarkably similar to that of man; *in fact, the entire ecology of the elephant is now seen to be more similar to that of man than to any other animal.* It is therefore not remarkable that man and the elephant are having to face similar and simultaneous crises—like survival.

In Africa today, animal populations are being increasingly confined within limited and unnatural boundaries—unnatural in the sense that they are more political than ecological. Within these boundaries, which are no more than sanctified ghettoes, animal populations tend to increase up to—and then beyond—the limits of the food supply. In a world with finite resources, the elephant is second only to man in its capacity to inflict long-term, irreversible damage on its environment—reducing the diversity and complexity of the habitat (as well as its own food base) by converting forest and woodland into grassland and desert. Not surprisingly, the elephant is ravaged by many of the same symptoms as man: stress, violence, vandalism, heart disease. Of 2,000 elephants sampled in Murchison Falls National Park in 1966, almost all the mature individuals (age 13-14) were discovered to be suffering from stress-induced diseases of the cardiovascular system. Together, elephant and man are being driven toward the edge of the world.

For decades, the political authorities in East Africa have explained away their own very parochial failures by attributing the decline of elephant populations to "poaching" [and more recently to licensed hunting] in the mistaken belief that the problem will evaporate once the poaching and hunting are controlled. But the problem will not evaporate. The anaesthetic that envelops it is wearing thin, and soon it will come to the full consciousness of all that the increasing concentration of any species in arbitrarily restricted areas will result in overpopulation, habitat destruction, and local—and perhaps even wholesale—extinction of that species.

The question is this: Should this species be allowed to find its own level in relentless competition with others for the world's limited land and resources, or should this species be brought into balance with the environment and the other species that inhabit it?

Today this species is elephant—

Dr. Richard M. Laws
Director, British Antarctic Survey
(Natural Resources Environment Council),
Former Director, Tsavo Research Project, Kenya,

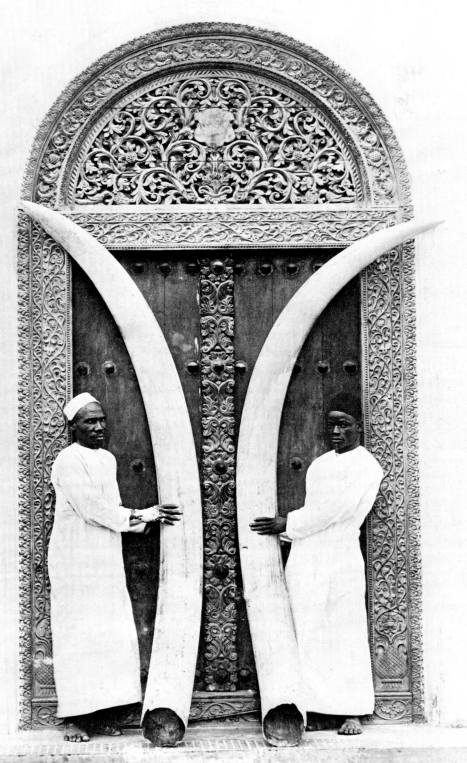

World-record tusks originally weighing 235 & 226 lbs
shot on the slopes of Kilimanjaro in the 1890's

Bibliography

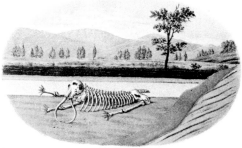

Fossil elephant found on banks of Hudson River 70 miles fr. N.Y.C in crowded bull area.

Akeley, Mary L. Jobe, E.R.G.S. *Carl Akeley's Africa; An Account of the Akeley-Eastman-Pomerey African Hall Expedition for the Museum of Natural History.* New York, 1929.

Austin, H.H. "East African Railway Survey Mombasa-Lake Victoria Nyanza-Mombasa, 4-12-91." Unpublished diary available in the Northrup McMillan Library, Nairobi.

Baker, Sir Samuel White. *Albert Nyanza.* London, 1866.

Baldwin, W.C. *African Hunting from Natal to the Zambesi.* London, 1863.

Beard, Peter H. *The End of the Game.* New York, 1965.

Bell, W.D.M. *The Wanderings of an Elephant Hunter.* London, 1923.

Binks, H.F. *African Rainbow.* London, 1959.

Blixen-Finecke, Bror von. *African Hunter.* London, 1937.

Blunt, David Enderly. *Elephant.* London, 1927.

Boedeker, Dr. E. "Early History of Nairobi Township." Unpublished MS. available at City Hall, Nairobi.

Boyes, John. *John Boyes, King of the Wa-Kikuyu; A True Story of Travel and Adventure in Africa "Written by Himself."* London, 1911.

————. *The Company of Adventures.* London, 1928.

Brode, H. *Tippoo Tib.* London, 1907.

Bryden, H.A., editor. *Great and Small Game of Africa.* Contributors: H.A. Brydon; T.E. Buckley; Lord Delamere; H.C.V. Hunter; F.J. Jackson; C.B.; Sir Harry Johnston, K.C.B.; F. Vaughan Kirby; A.H. Neumann; A.E. Pease; F.C. Selous; Alfred Sharpe, C.B.; Major H.G.C. Swayne; and others. London, 1899.

Buffon, C.L. De. *Histoire Naturelle.* Paris, 1782.

Burton, Sir Richard. *Lake Regions of Central Africa.* London, 1860.

Buxton, Edward North. *Two African Trips.* London, 1902.

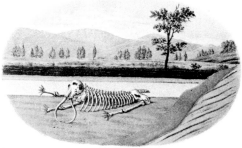

P.B. 1960

Carl Akeley

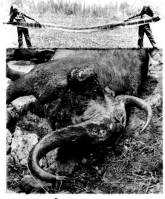

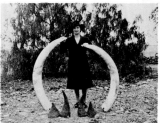

Cagnolo, Fr. C., I.M.C. *The Akikuyu; Catholic Mission of the Consolata Fathers.* Nyeri (Kenya), 1933.

Calder, Nigel. *Eden Was No Garden, an Inquiry into the Environment of Man.* New York, 1967.

Carothers, Dr. J.C., M.B., D.P.M. *The Psychology of Mau Mau.* Nairobi, 1954.

Carrington, Richard. *Elephants.* London, 1958.

Chedd, Graham. "Hidden Peril of the Green Revolution," *New Scientist,* October 22, 1970.

Churchill, W.S. *My African Journey.* London, 1908.

Cloudsley-Thompson, J. L. (ed.). *The Biology of Deserts.* London, 1954.

Collins, Douglas Tatham. *A Tear for Somalia.* London, 1960.

a warden's mother 1945

Cullen, Anthony. *Downey's Africa.* London, 1959.
———; and Downey, Sydney. *Saving the Game; The Story of the Destruction and Attempts at Preservation of the Wild Life of East Africa.* London, 1960.

Daly, Marcus. *Big Game Hunting and Adventure.* London, 1937.

Darling. F. Fraser. *Wild Life in an African Territory.* London, 1960.

de Watteville, Vivienne. *Out of the Blue.* London, 1927.

Dinesen. Isak (Karen Blixen). *Out of Africa.* London, 1937.
———. *Shadows on the Grass.* New York, 1961.

Drayson, Captain Alfred W. *Sporting Scenes.* London, 1858.

Eliot, Sir Charles. *The British East African Protectorate.* London, 1905.

WORST YEARER

Colvile, H. *Land of the Nile Springs.* London, 1895.

Cooley, W.D. *Inner Africa Laid Open in an Attempt to Trace the Chief Lines of Communication Across That Continent South of the Equator with the Routes to Europe and the Cazambe Moenemoezi and Lake Nyassa and the Discoveries of Messrs. Oswell and Livingstone in the Heart of the Continent.* London, 1852.

Corfield, F.D. "The Origins and Growth of Mau Mau; An Historical Survey." Sessional Paper No. 5 of 1959/60 for the Kenya Legislative Council.

Finaughty, William. *Finaughty; Recollections of an Elephant Hunter.* Edited by Edward C. Tabler. Cape Town and Amsterdam, 1957.

Findlay, Frederick Roderick Noble. *Big Game Shooting and Travel in South-East Africa.* London, 1903.

Foa, Edward, F.R.G.S. *After Big Game in Central Africa.* Translated by Frederick Lees. London, 1899.

Foran, W. Robert. *A Cuckoo in Kenya; The Reminiscenses of a Pioneer Police Officer in British East Africa.* London, 1936.

Foreign and Colonial Compiling and Publishing Co. *East Africa (British); Its History, People, Commerce, Industries, and Resources.* Compiled by Somerset Playne. London, 1908-1909.

Galle, Omer R., *et al.* "Population Density and Pathology: What are the Relations for Man?" *Science,* 1972.

Giamatti, A. Bartlett. *The Earthly Paradise and the Renaissance Epic.* Princeton, New Jersey, 1969.

Grant, J.A. *A Walk Across Africa.* London, 1864.

Graham, Alistair. *Gardeners of Eden.* London, 1973.

Greenwood, James. *Wild Sports of the World.* London, 1864.

Grogan, Ewart Scott, and Sharp, Arthur H. *Cape to Cairo.* London, 1900.

Hardin, Garrett. *Exploring New Ethics for Survival: The Voyage of the Spaceship Beagle.* New York, 1972.

Harris, Captain William Cornwallis. *The Wild Sports of Southern Africa.* London, 1839.
———. *Portraits of the Game and Wild Animals of Southern Africa; Delineated from Life in Their Natural Haunts during a Hunting Expedition from the*

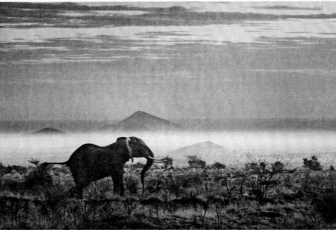

J.H. Patterson

Cape Colony as Far as the Tropic of Capricorn in 1836 and 1837 with Sketches of the Field Sports. Drawn on stone by Frank Howard. London, 1840.

Hayes, K. J. "The Virilizing Effect of Wheel Running in Male Rats," *Hormones and Behavior.* 1971.

Hempstone, Smith. *Africa—Angry Young Giant.* New York, 1961.

Henderson, Ian. *The Hunt for Kimathi.* London, 1955.

Hohnel, Ludwig Ritter von. *Discovery of Lakes Rudolf and Stefanie.* Vienna, 1892.

Elephant; in Art, Archaelogy and Science. New York, 1916.

Laws, Richard M., Parker, I.S.C., Johnstone, R.C.B. *Elephants and Their Habitat: The Ecology of Elephants in Northern Bunyora, Uganda.* Oxford, 1975.

Leopold, Aldo. *A Sand County Almanac.* New York, 1949.

Livingstone, David. *The Last Journals of David Livingstone.* London, 1880.

Lugard, F.J.D. *The Rise of Our East African Empire.* London, 1893.

Lyell, Denis D. *The African Elephant and its Hunters.* London, 1924.

and London, 1974.

Neumann, Arthur H. *Elephant-Hunting in East Equatorial Africa; Being an Account of Three Years Ivory-Hunting under Mount Kenya and among the Ndorobo Savages of the Lorogi Mountains, Including a Trip to the North End of Lake Rudolf.* London, 1898.

Ortega y Gasset, José. *Meditations on Hunting.* Trans. Howard Wescott. New York, 1972.

Oswell, W. Edward. *William Cotton Oswell; with Certain Correspondence and Extracts from the Private Journal of David Livingstone, Hitherto Unpublished.* London, 1900.

Patterson, J.H. *The Man-Eaters of Tsavo; And Other E. African Adventures.* London, 1907.

Glen Cottar 1965

& G.C. 1925

Hollis, Claude. *The Masai: Language and Folklore.* Oxford, 1905.

Hunter, John Alexander. *White Hunter; the Adventures of a Big Game Hunter in Africa.* London, 1930.
———— *Hunter.* London, 1952.

Huxley, Elspeth. *White Man's Country; Lord Delamere and the Making of Kenya.* London, 1935.

Jackson, Sir Frederick. *Early Days in East Africa.* London, 1950.

Johnson, Martin. *Camera Trails in Africa.* New York, 1935.

Johnson, Osa. *I Married Adventure.* New York, 1940.

Kirby, F. Vaughan. *Sport in East Central Africa.* London, 1899.

Krapf, Johann Ludwig. *Travels, Researches and Missionary Labours during an 18 Year's Residence in Eastern Africa together with Journeys to Jagga, Usambara, Ukambani, Shoa, Abessinia and Khartum and a Coasting Voyage from Mombaz to Cape Delgado.* London, 1860.

Kunz, George F. *Ivory and the*

Mackinder, H.J. "A Journey to the Summit of Mount Kenya, British East Africa." *The Geographic Journal,* Vol. XV, No. 5. May, 1900.

Maxwell Marius. *Stalking Big Game with a Camera in Equatorial Africa.* London, 1924.

Meikle, R.S. *After Big Game.* London, 1914.

Meinertzhagen, Col. Richard. *Kenya Diary; 1902-1906.* London, 1957.

Melland, Frank. *Elephants in Africa.* London, 1938.

Millais, John Guille. *A Breath from the Veldt.* London, 1895.
————. *Life of Frederick Courteney Selous.* London, 1919.

Moore, Audrey, *Serengeti.* London, 1938.

Moorehead, Alan. *The White Nile.* New York, 1960.

Muirhead, J.T. *Ivory Poaching and Cannibals in Africa.* London, 1933.

Nash, Roderick. *Wilderness and the American Mind.* New Haven

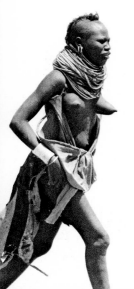

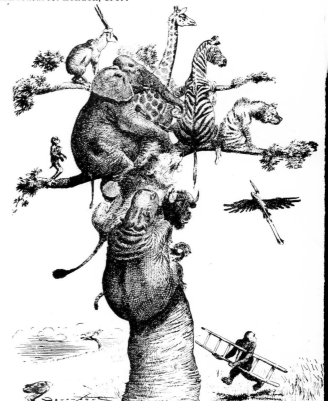

————. *In the Grip of the Nyika*. London, 1909.

Pease, Sir Alfred E. *The Book of the Lion*. London, 1913.

Percival, A.B. *A Game Ranger on Safari*. London, 1928.
————. *A Game Ranger's Notebook*. London, 1924-1925.

Peters, Carl. *New Light on Dark Africa*. London, 1891.

Pomeroy, Daniel E.; Akeley, Carl; Johnson, Martin; Eastman, George; Percival, Philip. *Chronicles of an African Trip*. Rochester, N.Y. 1927.

Pretorius, Major P.J. *Jungle*

Man. Autobiography. Foreword by Field Marshall J. C. Smuts. London, 1947.

Rampley, W.J. "Mathew Wellington; Sole Surviving Link with Dr. Livingstone." *East African Annual*, 1930-1931.

Roosevelt, Theodore. *African Game Trails; An Account of the African Wanderings of an American Hunter-Naturalist*. New York, 1910.
————; and Heller, Edmond. *Life-Histories of African Game Animals*. New York, 1914.

Royal National Parks of Kenya; Annual Reports 1946-1963. Nairobi (Kenya).

Schiffers, Heinrich. *The Quest for Africa: 2000 Years of Exploration*. London, n. d.

Schillings, C.G. *With Flashlight and Rifle*. London, 1906.

Beacon at top of NGONGS 1921 – 8,043!

Denys Finch – Hatton's grave on Lamwia

Kamante
AT K. BLIXEN'S

Selous, Frederick Courteney. *A Hunter's Wanderings in Africa*. London, 1881.
————. *African Nature Notes and Reminiscences*. London, 1908.

Sewell, Elizabeth. *The Human Metaphor*. South Bend, Ind. 1964.

Shepard, Paul. "A Theory of the Value of Hunting," *Transactions, 24th North American Wildlife Conference*, Washington, D. C., 1959.
————. *The Tender Carnivore and the Sacred Game*. New York, 1973.

Singh, Sheo Dan. "Urban Monkeys," *Scientific American*, 1969.

Speke, John Hamming. *Journal of the Discovery of the Source of the Nile*. London, 1910.

Stanley, Henry M. *In Darkest Africa*. Six volumes. London, 1890.
————. *The Autobiography of Sir Henry Morton Stanley, G.C.B.* Edited by his wife Dorothy Stanley. London, n. d.

Stevenson-Hamilton, Major J. *Animal Life in Africa*. Foreword by Theodore Roosevelt. New York, 1912.

Stigand, Captain C.H. *The Game of British East Africa*. London, 1909.
————. *Hunting the Elephant in Africa*. Introduction by Colonel Theodore Roosevelt. New York, 1913.

Stoneham, C.T. *Mau Mau*. London, 1952.

Sutherland, James. *The Adventures of an Elephant Hunter*. London, 1912.

Swann, A.J. *Fighting the Slave-Hunters in Central Africa*. London, 1910.

Thomson, Rev. J.B. *Joseph Thomson, African Explorer*. A biography by his brother. London, 1897.

Thomson, Joseph. *To the Central African Lakes and Back*. London, 1881.

Tippu Tip, Maisha Ya Hamed Bin Muhammed El Murjebi Yaani. *Tippu Tip*. Kampala (Uganda), 1908.

Topsell, Edward. *The History of Four-Footed Beasts, Serpents & Insects . . .* 1658.

Tucker, A.R. *18 Years in Uganda and East Africa*. London, 1908.

Wales, Prince of. *Sport and Travel in East Africa; Two Visits, 1928 and 1930*. Compiled from the private diaries of H.R.H. The Prince of Wales by Patrick R. Chalmers. London, 1934.

Ward, Roland. *Records of Big*

World-record ivories 226½ and 214 lbs.

Game (11th edition.) London, 1962.

Watt, Mrs. Stuart. *In the Heart of Savagedom; A Quarter of a Century of Pioneering Missionary Labours*. London, 1912.

Willoughby, Captain Sir John C. *East Africa and its Big Game*. London, 1889.

Wyner, Norman. *The Man from the Cape*. London, 1959.

Yeats, William Butler. *Collected Poems*. New York, 1933.

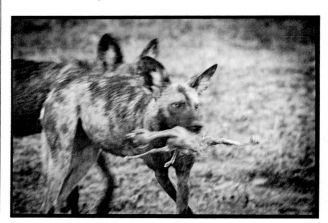

Acknowledgements

"The preparation of this narrative has taken much longer than, from my inexperience in authorship, I had anticipated...[You] have no idea of the amount of toil it involves." Dr. Livingston, *Missionary Travels,* 1857. For helping to make this book I cannot adequately thank Patrick Filley at Doubleday; Ruth Ansel and Marvin Israel, who did most of the work, Bettina Rossner, for final production, Steven M.L. Aronson, whose exacting, extensive and creative editorial consultation has brought this book to new life. Particular thanks are owed to Carol Bell, Richard Bell, Bill Dupont, Mary Giatas, Ian Parker and Bryan Patterson, and especially Carol Shaffer for research and general assistance; also Dick Cole and Bob Bishop for their work on the photographs.

Others whose assistance have been invaluable over the years are, in Africa: Don Bausfield, the Binkses, John Boyes, Doria and Jack Block, Bryan Coleman, Gilbert Colvile, Doug Collins, Glen and Pat Cottar, Mervyn Cowie, Syd Downey, Robert Foran, Bob Foster, Kamande Gatura, General Ndirangu Chui, Alistair Graham, Wambua,Galo-Galo, Iam Grimwood, Ewart S. Grogan, Mohamed Ali Hassam, John Kingsley Heath, the Hills, Harry Horn, the Howdens, J. A. Hunter, Iman, Mohamed Juma, Sgt. Camau, Kivoi, Richard Laws, Richard Leakey, Esmond Martin, Matasa, Mr. and Mrs. Ray Mayers, Gathura Muita, Joseph Murumbi, Philip Percival, Jennifer Percy, Gordon Plant, Harold Prowse, Ken Randall, Alan Root, Monte and Lisa Ruben, David Sheldrick, Phil Snyder, Major W.H. Taberer, Ian Tippett, and Murray Watson; also the National Museum in Nairobi, the *East African Standard* research department, and the Theodore Roosevelt Society, particularly Archibald Roosevelt.

In Denmark, Thomas Dinesen and the entire Dinesen family, Bitter and Keith Keller, Clara Svendsen, the Royal Library of Copenhagen, and the Rungstedlund Foundation.

In England, Francis Bacon, Miss Buxton and Mister Lees of the Oxford School of Geography, Ann Datta and the South Kensington Museum of Natural History.

In New York: Charles Adams, Barbara Allen, Norman Borlaug, Andreas Brown, Cornell Capa, Roz Cole, Harry Deutsch, the Ekstroms, Richard Estes, Joe Eula, Bart Giammatti, Robert G. Goelet, Larry Goldman, Bill Harrison, Kathy Heavey, Mr. Hillman, Steven Horn, Robin Hurt, Caroline Kennedy, Bill Knight, Diane Korling, Vito LaFata, Karen Lerner, Gladys Little, Hilda Lindley, Kevin and Roger McCann, Jay Mellon, Tee Miller, John Nilon, John Palmer, Phil Pessoni and the Lexington Labs, Margritte Ramme; at Rapoport Printers,Sid Rapoport, Ben Albala, Jethro Allen, Henry Austin, Joe Behar, Elaine Donnelly, Charles Fingerle, Richard Gurleski, Rod Leprine, Tom O'Brien, Pearl Kaplan, Peter Nassau, and John Shea; John Sargent, Peter Schub, Bernie Sendor and Jill Sendor, Arnold Skolnick, Lisa Sohm,Claudia Steinberg, Bob Williamson and Robert Zarem; also the Duggal Laboratories, the Kingsley Trust Association and the Yale Library; and to Random House Publishers for permission to reprint material from *Out of Africa* by Isak Dinesen, copyright 1937 by Random House and renewed 1965 by Random House, reprinted by permission of the publisher.